BILL DUNSTER

ZEDLIFE

ow to Build a Low-Carbon Society Today

RIBA ⌗ Publishing

Acknowledgements

The ZEDlife concept has evolved with the input of everyone that has either worked at ZEDfactory or collaborated with us to design, build and commission climate neutral development projects. We need your enthusiasm and your help to keep going and make progress every year. Special thanks are therefore given to: Alan Powers for patiently helping to craft the narrative, and asking me to keep trying harder; Sue Dunster for keeping ZEDfactory going and making sure this book got written; Fiona Qian for designing and project managing the ZEDlife book within the ZEDfactory, and working with the RIBA Enterprises so carefully. Above all, the ZEDfactory directors that carry these projects forward with their own skill and hard work: Rehan Khodabuccus for spending four years writing a PhD on the Zero Bills Homes concept and then helping set up the Zero Bills Home Co with David Burdett Brown; and Gilles Alvarenga, Yan Guo, and Lalit Chauhan for inspired input to the ZEDfactory live projects. The next generation is going to be an improvement in all respects. Credit too must be given to Jon Double for his visualisations, and the architects that have made these projects work: Taus Larsen, Asif Din, Steve Harris, Tianran Dong, Roberto Rocco, Shaoru Wang, Miguel Suarez, Yuan Ning, Leigh Bowen and Susan Venner. Finally, thank you to the BRE Innovation Park and Martin Milner (structural engineering) for working with us on both the Zero Bills Home and the ZEDpod prototypes, and to our most recent clients that have set the all-important challenge to deliver viable development solutions: Mr Li – President of the Yourun International Company – Jingdezhen ceramic quarter regeneration; Marcos Byington Egydio Martins and José Augusto Byington Leite de Castro of the Itayhe estate; Paul Heistein – One Planet Amersfoort; Matt Bulba – Shoreham Cement Works; David Burdett Brown – The Zero Bills Home Co.; Belinda and Colin Challenger of the Sir Arthur Ellis Trust – Newport Eco-village; Carl Grover – EcoGrove Eco-village – Barking and Dagenham; Tom Northway – ZEDpods; and of course, to Peter Bonfield and Jonathon Porritt for reading the book and commending it to others.

© RIBA Publishing, 2018

Published by RIBA Publishing, 66 Portland Place, London, W1B 1NT

ISBN 978-1-85946-999-6 / (PDF) 978-1-85946-876-0

The right of Bill Dunster to be identified as the Author of this Work has been asserted in accordance with the Copyright, Designs and Patents Act 1988 sections 77 and 78.

British Library Cataloguing-in-Publication Data
A catalogue record for this book is available from the British Library.

Commissioning Editor: Ginny Mills
Project Editor: Daniel Culver
Project Manager & Design: Alex Lazarou
Printed and bound by: Page Bros, Great Britain
Cover image credits: ZEDfactory

www.ribapublishing.com

Contents

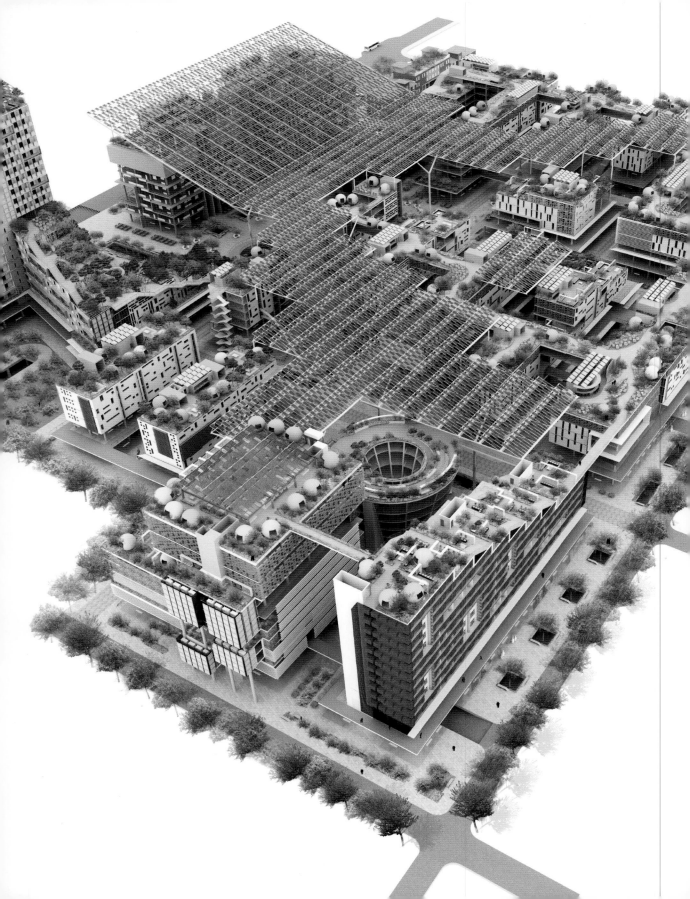

Preface

Generation ZED

When there is little or no environmental leadership from central government, if people want to protect the water, the air and the food that sustains them then they must take direct action themselves. This requires some thought but is now increasingly possible, affordable and desirable. The escalating financial costs of the healthcare required to offset unhealthy food, unhealthy lifestyles and toxic pollution, plus the rising costs of electricity, heat, fossil fuels and climate change adaptation make it possible to find alternative low environmental-impact strategies that are now viable.

The continuous development of new decentralised technology, coupled to our deeper understanding of building physics, climatic conditions and climate change, enable us to reassess achieving climate-neutral targets at much smaller scales than previously thought possible. The aspirational 'net zero-carbon' agenda that should form the basis for every national construction industry and housing programme can now be demanded by everyone who is asked to invest in a building or infrastructure. Instead of waiting for politicians to introduce mandatory legislation setting minimum standards, it is now time for the customer to demand construction that does not pollute the air, has no energy bills and offers a higher quality of life. Anything less means that all of us have been short-changed. Generation X was a protest over a dysfunctional and environmentally bankrupt society powered by fossil fuels. Generation ZED is going to try and find a future that works.

The Paris Agreement of 2016 was almost the first clear consensus from the majority of the human race about planetary-scale governance.

It is no longer clear that the existing industrial base and its funding capital will embrace the need to reduce its environmental impact fast enough to respond to the challenges set by international accord and defined in the Paris Agreement.

It is also no longer clear that national politicians are prepared to communicate the seriousness of the 'tipping point' as they are rarely rewarded for bearing bad news. A perceived conflict has emerged between compliance with the Paris greenhouse gas emissions targets and the short-term financial gain achieved by nations that reject this more onerous environmental-impact legislation.

The longer-term health benefits of planning in industrial production and the construction industry to reduce energy and materials consumption, at the same time as improving air pollution and

cleaning rivers and coastlines, is often forgotten by nationalists seeking to preserve the existing financial status quo.

However, synchronising environmental performance standards around the Paris Agreement creates an international 'common market' based on the highest standards. Any country delaying investment in clean technologies and industrial production that meets this 'common market' will quickly lose access to production economies of scale and will lose its export market. At the same time the quality of life in these countries will be increasingly degraded by air and water pollution, shorter life expectancies and increased expenditure on sourcing fossil fuels, either from fracking or aggressive procurement outside its national boundaries.

As Buckminster Fuller has said, 'The best way to predict the future is to design it.' If there cannot be leadership and responsible environmental legislation from politicians or governments the onus is for individuals, companies, towns, cities and even countries to set voluntary environmental standards and to participate in the behavioural and cultural change required to deliver the Paris Agreement. This becomes a 'grass roots' environmental movement led from the bottom-up not the top-down.

It appears we can no longer rely on the centralised supply of affordable services such as electricity, water and local public transport or even food production, education and healthcare. In many countries none of these essentials are taken for granted.

This failure of leadership due to vested interests means all of us must participate and collaborate to achieve the highest quality of life that can be available to the maximum number of people. This requires a set of low-carbon technologies and urban systems thinking that can transform the existing dystopia into an equitable, clean, green way of life. A mixture of voluntary birth control, interactive technology and systems planning can still stop our species becoming the plague that tipped climatic change into an irreversible process that could sterilise the planet.

The following questions could inform both the regeneration of our existing communities as well as change some the key factors informing contemporary architecture and urbanism:

- How does our electric grid change urban and architectural morphologies?
- How could energy storage change both urban and rural lifestyles?
- How could planning a circular economy change urban design?
- How can cities reduce air pollution while increasing the convenience of personal transportation?
- How can energy demand be reduced to the amount of renewable energy available locally, or even within the plot boundaries?
- How can the early adopters of this thinking be rewarded with no net annual energy bills and possibly no local transportation costs?
- How can existing buildings and urban quarters adapt and be transformed to meet the new standards required by the Paris Agreement?
- What could these new buildings and urban transformations look like, and can a new vernacular evolve from the Paris Agreement?

ZEDlife looks at a set of complementary tools that fit together to deliver low environmental-impact architecture and urban design at various densities and scales of deployment. It sets up clear supply chain and manufacturing opportunities for a clean tech industrial transformation and provides a roadmap for practical solutions that will enable almost any community to plan for meeting the environmental performance targets agreed by the global community in Paris 2016. The solutions are flexible and can be upgraded with technological progress. Those that embrace this thinking first will have a strategic advantage in future markets and will gain both experience and international trade in manufacture, design and planning.

They may also enjoy sleeping at night.

Foreword

Dr Peter Bonfield OBE FREng
Chief Executive, BRE

Bill Dunster is a rare visionary; an entrepreneurial and courageous individual whose belief and commitment to a more sustainable built environment is outstanding. His quest for positive impact has delivered a number of pioneering exemplar projects and developments that demonstrate and prove his thinking. However, the built environment at large has not yet managed to encapsulate and embrace the types of thinking and approaches Bill has promoted and developed on a large scale. As a consequence Bill continues to pursue his relentless quest for greater sustainability in the built environment by finding kindred spirits and organisations to work with him so that his ideas obtain wider impact, and with that more financial sustainability.

We have been very pleased to host two of Bill's buildings at our BRE Innovation Park on our Garston Site just south of St Albans. One, the Zero Bills Home, takes the concept of sustainability to a place beyond where most people think. The goal of this house is not to minimise negative impacts of the environment, but instead to use the house to be a net generator of positive impacts by combining energy efficiency and renewable technologies, for example. The house is also able to be built by major developers or individual house-building enthusiasts in a cost effective way.

The second building he has built is called the ZEDpod, which is an innovative design aimed at providing low cost and sustainable housing on 'grey field' sites – car parks and similar – which have the potential for providing dwellings as well as places for parking.

These two projects, the ZeroBills Home and ZEDpod are typical of Bill's approach; pushing boundaries and driving innovation ahead of the norm and showing others how the future can be delivered, today.

This book gives insights into Bill's sometimes uncompromising perspectives on how things and organisations are and how they should be. He shares his ideas, often in significant detail, to show how he thinks housing and developments should be delivered in pioneering and practical ways that meet the sustainable outcomes so needed by our society and our planet.

You may not agree with all he says or proposes, but if you have a passion for a more sustainable future and if you are willing to open your mind to new ways to design and build then, like me, you will enjoy reading Bill's book. You will be stimulated to try new ways and methods so that a much more sustainable approach becomes the norm. And in doing so better protects our society and environment in a way that creates and enables better economic prosperity through innovation.

PART I
INTRODUCTION

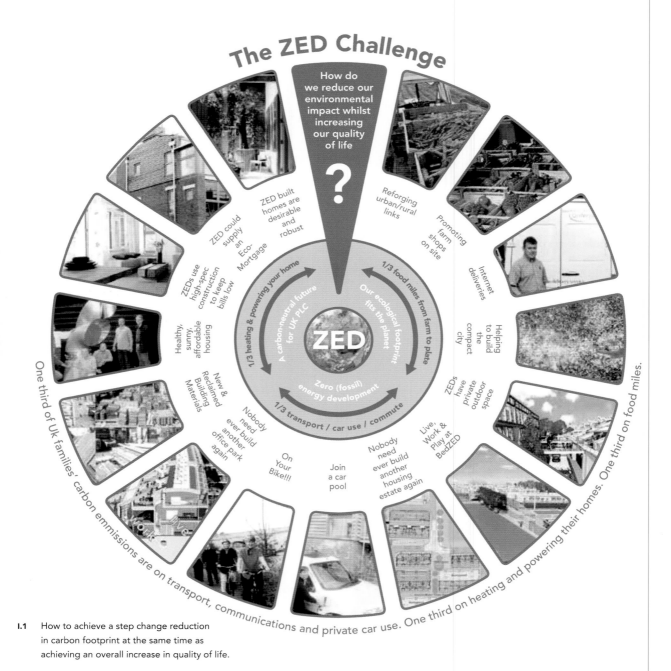

The ZED Challenge

How do we reduce our environmental impact whilst increasing our quality of life

?

ZED built homes are desirable and robust

Reforging urban/rural links

Promoting farm shops on site

Internet deliveries

ZED could supply an Eco-Mortgage

ZEDs use high-spec construction to keep bills low

Helping to build the compact city

Healthy, sunny, affordable housing

1/3 heating & powering your home

A carbon-neutral future for UK PLC

1/3 food miles from farm to plate

Our ecological footprint fits the planet

ZED

Zero (fossil) energy development

1/3 transport / car use / commute

ZEDs have private outdoor space

New & Reclaimed Building Materials

Nobody need ever build another office park again

On Your Bike!!!

Join a car pool

Nobody need ever build another housing estate again

Live, Work & Play at BedZED

One third of Uk families' carbon emmissions are on transport, communications and private car use. One third on heating and powering their homes. One third on food miles.

I.1 How to achieve a step change reduction in carbon footprint at the same time as achieving an overall increase in quality of life.

We use the word ZEDlife to describe how everyone could live in a way that will make things better if they knew how. The primary aim is to make fossil fuels, incineration and nuclear power things of the past. This is so much easier than people realise.

We have taken care to ensure that what we are suggesting here can be adopted without making drastic changes to current buildings and infrastructure. By keeping it simple, the transition to a resource-efficient society powered by renewable energy systems can move forwards gradually over the next three decades.

No doubt the solutions of today will be pushed aside by better ones in the future, but this book offers the best we can do for now – technology that sadly doesn't get discussed in the media. Once it is known about, the public can demand it and put pressure on politicians to play their part.

Whoever can do this first – companies or whole countries – will have the commercial advantage as they attract international investment and achieve economies of scale fastest, while reducing the money spent competing and cleaning up after fossil fuels. Think of Silicon Valley in the 1990s, but triggered in this case by national governments setting environmental performance standards that in turn set the rules for global industrial supply chains.

A painful failure in this regard occurred in March 2015 when the UK government, under pressure from volume housebuilders, decided to scrap the implementation of Code 6 of the Code for Sustainable Homes. Seven years of preparation by the house-building industry, under the expert guidance of the highly respected Building Research Establishment (BRE), was meant to lead up to compulsory adoption in 2016. This wasn't just the imposition of 'green crap' as the prime minister of the time chose to call it,[1] but a major opportunity for British manufacturing and services to compete internationally. Instead, the cancellation virtually handed the advantage to the European 'Passivhaus' supply chain. When (we hope, rather than 'if') this political decision is eventually reversed by a future administration, the UK will find its industry only fit for delivering the minimum legal standards required by the building regulations. We shall have lost the business advantage together with the benefits of lower energy bills for consumers and the stock of higher-value homes that could have accrued in the meantime.

Not surprisingly, the countries that set the highest environmental performance standards develop the international supply chains that win the most business. If our governments neglect to look after our interests in this way, we must do the best we can without their help. We called our office ZEDfactory to reflect the need for planning and collaboration with fabricators and industrialists. The 'ZED' stands for Zero [Fossil] Energy Development. Bringing together architects and engineers with industrial production is the only way to create the tools that will realise a workable low-carbon society. This way, architecture can play a role that is more valuable to society than its normally limited scope of giving cosmetic treatment to buildings whose design is really determined by market forces working with minimum environmental standards.

Humans are the only species that has tried to self-consciously plan its survival on earth. This attempt defines civilisation, so let's not lose sight of it now. The ability to observe what is happening to the environment, to understand the reasons for change and then to anticipate future change is unique to our species. Right now, the risks are higher than they have ever been. Fuel costs will rise over the long term, accelerating climate change and conflict over dwindling resources. The actions of governments, slowed by their own internal conflicts, cannot be expected to rise to the challenges of change (**fig. I.1**).

The good news is that we have reached the point where we can understand building physics and associated technology well enough to empower individuals to solve their own infrastructure requirements without asking for permission or assistance from a central authority.

The decentralisation of information technology, local transport, energy and infrastructure is similar to the displacement of landlines by mobile phones – all that was required was a piece of kit we didn't have before. This DIY future is well underway and it is time to assemble the tools and make them available to as many people as possible.

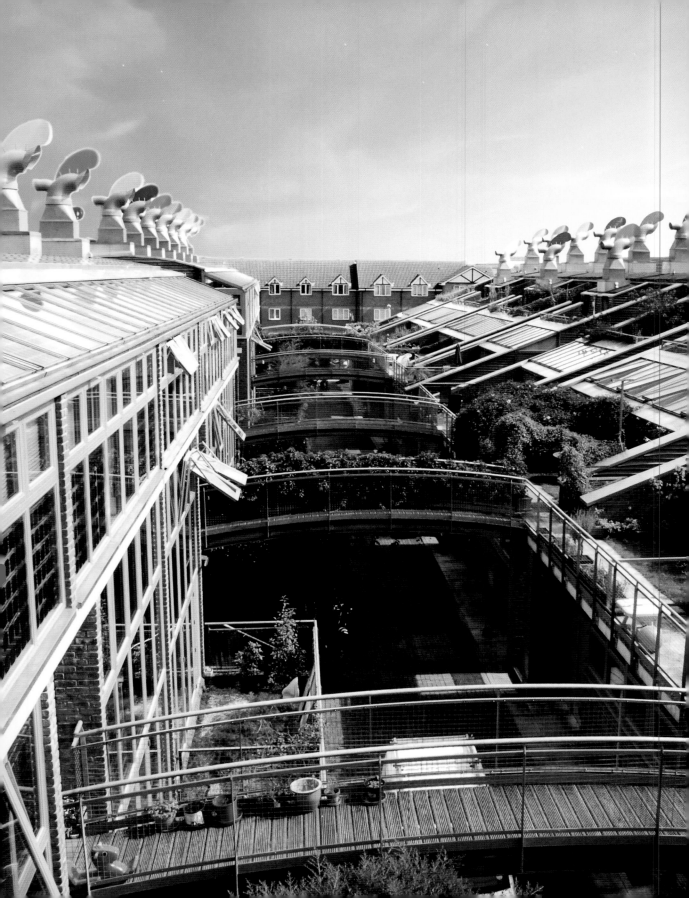

A Beginner's Guide to ZEDlife

The ZEDlife – a philosophy for the construction industry?

Humans are the first species that have tried to self-consciously plan their survival, but our ability to do so has fluctuated throughout time. Recently it has become clear that not enough people understand the problem, let alone the solution. We have formulated ZEDlife as a relatively simple plan for creating stability in society by ceasing to deplete the natural capital of the earth on which we live.

The need for such a scheme ought to be beyond question. Survival is far from assured, and in the face of such dangers there is no place for schemes that are too complex, or liable to fail. We need a plan robust enough to survive a wide variety of unexpected events. Solutions to the impending crisis have been held back by disagreement over details and the conflicts of political groups and their supporters. This is why attempts to achieve solutions by political means are too slow to keep pace with rising fuel costs, accelerating climate change and conflict over dwindling resources.

What is natural capital? It means resources such as fresh water, fertile soil and predictable climate events. As climate change accelerates, these resources are depleted and 'business as usual' becomes untenable, so our ingenuity will be tested. The ZEDlife strategy will undoubtedly change in response to new threats and our ever greater understanding of how best to adapt to them. The following 12 priorities are fundamental to our collective survival:

1: STOP RUNAWAY CLIMATE CHANGE

Climate change is not desirable and there is an international consensus for reducing human generated atmospheric greenhouse gases. The targets defined by COP21, the conference held in Paris in 2015, must be delivered well before the planned deadlines to maximise our chances of staying within relatively benign levels of global temperature rise.

2: LEAVE ALL FOSSIL FUELS IN THE GROUND

All fossil fuels should be left in the ground. Extracting them from the ground means they will be burnt by someone somewhere on the planet, no matter what international treaties have been signed. If the developed world increases energy efficiency, paradoxically this makes the problem worse, as the oil producers are likely to cut their prices and entice developing countries to abandon their drives for efficiency and consume more oil and gas instead. The outcome is at best neutral, and this in itself is a further step towards disaster (**fig. 1.2**, *overleaf*).

1.1 Mature skygardens at BedZED,
reaching the residential density of Soho.

1.2 Fossil fuels equals conflict.

1.3 It is important not to forget Chernobyl and Fukushima.

1.4 The capital cost of nuclear power could make it poor value for money and the high embodied CO_2 of construction and legacy suggest that a whole-life carbon footprint analysis may reveal that the electricity produced is far from carbon neutral.

1.5 The decommissioning and radioactive legacy containment costs of the UK's existing nuclear power programme are similar to the reported costs of the UK's two Gulf wars. Redeploying the same funds into energy efficiency and renewable energy could have avoided both.

1.6 Can carbon be the new currency in our social evolution?

3: REPLACE FOSSIL FUELS WITH PROGRESSIVELY VIABLE ALTERNATIVES

We must replace fossil fuels with renewable energy alternatives, and nuclear fuels are not among them. Nuclear materials can poison food and water supplies, and no one can confidently predict the indefinite continuation of high levels of monitoring and the absence of natural or man-made disasters at nuclear sites. Thirty years after the nuclear pollution from Chernobyl spread to the British Isles, Welsh lamb can still show high levels of radiation, while the only nuclear storage we have at Sellafield still discharges into local air, sea and land even though it is not supposed to. There is no independent evidence that nuclear is a valid low-carbon energy source – or that it can be responsibly managed for millennia. There are renewable alternatives that carry virtually no risks, so we should not be considering further dangers from this outdated fossil fuel technology (**figs 1.3–1.5**).

Investigation into bungle over nuclear plant deal

£6bn clean-up contract to finish early after minister admits tenders for Magnox reactors were 'flawed'

By Alan Tovey

AN INQUIRY has been launched into the contract to decommission Britain's Magnox nuclear power stations after the scale and cost of cleaning up the ageing reactors spun out of control, forcing the deal to be scrapped.

The Nuclear Decommissiong Authority (NDA) yesterday pulled the deal with Cavendish Fluor Partnership (CFP) to decommission a dozen reactors, as it was discovered far more work was needed than specified in the original contract.

Two years ago the deal was awarded to CFP – in which blue-chip Babcock has a 65pc stake – with it expected to run for 14 years.

However, with complications mounting and costs soaring, the NDA has decided to end the £6bn agreement after just five years in 2019, admitting the way the tendering process was botched.

In 2005 the NDA put the future costs of decommissioning Britain's entire nuclear estate at about £50bn though this has now soared to about £110bn, with the giant Sellafield plant - which is not part of the Magnox clean-up - accounting for about £87bn of the total, according to experts.

Dr Paul Dorfman, from University College London's Energy Institute, said: "They were set up to fail and have failed because the understanding of costs and complexity to nuclear decommissioning is changing all the time.

"Magnox reactors were thrown up in a rush to give electricity too cheap to meter and create plutonium and there

was no thought of how they would be decommissioned.

"Each Magnox reactor is bespoke so decommissioning each one is different with its own complexities and challenges. The more we learn about dealing with the 'back end' of nuclear power, the more we see how complex and costly it is."

Energy Secretary Greg Clark said an independent inquiry led by former National Grid boss Steve Holliday will investigate what went wrong with the contract, raising the spectre of disciplinary proceedings for those responsible. "Taxpayers must be confident that public bodies are operating effectively and securing value for money," Mr Clark said.

However, the botched contract has already left the taxpayer facing a £100m bill to settle the legal claims of two companies whose bids were unsuccessful, with Mr Clark admitting "it was clear the tender process was flawed".

Mr Clark said that the decision to end the deal early was "no reflection" on CFP's work. However, the news sent shares in Babcock down 4.3pc, to 877p, with the company's order book being reduced by £800m as a result.

Although the contract decision was one for the NDA, Mr Clark said it was so significant that it required his sign-off, along with that of the Treasury.

"We have a responsibility to ensure that the NDA's decisions reflect its legal obligations, including under procurement law, that further risks to taxpayers' money are contained, and that robust arrangements are put in place to deliver this essential decommissioning programme," he added.

The NDA will now start preparing a new contract for when the CFP deal ends in 2019.

However, analysts expect the company to be well placed on future decommissioning work.

Japan's nuclear warning to the UK: be prepared for the worst

Fukushima chief sounds alarm over hazards as Britain plans new reactor

Simon Tisdall Tokyo

The catastrophic triple meltdown at the Fukushima Daiichi nuclear plant was "a warning to the world" about the hazards of nuclear power and contained lessons for the British government as it plans a new generation of nuclear power stations, the man with overall responsibility for the operation in Japan has told the Guardian.

Speaking at his Tokyo corporate headquarters yesterday, Naomi Hirose, president of the Tokyo Electric Power Company (Tepco), which runs the stricken Fukushima plant, said Britain's nuclear managers "should be prepared for the worst".

"We tried to persuade people that nuclear power is 100% safe. That was easy for both sides. Our side explains how safe nuclear power is. The other side is the people who listen and for them it is easy to hear OK, it's safe, sure, why not?

"But we have to explain, no matter how small a possibility, what if this [safety] barrier is broken? We have to prepare a plan if something happens ... It is easy to say this is almost perfect so we don't have to worry about it. But we have to keep thinking: what if ...?"

British ministers recently agreed a commercial deal with the French state-owned energy company EDF Energy to build the UK's first new nuclear reactor in a gen-

eration at Hinkley Point in Somerset. The agreement included the UK government providing accident insurance.

Tepco's Fukushima Daiichi facility, on the coast about 124 miles north-east of Tokyo, was hit by a giant tsunami with waves peaking at 17 metres high caused by the Great East Japan earthquake on 11 March 2011. In what quickly became one of the world's worst nuclear disasters, operators lost control of the plant when the power supply, including emergency back-up, failed amid massive flooding. As cooling systems malfunctioned, reactors 1, 2 and 3 suffered meltdowns.

Hirose said that although the situation facing Fukushima Daiichi on 11 March was exceptional, measures could have been

hydrogen explosions blew the walls and roof off the reactor building. This week a delicate and lengthy operation to remove fuel rods from that reactor began.

Radiation leakage forced the evacuation of tens of thousands of people from the area. An exclusion zone 11 miles by 19 miles remains in force two and half years later. The facility is being decommissioned, but Tepco's clean-up, which has been criticised by environmentalists, is expected to take up to 40 years.

Continued on page 20 »

1.3

'Colossal' cost alert on Hinkley Point

● French minister says EDF was 'carried away' ● Fears over impact on utility of £18bn outlay

MICHAEL STOTHARD and ANNE-SYLVAINE CHASSANY — PARIS

France's energy minister has warned of the "colossal" cost of the £18bn flagship Hinkley Point nuclear project to EDF, saying the state-owned utility may have been "carried away" with its British investment.

The comments by Ségolène Royal are likely to fuel already fraught talks over a final investment decision for the plant that is critical to the UK's energy future. The Somerset power station is expected to provide 7 per cent of the nation's electricity within a decade.

Ms Royal told the Financial Times she was worried by the impact the project

would have on EDF's already stretched balance sheet if it were to proceed. "I am wondering if we should go ahead with the project. The sums involved are colossal," the minister said.

The French government has an 85 per cent stake in EDF, which said this week that it had put aside a further £2.7bn for "extreme scenarios" relating to the project, meaning the total bill could surpass £20bn.

As majority shareholder, France has the most clout on the decision for the project, which has already suffered repeated delays – the latest at the behest of Ms Royal. A final decision for Hinkley Point, which is being built with

Chinese partner CGN, is now not expected until September.

Other members of the French government, including Emmanuel Macron, the economy minister, have said the project must go ahead, as it has already been informally agreed with the UK government and it is crucial to the future of France's struggling nuclear industry.

Ms Royal is the only minister publicly to express doubts but, as President François Hollande's former partner and mother of his four children, she is an influential force in the administration.

Ms Royal dismissed Mr Macron's argument about the impact on France's nuclear sector if EDF were to back out.

'I am wondering if we should go ahead. Sums involved are colossal'
Ségolène Royal

"I think that if Hinkley Point did not happen it would not put the French nuclear sector in danger," she said.

But she conceded that withdrawing would damage the French state's reputation. "It would send a bad signal [and] competitors would say, 'look at France, the state does not keep its word'," she said, adding: "That kind of thinking tends to weigh very heavily on decisions over whether we can reverse things when we got a bit carried away."

Trade unions at EDF are trying to halt the project while the chief financial officer quit this year, citing fears that the investment could bring EDF down.

Call for plan B page 2

1.4

1.5

4: MAKE ANY HUMAN ACTIVITY CLIMATE NEUTRAL

Carbon footprinting is a key concept to apply to every operation that we undertake – housing, offices or industrial uses, among many others. It is based on an equation between a certain site area and a target of carbon reduction. The aim is to generate a slight surplus of renewable energy from within the site to 'repay' the carbon produced during its creation and maintenance on an annual basis, while also matching its annual energy demand. The target is reached if the carbon footprint represented by the set-up of the project ('the embodied carbon') can be repaid within the estimated lifespan of that project. If this can be achieved, the project can be deemed climate neutral.

This is the goal, and if every construction project were to adopt this overall target quickly enough, human induced climate change could gradually reduce. This strategy might be a turning point in the evolution of human civilization because the threat of runaway global warming could be averted and the situation stabilised.

This simple shared priority must form the basis of any future government or legislation that claims to be acting on behalf of the best interests of the majority of its citizens. Since the first work on this book, the political situation has deteriorated in this respect in the US and the contagion may spread. This is why the COP21 agreement represents both a practical and symbolic line that now divides hope from despair.

5: USE CARBON AS THE NEW CURRENCY

Carbon dioxide (CO_2) can act as a currency for measuring the impact of any proposed human intervention, because carbon footprint and overall environmental impact are closely correlated, similarly the cost of conventional goods and activities and their overall environmental impact (**fig. 1.6**). In general, allowing for some exceptions, a common metric capable of simplifying even the most complex footprint audits is better in practical terms than aiming at 100% accuracy. If the footprint analysis is too complex, or takes too long, it becomes expensive and nobody wants to do it. Even if construction of any kind represents production of CO_2 that remains a form of embodied carbon, this can be offset by renewable energy generated by the project.

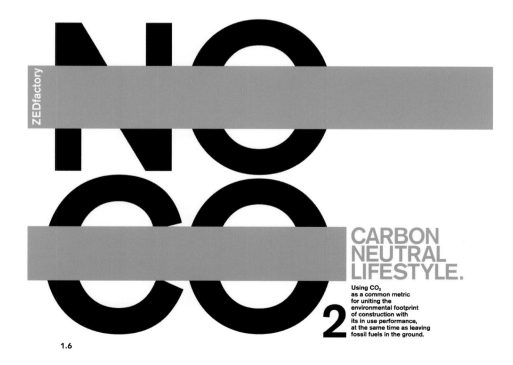

ZEDfactory

NO CO₂

CARBON NEUTRAL LIFESTYLE.

Using CO_2 as a common metric for uniting the environmental footprint of construction with its in use performance, at the same time as leaving fossil fuels in the ground.

1.6

6: DO NOT EXPORT YOUR PROBLEMS OFF-SITE

Developers of new construction projects have often paid to 'export' their CO_2 footprint by arranging that it should be matched by gains in a foreign country. Doing this takes away scarce opportunities for renewable generation, opportunities that will shortly be needed by more local communities. Therefore, this undesirable practice should be invalidated. All carbon offsets through renewables should be achieved on the same site as the project.

Because renewable energy is harder to store and transport, it tends to favour more local patterns of production and consumption. If the COP21 targets are achieved globally by 2050, almost every community will have to be running on renewable energy. No matter how much is invested in renewables we would not be able to meet the energy needs purely from renewable energy, even if demand were to be reduced by as much as a third.

At what point, then, do the carbon footprint accounts have to balance to ensure that the collective human civilization avoids causing runaway climate change? The ZEDlife solution favours simplicity because there is no right answer. As Mahatma Gandhi told us, 'Be the change you wish to see in the world.' From today onwards there is no excuse for all new human infrastructure not to be climate neutral, cancelling out its CO_2 footprint over its lifetime.

Making this resolve would mean that the construction industry moves into a 'transition' operation in which economies of scale start as soon as possible. This would still be only the first step, however, because the total carbon footprint of human civilization has to be not just zero but negative. We have to compensate for a hundred years in which excessive amounts of CO_2 were released into the atmosphere. This extra rectification can be achieved by taking the CO_2 that is already in the atmosphere out of the carbon cycle and sequestering it back into the ground, year by year. The scale of the problem is so large, and the urgency so real, that any investment in infrastructure or buildings must not contribute to accelerating climate change, but work in the opposite direction.

This is not an option that can be rejected just because the message is unpopular or worrying.

There is no workable alternative, and even the most ardent climate change deniers ought to have been silenced after a majority verdict from 155 nations to sign COP21 in Paris in 2015 – their future is the same as everyone else's and we are already on the brink of disaster.

The best plan is immediate positive action, demonstrating that we can still have a better future. Admittedly the problem of changing so much on which contemporary civilization has been built, above all the ability to extract fossil fuels, seems daunting. Humans have now become planetary curators and the question is whether the human race can change its culture fast enough to be qualified to do the job.

7: MAXIMISE ENERGY EFFICIENCY

Renewable energy is going to see us through and beyond the crisis, but while by definition it will not run out, it is still precious. We must use less of it than we have been used to using with fossil fuels. There are techniques now well established that help to reduce consumption of energy in buildings, chiefly insulation that really works, active thermal mass to absorb temperature change, high standards of draught proofing to hold heat in, and heat recovery ventilation in temperate climates that captures energy that might otherwise simply escape upwards. These form an essential set of safeguards that could save approximately one third of the current energy consumption.

However hard you try, it is unavoidable that in making buildings, energy-intensive materials have to be used – materials that add to the CO_2 footprint. Durability then becomes a key criterion, as if these materials have a short service life, little has been gained and the CO_2 payback becomes impossible. One largely neglected way of maximising energy efficiency is to configure the shape and orientation of the building to achieve further gains. Sunlight can provide both passive solar gain and electricity, but we as people want sunlight in our homes for well-being as much as we need it to feed our solar devices. If access to sunlight were to be enshrined in all future investments in buildings and infrastructure, we would choose better solutions to the complex process of juggling different demands and would end up with high-quality urbanism.

8: MINIMISE DELAY

Because climate change is not a linear phenomenon but an accelerating process, the amount of carbon emissions deferred today is an order of magnitude more effective than the same quantity deferred in, say, 2050. The further we allow it to go, the worse it gets: for example, if Arctic methyl hydrates or methane from fossil biomass were released by melting tundra.

9: REDUCE LAND FOOTPRINT

The areas of land and natural reserves available to species other than humans is already too low. The human species already takes 40% of the products of photosynthesis and has no right to direct the entire planet's natural capital towards its own frequently frivolous needs. The importance of maximising biodiversity and sharing our habitat with alternative species is essential to maintaining the ecologies that sustain us. Low-impact agriculture and fisheries are an absolute necessity for collective survival, and to achieve this the areas of land and sea currently used for food production must not be increased.

1.7

In terms of 'natural capital', which includes not only food but fresh water, energy and waste disposal, the area of productive land needed to meet the consumption of London is equivalent to the rest of the UK. As a result, the UK is forced to import around 70% of its related resources. This is bad on grounds of global justice and also in terms of security should other supplies cease to be available. It might seem as if we are stuck, for if we expand our cities we lose agricultural land and make the problem worse. The solution lies in changing patterns of consumption and production at the same time, through shifts in lifestyle that promise to make us feel better, not worse.

10: REDUCE RESOURCES CONSUMPTION

Enough metal, plastic and raw minerals may have already been extracted from the Earth's crust to satisfy the human population for millennia (**figs 1.7 and 1.8**). It is possible to recycle, refine and reuse this existing material for generations if 'cradle to

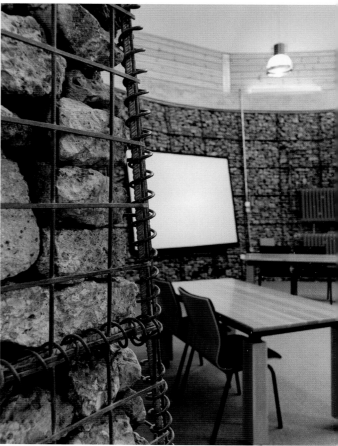

1.8

1.7 Crushed concrete and brick rubble from mining structures being sorted for gabion infill.

1.8 Reclaimed pitt head crushed concrete used as structural fill for sprecialist gabions with insulation in centre of cage. Reclaimed cast iron radiators provide low temp heating.

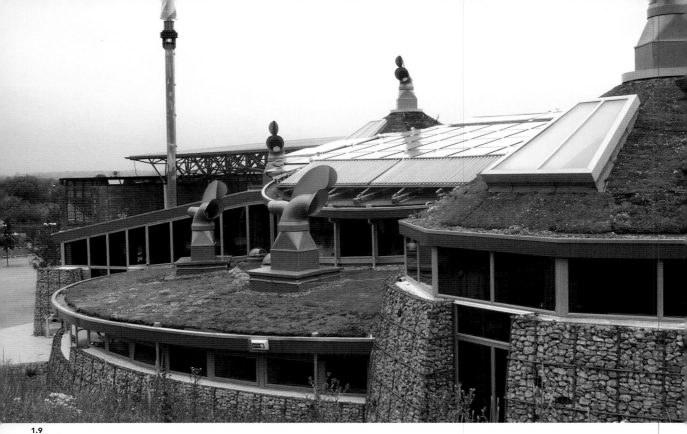

1.9

cradle' reclamation and reuse processes are built into every design or purchasing decision. It is possible to design new high-performance projects with up to 80% reclaimed material (**figs 1.9–1.10**). By 2050 this could have improved to nearly 95% reclaimed. The reduction in human land take if quarries, fossil fuels and mineral extraction was reduced by 90% would be spectacular.

11: CLEAN SKY, CLEAN WATER
Reduce or eliminate pollution or contamination of air, water, or other species' habitat. This maximises health benefits, reduces disease, and maximises food production and biodiversity. This is fast becoming one of the principal drivers pushing forward a transition away from a fossil fuel powered economy in the developing world. Air pollution is so bad in many Asian cities that the effects on human health are becoming a cause for concern. If it is only possible to see the sky clearly for 20 to 30 days a year in many cities, then it must be worth comparing the cost of the consequences of ingesting combustion pollutants with the cost of a transition across to a lifestyle powered by renewable energy.

12: ENSURE EVERYONE HAS A FAIR SHARE
Equitable sharing of these finite resources will be a major challenge, but the case is not hard to make. Inequality leads to conflict, and modern warfare has the capability to render the planet uninhabitable even faster than fossil fuel emissions.

Just living an urban lifestyle is already a problem. In the developing world the carbon footprint of populations moving from the country into cities increases fourfold. How rational is it to keep doing this? Is it possible to increase the quality of life in rural areas to discourage this process?

These 12 points provide a clear basis for designing a society that could just about survive the environmental challenges of the century ahead without descending into conflict over dwindling natural capital. We must not forget that every human

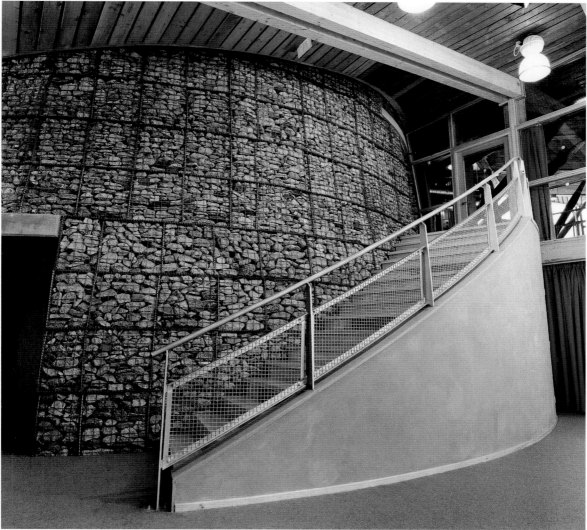

1.10

economy is dependent upon replenishable natural resources, and as Jared Diamond demonstrated in his book, *Collapse: How Societies Choose to Fail or Succeed*, every society throughout history that has ignored this truth has failed – often with considerable misery and unnecessary suffering.

For example, there are only around 25 kg of renewable wood fuel available per capita annually from renewable forestry in the UK. Using more fuel than this to achieve climate neutrality on one project will just deprive a local community of their fair share of a premium renewable energy storage medium

in the future. If scarce biomass is used to make an isolated project climate neutral today, and uses up more than its fair share of the national biomass quota, then it cannot be considered replicable.

1.9 View of the Earth Centre conference building from south-east hillside.

1.10 Internal view showing structural gabions filled with cleaned and crushed concrete rubble with reclaimed floorboard ceilings, new glulam beams, clay plaster curved walls and goat hair carpet.

The ZEDlife:
A call to engage

We may feel that we are on a knife edge, but at least for the first time in human history there is a broad consensus to reduce the emission of greenhouse gases in order to try and avert runaway climatic change. This has united almost all nations on the planet.

After COP21 in Paris 2015, the outgoing International executive director of Greenpeace, Kumi Naidoo, observed, 'The wheel of climate action turns slowly, but in Paris it has turned. This deal puts the fossil-fuel industry on the wrong side of history'.[2]

If business-as-usual carries on, there will be an increase in the levels of atmospheric greenhouse gases. The big idea is to limit the total global emissions of greenhouse gases, year by year, to a level such that they can be absorbed by the living metabolism of the planet. The international consensus agrees that unless this is done, humans will pass the critical tipping point. The direct result, an increase in global temperature, will threaten the habitat of almost every life form.

2.1 Hope House, the first experimental 'ZED' (1995). An automated pellet boiler for domestic hot water in winter, evacuated tube solar thermal collectors providing all hot water from late spring to early autumn and a 1.1 kW peak photovoltaic array.

This simple equilibrium must be achieved as quickly as possible, or it spells the end of humanity itself. There is literally no point in having children if human overpopulation means the increased emission of greenhouse gases, which would threaten the ability of the host environment to sustain future generations. Everyone needs a share of the atmosphere and a share of future natural capital. Nobody, however rich or powerful, will be exempt.

So the question must be, how to plan this transition? How do we get there, step by step?

The next major step in human evolution

The human race must decide whether to continue being part of the problem or to become part of the solution. We can't depend on governments to do this – the process must be started by individuals sharing a common aspiration.

The ideas that work must fit into existing social structures, so that the movement grows in size and effectiveness, displacing business-as-usual and achieving reductions in greenhouse gas emissions. Gradually all the different ideas and technologies can combine and collaborate, reinforcing each other to bring emissions down to the necessary target.

There are many different ways of achieving this, but each initiative must collaborate and reinforce its predecessor so that the choice of living, working, and feeding allows natural capital to be given to other life forms. We need infrastructure that works indefinitely.

Such a plan must be capable of easy adoption, involving not only a degree of altruism, but a greater extent of enlightened self-interest. This way lies hope for a workable future, without melodrama, that could be well underway within a couple of decades.

In other words, every human must take responsibility for their own lifestyle and work style and design their own personal future based on their fair share of local resources. Our proposal is that each of us becomes a 'planetary curator' rather than a passive 'consumer'.

Politicians, city administrations, large companies or conferences cannot be left to make these choices for us. The process has to be started right now by each and every person. As Naomi Klein says in the title of her book, 'This changes everything'.[3]

Stress to human societies is the outcome when finite natural resources become scarce, demand reaches a peak and scarcity threatens. A destructive cycle of competition and conflict is very hard to break and thus a higher percentage of national GDP is spent on securing resources from outside national boundaries. Military and security spending escalate, starving localised low-impact infrastructure of the investment that could have reduced the demand in the first place. Peak fossil fuel, peak uranium, peak lithium, peak phosphate, peak fresh water, peak forest cover, peak agricultural land, are all imminent. Surely the time is up for business-as-usual.

The energy input that enabled the current global civilisation increased exponentially over the past two centuries. Access to very low-cost fossil energy has fuelled the agricultural revolution, transport, medical advances, and, most recently, high-technology materials. We have benefited from these effects, but now we must switch over.

Leaving fossil fuels in the ground is part of the solution to a situation that will otherwise quickly get out of hand. We can fill their place by designing for a high-quality lifestyle that reconciles urban and rural activities to create a zero-carbon/zero-waste system. The city would then become an animate organism, sustained by a balanced ecology.

Harvesting ambient energy

Finite reserves of fossil fuels can never be replaced or economically returned underground. It no longer matters how many new reserves are discovered, as we cannot afford to release any more of this stored carbon into our shared atmosphere. One gallon of petrol burnt by a small car on the weekly school run represents about 98 tonnes of primeval biomass laid down as stored carbon that was originally a mechanism that allowed the earth to become habitable. Now that school run, and all the other unthinking uses, are reversing this process, producing CO_2 that is accelerating anthropogenic climate change. Fourteen per cent of current atmospheric CO_2 has been caused by humans burning fossil carbon.

To stop doing this, we need to run on weaker and less concentrated sources of renewable energy. What renewable means is that the energy is not a once-only resource like fossil fuels, but something that is renewed as fast as it is used.

To achieve this we have to accept a reduction in demand by harvesting weaker ambient forms of energy, preferably at the point of use. This is what is meant by decentralisation. It is difficult to route this kind of energy into centralised locations, so we have to abandon the centralised power storage and delivery (represented by the National Grid) that was possible with fossil fuels. As centralised power stations and centralised distribution interests become gradually obsolete, we can find the alternative in putting virtually every human structure to work as an energy harvesting device. Each community will need to live on its 'earnings', since there will be little or no possibility of moving energy around or compensating shortage in one area by overproduction in another.

The need for decentralisation

Concentration of resources is always preferred by politicians and wealthy investors as it is easier to tax and control. Helped by standardisation of components to create economies of scale for volume production, local provision of food, power and essential utilities will prevail. However, it is now likely that decentralised microgeneration will become the norm. It needs careful consideration to decide the level of population density and scale best matched to each technology or process, so a new discipline is evolving where the mechanics of each human settlement or 'metabolism' are designed to suit the scale, culture and climate of each host bioregion.

ZEDfactory climate neutral methodology flowchart

This study shows how to create a healthy building that works for the local occupants as well as in the global context, addressing all those 'peaks' that come ahead of shortages and accelerating climate change (**fig. 2.2**).

In a perfect world buildings would produce slightly more renewable energy than they need to meet their annual requirements, becoming power stations that export zero-carbon electricity to the National Grid and thus displacing carbon emissions from fossil fuel power stations.

During a working life of 25 years, enough carbon will have been displaced from the UK grid, currently supplied by fossil fuels, to offset the

Climate Neutral Standard Methodology

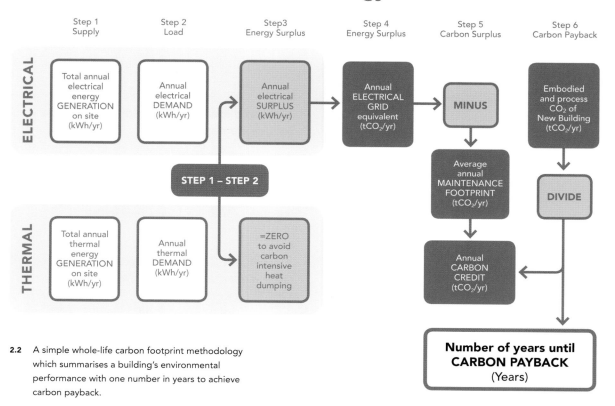

2.2 A simple whole-life carbon footprint methodology which summarises a building's environmental performance with one number in years to achieve carbon payback.

embodied CO_2 used in the initial construction and its eventual deconstruction for recycling of that building. Three aspects of the building have to come together: running on less energy, generating a surplus and keeping the embodied carbon low during construction. Achieving all three makes the whole project more or less climate neutral, setting a new standard for reducing the environmental impact of the construction industry.

It should be clear that many different technologies will be involved, but it is perfectly feasible. By reducing carbon outputs in construction and use, buildings will have a 'surplus' to offset other sectors in which the general public may be less willing to change its ways.

Technologies and strategy

We are familiar with the accelerating pace of technological change, and so guessing the future means understanding the trajectory of current innovation. Certain ideas will become obsolete almost as fast as they can be implemented. Remember the fashion for mounting small-scale wind turbines on urban buildings between the years 2000 and 2010? As we understood how unpredictable wind flows in cities are, and how the noise would upset neighbours, it became clear that this strategy could be fatal for clean technology investment. The output claims from small turbines sold over the counter were hardly ever realised, but things have already moved on and the latest affordable domestic-scale grid-connected systems with battery storage overcome most of the grid connection problems. This being so, small-scale building-integrated wind power could well be a good way of keeping the lights on in winter conditions with high winds, driving rain and reduced sunlight, provided turbulence can be reduced by the way the surroundings are designed. We advise keeping an open mind and checking to see if new ideas or economies of scale allow the re-evaluation of previously rejected ideas.

ZEDfactory has concentrated on plotting the trajectory of innovation and cost reduction and now has a simple suite of tools that work well together.

This is only one possible combination of energy harvesting strategies; others will emerge from alternative teams working with different priorities. It is important not to allow the initial cost to halt the progress of new ideas. Economies of scale can sway the balance once there is enough take-up.

As an example, the solar electric panels that we included at BedZED in the year 2000 would cost one-fifth less today for virtually the same product. It took political support from two important countries – Germany and China – to achieve volume mass production, and now this technology is approaching tradable commodity status, rather like potatoes, so the doom-mongers back then were wrong.

But the faint-hearted can still cause a lot of damage. At present, there is a well-funded campaign called 'fabric first' that seeks to concentrate on energy efficiency while building houses that face the wrong way and will never to be able to collect solar energy. For a small change that would cost nothing, future residents could have been able to reduce or eliminate their energy bills and contribute to the national effort. At every point we need to understand the mechanism of transition to a cleaner low-carbon future.

The basic low-carbon building principles – reduce demand

The following 14 principles and methods are the 'rudimentary blueprint' for a low-carbon-footprint development, and must be applied first to get the best out of the ZEDlife tools described in Part II.

1: FABRIC FIRST: ADOPT THE HIGHEST LEVEL OF ENERGY EFFICIENT BUILDING FABRIC APPROPRIATE TO THE CLIMATE

Start with insulation
The wall, floor and roof construction should aim to reduce U-values[4] to a minimum of 0.14 W/m²K and control heat loss through glazing elements by using windows, either double- or triple-glazed, with U-values around 1.0 W/m²K.

An obvious step that comes before insulation is to put large windows on the south-facing side of the building, and keep windows, glazed doors and so on, on the north side to a minimum. This is to reduce heat loss and maximise passive solar gains.

With good insulation, as many householders have already discovered, you can get by with a heating system smaller and more efficient than before, while running it for shorter periods of time. Heat generated in other ways, by human warmth, cooking and electric appliances, will also stay inside much longer.

Insulation to ZEDlife standard should be continuous and at a consistent depth across the whole building envelope. This is because any gaps that exist will create 'thermal bridges' which will allow heat to flow from inside to outside the building (or 'cold bridges' if you look at it the other way round). The higher the levels of insulation the more heat will be lost, proportionally, via thermal bridging (figs 2.3–2.4).

There are some kinds of insulation material that should be avoided, so here is a checklist of the desirable qualities:

- benign, odourless and vapour permeable;
- rot proof;
- inhibiting the growth of fungi, mould or bacteria;
- CFC and HCFC free[5] (low-ozone depletion and low-environment impact);
- ideally natural insulation materials which avoid fossil fuel products;
- low-embodied carbon; and
- maximum ODPs, CFCs or VOCs[6] content should be specified before adopting, since chemically unstable plastics and urea-based compounds are potentially toxic.

Use thermally massive materials

Materials that are 'thermally massive' have the ability to store heat and release it when the internal temperatures drop. The more thermally massive the building, the more effective solar gain will become. It is important to calculate the depth of the thermal mass in relation to temperature swings between the day and the night. In the daytime the building is

2.3

2.4

prevented from overheating because the thermally massive material stores heat. When temperatures drop at night, heat is released back into the building, thus reducing the load on the heating plant. Materials with a high specific heat capacity, a high density and a moderate thermal conductivity should be prioritised so that the maximum amount of heat can be stored in the minimum amount of material and released at a rate that is in line with the building's daily heating and cooling cycle.

2.3 Super-insulated thermally massive walls developed for BedZED.

2.4 Rockwool non-combustible insulation used in ZEDpods' stressed skin timber frame panels.

In conjunction with this, in the UK the building should be properly oriented (to the south or south-west) to maximise solar gains and natural lighting. The minimum standards in the ZEDlife tool kit form the basis of a well-designed zero-carbon home.

2: AIRTIGHT – MINIMISE EXTERNAL AIR INFILTRATION, AND RECOVER HEAT

Alongside good insulation comes airtightness. This involves taping and sealing joints and any perforations so that heat loss via small amounts of airflow is minimised. Plaster can contribute to higher levels of airtightness if detailed correctly so that the plaster finish runs down to the cement screed or floor surface, with the joint taped and hidden by a skirting. Once a building is highly insulated, thermally massive and as airtight as it can be made, ventilation is the next task in the sequence.

You do need some movement of air between the inside and the outside to live healthily, but it is best to be in control of it. Older buildings, especially in the UK, are notoriously leaky, meaning ventilation has been one of biggest sources of heat loss.

Whatever stale hot air you send into the outside world, the heat can now be conserved by the process of heat exchange while losing the staleness. In fact, around 70 to 90% of the heat or 'coolth' embodied in the outgoing stale air can be recovered and passed to incoming fresh air. The formula that describes the ZEDlife standard of air-tightness is 1.5 air changes per hour at 50 pascals test pressure. This will provide a healthy internal environment with sufficient air changes when used in conjunction with a heat recovery ventilation system. The beauty of the system is that it can be applied in to both hot and cold conditions (many parts of the world alternate seasonally or even daily between the two) with 'coolth' recovery in hot conditions being just as important as heat recovery in cold ones.

3: USE DIRECT SUNLIGHT TO CREATE HEAT

'Passive solar gain' is what you get by doing nothing, if your house is working for you. Providing it has been designed to maximise the harvest of passive solar gain, a super-insulated, thermally massive

building with a good standard of airtightness and heat recovery ventilation, is so energy efficient that it is possible to maintain comfortable internal conditions with hardly any heat having to be produced by conventional methods such as boilers. On the coldest days in winter, the skies are often clear and the level of sunlight provides enough heat to make it quite comfortable indoors. If heat loss through the windows at night is minimised by using triple glazing, these passive gains, even in winter, can really make a difference. Insulation, combined with reflective window treatments such as heavyweight curtains, blinds, external shutters or shades to stop night-time heat loss, also help. 'Tuneable' sunspaces, like those found at BedZED, provide several layers of protection, because 50% of the glazed external wall can be opened in summer, turning a winter sunspace into a summer veranda (**fig. 2.5**).

4: COORDINATE ORIENTATION AND GLAZING POSITIONING

Windows are absolutely necessary for daylight and just being able to see out, but they are a weak point in the battle between heat and cold. It is important to ensure virtually 100% shading from direct sunlight at 'peak insolation' in hotter climates (when the sun is hottest and highest), without darkening the room or blocking the view. The outside of the building needs to be designed with great care so as to block direct sunlight without creating excessive visual barriers. At Jingdezhen in China, ZEDfactory will use local industry to fabricate glazed ceramic external louvre screens to create diffuse daylight inside each room (see Case Study 9, Jingdezhen Ceramic Centre, p. 179).

In colder climates, it is more important to minimise north-facing windows and ensure that these are triple glazed with thermally broken frames (frames that prevent conductive thermal energy). To get the best out of the outside skin of the building, use a sun tracking programme with three dimen-sional digital models. This accurately identifies how heating and cooling loads can be reduced to a fraction of the standard levels.

Urban designers prefer to concentrate on the 'placemaking' agenda and rarely engage with the

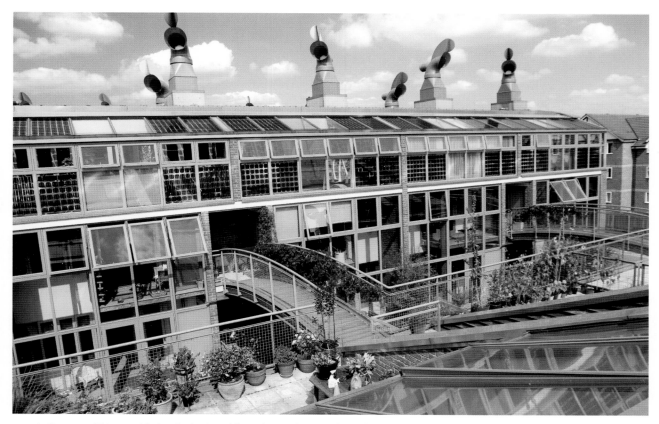

2.5 A climate modifying tunable facade developed for BedZED – the south-facing facade at BedZED is tuned to respond to daylight, solar control, access, ventilation and power generation.

more complex implications of building physics. Unless they also model the energy and daylight implications of their master-planning proposals, the architect working on an individual plot starts with his hands tied behind his back.

5: ACHIEVE CROSS-VENTILATION AND URBAN AERODYNAMICS

Few designers recognise how changes in the airflow around buildings can be included in the mix. The prevailing wind will make every building surface either positively or negatively pressurised, meaning that on one facade an open window will allow ambient air with positive pressure to blow into the interior, whilst opening a window on the opposing facade allows the internal air to be sucked out by negative pressure. This phenomenon can be used to create excellent cross ventilation, which can further

be advanced by stack ventilation using the principle of hot air rising or thermal buoyancy. Much of the time the outside air is at a temperature that makes it a welcome visitor passing through.

6: AVOID THE URBAN HEAT ISLAND BY PASSIVE COOLING

Allow the prevailing wind in the hot months to blow between building blocks so that it removes the heat created by sunlight hitting buildings or streets. The city fabric is a surprisingly effective solar collector, absorbing solar radiation and re-emitting infrared heat. It builds up so that in mid-summer the city centre can become 3 to 6 degrees warmer than the surrounding green countryside – creating an 'urban heat island'.

To mitigate this, allow the prevailing wind to blow down streets and through open spaces.

Maximise the green surface area with planting to encourage transpiration and evaporative cooling. Roof gardens and trees in the streets are attractive but still uncommon features, which the ZEDlife attempts to explore. The challenge is to increase the density of human occupation and still achieve something close to 100% coverage of the surface with green plants.

7: REDUCE ELECTRIC DEMAND

Make electricity use as efficient as possible. Some of the ways to do this are:

- induction hobs
- LED lighting
- class A+ white goods
- permanent magnet brushless electric motors
- voltage optimisers
- high COP (coefficient of performance) heat pumps and mechanical equipment.

Switch stuff off when it is not in use. Various high-technology automated building management systems claim to provide this service, and we have even had one client remove light switches as the building tracks its occupants. However, all computers break eventually and we recommend the simplest feedback system: the 'Watson' electric meter. This illuminates the wall surface behind it in different colours, depending on the levels of electricity used. The person in the room understands the situation by colour rather than numbers.

8: REDUCE WATER DEMAND

Water may not be metered, but it is still a precious resource. Spray taps and showers, and water-saving white goods can often achieve a 30% reduction in water usage. Preheated hot water makes these savings even more significant.

A lot of water falls from the sky and, rather than being used, just runs down the drains. At BedZED (see Case Study 10, BedZED, p. 189) we managed

2.6 The first water treatment plant at BedZED was a 'living machine', as developed by Nancy Jack and Dr. John Todd of Ocean Arks International.

to achieve nearly 50% savings in average water use by treating waste water on-site and installing a reclaimed water circuit (**fig. 2.6**). This supplies low-flush toilets and garden irrigation. Advanced membrane bioreactor filters are a new way of purifying water on-site, but are costly in electricity and new filters, so they don't provide such a useful alternative.

Flash flooding results from too much rainwater for short periods of time and not enough in between. Not so long ago, everyone had a water butt in the yard to collect rainwater. We can do the same thing in a more sophisticated way by including rainwater attenuation measures in the buildings and infrastructure from the beginning. Take care to collect the rainwater before it is contaminated by contact with pollution or fossil fuels at ground level, then use building-integrated water storage devices such as flat roofs, underground floor slabs, and spaces under roads and paths. Surface water runoff is avoided, and there is some water on hand when the rains are over.

9: REDUCE EMBODIED CO_2 CONTENT

Follow the instructions so far and you are on the way to getting a building adapted to its place and ready for the future. However, there is no point in designing buildings or infrastructure that reduce carbon emissions if the energy used to make and maintain them stacks up on the other side of the equation. Consider the carbon footprint for the whole lifespan of the building. As with food, a simple rule of thumb is to use materials in their natural state rather than highly processed.

Reclaimed materials or components are another recourse, but reliable information on the carbon footprint of re-manufactured products is hard to obtain. Local materials always begin with a substantial advantage because they reduce transportation, while a building that is simple to make saves in other ways. The rules always need to be questioned: very high-value products moved in slow ships across the globe can have a lower carbon footprint than the same product sourced relatively locally.

Craig Simmonds of the organisation Footprinter (formally Best Foot Forward) has produced an extensive carbon database that demonstrates the correlation between economic cost and carbon penalty. This means the quantity surveyor can produce a carbon footprint analysis of a developing design at the same time as measuring its financial cost.

10: CREATE HEAT FROM BIOMASS

We are used to the idea of burning wood. This is just one form of biomass – something grown that contains the carbon that will release heat. In any form it is potentially a climate-neutral fuel, although it needs to be thought about carefully. If everyone in the UK relied on burning wood we would run out all too soon and the carbon footprint from importing more would offset the benefits. Besides, trees are generally better alive than dead.

Wood isn't the only form of biomass, however. There are boilers fired by wood pellets made from compressed sawdust using natural lignin as a binder. These are reliable and can be programmed with automatic ignition and self-cleaning routines, modulating thermal output to match demand. Normal maintenance is restricted to ash removal and annual flue cleaning. Some 150 watts of electricity is needed to power the electric feed motors and fans. The fuel has a modest carbon footprint from transport and delivery plus packaging. It currently costs approximately £220.00 per tonne. The system can be used in a single home, provided there is some storage space.

Woodchip boilers are a less refined alternative, but their benefit is being able to use wood chipped directly from forestry or tree pruning operations that has been dried. The tipper truck needed to deliver woodchip calls for ramped access, and the best storage is underground, often with drying facilities and conveyor belts. All this makes woodchip unsuitable for a single home, but a possible option for public buildings and institutions (**fig. 2.7**, *overleaf*).

Log-burning stoves are now designed to burn cleanly and can draw air to feed the flames from a special inlet, so they are able to operate in buildings with good standards of airtightness. The ability to burn local logs that would otherwise have decomposed and rotted can make this a truly climate neutral fuel.

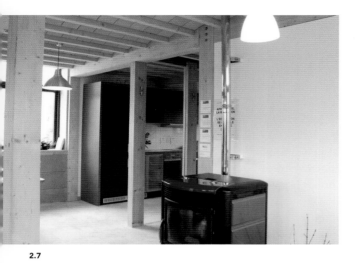

Here is a table showing the comparative thermal capacity of these alternatives:

WOOD PELLET	4 kW minimum output to 120 kW thermal output
WOODCHIP	25 kW minimum output to 125 kW thermal output
LOG-BURNING STOVE	4 kW minimum output to 15 kW thermal output

11: CREATE ELECTRICITY FROM BIOMASS

Using a combined heat and power (CHP) engine it is now possible to obtain almost the same thermal output as a biomass boiler, while also generating a modest amount of climate-neutral electricity (**fig. 2.8**). This has the benefit of displacing electricity generated by fossil fuel, which has three times the CO_2 footprint of fossil gas. Current CHP options are as follows:

- Wood pellet CHP with a Stirling engine is the most reliable and lowest cost, however a very low ratio of electricity to heat output is normal, perhaps 3 kW for a 15 kW thermal output and this is not easy to modulate. Atmospheric sealed pellet store keeps fuel flowing and at consistent moisture content.

- Wood pellet CHP with gasification has far more complex operations and maintenance implications, however it has a far higher electric to thermal output – often 25 kW electric to 65 kW thermal output with no modulation possible. Around 90% uptime is now possible.
- Woodchip CHP using steam and Stirling engines have been available for a decade, however they have a low-electric output and difficulties have been encountered in maintaining a consistent moisture content of the woodchip. Wet woodchip does not flow freely and clogs up automated feed mechanisms.
- Wood gasification and pyrolysis is now ready for megawatt (MW) scale installations requiring one tonne of feedstock per hour to produce one MW electric and two MW thermal continuous output.

Regrettably, the opportunities for micro-generation in the UK are not really being examined. The reason is clear: national politicians from the main parties still prefer nuclear as an alternative. Micro-generation technology is already on sale, but the regulations on costs make it a less attractive option.

Anaerobic digestion is another possible way we can 'keep the lights on'. This is a technology familiar to followers of *The Archers* on BBC Radio 4. This technology requires wet organic material such as animal waste, human 'black water' (sewage in less polite language), and damp biomass to be fed into large rigid tanks or flexible bladders. The organic material is digested in a similar way to an animal's metabolism, producing large amounts of methane and a relatively small amount of inert solid matter. The latter can be used to restore soil fertility. Provided the gas is stored and used without leakage, this process avoids the danger of venting methane and CO_2 into the atmosphere, which is inherent in composting in the open. A typical installation tends to be at community scale. It will be large and probably would not find a place where land values are high, as in most cities. This tends to restrict the use of anaerobic digestion to rural areas where there is ample animal and organic waste and cheaper land. This gas can be cleaned and scrubbed and fed into the existing mains gas grid. It can also be

used directly to feed gas turbines or gas internal combustion engines. The latest anaerobic digestion plants can feed fuel cells for generating heat and power. In this way, they could eventually replace combustion as the best way to use hydrogen-rich methane gas. It is even conceivable that the familiar gas boiler will be superseded by fuel cell technology, with each home having a micro CHP unit generating heat and electricity.

12: USE WIND TO CREATE ELECTRICITY

Wind turbines complement solar technologies perfectly because they generate power at night, in rain and in winter in a related but inverse pattern. Wind power used to be an expensive investment, but this is changing.

The industry has achieved economies of scale in the production of the necessary kit, including batteries for storage, so that community wind turbines are now a more realistic option. Wind turbines on land are controversial because of the way they look and the noise they make, but they can be placed offshore on the shallow waters of the continental shelf surrounding many coastlines (**fig. 2.9**).

In the national patchwork of renewable generation in the UK they can play an important part, for example as a cost-effective way of contributing to the energy requirements of historic urban quarters where so many of the alternative methods would be seen as unacceptable. There is, however, no excuse for developers creating new buildings in city centres to 'export' their renewable energy requirements to turbines at sea. This resource is already required by the listed buildings that must be preserved as part of a collective cultural heritage.

13: CREATE ELECTRICITY BY USING WATER FLOW

Electricity can be generated through flowing water in the following ways:

- Water flowing downhill due to gravity or tidal current can make a significant contribution to national renewable energy requirements, however it is site specific and often difficult to install without incurring flood risk.
- Low-head river turbines.

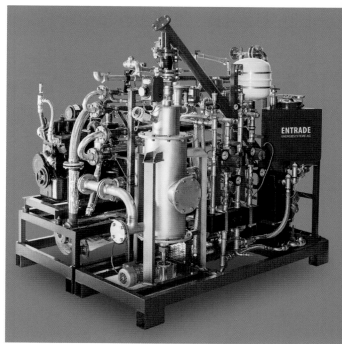

2.8

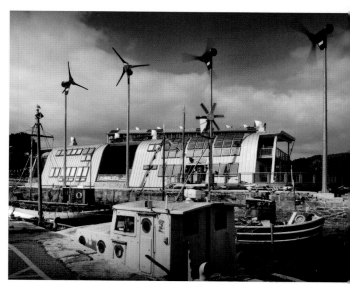

2.9

2.7 A RuralZED home with winter hot water and heat provided by a small wood pellet, room stove with back boiler.

2.8 A biomass wood pellet fueled combined heat and power (CHP) unit – now ski mounted and containerised.

2.9 Wind turbines applied in Jubilee Wharf, Penryn, Cornwall.

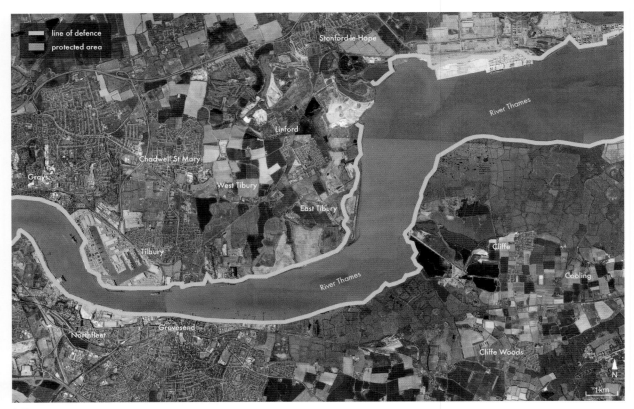

2.10

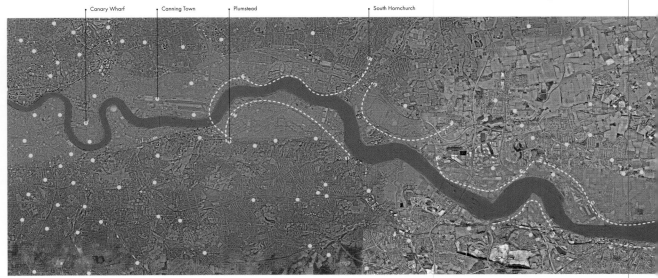

2.11

- High-head hydroelectric power stations in mountainous areas.
- Tidal-flow power stations along coastlines or barrages.

Geography and the lie of the land don't always present these opportunities but when the conditions are favourable, they can be a useful asset for a low-carbon community. ZEDfactory has recently proposed a scheme of this kind for the Shoreham Cement Works regeneration project in West Sussex, changing an existing large chalk quarry into two large lakes at different heights. On the abandoned steel frame of the cement works building ZEDfactory has proposed mounting an integrated photovoltaic roof to provide daytime electric power used to pump water from the lower lake to the higher lake. At night this water flows downhill to power a turbine of appropriate size that would help meet night time electric demand in a low-carbon hotel. The ability to store large volumes of water in the upper lake provides a degree of electric storage that can be switched on and off to meet peak demand or compensate for days of weak winter sunshine.

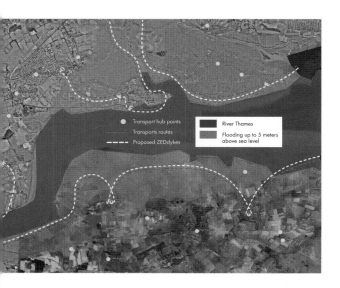

14: ADAPT AHEAD OF CLIMATE CHANGE

In the UK we can expect milder winter temperatures with higher peak rainfall and flash flooding. In summer, expect periods of drought and higher winds. We are relatively lucky, because other countries will certainly experience greater swings of temperature, disrupting agricultural productivity. Where are the foresight and planning to prepare us? Nowhere, alas, because decision makers asking for money to prepare for disasters ahead don't win votes until it's too late.

We have gained key insights from the unusual experience of designing and building houseboats in central London. At Vauxhall, the spring tides are already within 150 mm of the top of the river wall. That is not very much of a margin of error (rather less, in fact, than the height of this book), and the flooding of the tube and low-lying property is only protected from a combination of high and protracted rainfall upriver, plus high estuary tides down river, by the capacity of the Thames Valley floodplain to attenuate the flow, and the already overstretched Thames Barrier. Flooding only needs to happen once for millions to be wiped off the value of those houses and flats, and that would be the minimum damage (**fig. 2.10**).

ZEDlife have proposed a solution to this problem, based on a study of existing public transport nodes and high ground around the Thames Estuary, which suggested that a new Dyke or London Wall needs to protect large areas of suburbia from rising sea levels. Upstream of a new Thames Barrier, much more water storage capacity is required so that rainwater from the Thames Valley never flows over the Embankment wall. The new Thames Barrier will need to be longer than the present one, so as to prevent high spring tides from flowing upstream.

2.10 Area designated by the Environment Agency for abandonment due to rising sea levels.

2.11 Map of the Thames Estuary with existing transport nodes and floodplain. The idea is to join up existing train, tube and bus stations with a flood defense wall integrating a light tram.

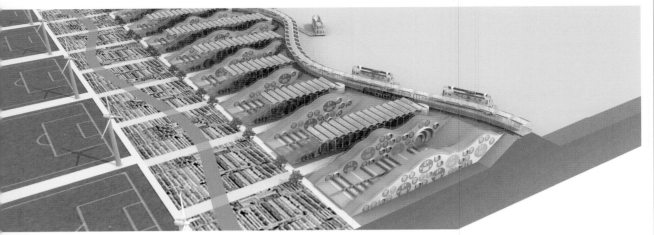

2.12

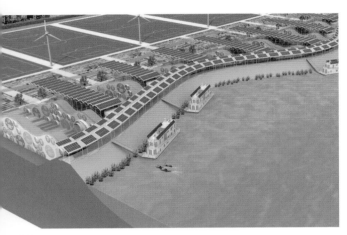

2.13

The dyke would join up areas of higher ground to the north and south of the river, thus holding back water from low-lying residential areas on each side. Added value could come from running a light tram on the top of the dyke, connecting existing transport nodes (**fig. 2.11**). The ZEDdyke would need to be as good as tried and tested Dutch sea defences, and then it might then be possible to integrate enough earth-sheltered housing into the flood defence wall to fund its initial construction (**figs 2.12–2.14**).

This type of thinking – solving several key issues with one master plan – is essential if we are to fund civil works like this to protect us from accelerating climate change before the economy collapses. Better if the lucky people protected by the new London Wall can continue their lives relatively unaffected. Any occupation of the land on the riverward side of the dyke will have to be on floating pontoons. With this in mind, ZED designed the 'London street of the future', and built two low-cost prototype pontoons that have been inhabited without any problems at Nine Elms Pier since 2010 (**figs 2.15–2.16**).

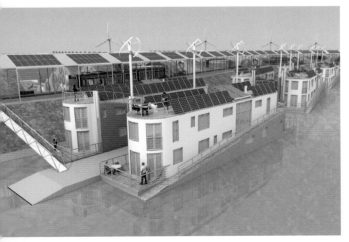

2.14

2.12+2.13	The aerial view of ZEDdykes.
2.14	Proposed ZEDdykes connected with transport hub.
2.15	The ZEB (Zero [fossil] Energy Boat) houseboats, low-cost prototype at Nine Elms Pier.
2.16	Solar electric panels are built into handrail balustrades.

worked with Arup's Chris Twinn and the National Physicsal Laboratory in Teddington, West London, to develop one of the first passive wind-driven ventilation systems ever installed in the UK (**fig. 2.19**). Building Regulations require a minimum of a 0.5 air change per hour for homes, and we found we could achieve this from 'thermal buoyancy' and passive stack ventilation. Wind pressure helps to achieve heat recovery ventilation for the whole house without the use of any extra electrically driven fans.

In the event of high-wind speeds, a counterweighted bypass valve makes sure that the air movement doesn't get out of control. The system works well and has been tested using tracer gas to see what is going on. It is difficult, though, to persuade conventional architects to adopt this technology, which seems to them too much like hard work. Improvements in fan-drive heat recovery systems and mass production has enabled heat recovery ventilation to become universally adopted for most new buildings in the UK – replacing the old campaign for full year-round natural ventilation. Ventilation without heat recovery in the UK climate wastes about 50% of the heat input to an energy efficient building. ZEDfactory has designed commercial buildings and laboratories with very high ventilation rates, but that use similar passive low-pressure-drop heat recovery ventilation systems.

Any building form that is designed with these effects in mind can harness the naturally generated positive and negative pressures produced by the prevailing wind. We have shown that it is possible to design internal air paths that create natural ventilation with heat recovery on low-, medium- and high-rise buildings. Tests done by ZEDfactory at Cardiff University indicated that the best results come from using aluminium heat exchanger plates, which achieved heat recovery efficiencies of circa 70% at 50 pascals test pressure or less. There is no doubt that breathing and self-ventilating buildings with very low-energy input and no moving parts are not a pipe dream, and could be produced for anyone who asked for them. If this beneficial idea took hold, a new discipline of aerodynamic urban design would be needed to inform the master-planning of new and existing urban districts. Access to wind

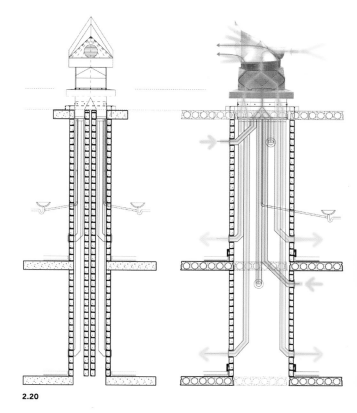

2.20

can often be as important as access to sunlight and good daylight. Since our society seems incapable so far of stopping the urban environment from making us 'passive smokers' in the atmosphere we have to share, breathing easily is more of a necessity than a luxury.

In colder countries around half the energy output is required to heat water for bathing and washing. For this reason some kind of heating system producing hot water will always be required. Therefore it makes sense to install heat recovery devices on waste water from bathing, so that this remaining heat energy can be used to preheat new fresh water entering the building from the cold outside, rather than going down the drain. Before the recent reduction in the cost of solar electricity we had a problem balancing the carbon 'books', but in the super-efficient homes we can now build with large solar electric installation, a small 600 watt electric input air source heat pump integrated with a hot water cylinder is a cost effective proposal (**fig. 2.20**).

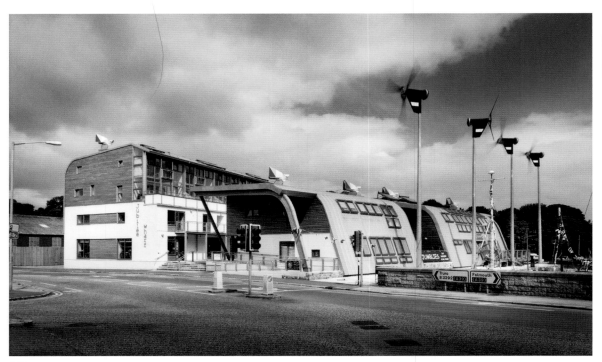

2.21

2.22

3: MEETING ENERGY DEMAND FROM RENEWABLES

Finally, after reducing heating and cooling to the lowest possible levels, it becomes possible to meet demand from renewable energy. A simple rural house on a fairly large plot may have sufficient exposure to sun, sky and wind to incorporate all these principles easily. It takes more ingenuity to achieve the same performance at higher occupation densities in both residential and commercial properties.

'Zero-carbon urbanism' is our term for the science of designing streets, urban blocks and entire urban quarters to ensure that scarce energy is not needed from outside their site boundaries. New shapes of buildings and streets will arise out of a contemporary understanding of building physics linked to financial viability, using energy efficiency and the kind of generating methods already outlined (figs 2.21–2.22).

2.21 Jubilee Wharf, Penryn, Cornwall.

2.22 Community Hall using reclaimed timber from the client's family home.

PART II
THE ZEDLIFE TOOLS

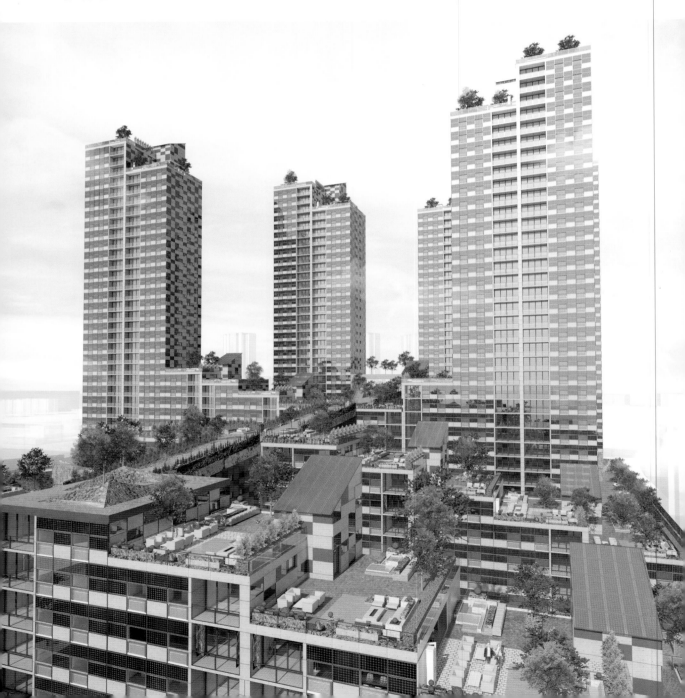

Over the past 10 years, ZEDfactory has developed a range of eight tools to make it easy to deliver a new development that avoids many of the usual negative factors, such as the need for waste disposal and transport powered by fossil fuels.

What has been important during this period is to achieve compatibility between tools, many of which have existed for some time, but which underperformed when they weren't linked together.

ZEDlife ideas and tools reinforce each other to create an urban system that can be gently introduced into many existing cities or regeneration projects. Compared to conventional centralised infrastructure investment, these alternatives are already competitive on cost when viewed at a city scale. As economies of scale are achieved, this coordinated urban metabolism will outperform conventional systems (**fig. II.1**).

II.1 The development of a new integrated supply chain where each component contributes to the overall ZEDlife concept facilitates low- and zero-carbon urbanism. Integrating high density at public transport nodes with high amenity and solar electric generation helps cities move towards reducing fossil fuel consumption and towards clean air.

TOOL 1
The ZEDroof

TOOL 2
Solar-charged exchangeable batteries

TOOL 3
Low-carbon transport: The ZEDbike, electric vehicles and the filling stations of the future

TOOL 4
Building-level energy systems: Air-sourced heat pumps and solar-assisted heating and cooling

TOOL 5
District-level energy systems and food production

TOOL 6
Retrofit adaptation of existing buildings

TOOL 7
Rainwater harvesting and water re-use

TOOL 8
Tool combinations

TOOL 1

THE ZEDROOF

Whilst 'bolt-on' solar panels are generally a good idea, we thought if almost exactly the same volume of durable construction materials could be reconfigured to become a waterproof rainscreen then there would be no need to purchase a conventional roof or facade, or worry about making waterproof fixing holes in it. The productivity gains could reduce the payback time of a typical solar system by up to half. Equally importantly, it has been found that by making an entire roof plane or an entire wall in BIPV (building integrated photovoltaics, as opposed to bolt-ons), conventional homes that struggled to achieve 4.5 kW peak could easily achieve 7.5 kW peak per home from the roof surfaces alone.

The cost involves the hardware itself and the fixing and connecting processes, referred to as 'installed cost'. This is a major variable in determining the length of the payback period. Not all buildings will have the best orientation, but east- or west-facing surfaces can still play a part and we have found ways to reduce installed cost so that it is now economic to clad roof surfaces other than the optimum south-facing ones.

Then there is a question of what goes under the panels. For reasons of aesthetics, a smooth flush surface is favourable, although adds to the expense partly because of the layers of conventional material that have to go underneath the panels. It is this secondary cost that we have tried to minimise, replacing the layers so that the photovoltaic (PV) panel becomes a roofing substrate as well. We have paid attention to the edges and junctions, especially in conditions of wind-driven rain. It makes sense if the panels are securely fastened to the rafters to protect against being lifted up by wind, but only if there is a built-in channel to prevent condensation forming on the underside. Finally, we developed eaves, ridge and verge flashings to complete the roof (**fig. 3.2**, *overleaf*).

The finished design was tested and certified by the Building Research Establishment to meet with the appropriate BS (British Standards) and EN (European Standards) for roofing products and before being released onto the market. According to calculations based on the building price guide, SPONS 2012, the cost of a roof occupying the same area equates to around £83 per m². The cost of the

3.1 ZEDroof system applied in Africa.

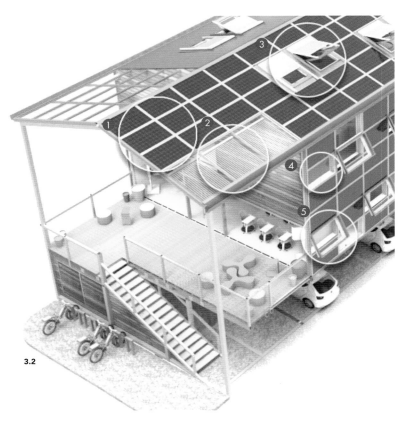

3.2

3.2 The intelligent BIPV enclosure providing vision, daylight, ventilation, hot water, cooling, heating, and electricity.

3.3 ZEDroof applied at Zhangwu Tourist Centre, China.

3.4 Alternative profile for fixing to timber structures.

3.5 ZEDroof box extrusion section.

① Insulated BIPV Panel

② Evacuated tube solar thermal collector filled with refrigerant for solar cool solar assisted heat pump system

③ Matching rooflight - tripled glazed to provide ventilation to heated thermal envelope

④ Clear panel

⑤ Triple glazed low-E window

3.3

Solar trees

The solar tree is a sculptural piece of street furniture that creates a memorable public space, while generating green electricity and integrating public amenities (fig. 3.9). As well as providing shade from the summer sun, the solar trees can power a range of services such as phone and laptop charging points, docking for electric bikes, a mini coffee shop and advertising space with animated visual images, if desired. Or it can simply provide a comfortable place to sit and rest, out of the summer sun (figs 3.10–3.11).

The primary function of the solar tree, though, is to harvest and store solar electricity without requiring any existing building to be modified. When the energy-harvesting panels are placed in the landscape, only a cable connection to the

3.9 Anatomy of a free-standing, off-grid holiday glamping tent with integrated solar powered e-bike personal transport.
3.10 ZEDfactory designed holiday solar glamping tent.
3.11 ZED solar tree at Ecobuild, London.

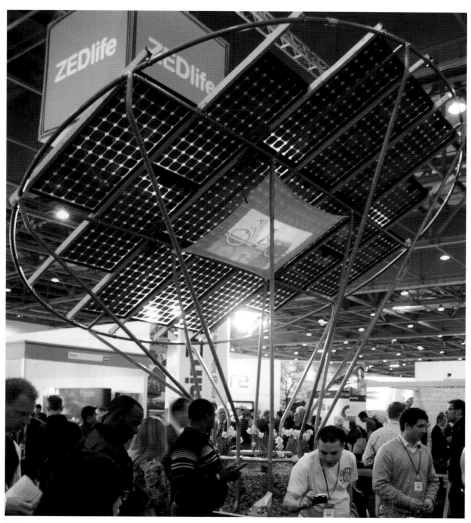

3.11

nearest consumer unit is required to power existing buildings. This will usually be preferable to putting solar panels directly on historic structures. Almost any street could accept solar trees in hard-paved spaces, private drives, front gardens or green verges, mixed in with live trees, provided each receives its ration of sunlight (**fig. 3.12**). By avoiding the large areas of white plastic seen underneath conventional solar panels, the solar tree panels allow sunlight to filter between the embedded silicon wafers, creating dappled sunlight beneath.

Each tree has a total peak power output of 3 kW from a canopy composed of PV panels oriented 20° south. Electricity generated from them can be stored in batteries or connected to the national grid. Each solar tree, feeding into a 4 kWh storage battery with a connection to the grid, should be able to power

a home without any need for centralised power generation. It is a gradual method, allowing any existing community to reduce their reliance on the electric grid as more trees are connected together to make a 'solar forest', a community microgrid.

The tree has been designed and engineered to stand up to the strongest of winds, yet it can be installed without foundations or mechanical fixings to the ground. Because it isn't rooted, it can be considered temporary and can be moved from one position to another with ease.

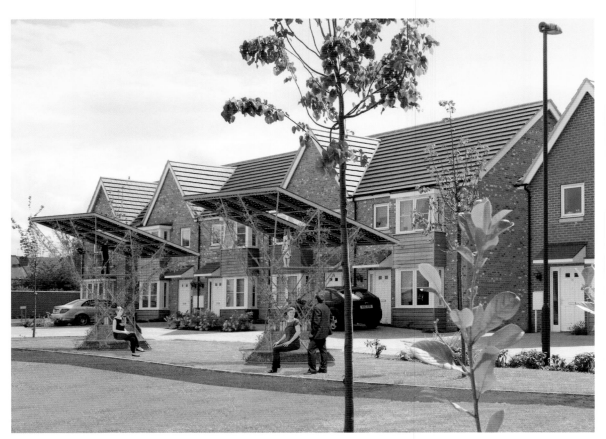

3.12 ZED solar tree in urban design.

TOOL 2

SOLAR-CHARGED
EXCHANGEABLE BATTERIES

Up to now, batteries for electricity storage have been the weak point of the whole renewable generation proposition. There is now a reliable battery storage technology that allows energy to be locally generated at all hours of day and night by sun and wind, and stored conveniently. There is no longer any need to put 40 kWh of advanced lithium batteries in a car, another 6 to 9 kWh in a house smart grid inverter, another 2 kWh in a scooter, 0.5 kWh in an electric bike and 0.25 kWh in diverse small portable tools from vacuum cleaners to drills to lawnmowers. The world could run out of lithium before this demand is satisfied, although replacement battery chemistries are coming on stream fast. Is there any electric device on the market that cannot benefit from going cordless? Almost all of these appliances use the same internal battery cells. About half of the cost of any cordless appliance is attributable to the battery. It could be far better to have one modular solar charged 1 kWh battery that is easily carried by children and can be quickly exchanged for a fully charged battery when required, with automatic rental charging on a smart

phone application. The larger the power needs of the appliance, the more exchangeable batteries can be inserted to meet the higher demand.

The ZED powerbank battery can store around 0.5 kWh and be easily picked up, traded and exchanged so that it can be rented or purchased. One standard solar panel producing a maximum of 250 W can easily charge one of these batteries in one day in most climates (**fig. 4.1,** *overleaf*). In northern zones, a community-scale wind turbine could supplement or replace solar charging. Suddenly it has become possible to generate, store and trade renewable energy almost anywhere. Decentralised local production of the power banks and local recharging eliminates the need to ship fossil fuel across continents. By designing a bus-bar system into the powerbank it can be connected in series or in parallel to match the loads required. For example, one battery could happily run an LED lighting circuit, charge a phone and tablet and provide communication and light to rural areas without electrification. Two batteries could power a low-performance work bike that could get a child

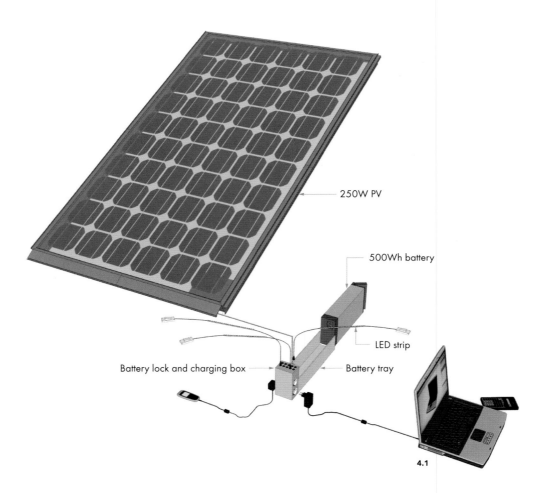

250W PV

500Wh battery

LED strip

Battery lock and charging box

Battery tray

4.1

to school across rough rural tracks. Four batteries could run a light moped, eight a high performance motorcycle or power a household with a fridge and washing machine. Between 12 and 24 batteries could power a lightweight three-wheel electric car, while a conventional electric car, such as a Nissan Leaf, could perhaps store 25 batteries in the boot as a range extender supplement to the existing 30 kWh store installed in older models. These could be rented out only when longer journeys are planned.

The most exciting implication of this type of battery system is its ability to take pressure off the 240-volt mains grid and ultimately replace it altogether. Most consumer appliances actually run below 24 volts, and require expensive and energy-wasteful transformers (we all have them) to create the correct voltage for LED lights, laptops, tablets and phones

(**fig. 4.2**). Even larger A++ white goods and fans incorporate devices to reduce their power consumption. It is really only appliances that heat water or heat food that actually depend on mains voltages.

The following is the specification for a 0.5 kWh exchangeable battery:

- Long-life high performance LiFePO4 (lithium iron phosphate battery) cells, a common and safe type of rechargeable battery, are rated for 2,000 charge cycles at 80% depth of discharge. A screw battery connection enables easy cell exchange with no soldering. If one cell breaks down it is easy to exchange a defective cell without throwing the entire battery away. This makes its useful life two or three times longer than portable lithium batteries. If the battery is docked with

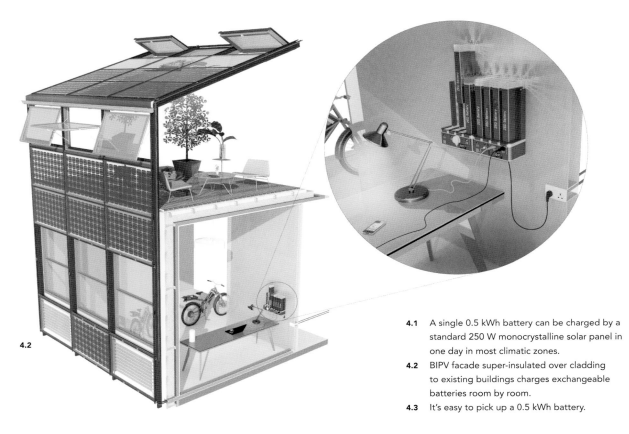

4.2

4.1 A single 0.5 kWh battery can be charged by a standard 250 W monocrystalline solar panel in one day in most climatic zones.

4.2 BIPV facade super-insulated over cladding to existing buildings charges exchangeable batteries room by room.

4.3 It's easy to pick up a 0.5 kWh battery.

the solar charger when not in use, and discharge depth is limited to nearer 50%, it could last well over 5,000 discharge cycles.

- Super stable LiFePO4 battery chemistry eliminates risk of fire due to self-combustion.
- Cheaper lithium batteries have more unstable chemistry and shorter life expectancy.
- Push-fit connector allows instant plug-in electricity supply.
- The batteries are lightweight and have a fast discharge rate suitable for high-performance electric vehicles.
- The light weight allows them to be easily carried (**fig. 4.3**).
- The transparent polycarbonate battery case allows for visual inspection, so that any potentially dangerous material (inserted, for instance, by terrorists) can be detected.
- The extruded aluminium carrier case allows for easy maintenance and replacement of components.

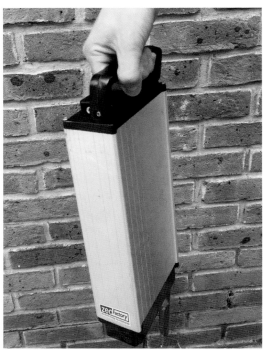

4.3

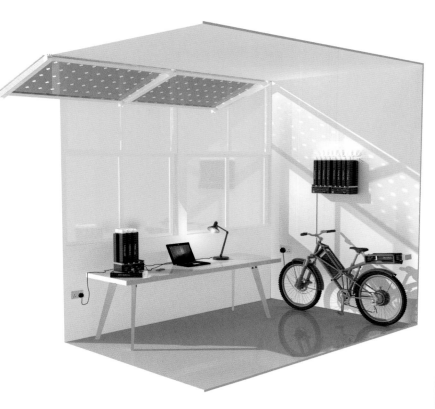

4.4 A desktop dock holds the exchangeable batteries that change colour when fully charged. The grid only tops up the dock when no solar electricity is available from the external envelope. Most, if not all, of the gadgets in the room, such as laptop, desktop, tablet, phone, LED lights, television and electric bike, can be powered directly from the dock.

- The battery cannot be used without its purpose-designed dock, so has little theft value.
- Contains a male contact for electrical connection.
- Protected by trackable RFID (radio-frequency identification) chip, which uses electromagnetic fields to automatically identify and track objects.
- Available for rental or purchase.
- The monopoly on fossil fuels and grid electricity is broken. By adopting the smallest convenient power module and creating varying combinations of power and voltages, almost any domestic or office load can be met. But the most important feature is that there is no need to wait while your battery recharges. Imagine exchanging it at your local corner shop, or supermarket.
- It would be possible to control the import and export of power from a variety of renewable sources to meet peak electrical demand. This scenario would challenge the need to invest billions in centralised power stations. The long-term dangers and radioactive waste legacies of these will then be unnecessary.
- New developments in the storage chemistry of static batteries, particularly the larger-scale and heavier carbon-cased salt-water battery systems developed by Microsoft, mean that that lithium supplies will not be exhausted, which is currently a serious problem.

The argument that batteries are toxic and the materials used on this scale will cause environmental degradation and resource depletion now needs to be challenged head-on. A combination of eight transport-grade exchangeable batteries and one static 4 kWh aqueous ion salt-water and carbon battery would make almost any household independent of fossil fuels. However, to avoid any energy bills at all, embedded building-integrated microgeneration has to be the way forward. This is why building design and urban planning has to change fast and incorporate large-scale building-integrated renewable energy from the start (**fig. 4.4**).

TOOL 3

LOW-CARBON TRANSPORT: THE ZEDBIKE, ELECTRIC VEHICLES AND THE FILLING STATIONS OF THE FUTURE

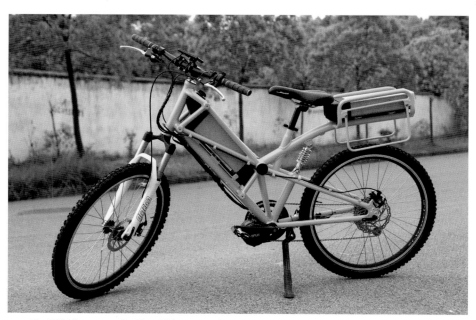

5.1 The ZEDbike can run for 50 to 70 km on one battery.

The ZEDbike

Personal transport, such as cars, taxis, motorbikes and scooters, is normally the dominant cause of CO_2 footprint and cost. If city-scale public transport can be powered by large-scale wind and communal renewable energy systems, it becomes important to develop smaller-scale personal transport systems that are cheap to use without involving fossil fuels. A contemporary electric car only works with a 30 kWh of lithium battery storage, but pedal assisted bikes could be built at low cost for maximum durability. Up to now, the problem has been that such hybrid two-wheelers either burnt out on hills, ran out of power

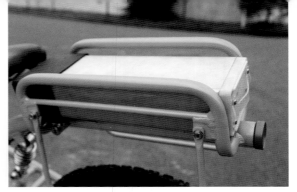

5.3

5.2

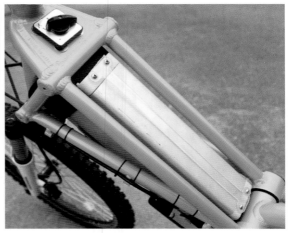

5.4

too soon or were simply too slow for most people. For better or worse, low speeds are a safety requirement, so ZEDfactory has developed a low-cost 24-volt battery limited to a top speed of 25 km/h that could extend the range of an ordinary bicycle to 50 km, and a faster 48-volt full suspension twin battery version that increases the top speed to 45 km/h (figs 5.1–5.7).

An electric bike (e-bike) like the ZEDbike opens up new routes across a congested metropolis or even rolling countryside. Anywhere that a bicycle can legally go, an e-bike can go as well, so while cars are queueing in near gridlock the e-biker can reach the same destination by travelling across footpaths, through parks, along riverbanks, through cemeteries or along quiet backstreets. These routes may only share 20% of the same road taken by car driving between the same two points. A power-hungry electric car such as a Nissan Leaf uses 10 times more electricity to make the same journey than a ZEDbike. In urban areas, a bike will normally get there faster, and the e-biker has a healthier ride that uses fewer resources. In a society running on renewable electricity, it will be important to move from cars to bikes for the daily commute, as electricity needs to be shared among many users (fig. 5.8).

5.5

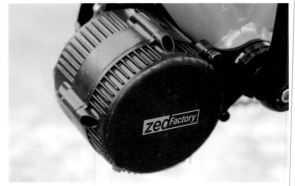

5.6

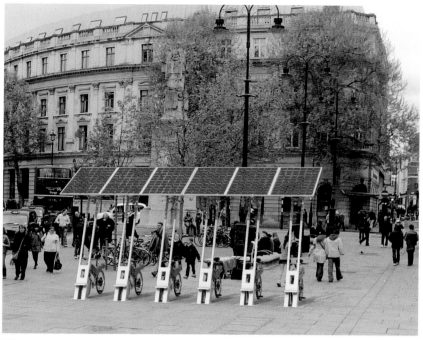

5.7

5.2 Daily route of 15 miles from Kingston to Sutton via parks, rivers, cemeteries and the occasional cycle path, missing long stretches of main road and avoiding the need for public transport. Route tested for two years and 5,000 miles.

5.3+5.4 Every ZEDbike has two LifePO4 batteries.

5.5+5.6 ZEDbike features.

5.7 ZEDbike docks in London.

5.8 Electric bikes make a 15 mile each way daily commute possible in 45 minutes, suggesting that cycle superhighways should extend to Zone 6 and allow radial movement around London.

Cycle Superhighways
Indicative routes subject to consultation*

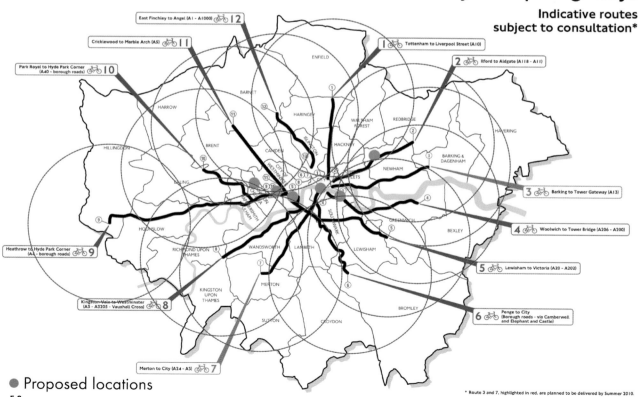

12 East Finchley to Angel (A1 - A1000)
11 Cricklewood to Marble Arch (A5)
10 Park Royal to Hyde Park Corner (A40 - borough roads)
1 Tottenham to Liverpool Street (A10)
2 Ilford to Aldgate (A118 - A11)
3 Barking to Tower Gateway (A13)
4 Woolwich to Tower Bridge (A206 - A200)
9 Heathrow to Hyde Park Corner (A4 - borough roads)
5 Lewisham to Victoria (A20 - A202)
8 Kingston Vale to Westminster (A3 - A3205 - Vauxhall Cross)
6 Penge to City (Borough roads - via Camberwell and Elephant and Castle)
7 Merton to City (A24 - A3)

● Proposed locations

5.8

* Route 3 and 7, highlighted in red, are planned to be delivered by Summer 2010

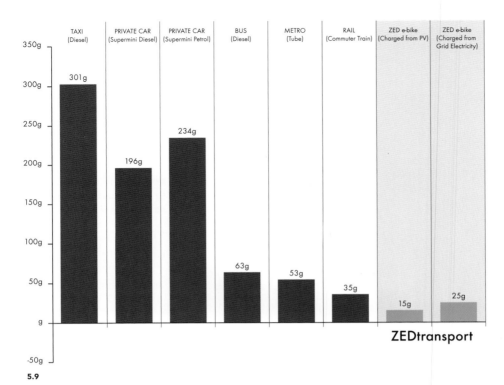

TAXI (Diesel)	PRIVATE CAR (Supermini Diesel)	PRIVATE CAR (Supermini Petrol)	BUS (Diesel)	METRO (Tube)	RAIL (Commuter Train)	ZED e-bike (Charged from PV)	ZED e-bike (Charged from Grid Electricity)
301g	196g	234g	63g	53g	35g	15g	25g

ZEDtransport

5.9

5.10

5.9 Grams of carbon emitted per person per kilometre for each different transport mode.

5.10 A ZEDbike charging from a foldable PV panel.

5.11+5.12 The ZEDtrike sits four people within half a parking space and it is the same price as motorcycle. A zero emissions 6 kW electric hub motor is powered by up to 10 exchangeable solar charged 0.5 kWh batteries. Small PV glazed panels help recharge batteries whilst parked.

5.13 The ZEDtrike tilts for improved cornering and it is simple to construct and maintain.

ZEDfactory has compared these two modes of transport on the basis of the carbon emitted per passenger kilometre, taking into account the carbon and energy invested into the manufacture of the vehicle. When the carbon emitted during the manufacturing process for the average supermini car is included in the calculation, it doubles the level quoted by the manufacturers that relates to carbon emissions in use (**fig. 5.9**). The ZEDbike uses the least amount of carbon per passenger kilometre per unit cost of any powered vehicle; even less when charged from a ZED PV panel.

Each ZEDbike needs 1 kW energy to charge it fully, so that a single PV panel can generate enough energy to cover 6,000 miles per year (**fig. 5.10**). Each solar tree can potentially generate enough energy to power 12 bikes annually, or about 16,000 to 28,000 miles for a ZEDtrike or a Renault Twizy (**figs 5.11–5.12**). These are three-wheeled alternatives that overcome the problems of carrying bulky goods or children, while adding protection from the weather. Two wheels at the front allow for higher-speed cornering, with the simplicity of an electric motor with a single geared hub to drive a

rear wheel (**fig. 5.13**). This arrangement avoids the cost of transmissions, differentials and expensive, heavy engineering essential to a robust four-wheeled vehicle.

There are major social benefits in halving the size of a contemporary car and running it on clean and silent electric power generated from local renewable sources. Cars are unlikely to disappear suddenly, because they are so popular and convenient, but they often result in excessive air and noise pollution and take up large areas of land when parked. On many building projects the area given over to car parking can be as much as 30% of the total land area, in addition to areas of land sterilised by high-speed roads. The social and environmental cost of this non-productive and barren, hostile space is high. Instead there could be green open landscape and amenity space, while urban populations could be relieved of much of the visual and psychological stress that roads are apt to generate. To improve this situation, we have designed a car that seats three or four people, but is half the length of a conventional car, so that two e-trikes could be parked within one conventional parking space. Doors are optional, there is space to stow the shopping, and PV surfaces can generate part of the necessary power.

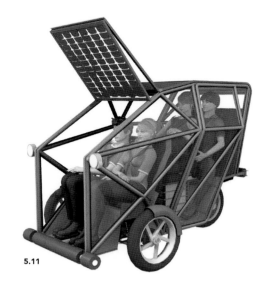

5.11

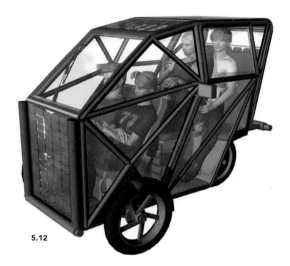

5.12

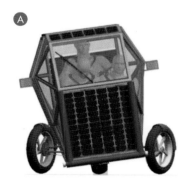 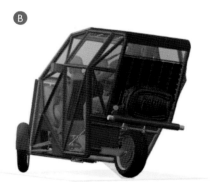 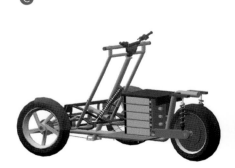

A B Balanced Tilt-Turn Mechanism

C 2x Core Batteries and 10x Removable Batteries

5.13

5.14

5.15

5.14 BMW Isetta bubble car.

5.15 Messerschmitt KR200 bubble car.

5.16 Electric village with aerial streets optimised for street life and personal electric vehicles.

5.17 Park in your own hall or balcony and charge from the roof.

Looking for inspiration, we went back to the immediate post–World War II years, when severe shortages of materials dictated careful use of resources. The BMW Isetta bubble car and the Messerschmitt bubble car were little more than enclosed three-wheeled motorcycles, but they were happily adopted for a decade by younger people until prosperity made larger four-wheeled cars widely affordable (**figs 5.14–5.15**). If it is possible to drive your e-trike along a pedestrian-priority street or pathway, right into a lift, and park it in your apartment hallway, charging it with electricity from your own facade or roof, then we can rethink the dominance of cars as we know it.

This was the brief given to ZEDfactory by the Beijing deputy housing minister, Zhao Bao Zhing, to consider how innovative forms of transport could inform the design of medium density apartment blocks. Aerial ramped streets with solar electric canopies might replace elevators, and e-bikes and e-trikes could drive into each apartment (**fig. 5.16**). The covered streets would provide shelter and shade, encouraging precious casual meeting and passing contact among neighbours. ZEDtrike is not only more economical and more convenient than a conventional full-sized electric car, it has zero tailpipe emissions, so it is clean enough to be parked in your lobby (**fig. 5.17**). We see this as a way of replacing the anonymity of closed corridors with a new version of 'streets in the sky' that would really bring people together.

What is the 'filling station of the future'?

The old problem of lack of battery capacity in an electric vehicle (EV) is now a thing of the past, and the affordable Nissan Leaf can travel up to 155 miles on a single charge. The latest challenge is how to charge multiple EVs at once, as fast as possible. It becomes even harder when green electricity is required to make this mode of travel even cleaner. While EV charging points are few and far between, it usually means a long wait to get onto the charge point, and even longer for the EV to charge itself. As these charging points are connected to the grid,

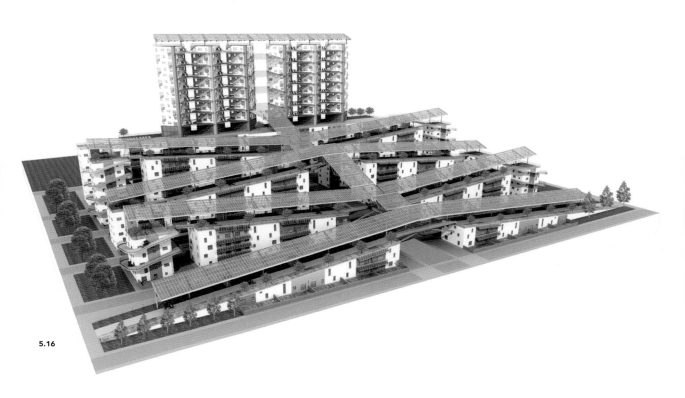

5.16

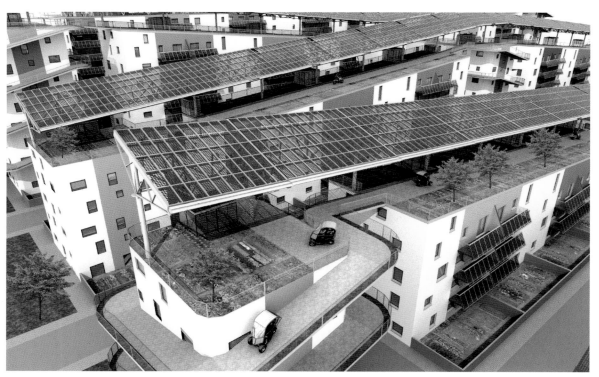

5.17

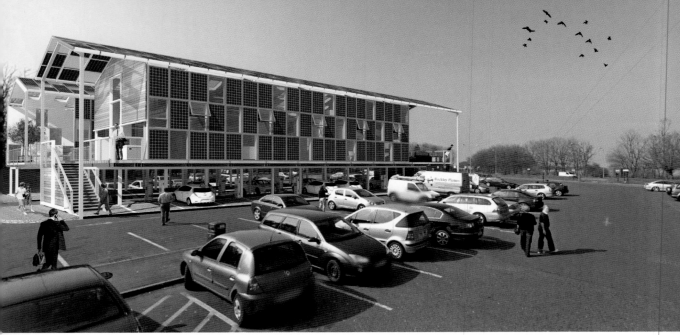

5.18

5.19

5.20

a large percentage of their energy is generated from burning fossil fuels, so that EV travel still trails a high-carbon footprint.

The 'filling station of the future' proposed by ZEDfactory meets all of these challenges (fig. 5.18). With the space for 22 vehicles to charge at once, there would rarely be the occasion when a time-pressed driver would have to wait. Powered partly by the building's integrated PV panel array, the filling station would also provide a higher percentage of free low-carbon energy. Like other charging points, the filling station would be fitted with fast charging points powered by direct current, so that customers would need to spend 45 minutes 'filling up', a lot less than at present.

There is a difference between a new filling station like this and a conventional one for petrol and diesel, where drivers pass through and only a few want to park. In front of motorway service stations, ZEDfactory would provide 25 to 40 parking bays 'ring-fenced' from the existing car parks. The entire building would be clad in solar electric panels, a form of self-advertisement for its commitment to renewable energy. Above the charge terminals there would be a new cafe and bar with toilets and a bookable meeting room for business (figs 5.19–5.20). The charging progress of your vehicle would be

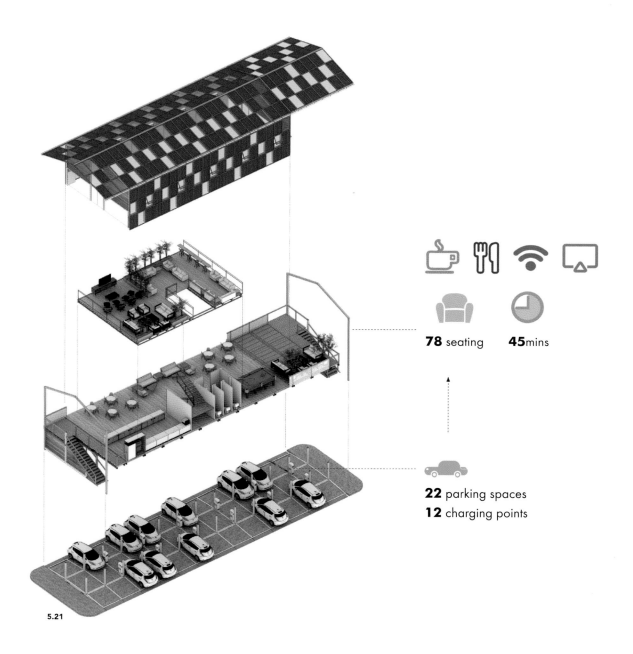

78 seating **45**mins

22 parking spaces
12 charging points

5.21

displayed on large information boards, and with your downtime you could relax, drink good quality coffee, eat organic food, connect to Wi-Fi, hold a business meeting, or sleep in hammocks suspended from the ceiling (**figs 5.21 and 5.22,** *overleaf*). In short, a heavenly upgrade on existing UK motorway facilities.

Fast-charging electric vehicles

For technical reasons, using stationary DC charging points increases the amount of power that can be delivered as compared to AC charging, therefore

5.18 Exterior view of the 'filling station of the future'.
5.19+5.20 ZED workspace interior view.
5.21 Isometric diagram.

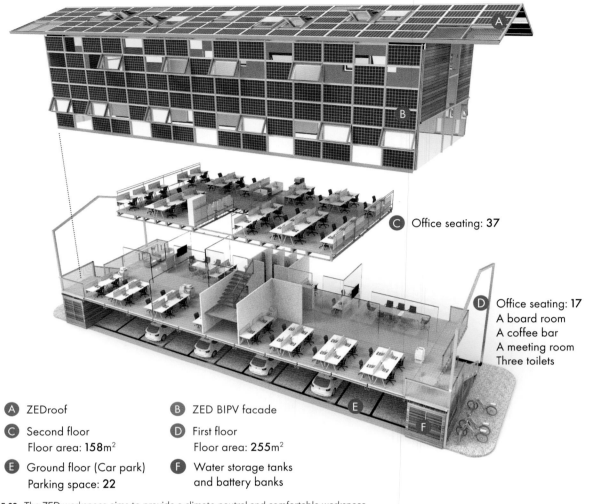

C Office seating: **37**

D Office seating: **17**
A board room
A coffee bar
A meeting room
Three toilets

A ZEDroof

B ZED BIPV facade

C Second floor
Floor area: **158**m²

D First floor
Floor area: **255**m²

E Ground floor (Car park)
Parking space: **22**

F Water storage tanks
and battery banks

5.22 The ZED workspace aims to provide a climate-neutral and comfortable workspace
above existing parking areas with integrated zero-carbon transportation

reducing charge time. Like mobile phone companies, EV would use a selection of different sockets to deliver charge, therefore the filling station would accommodate the two main charging points to ensure most EVs are able to charge: these include CHAdeMO for Japanese EVs and Combined Charging System (CCS) for European EVs.

While the 'filling station of the future' would be able to charge the EV, there would be time to go shopping, so including these filling stations at supermarket outlets would allow for a productive use of 45 minutes or so, rather than being at the usual type of petrol station, perhaps stuck in the car waiting for one of the points to come free or keeping out of the rain. Satellite navigation systems would make it easy to find the closest point.

We see these new filling stations providing dual services initially – electric and fossil fuels – as a way of easing the transition process.

TOOL 4

BUILDING-LEVEL ENERGY SYSTEMS: AIR-SOURCED HEAT PUMPS AND SOLAR-ASSISTED HEATING AND COOLING

Air-sourced heat pump

When a building is super-insulated, the function of the heating system is to provide hot water for kitchen and bathroom use rather than for space heating; the latter can be shrunk by good building fabric and passive solar design, to the point that heat input is only required on the coldest of winter days. The rest of the time, space heating is provided by passive solar gains, internal gains and MVHR (mechanical ventilation with heat recovery) and, when these don't suffice, very small air-source heat pumps (ASHPs) can be used to provide top-up space heating. ASHPs use an electric powered compressor to circulate refrigerant between coils exposed to both the hot and cold external environment and the internal room. The latent heat of evaporation and liquidification provides heating and cooling on demand – rather like a reversible fridge. The more efficient the system, the less electrical energy is needed to meet thermal demand. Systems as small as 600 W, which use only 1 unit of electricity to provide 3.5 units of heat (average annual efficiency), provide the minimal load of the home while reducing electrical energy. ASHPs can supply warm air, underfloor heating systems and low-flow temperature eco-convector radiators according to choice.

Solar assisted heating and cooling

When the sun is shining you could potentially double the amount of heating and cooling available from conventional ASHPs. Cooling is sometimes forgotten as a consumer of energy in the existing conditions. Indeed, in many eastern cities air conditioning accounts for 70% of the total power load from conventional fossil-fuel powered sources.

This is the method we propose: the heat captured by the solar collector evaporates the refrigerant, thus reducing the amount of electricity required by the compressor motor to run the cooling circuit. This system is relatively simple and easy to maintain with existing materials and components. Making it can be integrated into the external envelope of new and existing buildings alike and make a significant contribution.

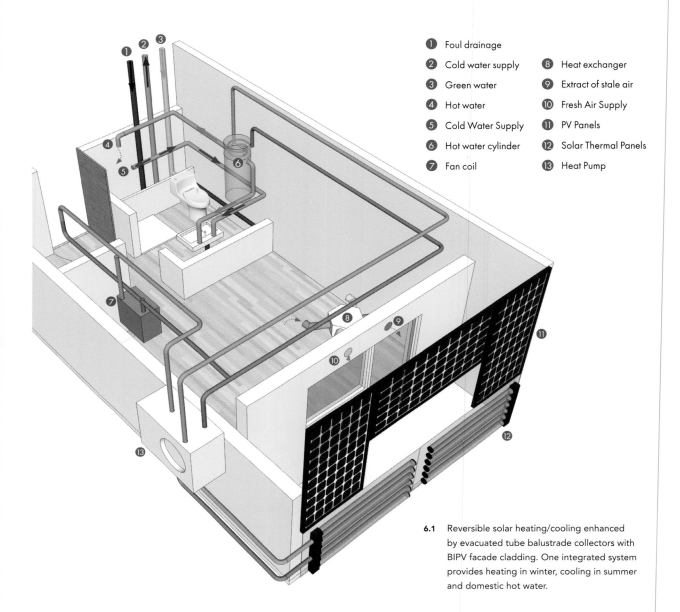

❶ Foul drainage	
❷ Cold water supply	❽ Heat exchanger
❸ Green water	❾ Extract of stale air
❹ Hot water	❿ Fresh Air Supply
❺ Cold Water Supply	⑪ PV Panels
❻ Hot water cylinder	⑫ Solar Thermal Panels
❼ Fan coil	⑬ Heat Pump

6.1 Reversible solar heating/cooling enhanced by evacuated tube balustrade collectors with BIPV facade cladding. One integrated system provides heating in winter, cooling in summer and domestic hot water.

If the solar cooling system can be added to rainscreen BIPV systems, then the building envelope gains another valuable property. It would not only provide heat and electricity but also potentially chilled water, useful for dehumidification in humid climates.

Using solar thermal collector technology in these ways means that solar electricity generated by PV panels and stored in the battery system can now make a comfortable internal environment for most of the year (**fig. 6.1**). The advantage of this system is that the hotter the sun shines, the more efficient the cooling system becomes. Glazed frameless balconies can be used to mount the vacuum tube solar collectors, or they can be mounted behind clear glazed panels set within a BIPV roof and facade system. This new intelligent skin replaces conventional rainscreen cladding systems and it should be achievable without significant additional cost because the standard alternative is already expensive.

TOOL 5

DISTRICT-LEVEL ENERGY SYSTEMS AND FOOD PRODUCTION

We should factor into future plans the need for a surplus of renewable energy, since not every building will have the potential to become self-powering. Protected historic buildings are the most obvious category. This is not a problem because the productive farmland surrounding almost every major city or conurbation has the potential to fill the shortfall, providing a quarter of the total consumption with biogas energy produced using pyrolysis.

Pyrolysis occurs when organic or man-made carbon-based matter is heated but starved of the oxygen that is normally part of the process of burning. It is really a high-tech equivalent of traditional charcoal burning, only more efficient and controlled.

Burnt in this way, with high temperatures and without oxygen, matter breaks down into hydrogen rich biomethane and a small amount of residual oil. Twenty per cent of the carbon can be 'sequestered' – removed from the annual atmospheric carbon cycle – in the form of solid carbon char that can be buried/mixed with soil.

There is no combustion and there are no atmospheric emissions from the pyrolysis process. There is another by-product, organic biomethane, which can be burnt to generate electricity, and when this happens CO_2 will be produced, as with a conventional fossil-gas motor. However, we believe that in the longer term, biomethane could be used with fuel cells and so reduce this problem (**fig. 7.1,** *overleaf*).

What contribution can pyrolysis make to a community?

A five-module plant could process 40,000 tonnes of waste a year and generate enough electricity for 10,000 households (based on the Department of Trade and Industry's Energy Review 2006)[9] (**figs 7.2–7.3,** *overleaf*).

URBAN	0.88 MWh per year +
RURAL	0.79 MWh per year =
TOTAL	1.67 MWh (e) per year

URBAN: A typical city household produces approximately 0.88 tonnes of MSW (municipal

7.1

Fuel: green waste/
other waste 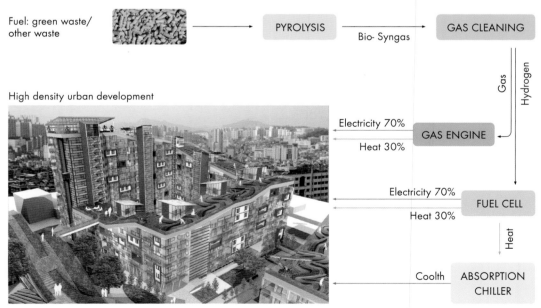 → PYROLYSIS —Bio-Syngas→ GAS CLEANING

Gas · Hydrogen

High density urban development

←Electricity 70%— GAS ENGINE ←
—Heat 30%

←Electricity 70%— FUEL CELL
—Heat 30%

Heat

←Coolth— ABSORPTION CHILLER

7.2

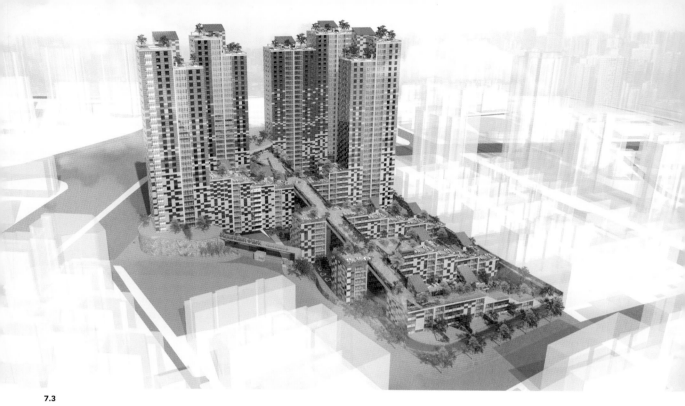

7.3

solid organic waste) per year, which could generate approximately 0.88 MWh per year. This is a resource that could normally produce:

> 26% of each home's annual electric demand

> 9.3% of each home's annual thermal demand

RURAL: Agricultural waste is an unavoidable by product of the food that any household consumes. The average weight of crop actually used by each household per year generates an unseen waste of about 0.79 tonnes per household which, if fed into a pyrolysis unit, could generate approximately 0.79 MWh per year. This is the equivalent of:

> 24% of each home's annual electric demand

> 8.8% of each home's annual thermal demand

7.1 A typical installation of an EPi pyrolysis unit.

7.2 Tri-generation concept capable of matching heating, cooling and electric loads powered by agricultural waste or organic waste.

7.3 On a 1,000 home regeneration scheme it is possible to achieve a plot ratio of four and meet approximately half the total electric demand from solar electricity and the remainder from pyrolysis.

7.4 Agricultural waste.

What materials can be pyrolysed?

Anything derived from plant or animal sources that is purely organic can be used, including wood chippings, palm husks and crop residues (**fig. 7.4**). The material must, however, be thoroughly dried out.

Organic material forms a large part of what we throw out, including not only food, textiles, paper and card, but plastics, film, rubber, or parts of a vast range of materials derived from oil or other fossil

7.4

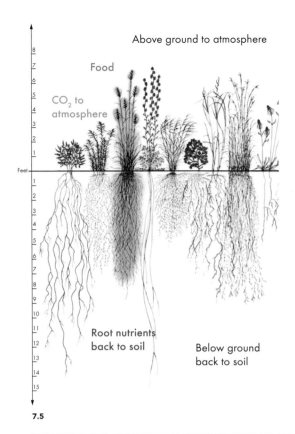

Above ground to atmosphere

Food

CO_2 to atmosphere

Feet

Root nutrients back to soil

Below ground back to soil

7.5

fuels. In essence, if it isn't metal or mineral (glass counts as mineral), and if it's solid, it's organic. As with other new devices, the more they are taken up, the cheaper they will become. A farm-based pyrolysis plant could then be similar in price to a combine harvester. There is a particular benefit for farmers of grain crops, since carbon absorbed from the atmosphere as straw can be ploughed back into the soil as biochar fertiliser, thus sequestering this carbon whilst increasing soil fertility. (**fig. 7.5**).

How can the pyrolysis gas be used?

1. Direct use – at the point of production, gas from pyrolysis can be cleaned and fed into a gas engine, or a hydrogen fuel cell, or even used directly for industrial processes such as cooking. This application obviously works best when the supply and demand are matched, so that there is less likelihood of 'heat dumping'. If the heat is transformed into electricity, of course, it can be exported via the National Grid and so it would not be wasted.

2. Storage and distribution – biogas can be compressed and liquefied much in the same way as petroleum gas (LPG) – we could call it liquid biogas (LBG). It could be stored and distributed around the country in much the same way as Calor Gas is now. It could also be processed into a transport grade gas and so replace petrol in converted vehicle engines (**fig. 7.6**).

3. Virtual biogas – biogas opens up exciting possibilities for farmers. In Austria and Germany, they can put local waste to use, and 'inject' processed and cleaned biogas back into the national gas

Parameter	Sample 1	Sample 2	Sample 3	Average
	Woodchip	Mixed Construction	Sudge Pellets	
Gas Analysis (Vol %)	Vol %			
Carbon Dioxide	12.2	15.0	13.6	13.6
Oxygen	0.7	1.1	0.7	0.8
Nitrogen	2.0	3.0	2.0	2.3
Hydrogen	17.0	23.1	13.5	17.9
Carbon Monoxide	43.0	34.0	42.0	39.7
Methane (CH_4)	17.5	16.1	17.5	17.0
Ethane (C_2H_6)	0.54	0.46	1.21	0.7
Propane (C_3H_8)	0.02	0.02	0.04	0.0
Butane (n-C_4H_{10})	0.05	0.03	0.12	0.1
Pentane (n-C_5H_{12})	0.04	0.02	0.05	0.0
Hexane (n-C_6H_{14})	0.0015	0.0122	0.0272	0.0
Heptane (n-C_7H_{16})	0.0032	0.0044	0.0147	0.0
Octane (n-C_8H_{18})	0.0030	0.0034	0.0064	0.0
Ethylene (C_2H_4)	4.50	3.90	5.10	4.5
Cyclopropane (Propene) (C_3H_6)			0.59	0.6
Acetylene (Ethyne) C_2H_2	0.00	0.00	0.00	0.0
Hydrogen Sulfide	0.00	0.00	0.00	0.0
Carbonyl Sulfide	0.00	0.00	0.00	0.0
Total Vol %	97.51	96.70	96.46	97.3
Heating Value (Btu/ft3)				493

7.6

7.7

network to be purchased by consumers elsewhere. This suggests an urban/rural symbiosis, whereby a high-density urban development could fund the capital cost of installing a rural waste processing system for mutual benefit. Fuel cells located in the heart of the city could take the biogas from the grid and convert it into heat and power where it is most needed (**fig. 7.7**).

Why pyrolysis instead of incineration?

The calorific value of one tonne of organic waste can vary, but when measured against the amount of heat and electricity that pyrolysis can produce, we can work out the extent to which pyrolysis could contribute to future energy supply.

For example, in 2008 just under 5 million tonnes of excess straw waste was produced in the UK from farming,[10] equivalent to just under 80 kg per person. Add in the 170 kg of organic waste, for which the average person is responsible per year,[11] that gives you a total of 250 kg of organic waste per capita that could potentially be fed into a district pyrolysis unit.

If the UK were to embark on a national pyrolysis installation programme right away, then the national stock of straw and organic waste would only be able to contribute 5% of the UK domestic electrical consumption and 2% of its thermal consumption on an equal distribution basis, given the inefficiency of the majority of homes (**fig. 7.8**). If by 2050 every home in the UK had solar panels equivalent to an average output of 3 kWp, an additional 12% of electrical/thermal demand could be met from solar sources, leaving 81% of power to be derived from grid gas/electricity.

However, this also assumes no improvement in the energy efficiency of the UK housing stock.

Upgrading the UK housing stock is a significant precondition for getting the most out of pyrolysis. The building fabric plan, overlaid on the BedZED site, shows how important this is (**fig. 7.9**, *overleaf*). Each circle represents the area of agricultural land required to produce enough excess straw for one person's annual needs, so

7.5 Only the grain is eaten, but the straw can be pyrolysed.

7.6 Pyrolysis gas content.

7.7 Energy rich carbon char provides a number of opportunities for the production of additional energy. As a source of heat the char has an energy value better than coal.

7.8 Left: Pyrolysis's potential contribution to UK domestic energy needs (using BedZED average consumption, 2008). Right: Pyrolysis's potential contribution to UK domestic energy needs (using UK average consumption, 2008).

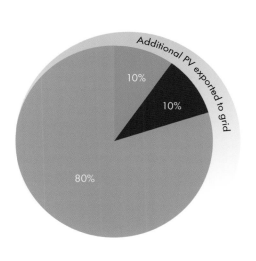

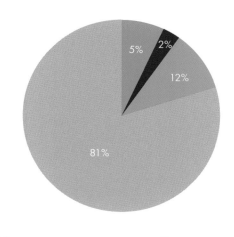

 Pyrolysis electrical consumption On-site PV production 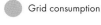 Pyrolysis thermal consumption Grid consumption

7.8

UK Average Resident's
Electrical Demand:
8.25 Hectares

BedZED Resident's
Electrical Demand:
2.79 Hectares

Area of BedZED: **1.7** Hectares

UK Average Resident's
Heating Demand:
18.33 Hectares

BedZED Resident's
Heating Demand:
2.54 Hectares

N

7.9

that even a BedZED resident would require 5.33 hectares of land to produce enough straw to meet 100% of their electrical and thermal requirements via pyrolysis. A typical UK resident without the benefits of energy efficient BedZED housing would require nearly 27 hectares of productive land growing biofuel. The UK available reserves can only provide 0.28 hectares/capita.

When applied as an energy solution at the scale of a community, pyrolysis has other benefits. This is critical when compared with ordinary incineration, to which urban waste is currently directed, because landfill sites are no longer operating, and there is now a cash benefit for anyone prepared to take care of it. In many cities across the world incineration has been sold to the unsuspecting public as a beneficial use of waste, but it is only economical because of the payments received. It is an inefficient way of

producing heat and since the incineration plants have to be sited far from high-density residential areas, their low-grade heat doesn't work out economically for use as district heating because of the cost of installing insulated distribution pipework over longer distances.

If incineration takes place closer to where people live, it creates a serious pollution problem, which can only be overcome if the incinerator building has a volume equivalent to St. Paul's Cathedral, with a 50 m high chimney to disperse the toxic gases and particles.

The popularity of this imperfect process began with a scare about landfill producing large amounts of methane, a greenhouse gas 24 times more damaging than CO_2. This particular problem has now been solved and most landfill sites are now capped with methane collecting membranes, so

Before

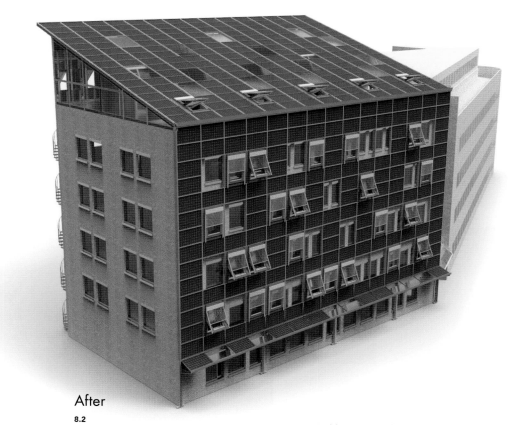

After

8.2

8.1 Building external fabric.

8.2 Render shows how fabric renovation can improve
 the visual impact of the building, while creating an
 opportunity for generation of electricity.

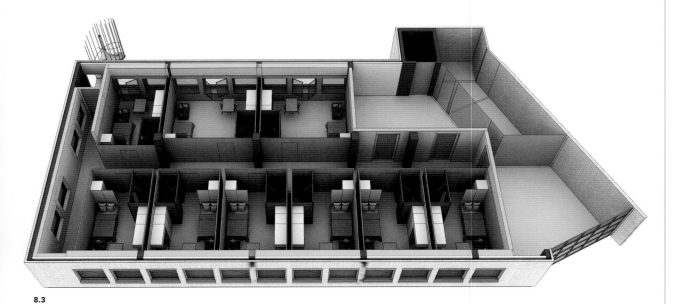

8.3

1

2

3

4

5

8.4

1 Kit House components off-loaded from truck

2 Steel frame is assembled inside empty office building

3 Frame is covered in fire-rated solid wooden panels

4 Outside surface is covered in fire-protecting mineral wool

5 Exposed end walls are covered in finishing panel. Passage walls have extra wood panel to double the fire rating.

8.3 Plan view – the yellow line encloses the super-insulated building envelope.

8.4 Construction sequence turning an open-plan office into a super-insulated fireproof habitation pod for young people or refugees. The process is reversible back to an office with zero waste.

to the owner in exactly the same condition after 10 or 15 years. This meant leaving all the services intact and not disturbing the suspended ceilings. Conversion to residential use imposed onerous fire regulations, but energy efficiency could be increased to achieve near-zero-carbon status, meeting the targets of the Dutch Energiesprong programme. The project required that the fit-out kit of parts had to be quickly erected by a relatively low-skilled workforce in a few days and easily taken down and rebuilt with zero waste in a new location.

This potential 'transition' concept allows high performance new homes to be created from inefficient buildings without the need for demolition and rebuilding, while fitting into conventional commercial lease requirements. It is replicable wherever there is demand for a certain type of small starter home rental units and relatively low-rental commercial space with openable windows.

8.5

An acoustically isolated fireproof self-contained room with walls and ceilings was built, with the window apertures of the existing glazed window wall sealed. By spacing the new fireproof enclosure 300 mm away from the existing internal wall surface and filling the gap with mineral wool, the new homes effectively became super-insulated. A heat recovery ventilation system was added, serving each floor level with flexiduct inserted in the suspended ceiling. An externally mounted heat pump attached to the fire escape supplied domestic hot water to a well-insulated cylinder in each micro-flat (**fig. 8.4**). Solar electric panels are ranged above the existing flat roof and suspended parallel to the walls, down to street level, with ballast blocks becoming a new kind of street furniture.

Other features include:

- 18 m² internal space with kitchen, bathroom, sleeping/living room and two large windows (**figs 8.5–8.7**).
- Very robust construction, 60-minute fireproofing, good heat and sound insulation.
- Connection to electricity, water and sewage in the host building.

8.6

8.5 Kitchen and dining space.
8.6 Shower room and toilet.

8.7　Living space.

This long life/loose fit adaptation of standard office space can provide large numbers of new homes very quickly without requiring new residential construction, when the number of development plots already allocated to housing is already too low. This kind of adaptation could bring new life to some very ordinary office buildings, particularly where the new residents are encouraged to colonise the barren flat roof terraces, and the deserted public realm at street level outside, as areas for planting or other uses.

TOOL 7

RAINWATER HARVESTING AND WATER RE-USE

Water scarcity is a major problem today, with around 1.7 billion people living in places with a serious scarcity.[12] This number will only rise as populations grow, while negative climate change reduces access to water. For climates with more rainfall, the value of storing rainwater becomes clear when trying to build an environment that revolves around having zero-carbon emissions. It is simply madness to be transporting filtering and treating water simply to flush it down the toilet when gravity-fed rainwater could do the job just as well without needing additional energy. The need to use water sensibly, and to save as much as possible, becomes ever more obvious, and decentralisation is the best way to achieve it.

Rainwater harvesting means catching and storing rainwater in tanks inserted within a building. Unfiltered, this water can be used for basic applications such as toilet flushing, clothes washing and garden irrigation. When filtered, the water can then be used for showering and catering.

Benefits of a rainwater harvester

- Capturing water directly saves building users the costs of consuming water delivered by the mains.
- Reducing the stress on dams and reservoirs water reduces the energy needed for what comes out of the tap.
- Storing rainwater and releasing it slowly decreases the damage of flash floods after sudden and heavy storms.
- Storing water this way means saving money on increasing drainage systems capacity.
- Harvesting systems ensure that all available water in the area is used before any needs to be pumped from already over-exploited wells and rivers.

Water re-use

Recycling does not apply just to waste and rubbish, but also to water, which can be recycled safely and sensibly. Grey water – draining from showers,

bathtubs and sinks – can be reused for toilet flushing and gardens after light treatment, but should not be used for cooking or drinking, as additional treatment is required.

In the area around a development, grey water can be used for farming and landscape irrigation, topping up waterscapes and artificial lakes. It can also contribute to the water requirements of the construction process, including concrete mixing, pressure washing and dust control.

There are cost savings all along the line, using less energy to bring water to the site for uses other than drinking, and dramatically reducing the cost of waste-water drainage. These benefits in turn help to maintain the ambient environment by protecting delicate freshwater ecosystems from contamination and also from being drained for uses that can be offset.

The ZED water surface

This new proposal by ZEDfactory enables a rainwater tank to be created from the large expanses of concrete found across all of our cities in the forms or roads, pavements and parks, potentially a huge volume for storage. As concrete is a porous material, water can be stored within the structure of the pavement without restricting the stability of the surface.

We propose this partly because the conventional solution of polypropylene cellular rainwater storage tanks is so unsatisfactory. They require large wall thicknesses for strength and one metre of topsoil cover. Their life expectancy is only 25 years, after which they become brittle and eventually fail under high loads, so that beautiful and expensive mature landscape has to be dug up and remade.

ⓐ Internal wall insulation
ⓑ Blown EPS bead insulation
ⓒ EPDM membrane
ⓓ Filling conical pedestal with concrete

ⓔ Rainwater storage
ⓕ Coolth transfer up through concrete pedestal via conduction
ⓖ Water permeable paving
ⓗ E-bike charging point

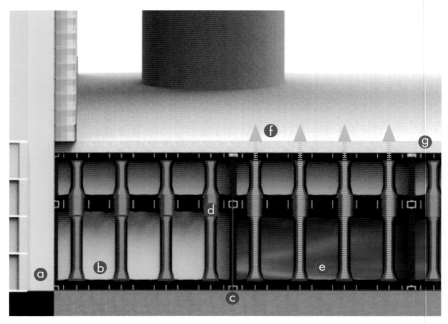

9.1

9.1 Diagram illustrates the internal load-baring insulated water storage foundation system.
9.2 Road permeate discharge integration system.

Load-bearing foundation system with heating and cooling storage

ZED has seen the potential for the water-holding polypropylene cones within the tank structure to act as permanent shuttering for poured concrete, which then takes compressive load, so that brittleness ceases to be a limitation. Apart from avoiding the cost and disruption of remaking the installation every 25 years, the concrete base could be adapted with foundation pads to carry a superstructure. If a cementitious floor tile or paving slab rides directly on top of the cellular tank, that means less excavation and lower earth-moving costs.

By filling the cellular tanks with blown EPS bead insulation, they would act as a storage sink by retaining heat in winter and staying cool in summer (**fig. 9.1**). A polybutylene underfloor heating/cooling coil could transmit heat or coolth from an external heat pump into the insulated rainwater store, increasing the levels of energy stored in the water. Heating and cooling equipment adapted to this system would no longer need to meet peak loads, so could be smaller and run off solar energy.

Permeable street surface with integral drainage and rainwater thermal storage system

How does the water get into the system? ZEDfactory proposes a removable polypropylene paving system that sits directly on top of the concrete-filled tank cones. The paving system could be filled with porous concrete so that water drains directly into the storage tank and large solids are filtered out (**fig. 9.2**).

In hot, humid climates, many people travel by car to benefit from the air conditioning, but you could walk in comfort along streets shaded by a solar-cooled canopy with integrated water storage. The surface of the paving slab would transmit coolth from the tanks to the walkway under your feet by conduction.

The solar canopy would be fixed to the steel foundation tubes and within it you could make bus shelters, bike shelters and covered walkways, generating enough electricity to power an ice slurry generator pumping chilled water through the cellular storage tanks.

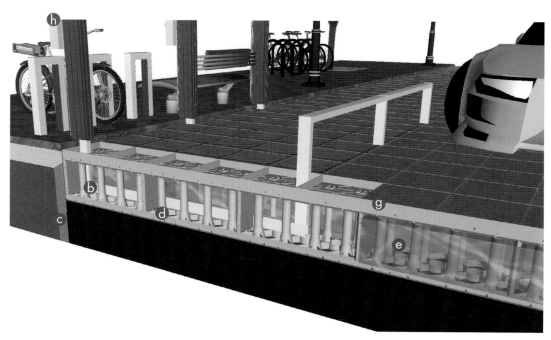

9.2

Roof garden integrated with water-storage tank

If some of the tanks were filled with concrete, they could provide a firm base for the components needed for a roof garden without needing to penetrate the EPDM (ethylene propylene diene monomer (M-class) rubber)[13] membrane tanking, which normally leaks because of handrails and other fixings sticking through it (**fig. 9.3**). The roof can have a mixture of paving, rainwater storage and insulation, with rooftop structures such as plant rooms or terrace bars.

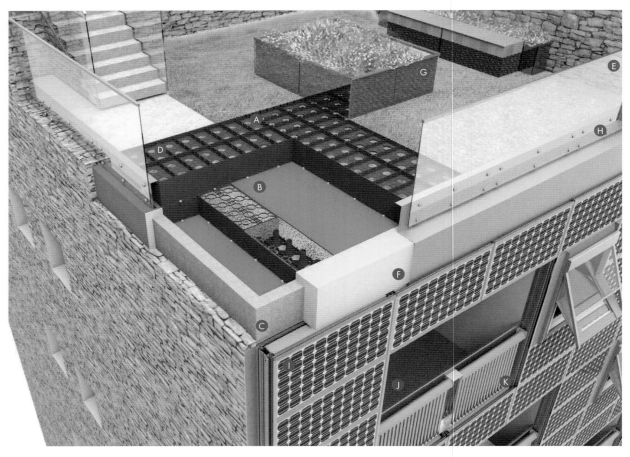

- (A) Water storage tank
- (B) EPDM membrane
- (C) Existing reinforced concrete
- (D) Filling conical pedestal with concrete
- (E) Frameless glazed balustrade
- (F) 100mm XPS insulation
- (G) Soil container
- (H) Galvanised steel RHS
- (I) Insulated BIPV facade system
- (J) Balcony
- (K) Evacuated tube solar thermal collector

9.3 Insulated roof garden with water storage.

TOOL 8

TOOL COMBINATIONS

ZEDlife describes a set of tools that in an ideal world would be used together to support each other. To highlight how this can be done we have outlined some examples of tool combinations. More tool combinations can be found in the case studies in Part III.

Reconnecting the city with the farm: ZEF (zero-energy [fossil] farm)

Organic agriculture should be an integral part of the overall ZED approach, increasing the quality of life for ordinary people and ensuring a stable and peaceful society.

The best way to plan new cities and upgrade existing ones is to set up a new agricultural model, supplying methane rich hydrogen gas through pyrolysis. The gas can be easily cleaned and scrubbed for distribution through the existing underground network, and turned into heat and power within each urban block using micro-CHP plants within the building. Imagine small hydrogen farms feeding the city through a network of gas-harvesting capillary

veins as a living metabolism, with benefits to the farm sites in the form of biochar fertiliser, sequestering atmospheric CO_2 in the process. As well as taking waste methane out of agricultural production, they create an easily distributed fuel that can power high-density city centres. The important innovation here is that pyrolysis transforms waste agricultural straw into biochar charcoal. Thus growing food can now help reduce CO_2 levels, without biomass consumption for fuel competing with food production. Farmers, surprisingly, can become the key to creating a better city life (**fig. 10.1**, *overleaf*).

ZEDstreet

The complex buildings in historic urban centres that now attract wealthy residents cannot be easily adapted for new technologies or harvesting renewable energy. One solution could be to create linear shelters over the only open space commonly available – the road or the car park. These shelters would constitute a new type of urban arcade, comfortably shaded with

dappled daylight and open sides for unrestricted airflow and access. All the communal services needed to sustain a local neighbourhood could be inserted: generating and storing electricity from sunlight, providing cooling and dehumidification from pumpable ice slurry, and even heating from biogas or pyrolysis. They could store rain and purify water for drinking and treat waste grey and black water with dry composting facilities. The street could charge personal electric vehicles (EVs), lend out communal batteries while powering light trams, electric buses and shared pool cars. This innovation would relieve the burden on existing centralised energy, water treatment and transport, significantly reducing air pollution and the cost of modernising or regenerating urban districts. This concept is especially apt for making a gradual change from fossil-powered centralised infrastructure (**figs 10.2–10.3**, *overleaf*).

The following applications could be proposed:

1: A COVERED ROUTE FOR CYCLES, PERSONAL EVS AND PEDESTRIANS

This would encourage more people out of their cars. Rain protection in northern climates and shade in hotter countries would make walking and cycling more comfortable. Insulated cellular storage tanks for rainwater under the street can store diurnal coolth, lowering pavement temperature in summer and preventing hazardous ice and frost in winter. Social cohesion can arise in friendly gathering places, unlike the arid tarmac habitat of cars.

2: ZEDSTREET CANOPIES

These could replace conventional ground-mounted solar farms that are in danger of restricting the production of farmland around cities. Wide multiple-lane roads offer a good opportunity for covering and if the number of lanes is reduced, valuable street areas for pedestrians and market stalls could run alongside the traffic.

3: CONTAINERISED PUMPABLE 6RT ICE-SLURRY PRODUCTION FOR DEHUMIDIFICATION AND DISTRICT COOLING

To make this work, we needed to find a way of making ice without much power and discovered that

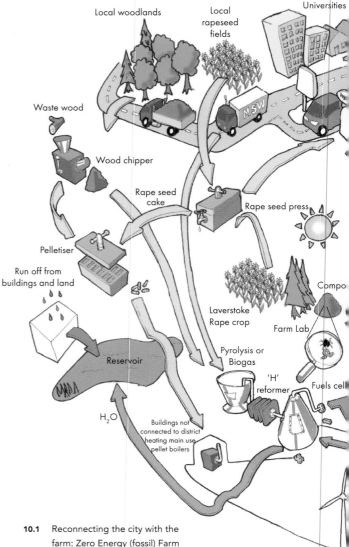

10.1 Reconnecting the city with the farm: Zero Energy (fossil) Farm

this already existed in the form of the ice-making machinery normally fitted to deep-sea fishing boats. We placed it in an insulated shipping container with large ice-slurry storage chambers and used solar electricity to make large volumes of pumpable ice slurry during the day when the sun was at its strongest. The ice slurry was then pumped into homes, greenhouses and commercial buildings

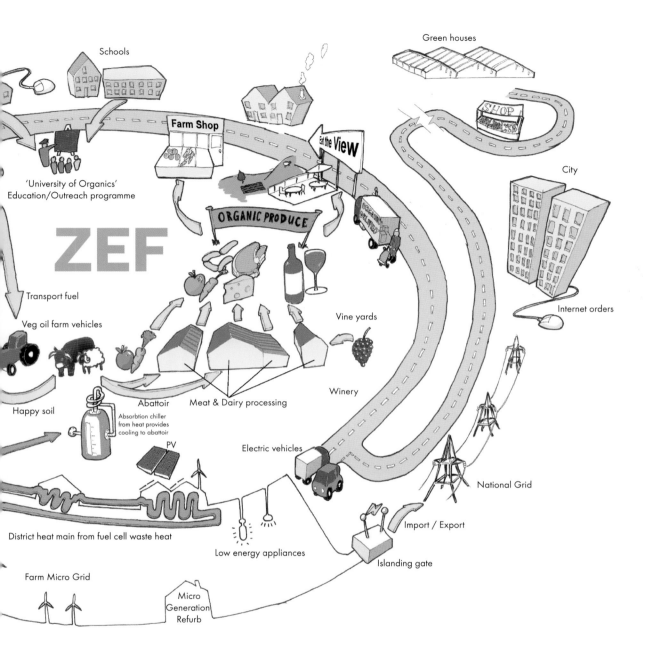

Schools

'University of Organics'
Education/Outreach programme

ZEF

Transport fuel

Veg oil farm vehicles

Happy soil

Farm Shop

Eat the View

ORGANIC PRODUCE

Vine yards

Abattoir

Meat & Dairy processing

Winery

Absorbtion chiller
from heat provides
cooling to abattoir

PV

Electric vehicles

District heat main from fuel cell waste heat

Low energy appliances

Islanding gate

Import / Export

National Grid

Internet orders

City

Green houses

SHOP

Farm Micro Grid

Micro
Generation
Refurb

with the added benefit that when the ice slurry pipe is exposed to humid air, pure water runs off as condensation in large quantities. This innovation could therefore provide valuable fresh water in arid but humid environments at the same time as dehumidifying a room or building interior. Keeping food fresh in hot climates is a major benefit to local farmers, and the ice slurry can be used for refrigerated cold stores in local food markets. This way, shipping containers adapted to storage of refrigerated food can now be achieved without using fossil fuels or noisy polluting generators.

4: LOCAL ZEDENERGY HUBS
Along the route, electricity could be on tap for assembling and servicing small-scale personal EVs

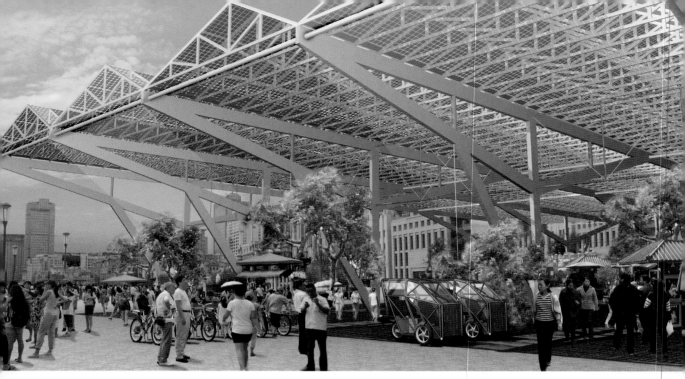

10.2

and powering exchangeable batteries. Large-scale local neighbourhood electric storage is also an option, at a suggested rate of 100 kWh per 100 m street run. This switchable electric storage can feed into the National Grid to meet local peak demand as well as providing a measure of essential services and communication for off-grid periods.

5: LOCAL SHOWROOMS AND CONTRACTORS

There are some local businesses who will retrofit existing urban fabric with energy efficient lighting, insulation and solar air-con technologies.

6: LOCAL SANITATION HUB TREATING GREY AND BLACK WATER

A ready-to-use advanced membrane bioreactor, powered by solar electricity, could create fresh drinking water as well as treating grey water. Advanced one-pint flush water closets can pump black water to a centralised composting unit, reclaiming nutrients locally by drying all solids to produce a sterile powder that can be used as a biomass fertiliser. This is far better than discharging large quantities of waterborne sewage to centralised treatment centres because, despite their long-established use and high-

maintenance costs, these still release large amounts of pollution into local watercourses.

ZEDfactory believes that advanced centralised composting within the street system is a cheap and practical scheme that would answer one of the main problems relating to the slums and favelas that surround many cities in the developing world. This is because it does not require extensive excavation or the large volumes of fresh water needed to flush gravity-drainage pipework. The one-pint flush pipework is continuously flooded, relying on the modest pressure exerted by a hand pump or an electric pump to push the black water to the street-mounted composting chamber, which can be fitted inside a standard shipping container.

7: COMMUNAL RAINWATER STORAGE TANKS

These can be incorporated in shipping containers above street level and act as a local source of clean drinking water.

8: SURFACE WATER ATTENUATION AND FLASH-FLOODING CONTROL USING THE TIDELION CELLULAR WATER STORAGE TANKS

Much of the local rainfall can be collected in surface-

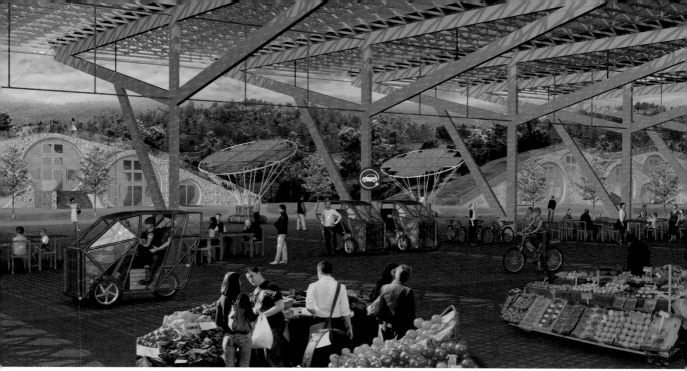

10.3

water-collecting drainage gulleys (ACO drain) and diverted into large linear rainwater storage (Tidelion) tanks running the entire length and width of the street. It is possible to filter out petrol and oil along the way. This provision not only stops flash flooding, but also provides a local source of grey water.

9: RECOVERING EASILY RECYCLABLE MATERIALS FOR RECONSTITUTION INTO FRESH MANUFACTURING INGREDIENTS

Local recycling centres can collect these materials. The need to extract new minerals from mining activities is reduced.

10: ANAEROBIC DIGESTION (AD) OF LOCAL FOOD WASTE INCORPORATING BIOGAS PRODUCTION

The relatively small amounts of methane created in this process would contribute cooking gas for street food and small cafes. A further benefit is that food waste would not be available as an encouragement to vermin. The AD unit should be placed away from residential areas, but the biogas could be distributed within the ZEDstreet services racetrack.

11: LARGER QUANTITIES OF BIOGAS

If this is generated from larger-scale local pyrolysis units it can top up the AD gas and power in larger-scale historic city centres or existing higher-density business districts with their high-energy demands.

12: THE STREET CAN ACT AS A LOCAL HUB FOR HIGH-SPEED INTERNET

This would remove the inconvenience of load shedding and blackouts when the centralised power supply fails. By creating local resilience to extreme events, the community is also protected against rises in electric prices that are inevitable if nuclear energy is pursued as national policy.

Eventually the ZEDstreet system can be introduced over major roads joining urban neighbourhoods and could supply most of the required utilities, reducing and eventually eliminating the need for centralised power stations of any sort (**figs 10.4–10.5**).

10.2 ZEDstreet applied at local street market, China.
10.3 Market under the ZEDstreet canopies.

ZED development strategy

This proposal is to set up a landowner/ZED joint venture to build a prototype show home that tests the following development delivery strategy:

- A master plan is designed that designates the landowner's estate as a clean air/zero emissions zone. No combustion engines or oxidation processes can take place within this site boundary unless they are for farm management, maintenance or construction. This means no petrol or diesel cars, or delivery vehicles. All internal transport is electrically powered or human powered. Pedestrian and cycle bridges across streams and along footpaths make it more convenient to walk, cycle or e-bike than to use cars.
- The development is planned to retain as much of the existing landscape as possible, cutting down as few trees as possible and keeping any excavation or land clearance to a minimum. Where possible, low-quality human structures are cleared and the original land use re-established with crops or foliage.
- Existing buildings of quality should be refurbished and celebrated as part of the local historic legacy. Where possible these should be renovated for community use, or workshops and markets. Existing animal farming and horticulture/agriculture should be revived and celebrated, converting to organic status where possible. There need be no conflict between farming and sensitive property development. One can enhance the other.
- The new development often becomes a network of contour-hugging local roads that enable clusters of small urban village communities to occupy areas of land that are too steep or rocky for economic farming. These communities can create an instant demand for local farm produce, and will have a direct relationship with the farm and its workers. Other typical activities on a rural estate, such as forestry, woodworking and even quarrying and brick and tile making, will also create local distinctiveness and character. Leisure activities such as horse riding can also improve the quality of life for residents.
- The new homes are laid out to give every home as much privacy as possible, whilst retaining views out over the existing landscape and enjoying good solar access for renewable energy harvesting. Generous gaps are retained between buildings to create landscape strips that break up the terraces of dwellings. No private gardens at ground level are permitted and the estate landscape is continuous below the new homes. The estate owner/landowner retains the ownership of his estate in perpetuity and only the air rights above the landscape are purchased by new residents.
- The best way to introduce this new development and master planning concept is build a show home.
- The purpose of the show home is to demonstrate the benefits of this alternative housing product to potential purchasers, with the objective of achieving advanced pre-sales that can help fund the construction of the new development. This avoids much of the funding required by a conventional development strategy. The majority of the conventional strategy investment was required to fund expensive landscape scraping and forming terraces – damaging the existing habitat and associated ecology. However, it is this existing landscape, foliage and strategic views that can potentially provide significant added sales value to the landowner. With the possible incorporation of an organic farm and the reconciliation of development plots with farmland and outstanding natural landscape, it is speculated that a minimum of 15% added sales value, and possibly higher, could be achieved. This uplift is difficult to check with local sales agents, as this development concept is not common, and it must be tested and the strategy de-risked by achieving pre-sales from a show home cluster erected as soon as practical. We suggest one demonstration show home is built close to the heart of the farm to act as a marketing suite, and a larger cluster built for sale on adjoining sites (**figs 10.4–10.5**).

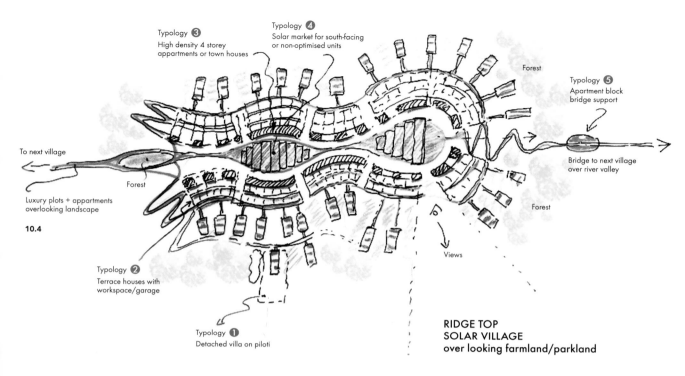

Typology ❸
High density 4 storey
appartments or town houses

Typology ❹
Solar market for south-facing
or non-optimised units

Forest

Typology ❺
Apartment block
bridge support

To next village

Bridge to next village
over river valley

Forest

Luxury plots + appartments
overlooking landscape

Forest

10.4

Typology ❷
Terrace houses with
workspace/garage

Views

Typology ❶
Detached villa on piloti

**RIDGE TOP
SOLAR VILLAGE
over looking farmland/parkland**

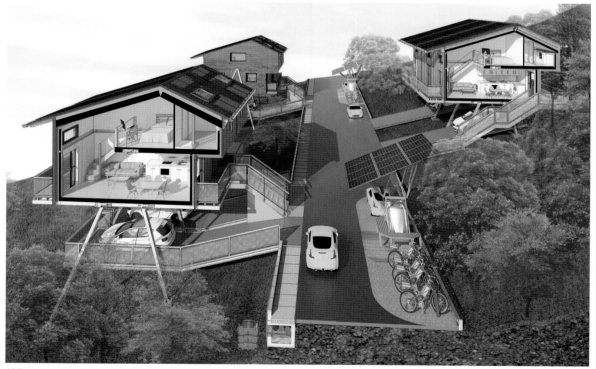

10.5

10.4 Sketch of hilltop village plan – minimising impact
on host landscape and maximising the value of
retaining the existing vegetation.

10.5 The new clean ZED development strategy to create a zero
emissions urban neighbourhood within integrated parkland
and wilderness without erasing the existing landscape by
cutting terraces.

PART III
CASE STUDIES
Applying the tools

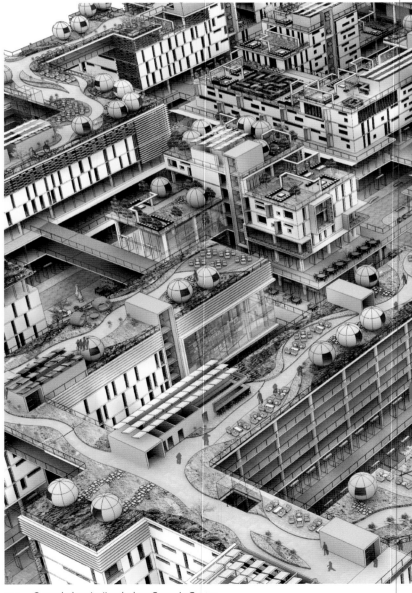

III.1 Central plaza in Jingdezhen Ceramic Centre.

The best way to illustrate the ZEDlife principles
is to highlight a series of successful case studies
and applications to inform the reader, designer and
engineer how ZEDlife can reduce the environmental
impact of their projects (**fig. III.1**).

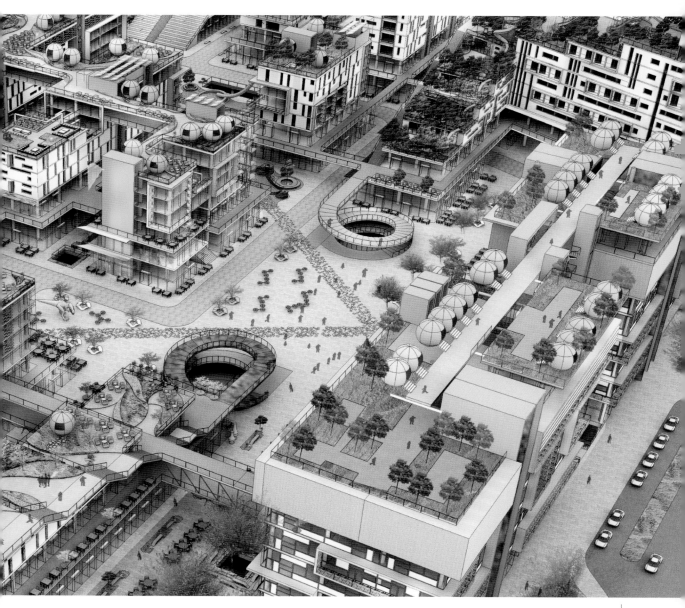

CASE STUDY 1

THE ZERO BILLS HOME

KEY PROJECT INFORMATION

Programme: Residential
Client: ZEDfactory Ltd.
Site location: Watford, UK
Project date: 2016

*Based on research by Dr. Rehan Khodabuccus,
The University of Surrey and ZEDfactory
Europe Ltd.*

TOOLS USED

The ZEDroof
Solar-charged exchangeable batteries
District-level energy systems

*The tools used in this project are appropriate to
the construction of a residential property and
some tools have been omitted because they were
not suitable to this particular project.*

11.1 The Zero Bills Home launched at
BRE Innovation Park, 2016.

A new model for designing cost-effective zero-carbon homes

Why do so few UK homes in the new-build sector offset all operational carbon emissions? Costs have come down and with improved reliability technologies become easier to use, yet national resistance to zero-carbon homes doggedly persists. The Zero Bills Home concept proposes linking technology and cost-based metrics to get the most out of zero-carbon housing design. We will explain why an optimised zero-carbon home can function more efficiently and economically than a building compliant with Part L of the 2013 Building Regulations. We also have thoughts on how zero-carbon homes could be marketed more effectively on their economic, rather than on their environmental or technical, attributes (**fig. 11.1**).

Introduction

As the cost of the ZEDlife tools reduces with economies of scale, and at the same time we have learnt from teething troubles early on how to close

11.2 The Zero Bills Home build at the BRE Innovation Park represents the first show home for a new 96 home zero bills development in Newport, Essex, for the Sir Arthur Ellis Trust. The house generates enough electricity to power its annual demand and to power the average daily commute.

the performance gap between the expectations of design and the sometimes disappointing results of occupation, people are starting to question the benefit of centralised services provision to new buildings.

We actually don't need fracking or nuclear energy and, despite these remaining part of the UK national energy policy, the value of the alternatives manifested in energy efficiency, shorter paybacks on BIPV and decentralised electrical storage, are rapidly becoming clear. As millions of new homes must be built to meet demand, there is a unique opportunity to transform a large section of the construction industry from energy consumer to net producer. For nearly 10 years, the entire housebuilding industry had been following a low-carbon legislative roadmap

with performance targets escalating every couple of years, when in 2016, rather than making the BRE's Code 6 zero-carbon standard mandatory for all new homes, the UK government succumbed to pressure from the volume housebuilders and scrapped the long-awaited Code for Sustainable Homes instead. Implementation was postponed till 2021, just as rising electricity prices and falling delivery costs made the Code 6 target commercially viable. The countries that set the highest environmental performance standards create a high-quality supply chain to meet their internal market. This generates export opportunities, supplying other countries further behind with their own legislation. Sadly, the UK has recently lost this leadership and will

be forced to import from Denmark, Germany and China, all of whom have wisely reduced the costs of zero-carbon technologies.

The goal is to deliver zero-carbon homes that are commercially viable, but our local situation is happily not one of total gloom. Just when the UK politicians gave up, some sectors of the industry had actually solved the problem by substantially reducing the construction cost of all-electrically powered homes in a climate that does not really require heating systems. As the cost of building-integrated renewable electricity generation and storage systems comes down, it becomes sensible and practical to build homes that have no net annual energy costs. The funds normally swallowed by energy bills can be redirected to cover the slightly higher capital cost of building these net zero-energy homes.

It's a shame if the government doesn't get it, but we, the design teams working with the industry, are already at the point where we can challenge the UK volume housebuilders' hegemony on simple comparison of cost. Welcome to the Zero Bills Home concept. Let's just build them anyway.

The Zero Bills Home typology at Newport Eco Village

Zero-energy bills buildings at different density bands

Can this model work at across a range of urban densities, for both residential and commercial uses? The industry wisdom is that contributions from solar harvesting technologies are only meaningful at residential densities of around 30 to 100 homes/ha. This is at the low end of the scale, but experience shows that the urban residential master-planning strategies described here work well in many climatic zones:

1. 30 to 50 homes/ha. All solar harvesting surfaces can probably be accommodated on each home's roof surfaces, with large projecting eaves to maximise roof surface. Enough exposure to solar radiation can be achieved with careful design to minimise overshadowing.

2. 50 to 120 homes/ha. Some communal solar canopy or shared solar arcade will be required to meet additional electric demand.

3. Above 120 homes/ha. The ratio of roof surface to floor area of the building fabric becomes too small and the major opportunity for harvesting sunlight is, by necessity, the vertical facades. This frees up the horizontal roof surfaces for roof gardens and shared amenity space – particularly if the vertical circulation cores (lifts and stairs) give access to roof terrace level.

A carefully designed master plan will ensure that each home or floor plate receives enough solar electricity from the electric-generating rainscreen facade system to make a substantially reduced imported electric demand. This has a major implication on urban design, and needs careful exploration and discussion, but the higher values of self-powering homes makes them competitive in the market, with added benefits of sunlight, ventilation and shared amenity space with planting.

The Zero Bills Home was trialled at the BRE innovation Park at Watford, UK, becoming the first show home for a new 96-home Zero Bills development in Newport, Essex, for the Sir Arthur Ellis Trust (**fig. 11.2**).

The architect and the engineer are responsible for designing buildings that reduce the electric, heat and coolth loads and including them in a wider master plan. The requirements and standards have been described already and each building on the master plan should use the least amount of energy and produce the least amount of carbon. In the past, developers have stated that the cost of zero-carbon design can push up capital costs by 25%. If this were so, the houses in the Newport master plan could have cost up to £2.6 million, so it was critical to either remove these costs or generate additional profit to cover them.

When trying to win this sort of argument, it is important to know what is being compared. To create more commercially viable zero-carbon homes for Newport, a baseline design was developed, represented by a standard detached four-bedroom property. The house type was a compact three-storey

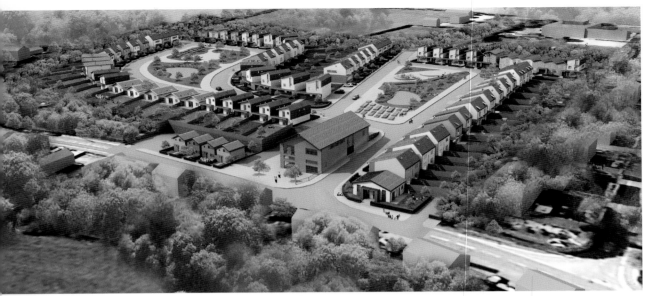

11.3

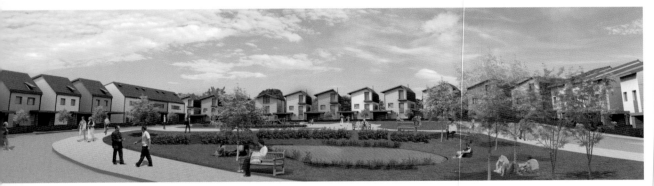

11.4

home with a gross internal floor area of 142 m² designed to fit into a site master plan of 50 homes per hectare. The 'planning portal' official advice states that designers of 'eco towns' should aim for densities of 50 to 100 homes in city centres and 50 to 65 along transport corridors. At this density, all homes can be oriented for maximum solar gain and renewable energy generation in line with the ZEDlife principles. The buildings on the master plan were therefore oriented to maximise the south-facing roof space (figs 11.3–11.5).

The first stage in optimising the design was to conduct a technical and cost analysis of the best available zero-carbon microgeneration technologies.

Typically, heat is lost through the building fabric and ventilation, and the need for space heating to compensate for this loss becomes the largest cause of carbon emissions. We investigated the key technologies needed to reduce this and other electric loads, while supplying the residual energy demand via zero-carbon energy generation. These technological solutions were then combined to create a number of

11.3　Aerial view of Newport from the north east.

11.4　Layout enriched with public and private green areas, including around the village green.

11.5　Zero Bills Home house types.

East West Three Storey

West Elevation

East Elevation

South Elevation

North Elevation

South Facing Three Storey

South Elevation

North Elevation

West Elevation

East Elevation

South Facing Two Storey / Terraced House

South Elevation

North Elevation

West Elevation

East Elevation

East West Two Storey / Terraced House

West Elevation

East Elevation

South Elevation

North Elevation

East West Bungalow

West Elevation

East Elevation

South Elevation

North Elevation

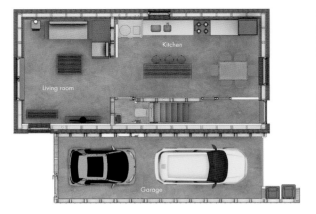

Ground Floor Plan

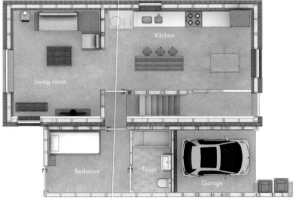

Ground Floor Plan (Lifetime Home / Granny Flat in the Garage)

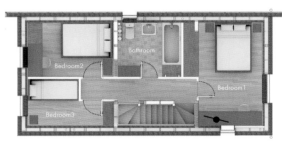

11.6

First Floor Plan

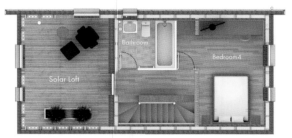

Second Floor Plan

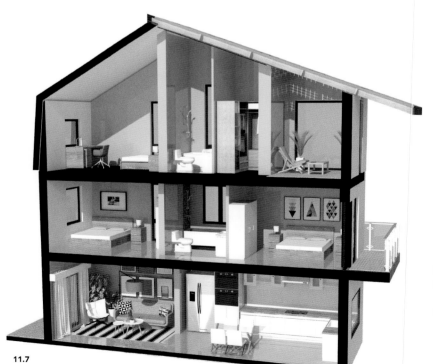

11.7

11.6 The Zero Bills Home floor plan.

11.7 The Zero Bills Home section view.

11.8 The timber frame construction system, with floor level beam system allowing flexibility of window and door positions.

different holistic groupings of building fabric, space, hot water and electrical generation systems.

Our designs were modelled to work out energy losses, energy usage, energy use reduction and energy production outputs. Costs were obtained from manufacturers and distributors for a 100-home development based on the capital cost of construction plus running costs, and these could be offset against savings from reduced consumption and additional income from feed-in of current.

Fixed parameters were applied for space heating demand, using an 18°C set point. Hot water demand was based on five-person occupancy at a rate of 50 litres of hot water/person/day, and the estimated electrical consumption, including lighting energy use, was added. The variable parameters included:

- wall and window U-value
- space-heating consumption
- ventilation-rate energy loss with heat recovery
- heat-recovery efficiency
- heating and hot water system efficiency
- passive solar gains and internal gains
- energy generation by different renewable energy systems
- renewable energy system sizing
- implementation costs
- build costs
- running costs.

We matched each of these against the others to find the best approach to the building fabric, energy-generating mix and running costs. There were varying combinations of PV, air and ground-source heat pumps, passive and mechanical heat-recovery ventilation systems and thermal stores. We also tested how cashflows would come out by adding in FITs (feed-in tariffs)[14] income. The saving on energy costs from load reduction and energy generation would bring a further cash benefit. All were calculated using 2014 market rates and mortgage costs. At the end of this process, we got a fair idea how the optimised building would compare to a home built to 2013 Part L Building Regulations (**figs 11.6–11.7**).

The Zero Bills Home construction system

The 'balloon frame' was the most common way of building a timber house in the US during the 19th century. It uses lightweight and thinner framing members than traditional wooden construction and the studs in the wall carry an equal distribution of the vertical and compressive loads of the building – hence the rather unexpected borrowing of the word balloon, because the frame carries the same load evenly all over. The Zero Bills Home uses semi-balloon frame construction, with oversized timber. Rigidity is provided by the outer OSB (orientated strand board)[15] sheeting, with the upper floors carried by horizontal joists on top of the studs. The oversized studs meant that the building could bear the weight of thicker insulation and other loads, while allowing for thermal mass to be created between the studs. Another benefit of the semi-balloon frame is that it allows the breather membrane and airtightness layer to be dressed in a continuous layer up the wall face. This makes airtightness detailing easier in the upper parts.

To avoid on-site construction work, all the components arrive on-site pre-cut and dimensioned. The Zero Bills Home system frame departs in a

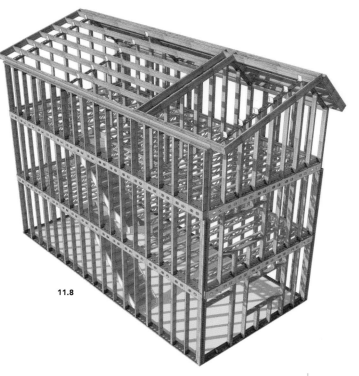

11.8

Bullivants Foundations plus Tetris

Factory laser cut steel structural ring beams

Prefabricated steel sections

Factory cut steel easily combined with timber studs sourced through local builders merchants

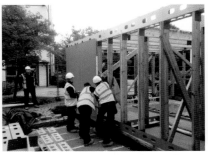

Self-adhesive airtightness and weather proof membrane bonded to OSB board and then fixed to timber studs

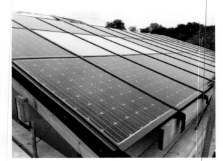

Zero Bills Home Frame with BSW Timber

OSB fixed to floor joists

Breathable external insulation skin removes thermal bridges

PV roof install

11.9 The Zero Bills Home construction sequence.

significant way from the norm, using a ring beam or lintel at each floor or at roof level, which speeds up and simplifies the framing process. These are made of laser-cut folded steel; a new application of this technology. The framing system based on this hybrid shell is shown in **fig. 11.8** (*previous page*).

Whereas a typical timber frame takes at least three months to order from an off-site factory, you can now order all the components for a ZEDhome from stock. This reduces construction lead-in times and hence loan costs, while minimising the danger of programme slippage. The skills level means that the majority of the labour can be sourced locally, in such a way as to incorporate skills training. Construction quality would be inspected and certified to high standards (**fig. 11.9**).

Fabric energy performance strategy

The timber frame construction method brings additional benefits. It is easier to adapt the frame dimensions to allow different thicknesses of insulation between the studs, internally and externally. This makes it easier to optimise the energy-reduction and energy-generation strategies. More choices can be made to achieve the best outcomes of cost for the initial build and the lifecycle of the building. Among these choices is to increase the capacity for thermal mass, which in turn enables the inside spaces to perform better, similarly reducing energy inputs and lifecycle costs.

The timber frames are 'dry construction' and the less predictable 'wet trades' involving concrete, cement and plaster could be avoided, reducing the number of contractors and simplifying the build process. When combined with partial off-site construction and prefabrication of wall panels, we could benefit from 'just in time' deliveries and a general speeding up of the process.

Warranty providers like to know that anything they cover will last longer than 60 years. 'Modern method of construction' (MMC) is a danger signal to them for this reason, making mortgaging more difficult. For a new home to be mortgageable, the main structural components must last for three generations – which is around 60 years. Almost all traditional homes last far longer – however key fixings or structural brackets in a modern MMC home sometimes only just last this period of time. For example, if a plastic vapour control layer is installed to prevent internal humidity condensing on light-gauge galvanised steel framing, and this has a practical life of 25 years before failure, it cannot be assumed that the structure would not suffer from serious corrosion caused by interstitial condensation occurring well within its 60-year minimum required life expectancy.

The Zero Bills Home uses no vapour control layer and always uses vapour permeable materials throughout its external envelope with careful attention to minimise or avoid cold bridging. This avoids almost all interstitial condensation, and even if any occurred it would be allowed through the 'breathing wall' to the ambient external airspace, in much the same way as a Goretex raincoat. No urethane foams or vapour-blocking materials are specified above ground to avoid toxic fire load and condensation occurring at impervious board joints.

As our type of frame avoided MMC, developers should be happy because buyers would not suffer this hassle and expense. National house builders have a reputation of being conservative, but we can offer them cost reduction, straightforward lending and LABC warranty under standard terms, so there should be no barriers to taking up our offer.

Due to its cost effectiveness and inert nature, a mineral wool roll with a Lambda value of 0.037 W/m^2K was chosen to insulate between the studs to a thickness of 140 mm. Fossil fuel-derived materials have high embodied carbon, ODPs, CFCs or VOCs, so we left them out of the study. Mineral wool is odourless and doesn't get wet, so it is also rot-proof and no friend to fungi, mould or bacteria. Mineral wool is also CFC free, HCFC free has a low-ozone depletion and low-environment impact potential. Compared to natural insulation it offered the best trade-off in terms of price and performance at the same U-value.

To super-insulate the building, insulation was added internally and externally to a combined thickness of 335 mm. Externally cork or wood fibre panels can be used, with cork on the inside, since it is one of the most environmentally benign products available. Based on its sequestration over its growing life, cork can be deemed carbon neutral. It is naturally bonded so has zero ODPs, CFCs or VOCs and is technically a waste product. Expanded cork beads are naturally bonded to create the insulation panels offering a Lambda value of 0.038–0.040 W/m^2K.

Having three layers of insulation – outside, inside and in-between the studs – meant that low wall U-values could be created to reduce heat loss, since any potential thermal bridges were stopped off.

The ground floor slab was insulated using a high-density polystyrene (EPS) Passive Slab foundation system. We made a concrete ring beam first, rising from a 300 mm permanent form insulation raft of polystyrene (EPS). This method eliminated cold bridging at the wall-floor junction

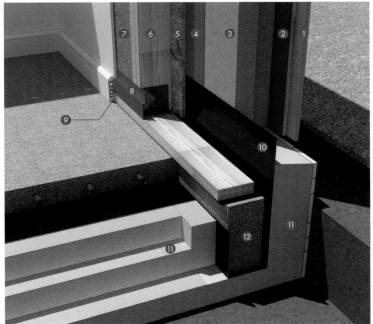

1 External Render/Cladding
2 Breather Membrane
3 Wood Fibre Insulation
4 Airtightness & Weather Proof Membrane
5 OSB3 Board
6 Timber Studs
7 Stonewool Insulation
8 Metal structural ring beams
9 Electric Conduit
10 DPM (Damp Proof Membrane)
11 EPS Insulation
12 Raft Foundation

11.10

detail, a critical way of reducing heat loss because the cold thermal bridge between the floor and the walls can become a serious means of heat loss when the upper part of the building is so snugly protected. With this precaution in place, we achieved a U-value of 0.1 W/m²K. Details can be seen in **fig. 11.10**.

A few aspects of this scheme turn out to be frustratingly imperfect, or subject to a pay-off between different benefits. On a constrained site, the very thick walls could mean lower-density housing and/or reduced gross internal space, with the result that fewer homes on a given area of land cuts the developer's profit.

While the walls of the building were insulated to a U-value of 0.14 W/m²K, it was impossible to get the ground floor slab beyond a U-value of 0.1 W/m²K, owing to the disproportionate cost of reducing the U-value further than 0.14 W/m²K for the walls. This represents the level of insulation that enables us to reduce the heating system to about a fifth of that of an equivalent home.

On a more positive note, a U-value of 0.14 W/m²K still allowed us to design a cost-effective energy system, as the impact on the thermal load did not significantly increase the plant size. For example, a

reduction to 0.12 W/m²K would require an additional 100 mm of insulation, but this was not worth the effort because the saving on thermal energy input was small – only 200 kWh per annum. This additional thermal load did not require a larger heating plant to satisfy it, as the peak load only changed from 4.025 kW to 4.107 kW with the reduction in insulation. The increase in the wall thickness was 200 mm on the north–south and 200 mm on the east–west walls when combined, both of which would raise the cost of additional insulation and upset the building footprint/site density ratio.

It was also easier to incorporate additional insulation into the ceiling plane to achieve 0.1 W/m²K more cost-effectively than it was in the walls, thanks to the way the timber beams had to be oversized for the structural load. As ceilings do not affect the gross internal floor area or the plot size on a site master plan, this was not detrimental to density or building footprint size.

Built as described, the ground floor slab was easier to insulate to a U-value of 0.1 W/m²K and an additional benefit was to eliminate the need for external footings and the amount of concrete required. This meant that the concrete only needed

to be poured once, making it much cheaper than traditional strip foundations. The cost of the foundation ranged from £5,800 to £15,000, depending on ground condition. The mid-range option of £10,700 was used in this study.

Insulation strategy

Airtightness, provided by the materials and continuity of the airtightness line, is another critical factor in reducing heat loss. At 15 mm, the OSB3 is considered to be airtight if correctly taped and sealed. The detailing of all critical junctions ensures the continuity of the airtightness line, along with the correct taping and sealing around projecting window apertures. The goal for this building was to achieve 1.5 air changes per hour at 50 pascals based on the taped and sealed OSB3 (**fig. 11.11**).

Energy strategy depends equally on thermal mass. Because timber-framed buildings are lighter in weight they are less effective in this respect. We would normally hope to exceed 200 kJ/m²K as a measurement of thermal mass and we actually achieved 239 kJ/m²K, which shows that this need not be a problem area.

11.11

11.10 Section through foundation detail.
11.11 The BRE house has achieved an airtightness of 1.3 ach @50 pascals text pressure on first test without walls plastered.
11.12 Thermal envelope strategy on construction drawings.

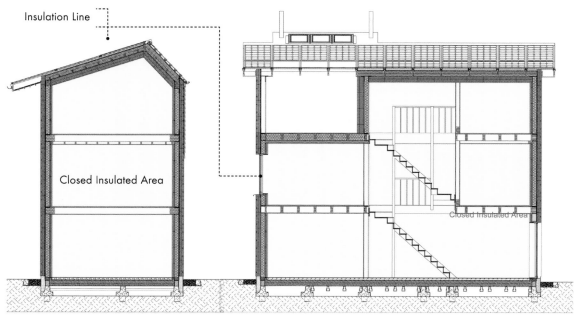

Insulation Line

Closed Insulated Area

Closed Insulated Area

11.12

It was important, too, to choose the right windows, which can be a weak spot for heat loss. Triple glazing helps and thermally broken timber frames avoid further heat loss. Compared to a light-gauge steel-framing stud, timber doesn't transmit so much heat, so less heat leakage occurs from thermal bridging within the load-bearing frame's structural studs. A layer of OSB provides racking resistance against near horizontal wind loads and in a Zero Bills Home this is covered in a vapour permeable self-adhesive airtightness barrier. Finally, 150 mm of wood fibre external insulation board is applied to all external surfaces to further minimise thermal bridging (**fig. 11.12**). Thus equipped with a U-value of 0.9 W/m²k, G-value of 0.51, a frame factor of 0.65 and light transmission of 0.72, these windows played an important part.

Energy systems

Even after all these energy-saving measures, electricity needs to come from somewhere. We installed a 200 L insulated hot water tank and, allowing for some heat loss along the pipework

and taking the manufacturer's data as a guide, we calculated that an allocation of 951 kWh of energy per person was required to meet the hot water load.

These figures have to take seasonal variation into account, including the positive effect of the warm months. Factoring in unregulated loads based on LED lighting and low-energy appliances we achieved a figure of 3,400 kWh per annum for the annual load. The total for the building came out at only 6,058 kWh per annum.

For this level of demand, what is the best way to meet it? The energy system that offered the best balance of costs and usability was based on BIPV according to the ZEDlife standards, meaning that a combination of solar PV, MVHR and a small ASHP could meet the energy loads easily, with heating and hot water reduced by a factor of 3.5 to account for the annual heat pump efficiency. Extra PV and efficient heat pump added to the mix. The PV offered better cost-benefits than the solar thermal and thus although it increased electrical energy demand it also reduced costs in use.

To calculate the full building specification, all elements were priced using current data. If the cost of construction and interior finishing (£1,350 and

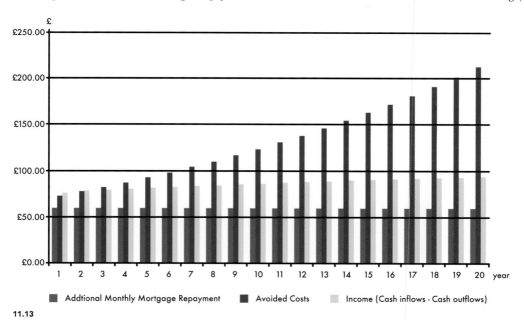

11.13

■ Addtional Monthly Mortgage Repayment ■ Avoided Costs ▨ Income (Cash inflows - Cash outflows)

11.13 Monthly cash flows and avoided costs.
11.14 Contribution to net monthly benefits from income/cost savings.
11.15 Short-, mid- and long-term viability under different income scenarios.

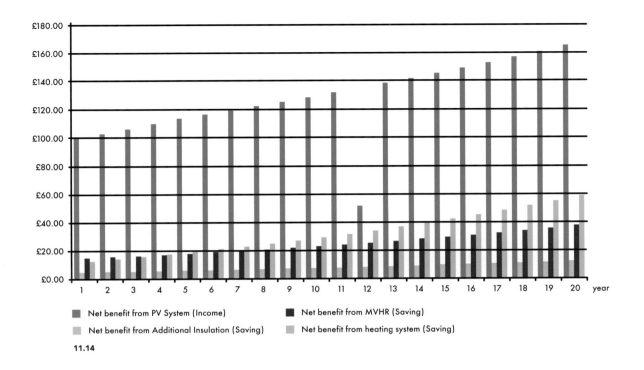

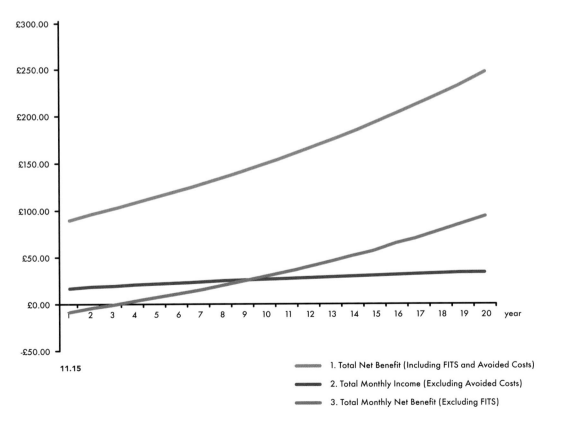

£1,500 per m²) came out 6–10% above minimum standards, the uplift could be justified through lifecycle cost savings. **Figures 11.13–11.15** show the results of the lifecycle cost modelling, showing that consumption and production of energy well outweigh the extra start-up cost quite early in the lifespan of the building.

Figure 11.13 shows the monthly cash flows and costs avoided. The chart demonstrates that the additional monthly mortgage payment is always lower than the income generated from the FITs without having to take into account the avoided costs. It also shows that inflation and fuel price escalation significantly increases the effect of the avoided costs over time, so who wouldn't choose this future security? The technologies responsible for reducing energy consumption turn out to be as important as the income generated through the BIPV.

In **fig. 11.13** we can also see that the running costs are effectively substituted by the increased mortgage cost. If it had been a normal building compliant with the 2013 Part L standards, this money simply would have gone to pay an energy provider, but in this case, the money can be used to pay down the debt on the building instead. A note of caution is needed, however, because although this sounds good, recent policy changes suggest that the FITs payback levels may not be maintained indefinitely.

Positive net benefits can be achieved in both the short and long term, all the same. The positive cash flows achieved with the FITs mechanism give at least a short-term viability shown by positive cash flows over the first 20 years. Using cash inflows alone, it is still possible, as line two in **Fig. 11.15** demonstrates, to come out on top through the costs that have been avoided. This means that, even with an increased mortgage payment, the optimised zero-carbon home is more economical to live in than a 2013 Part L building regulations home from the outset. This means that money otherwise destined for energy bills can be switched to increased mortgage costs and still provide a cash benefit. Line three in **Fig. 11.15** shows that when the FITs generation tariff is omitted, the model still returns a positive net benefit from year three onwards. While there is a slight deficit in the first three years of the investment, the 17 years of positive cash flow far outweighs this. As such, the Zero Bills Home should be more attractive to the consumer.

Going off-grid:
The next stages in a Zero Bills Home

The Zero Bills Home energy strategy and concept set out in the previous parts of this case study have been based on offsetting the residual energy load, after energy-saving strategies have been employed, with solar produced energy (**fig. 11.16**). While this works well for the annual energy balances the reduced load is met in three ways:

1. By directly using solar energy from the PV array. This requires appliance loads to be matched with generating times from the array. It is hard to match the demand to the supply, but some small changes in behaviour go some way to closing the gap. The limitations of both, however, mean that to keep increasing the size of the array does not on its own solve the problem.
2. An LiFePO4 battery to store some of the excess energy produced by the PV is a way of getting round this, while reducing the amount of grid energy imported (**fig. 11.17**).
3. In a country with low winter temperatures, the system will not generate enough to allow users to go off-grid. When the system does not generate sufficient energy during times of low production, residual loads must be topped up from other renewable energy sources. If the grid is not available, then micro wind turbines or small biogas-powered generators may be required.

The length of time during which a house must draw energy is actually surprisingly small. While it is true that renewables do not produce a constant level of supply, as we go on to explain, evidence shows how houses can be designed to maximise 'off-grid' time without their residents having to change their lifestyle

to an inconvenient extent. This means that the centralised energy produced and distributed via the National Grid could be scaled down, and that the commonly made claim that nuclear power stations are needed to 'keep the lights on' is dangerously misleading.

PV array sizing

Getting the right size for an array and battery system requires balancing the interplay between daylight usage, total usage, generation and cost. There is a range of activities requiring electric power, such as heating up water, using it for washing clothes and dishes, that if done in daylight hours can be powered directly from PV. That leaves other things, such as part of the daily cycle of space heating, ventilation, fan and pump loads and fridge-freezer loads, that have to continue round the clock.

The Zero Bills Home was originally designed to be cost-neutral to any owner-occupier who used the FITs tariff to offset additional payback costs incurred by an increased mortgage. If you can create a building that produces 8,033 kWh of PV-generated energy with an annual demand of only 4477 kWh, then the excess can be exported to the grid and made available for electric transportation, among other uses. The array is large enough to cover, at least partially, the largest deficits in winter peak loads and tough production.

We need to think about the right size for these arrays in the coming years, because an array sized to offset winter load is massively oversized for summer demand. If the house is fully electric, then daylight consumption should equate roughly to between 30% and 40% of the PV-produced energy taken for use by the home itself. This means that between 60% and 70% is available for direct export back to the grid. Considered in this way, the grid is essentially being used as a battery to store excess production and allowing it to be drawn back during hours of production deficits. It is a neat system, but the

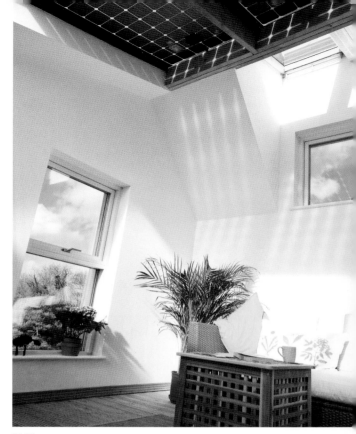

11.16

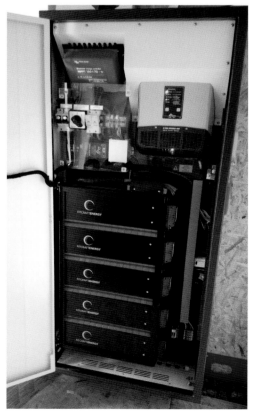

11.16 Inside the solar loft.
11.17 The Zero Bills Home's 7.5 kWh battery inverter.

11.17

money equation relies on the FITs payments, which are shrinking. This means we need to look at further opportunities to reduce cost and maximise returns. Additionally, flowing surplus energy into the grid tends to happen when demand is at its lowest, which creates problems because of the ageing UK grid infrastructure, when many network operators are claiming to be close to the limits of what the grid can accept. The answer to all these issues must lie in energy storage by means of the new batteries.

Determining the load and self-consumption rates

Assuming that many people may not wish to make changes to their lifestyle in order to reduce energy consumption, we have calculated what savings they could make without trying too hard. Loads such as hot water can be relatively easily switched if showers and baths are taken in the morning to allow the tank to recharge while the array is producing. Similarly, dishwashing, clothes washing and drying could also be switched to daytime hours with relatively little upheaval. If we can assume this level of active participation, the energy loads can be modelled, based on the average PV energy production, during sunshine hours.

The result is a balance between usage during daylight hours set against total usage and the cost of generation, and from this we can work out how much battery capacity would be needed. These small but significant LiFePO4 batteries, with their lifetime of 5,000 charge cycles, are the key. Their BMS (battery management system) controls allow them to charge and discharge at the same time.

This system can remove around 78% of the building load from the grid, with 80% depth of discharge, using a 7.5 kWh storage capacity. In this way, the battery system effectively takes away the familiar problem that solar power comes and goes with the sun. If we are going to manage with a reduced capacity grid, this is important. The results show that the building requires 80% less grid electricity than a building without the PV array. Energy transmitted through the grid for the building (import plus export) is reduced by 57%, so if this technique is replicated across all new builds, the amount of grid power needed from all such new housing would be 80% less, compared to a 'fabric-first' approach.

The conclusion should be obvious – fabric first isn't going to solve the critical problems. A system based on battery storage wins hands down and makes it realistic to imagine a reduced-capacity grid without everybody sitting in the cold and dark in their homes. Building any new centralised power plants other than those relying on renewables is not a question we shall need to agonise over any more.

If you are thinking that there are some issues with the problem months of December and January, months when demand far outstrips production from the PV array, we would answer that the negative balance can be offset with the addition of larger communal-scale wind farms, biomass or pyrolysis.

Hastings Zero Bills Home development

Overlooking Hastings' Old Town to the east, and Hastings and St Leonards to the west, Hastings Castle was built by William the Conqueror shortly after the invasion of 1066. The completion of five state-of-the-art eco homes directly opposite the castle marks the 950th anniversary of the Norman conquest (figs 11.18–11.19).

ZEDfactory was appointed in 2014 by a local builder and landowner who had assembled a small group of friends and local residents interested in funding their own new-build eco homes. Since the site is in the Hastings Castle Conservation Area, a number of proposals had been rejected over the years as inappropriate. A breakthrough came in 2015, when full permission was granted for a revised scheme that proposed a highly energy-efficient terrace of zero-carbon dwellings.

The five timber-frame homes, arranged as a terrace, are constructed on a raft foundation that was

11.18 Zero Bills Homes on-site at Hastings, UK.
11.19 Front view.

CHAPTER TWELVE

CASE STUDY 2

ZEDPODS

KEY PROJECT INFORMATION

Programme: Residential
Client: ZEDfactory Ltd.
Site location: Watford, UK
Project date: 2016

TOOLS USED

The ZEDroof
Solar-charged exchangeable batteries
Low-carbon transport

It has become notoriously difficult in recent years for graduating students and young professionals to break into the property market. As a result, they are forced to spend more time and money in rented properties than they would wish, and the problem is made worse in built-up urban environments because prices are so high. The pressure on a decreasing area of central urban space for property developments comes at a time when there is increased pressure to ensure that the environment does not suffer as a result of people's behaviour. This case study outlines a potential 'step-up' option for people wishing to enter the property market, while showing how a more considered use of urban space can be combined with ways of creating affordable homes, all potentially avoiding net annual energy bills (**fig. 12.1**).

Introduction

As cities expand, the edge of the built-up area tends to attract light industrial uses, usually with associated workers' housing. Because these areas are rarely served by public transport, we find very large car parks for workers who come here from large

12.1 The ZEDpod at BRE Innovation Park, 2016.

TODAY

50% of annual CO₂ emissions + GDP
attributable to constructing new buildings
and infrastructure

15 year cycle?
average building life?

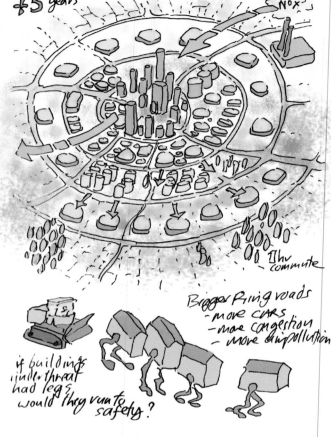

+5 years NOₓ

The commute

Bigger Ring roads
- more CARS
- more congestion
- more air pollution

if buildings
under threat
had legs
would they run to
safety?

12.2 Affordable homes 'walk' to the next ring as
city centre property prices escalate.

high-rise dormitory suburbs (**fig. 12.2**). It is not only
light industry that offers this opportunity. Hospitals
usually have large car parks, while at the same time
there is a concern for providing affordable housing
for nurses and junior doctors close to their jobs.

The ZEDpod is a proposal for creating
alternative living accommodation next to the
workplace in 'pop-up' workers' villages above these
parking areas, so that for these workers, at least,
commuting becomes a thing of the past.

The roofs of these villages can become a
waterproofed rain-shedding solar farm, making it
possible to power electric cars and scooters directly
from sunlight, reducing emissions from conventional
fossil-fuel powered vehicles in the process. This could
remove the need to build ground-mounted solar

farms over premium agricultural land. In the process,
this proposal would increase local air quality.

The housing pods and the workplace structures
can be designed to be demountable so that if the
workplace moves further out of an expanding town,
the housing can follow.

What is a ZEDpod?

The ZEDpod is an affordable starter home using
air rights over existing parking lots, so incurring
no direct cost for land. This is what makes them
different, and enables them to cut the knot of
unaffordable housing. These homes, built with high
energy-efficient performance standards that exceed

the building regulations, have the added attraction for residents of avoiding net annual energy bills.

Because they are prefabricated in a factory, construction time is shorter without affecting the durability of the pod. It is a durable, permanent construction that, unlike other permanent homes, can easily be relocated with minimal wastage.

Where can the ZEDpod be used?

Since the pods are built on elevated platforms in car parks, there is no need to buy the land, or to take away any of the land already allocated to housing. Equally, there is no need to release greenfield or green belt land to meet housing targets.

Who is the ZEDpod aimed at?

The ZEDpod is a small, low-cost energy-efficient home intended for young professionals, singles or couples wishing to get on to the property ladder or seeking genuinely affordable rental housing. Like all good housing, however, it will work for anyone. In terms of size, single pod units can be combined as double pods, creating two-bedroom homes or even larger combinations.

How does it work?

With their integrated solar PV panels (ZEDroof), the pod homes are more energy efficient than a building regulations home. They would be built from durable materials, avoiding the potentially harmful urethane foams, UPVC windows, high VOC paints and plastic water vapour barriers found in much conventional affordable home construction today. Water-saving showers and taps are fitted as standard.

These quality standards exceed those of conventional affordable homes which only meet the legal minimum of the building regulations. This is achieved at an affordable price by not having to purchase land and not having to spend large sums on infrastructure provision, such as services and foundations. That removes between one-third and half of the cost of providing a conventional home.

By super-insulating the pods and providing heat recovery ventilation and high standards of draught proofing, only very small amounts of space heating would be needed to make them comfortable. The biggest remaining heat demand would be domestic hot water, and this can be met by a tiny 400 W electric evaporator plate heat pump. This heat pump works like a fridge in reverse, circulating its refrigerant through an absorber plate fitted to the upper roof. No fan noise is heard. One unit of solar electricity will normally produce around three units of heat, enabling each home to be substantially powered by solar electricity generated by the photovoltaic roof panels. When massed together in sufficient numbers, the pods can create a solar farm without taking agricultural land out of use. Over the lifetime of the project we would expect that larger ZEDpod communities would have no net carbon footprint, and could offset both the carbon footprint of the original construction, plus the annual maintenance and annual energy needed to run the homes (**fig. 12.3**, *overleaf*).

The solar electricity produced during the day would be stored in a large 60 kWh LiFePO4 store with integrated inverter that can power the homes at night. On the rare occasions when solar radiation is low in mid-winter, the battery store could automatically trickle-charge itself during the day from the street light circuit. This way, the unwelcome cost of digging up the car park to install new electricity supplies can be avoided. There should be enough excess renewable electricity to charge a number of electric vehicles during the day (**fig. 12.4**, *overleaf*).

The interlocking array of solar panels provides the roof surface and covers the access decks, a cost that would more than pay back the initial investment. The increased demand on the local electricity grid will be barely noticeable, so that however many new homes are built this way there is no need for new power stations and new cables. With the provision of grey and black water handling on-site, there is likewise no need for new water treatment plants or to put stress on existing ones. This saving in centralised infrastructure provision can both

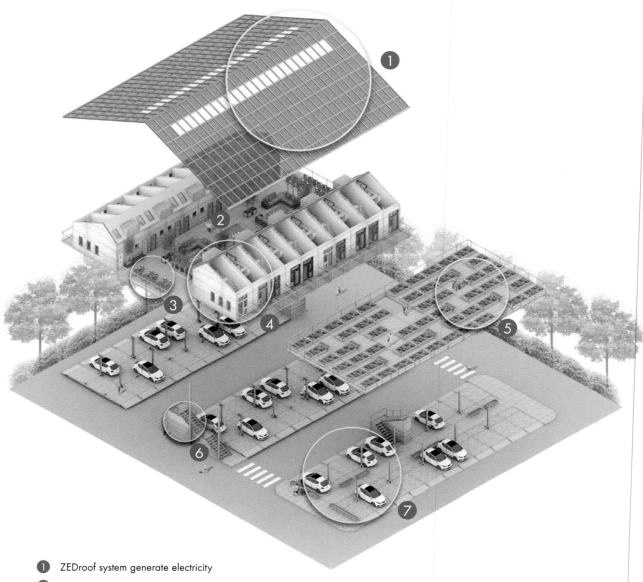

1. ZEDroof system generate electricity

2. Communal space under the solar canopy

3. Solar powered electric bike pool with charging points

4. Accommodation (Pods)

5. Raised amenity area provides a 'centralised' open space, that is intended to be shared by occupants

6. Integrated rainwater storage tanks under staircase

7. Solar powered car pool with charging points

12.3

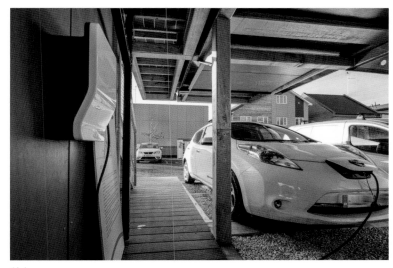

12.4

12.3 Pop-up community that uses existing parking to create accommodation, generate electricity and de-carbonised urban mobility.

12.4 Electric vehicle charging point at BREpod.

make sites viable without good mains services, thus saving investment by the local government and local utilities. An off-grid drainage strategy can also be deployed where necessary, which leaves a fresh water supply and a street lighting circuit to tap into as the only conventional services required. In this manner, a totally off-grid lifestyle can easily be achieved at a modest extra cost.

Are the pods large enough?

The pods have been designed to sit over existing areas of tarmac-covered parking bays. By necessity they must respect the bay size of a typical parking space. This is either 2.4 m wide and 4.8 m long, or more recently 2.5 m × 5 m. The support columns for the pod housing sit between parking bay spaces, spaced to allow the car front doors to open without obstruction. Rubber 'D' profiles stop careless drivers causing any impact damage to the support columns (or to their own cars). It is, admittedly, a rather tight and narrow shape, but we believe that any perceived disadvantages can be overcome by careful thinking about the quality of interior space and its connections to outdoors.

By taking two back-to-back bays, we get a planning grid of 2.5 m × 10 m, which is enough space to fit a 22.4 m² pod with a generous private balcony on its living room side, and a generous communal access deck to its front door (**figs 12.5–12.8,** *overleaf*). The pods do not touch each other, and a small fire-proofed cavity between them prevents sound and impact transmission between party walls. Placing up to 12 pods in a line with a shared staircase at each end provides good fire safety and allows the bin stores, batteries and water treatment tanks to be integrated with the staircases (**fig. 12.9,** *overleaf*).

A roof-light window gives direct light and ventilation to the bedroom. A generous wraparound desk makes a good home office space, which looks down on the living room, suitable for students or anyone else wishing to work at home. Each pod can have 7.5 m² of shared communal space below the raised roof solar canopy, and some of this can be enclosed, if required, to make a shared living room of the kind needed in co-housing. This is achieved economically by adding a vertical glazed screen at either end, thus enclosing the space between pods.

Another plan variant, measuring 60 m² including a share of the communal space, consists of a double pod with two large bedrooms, a larger living room, kitchen and bathroom (**figs 12.10–12.11,** *overleaf*). This would meet the recommended national affordable homes space standard should this be insisted on by the planners.

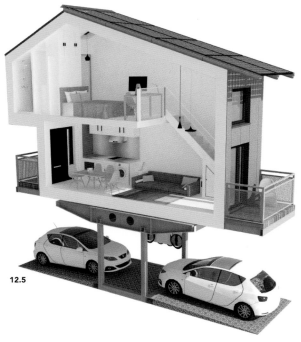

12.5

12.5 Section view.

12.6 Single Pod Plan.

12.7 Double height space.

12.8 Open plan kitchen and living space.

12.9 A single Pod terrace.

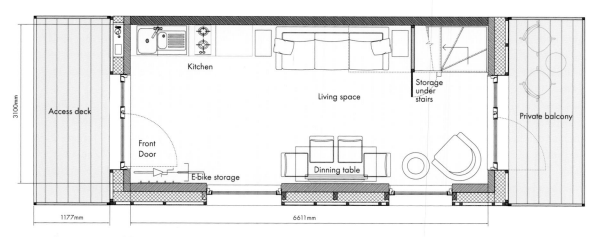

Bathroom

Hot water cylinder

Walk-in wardrobe

Bedroom

Study desk

Void

3100mm

800mm

7920mm

Second floor gross internal floor area: 17.53m²

Access deck

Kitchen

Living space

Storage under stairs

Private balcony

Front Door

E-bike storage

Dinning table

3100mm

1177mm

6611mm

First floor gross internal floor area: 20.61m²

12.6

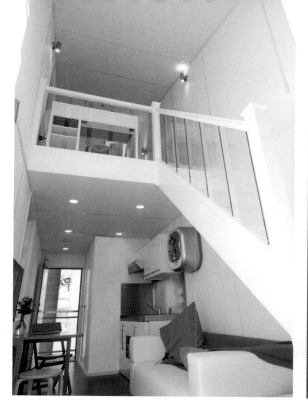

12.7

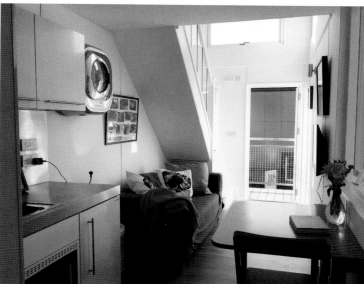

12.8

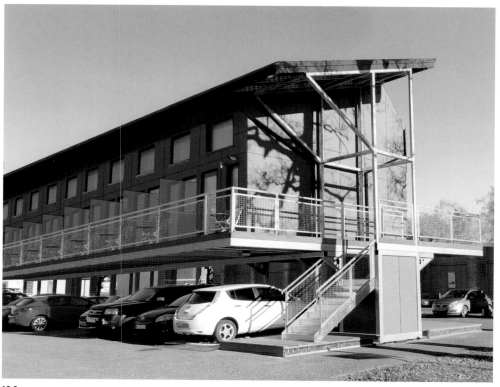

12.9

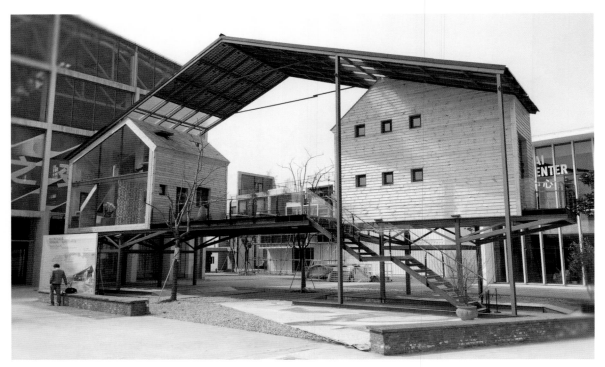

12.10

12.11

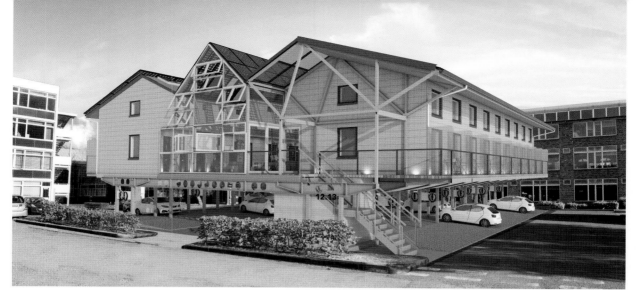

12.12

Providing future flexibility for landowners

All landowners want to maximise the value of their land. The trouble is that many vacant sites or car parks are seen as possible long-term development opportunities, so they are left empty for 20 years or more as land speculation. This less-than-ideal process of urban regeneration needs to be recognised and understood by local communities, because a site could be used to support a temporary use for a minimum of five years, a timescale corresponding to a temporary planning approval. Providing the community can be rehoused on another comparable car park, and the rental income from the pods continues to flow to the investors that funded their creation, the attraction of this bonus profit could be expected to unlock many underused urban sites (figs **12.12–12.15**). While this idea depends on the availability of another site when it is time to move on, most local authorities or large landowners owning a large number of car parks should be in a position to make this commitment (figs **12.16–12.18**, *overleaf*).

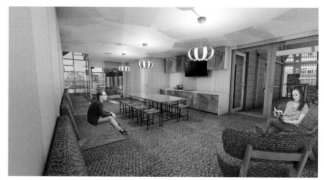

12.13

12.14

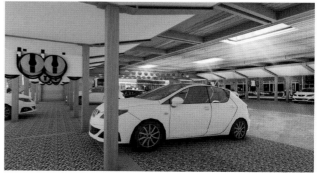

12.15

12.10+12.11 ZEDpod at Shanghai Design Week, 2016.
12.12 A double terrace with a solar lobby in between, with vehicular access either side, as well as directly underneath the lobby.
12.13 Communal space under the solar canopy.
12.14 Communal lounge with kitchen and dining area.
12.15 Electric vehicle charging points in line with SHS columns. One charge point for each parking bay.

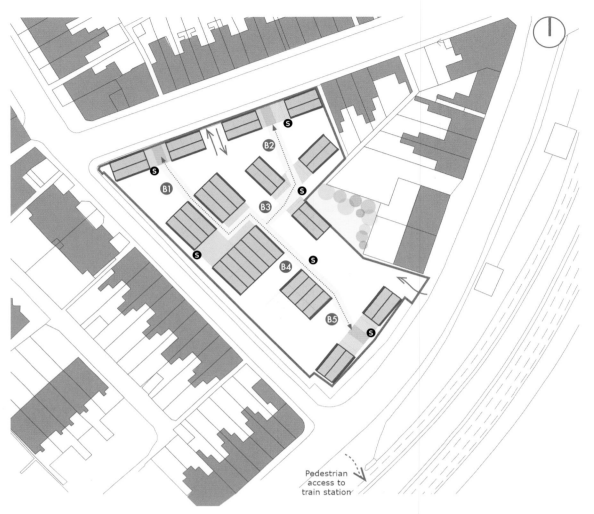

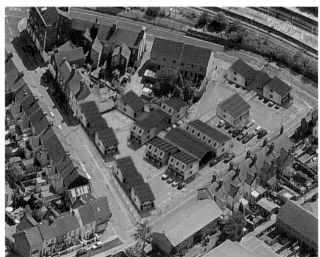

Car parking spaces (**91**)

	Existing buildings
	ZEDpods Terraced (**12**)
	ZEDpods rotated 90° (**22**)
	Communal space
	Raised circulation
	Vertical circulation
◄····	Pedestrian circulation
S	Staircases (**6**)
▬	ZEDpods' gable end (**26**)
B1 **B2** **B3** **B4** **B5**	Link bridges (**5**)

12.16

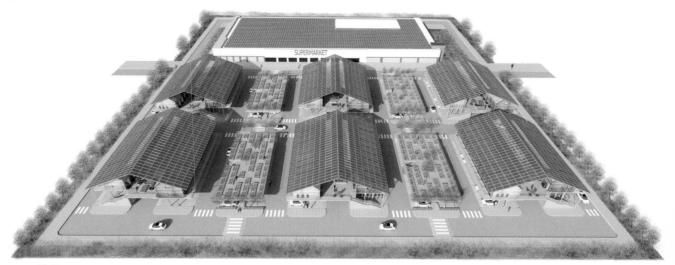

12.17

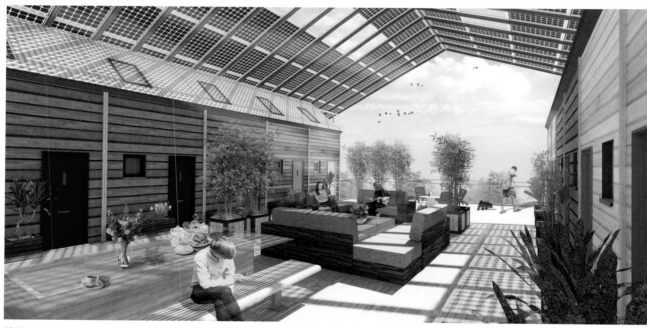

12.18

12.16 Inserting the ZEDpods' urban system into a car park located next to a suburban railway station and surrounded by low rise Victorian terraces.

12.17 144 ZEDpods applied to a supermarket or retail park context.

12.18 Shared ZEDpods' communal space on decking placed over the roadway access to the parking spaces below. The glass tables double as light wells to the covered parking bays.

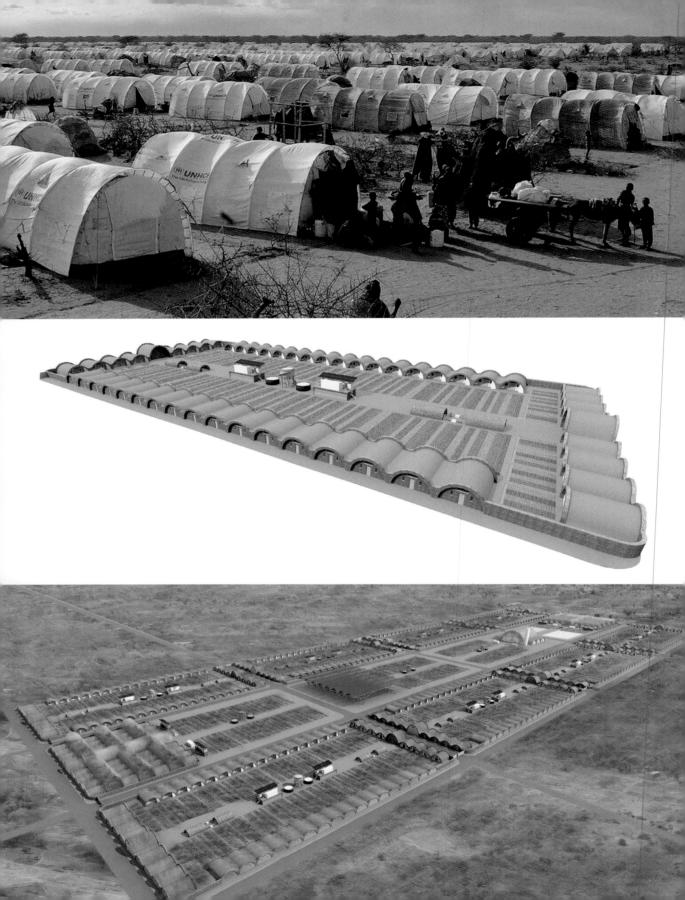

CASE STUDY 3

REHOUSING SOMALIA'S IDPS: FROM EMERGENCY HOUSING TO A LONG-TERM URBAN SOLUTION

KEY PROJECT INFORMATION

Programme: Mixed use
Client: The European Somalian Business Chamber
Site location: Mogadishu, Somalia
Project date: 2013

TOOLS USED

The ZEDroof
Solar-charged exchangeable batteries

Since the priority in emergency housing is to provide essential services right away for as many people as possible, the ZEDtools involved in this project are more limited than in our other proposals.

13.1 (a, *top*) Disaster relief tents donated every three years to the same families do not provide a permanent infrastructure.
(b, *middle*) The home starts off as a steel vault with canvas sides, and upgrades to a permanent dwelling with locally made soil cement block walls and earth-sheltered roof to keep cool in summer.
(c, *bottom*) Replacing tents to create permanent settlement.

The Somalian Civil War has caused a huge number of people to be displaced within their own country. In response, we have developed a scheme for rehousing approximately 15,000 internally displaced people (IDPs) from around Mogadishu to a brief that meets short-, medium- and long-term targets for housing, while also maximising the opportunities for employment and the utilisation of local resources. Part of the task was to understand how to effect a transition from the current use of tents as emergency housing towards building permanent, secure and durable urban settlements. We think it is possible to make this change without wasted investment over the course of five years.

ZEDfactory has suggested how to incorporate food production, water and energy management into this proposal for a holistic urban environment that solves emergency needs at high densities and turns into a low-density permanent city as soon as stable political conditions permit. A significant precondition is to make secure and defensible streets with gates that can be shut at night, so as to prevent hostile soldiers from driving over the vulnerable fabric tents. With massive construction planned in the form of enclosed perimeter block units refugees have a chance to protect their families.

Introduction

Somalia has been hit by both natural disasters and man-made humanitarian crises and there is now an urgent need to help the new government build its way towards a more prosperous future. There are currently an estimated 1.1 million IDPs in Mogadishu whose need for the following basic necessities is urgent:

- shelter/housing
- food
- water
- sanitation
- energy
- employment
- transport.

13.2 Images of typical containerised homes. Streetscape provides poor levels of security and homes require mechanical cooling for comfort.

13.3 The accommodation clusters and communal facilities are enclosed within a secure perimeter wall. The only entrances are through steel gates that will be under the surveillance of security guards.

Shelter/housing

Most methods of providing emergency and quick-to-erect housing rely too heavily on short-term materials and fail to balance the need for quick low-cost housing with basic levels of comfort. Nor do they create an acceptable level of living standard that can be projected into the future. Providing tents offers shelter without maximising opportunities for creating jobs, generating energy and equipping the community for food production (**fig. 13.1a**). As previously mentioned, the threat of insurgent armed forces running over entire sleeping communities in four-wheel drives at night is of another order of horror.

Containerised housing

Containerised housing is expensive and generally creates high levels of discomfort in hot climates. To reduce internal temperature in these uninsulated metal boxes requires electrically-powered cooling devices, which are unnecessary and wasteful (**fig. 13.2**).

13.2

Portable multi-storey housing

Portable multi-storey housing is expensive and similarly ill-adapted to hot climates. Shipped in from outside, they offer minimal scope for employing local labour or using locally produced/sourced materials. This does not help the local economy, its people or the environment.

Earth-sheltered dwellings

ZEDfactory and the Zero Bills Home Company have been developing a third way that maximises the benefits that emergency housing brings, while also using local labour, materials and renewable energy to create a long-term solution (**fig. 13.1b–c**).

Earth/rock-sheltered dwellings are an inexpensive and permanent solution to creating comfortable homes adapted to local conditions. The mass of material dug from the site and placed over corrugated galvanised steel-vaulted permanent formwork provides increased levels of thermal comfort and a low-cost durable construction (**fig. 13.3**).

Construction sequence

A stone gabion floor made of loose stones packed tight in light steel cages is laid first. The multi-plate pipe, seen in **figs 13.4–13.6** (*overleaf*), is assembled using a bolt-on construction technique. Locally sourced sandbags, or Cinva Ram compressed earth blocks, are then built up into the retaining walls between units and filled with a thick layer of earth designed to act as a passive cooling layer of thermal mass. The compressed earth blocks can be constructed using the manufacturing kit designed by ZEDfactory in a labour-intensive work programme that does not require specialised skills.

The front and rear facades are then fixed and finally the internal facilities and partitions are erected. The majority of the materials are sourced locally and relatively unskilled labour can be used to erect them, maximising employment opportunities.

Emergency housing proposed by ZEDfactory comes with the opportunity to customise the premises to suit the occupants. There are three different arrangements currently available, each suited to a different group of people. One such arrangement is shown in **figs 13.7–13.8** (*overleaf*).

Water and sanitation

Water can be supplied from different sources such as riparian or reverse osmosis, depending on location, but it is bound to be scarce and needs conserving. In order to balance costs and create a renewable supply, a shared water and sanitation block is proposed.

Sanitation is provided via three options:

1. Basic composting toilets.
2. Containerised toilet block connected to an anaerobic digester.
3. Biogas generation plant.

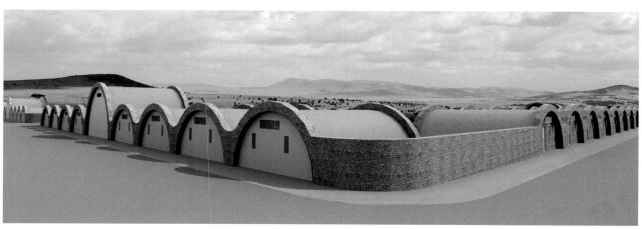

13.3

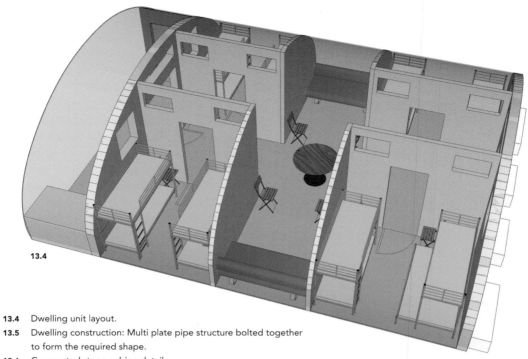

13.4

13.4 Dwelling unit layout.

13.5 Dwelling construction: Multi plate pipe structure bolted together to form the required shape.

13.6 Compacted stone gabion detail.

13.7 Single dwelling unit – the galvanized steel vault shell supports 450 mm of locally sourced rubble and rock, greatly reducing the heat transferred into the interior.

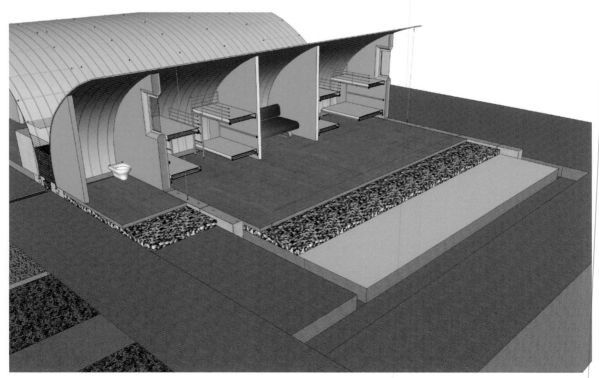

13.5

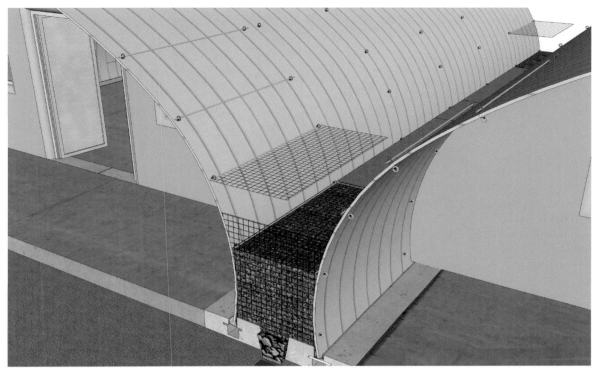

13.6

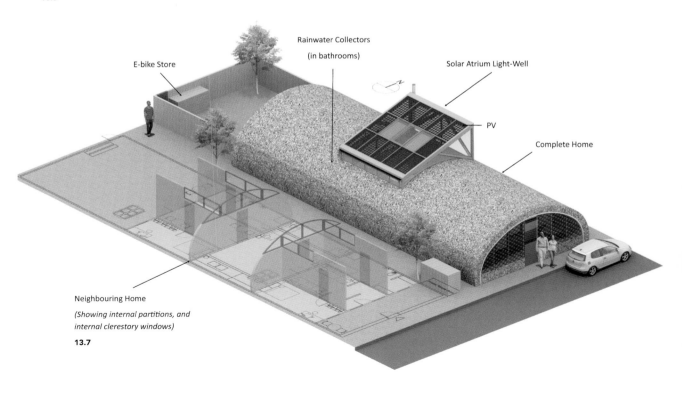

E-bike Store

Rainwater Collectors
(in bathrooms)

Solar Atrium Light-Well

PV

Complete Home

Neighbouring Home

*(Showing internal partitions, and
internal clerestory windows)*

13.7

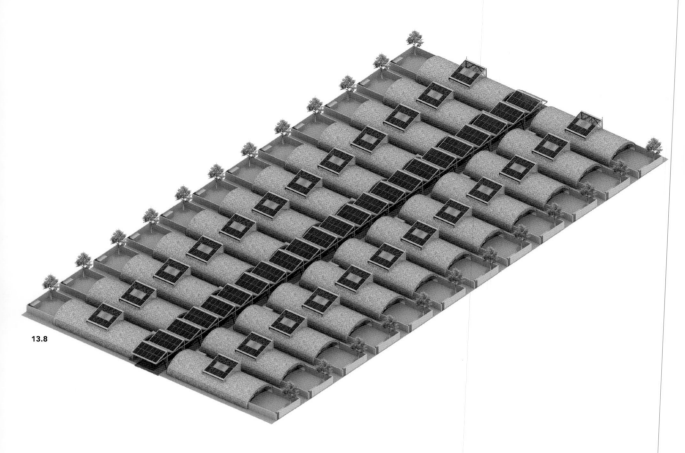

13.8

Containerised toilet block

We propose providing a central satellite block for washing and toilet facilities, with separate male and female sections. This would feed into a supply feedstock for an anaerobic digester unit. In addition to the benefits of the basic options, processed human waste can provide biogas for cooking, generate fertilizer for crops and has the potential for waste-water recovery.

Energy and communal facilities

Energy will be provided across the site and to the dwellings and street lights by a raised solar power array centrally located to each dwelling cluster. This has many benefits as having the array raised makes it safer, while creating useable communal space underneath. The energy can be stored in a battery bank under the array and distributed over short distances to power the sanitation pod, the street lights and the homes.

A large array over a central market can also be developed to provide refrigerated storage for locally produced food, as well as powering centralised communal facilities, such as a health centre and mosque. The size of the array can be adjusted depending on the level of need, which might grow to include powering electric taxis, bikes, vans, and buses. This solar resource can sustain a community without any need for fossil fuel.

Conclusion

This case study shows how easy it could be to set up durable, super-efficient zero-carbon communities, where people need contribute little except 'sweat equity'. However, after a decade or more running with low- or near-zero-energy and water bills, these initially disadvantaged communities could become more prosperous than their neighbours whose land would have been considered more fertile. With

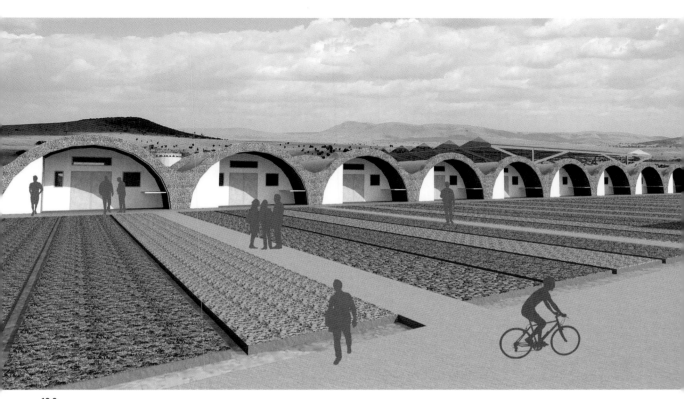

13.9

careful planning and proper utilisation of local materials and local labour, food production, clean energy generation and waste management all work in conjunction (**fig. 13.9**). Starving refugees are often willing to fight hostile forces for as little as one piece of fresh fruit a day, so if the aid agencies adopted this longer-term strategy in place of offering tents, the reconstruction project would become an alternative employer, in a process that would lead to the construction of a new urban extension.

13.8 Earth-sheltered homes – built around a PV canopy street (with ice slurry cooling system).

13.9 Merging food production with shelter and security.

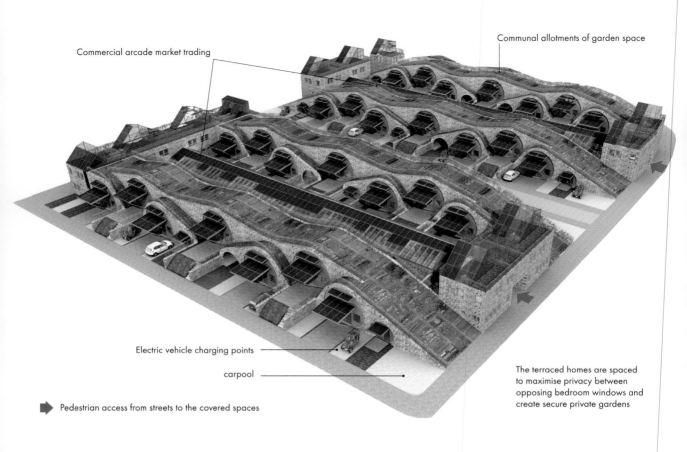

Commercial arcade market trading

Communal allotments of garden space

Electric vehicle charging points

carpool

The terraced homes are spaced to maximise privacy between opposing bedroom windows and create secure private gardens

Pedestrian access from streets to the covered spaces

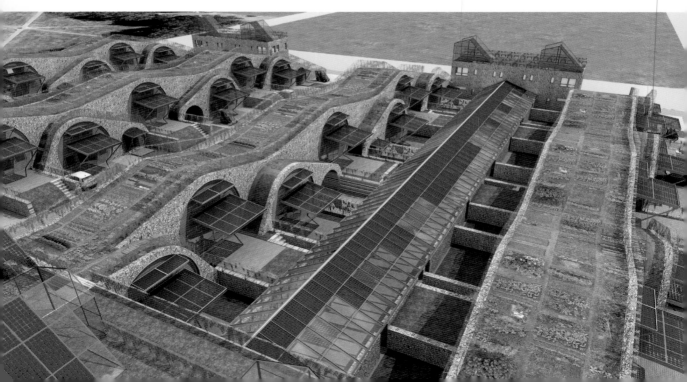

CASE STUDY 4

SHOREHAM CEMENT WORKS: MIXED-USE REGENERATION

KEY PROJECT INFORMATION

Programme: Mixed use

Client: South Downs National Park Authority

Site location: Old Shoreham Cement Works, Upper Beeding, UK

Project date: 2014–present

TOOLS USED:

The ZEDroof

Solar-charged exchangeable batteries

Low-carbon transport

Retrofit and adaptation of existing buildings

Rainwater harvesting and water re-use

Overview

With this project, we wanted to offer visitors to the National Park the experience of a zero-carbon / zero-waste future that is fun and has no snags. Our proposal is to make a large holiday park development by transforming a typically ugly redundant quarry into a working and breathing Eden of zero-carbon earth-sheltered holiday houses situated on terraces around the natural amphitheatre of the quarry (**fig. 14.1**).

Master plan

Our proposal uses landscaped terraces to repair an industrial scar on this cherished part of the countryside. This major leisure complex is imagined on the 48-hectare site of the present Shoreham Cement Works, an inactive chalk quarry with extensive semi-derelict industrial buildings, in the heart of the South Downs National Park. It happens to be the largest brownfield site in the south east of England in a prime position, situated on the river Adur, 5 km north of Shoreham-by-Sea, close to Brighton and within easy reach of London. The proposal would bring new

14.1 Earth-sheltered terrace with communal solar arcade and rooftop allotments.

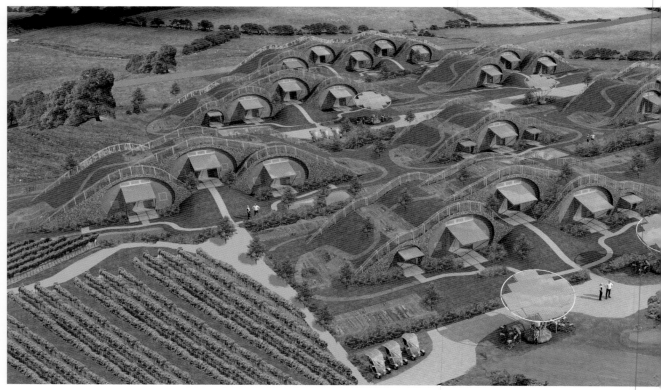

14.2

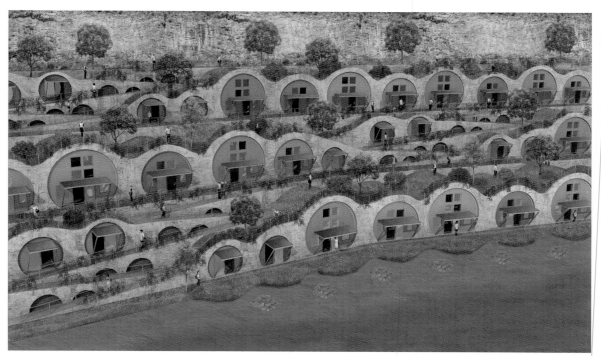

14.3

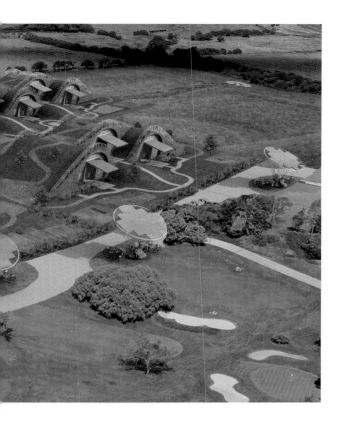

life and employment opportunities into the area in the form of a vibrant zero-energy development. It could include an entertainment venue for open air performances by the world's leading musicians and performers in a vaulted amphitheatre. Plants and wildlife would return to this degraded environment with the majority, if not all, of the project's energy demand delivered by renewable energy.

It is the duty of any national park authority to work with other partners to foster the economic and social well-being of the local communities within their national park. A planning inspector recently called the cement works a 'major visual intrusion at a strategic point within the South Downs', and called for the restoration of the site, with its unsightly buildings demolished or renovated and the quarry faces suitably treated. The site is considered unsuitable for a major housing development, but its potential for visitor accommodation, employment and leisure uses is recognised, especially if supported by green transport measures. Following

lengthy discussions with the local parish council and the South Downs National Park Authority, the proposals have been built into the draft local plan and are currently under public consultation. The proposals are as follows:

Holiday and hotel accommodation
Earth-sheltered holiday accommodation of over 700 units would include:

- 120 accommodation pods located in the main car park on an elevated platform over parking spaces under a solar PV canopy.
- 650 earth-covered vaults, designed to blend in with the surrounding countryside in an 'inhabited landscape' (**fig. 14.2**).

Hotel accommodation of 130 rooms, including:

- 80 hotel rooms in the renovated cement works.
- 50 rooms in a vaulted riverside hotel.

A live/work village
Fifty earth-sheltered homes built into terracing around the existing cement works will provide affordable homes and live/work starter homes (**fig. 14.3**).

Activities
- Wildlife: Bodies of water are incorporated into the landscape design in two key areas. The consistent water levels in the lakes provide excellent wildlife habitat potential.
- Natural swimming ponds: Two tanked lakes will be created, with perimeter reed water-polishing systems to collect surface water runoff and create wildlife habitat.
- Cable-powered wakeboarding, rock climbing, high-rope centre and mountain biking, plus electric biking sports integrated in quarry landscape with an observation/spectators' cafe (**fig. 14.4**, *overleaf*).

14.2 Earth-sheltered rural communities for key workers and leisure can blend easily into sublime landscapes particularly in national parks and the green belt.

14.3 New terraces create earth-sheltered 'hobbit' holes.

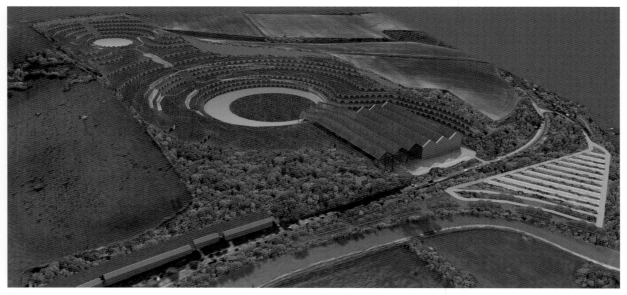

14.4

14.4 Terraforming the existing chalk quarry to heal the South Downs.

14.5 Underneath the solar farm with north light.

14.6 Glastonbury meets Glyndebourne.

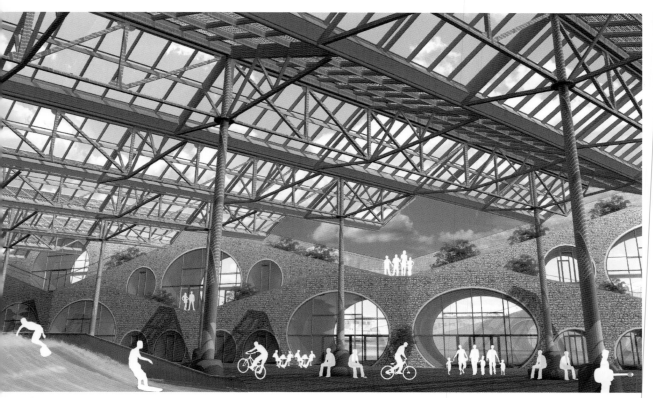

14.5

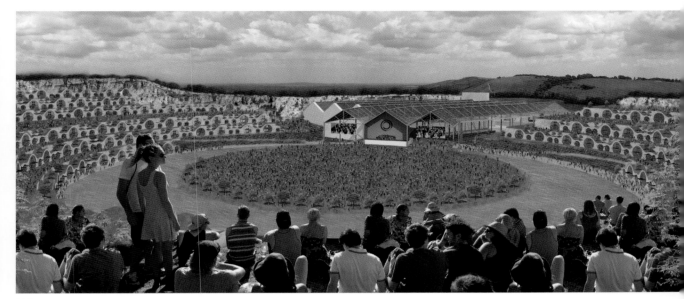

14.6

Covered market

A central area covered by a translucent solar PV canopy, capable of accommodating a farmers' market for the sale of local produce, along with street food kiosks and other attractions in the style of London's Borough Market (**fig. 14.5**).

Covered performance stage

The stage will be located alongside a lake, with a solar PV canopy to protect the performers, while generating electricity. With provision for all-weather performance events, the venue can achieve year-round use (**fig. 14.6**).

Providing the power

Solar

The site will be entirely powered off-grid by solar PV panels in the form of solar canopies over the main parking, the covered market and the concert stage. Smaller arrays will be interspersed conveniently throughout the site for charging electric vehicles. The electricity generated will give also provide FIT revenues.

Pyrolysis – not incineration

A 1 MW electrical demonstration pyrolysis unit with carbon sequestration facility will be powered by dry agricultural waste from the National Park. The current plans require 1 tonne per hour of local agricultural biomass crop waste which equals one heavy goods vehicle a day. A modest stockpile of this fuel, stored dry under the riverside parking deck, would feed a 1 MW electric output pyrolysis unit, meaning that local agricultural waste, or any other site-generated dry organic waste, can be treated on-site.

Storage

By pumping water from the lower lake to the higher lake while the PV is active, we can effectively create a mini hydroelectric generator when extra power supply is needed. All vehicles and holiday homes will be powered by singles or multiples of the same 500 Wh Fitcraft lithium batteries. Batteries will be charged by the AC microgrid in the renovated cement works building and hired out to users.

Biogas

A medium-scale anaerobic digestion unit, powered by wet organic material, creates biogas that can be compressed on-site and used to fuel converted historic buses and other vehicles.

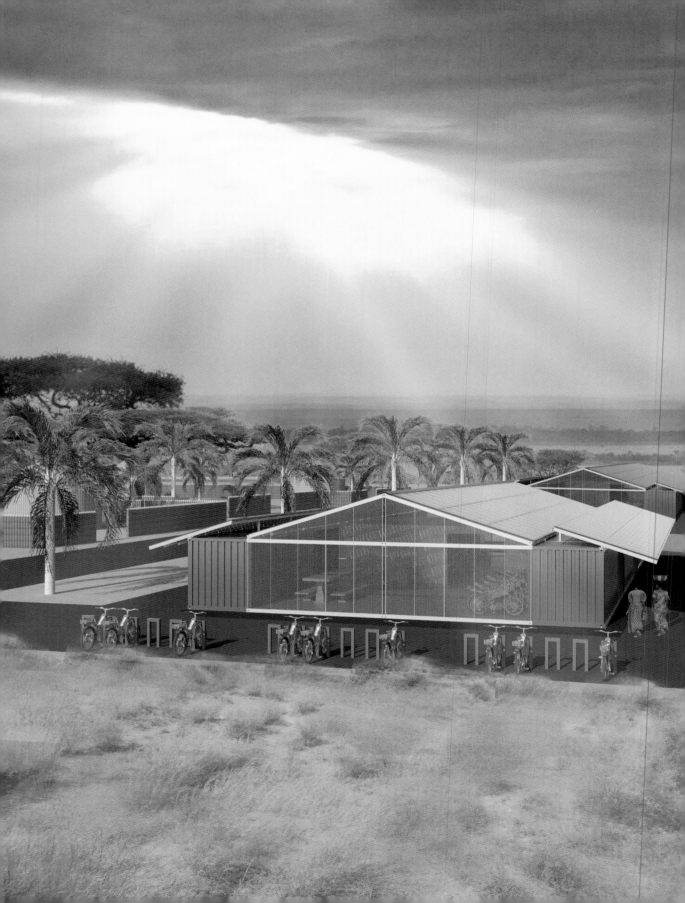

CASE STUDY 5

AfricaZED

KEY PROJECT INFORMATION

Programme: Mixed use
Client: Community Let Initial
Site location: South Africa
Project date: 2015

TOOLS USED:

The ZEDroof
Solar-charged exchangeable batteries
Low-carbon transport
Rainwater harvesting and water re-use

AfricaZED adapts the ZEDtools already described to ease the quality of life for low-income people in the countryside and townships around major conurbations, such as Johannesburg. Electricity supply in South Africa is already subject to load shedding and blackouts, so any alternative power sources for light, the internet and affordable transport would be of benefit.

Introduction

The shortage of electricity supply in South Africa is estimated at 5,000 MW, and the resulting blackouts have far-reaching detrimental effects, not only as an unwelcome inconvenience for industrial and domestic users, exacerbated by recent substantial price increases, but as a constraint on the nation's economic and social growth. It is difficult to plan the construction of much needed new houses when there is no immediate prospect of connecting the houses to grid electricity.

Any substantial increase in electricity supply through the grid will normally involve increasing centralised generating capacity, which is a long-term

15.1 External view of the local energy hub.

project. However, a more immediate solution can be provided by modern technology combined with a natural resource that is abundant throughout Africa: the sun. This can supply energy off-grid and provide a cost-effective solution that will bring a wide range of benefits.

Development strategy

In Africa reliability, robustness and local repair matter. The First World habit of throwing out products rather than repairing and servicing them should be resisted. Instead a diagnostic service to work out what needs repair by well-trained local staff, combined with a 'plug and play' replacement parts service, would maximise local employment and assist in developing a future skilled workforce.

ZEDhub: Local manufacture, employment and long-term ongoing servicing and maintenance of off-grid power and transport

It is a basic principle of ZEDlife to create employment and develop a manufacturing base for local Africans. We would therefore envisage that a range of technologies would be manufactured in Africa in a network of relatively small regional assembly factories, providing local employment at a manageable capital cost.

 The ZEDfactory is designed to meet these needs, with a prefabricated galvanised steel portal frame and a roof entirely clad in solar panels, while the walls are made of low-cost locally-sourced materials. It will have a large 60 kW three-phase battery store able to provide backup power to the local community on demand (**fig. 15.1**). The ZEDfactory would promote the project, acting as a social focus and providing energy solutions to existing communities with blackout problems. At the same time, it will offer local manufacturing capacity and low-carbon jobs.

 Each ZEDfactory provides 500 m² of secure ground floor space. The units can be deployed as

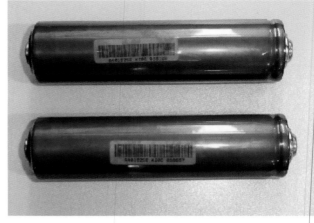

Specifications:
Nominal Voltage - 3.2V
Nominal Capacity - 15000mAh
Weight - Approx.480g
Max. Continuous Current - 5C(75A)
Max. 10 sec Pulse - 10C(150A)

Cut off Voltage - 2.0V
Charge Voltage - 3.65V±0.05V
Recommended Charge Current - 2A
Charge Time - 8 hours
Internal Resistance ≤4mΩ
Self-discharge rate ≤5% per Month

15.2

15.3

15.2 Long-life Headway 40152S high performance LiFePO4 cells rated for 2,000 charge cycles at 80% depth of discharge with screw battery connection, enabling easy cell exchange with no soldering. Most portable lithium batteries have half to one-third of this battery life.

15.3 Africa battery: lightweight and fast discharge rate for high performance electric vehicles.

15.4 One battery – multiple uses and voltages.

Power Source	Separate Battery Management System (BMS)		Power Use

Power Source

Separate Battery Management System (BMS)

Power Use

12V LiFePO4–Sub-Module

 A
12V =

Small appliances

(LED lighting)

Base 24V LiFePO4–Module

 B
24V =

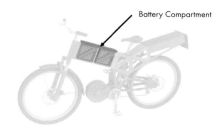
Battery Compartment

 x2
Multiple 24V LiFePO4–Module–in SERIES

 C
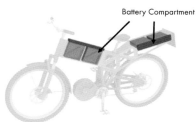
Series Wiring
48V =

Battery Compartment

500W–E-bike

 x3
Multiple 24V LiFePO4–Module–in SERIES

 D

Series Wiring
72V =

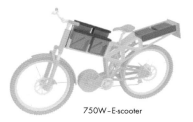
750W–E-scooter

 x8
4 x 24V LiFePO4–Modules–in SERIES
Creating 2 x 96V banks operating in Parallel

 E

Series & Parallel Wiring
96V =

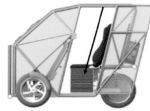
1500W–E-trike

 x10
Multiple 24V LiFePO4–Module–in SERIES

 F

Series & Parallel Wiring
240V =

Off-grid Homes

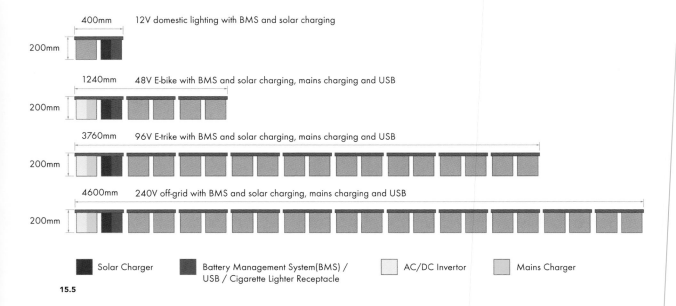

400mm · 12V domestic lighting with BMS and solar charging
200mm

1240mm · 48V E-bike with BMS and solar charging, mains charging and USB
200mm

3760mm · 96V E-trike with BMS and solar charging, mains charging and USB
200mm

4600mm · 240V off-grid with BMS and solar charging, mains charging and USB
200mm

Solar Charger Battery Management System(BMS) / AC/DC Invertor Mains Charger
 USB / Cigarette Lighter Receptacle

15.5

needed for assembly, training, repair, fabrication centres, sales centres, equipment rental depots, and as demonstration sites.

All the technology discussed within the ZEDenergy solution will be demonstrated here, with an emphasis on energy-efficient load management as well as renewable electricity production and storage. With sufficient investment in battery storage and solar power electricity generation, it makes equal sense to invest in a showroom selling the products appropriate to its use, such as LED lighting, energy-efficient air conditioning and water heating, and battery powered transport (**figs 15.2–15.5**).

These batteries can satisfy a full range of energy requirements from the small and portable at one end of the scale to enough power to keep a business functioning during a grid outage. As already discussed, the batteries can be stored in the home and when run down can be swapped at street outlets for newly charged ones.

Suppliers of larger rechargeable batteries have underestimated the value of portability to the end-user. We at ZEDfactory think that there are many advantages from the kind of battery we are proposing:

- **Lightweight and affordable**
 High-end, high-cost electric cars are beginning to reach the market, but viable electric transport for the majority of people is still out of reach.

 By reducing the weight of the vehicles and expanding the battery capacity to its extreme, the ZEDlife offers an efficient hybrid form of transport which maximises performance and minimises cost, making it a realistic option for far more people in place of fossil fuels.

- **Diverse usages**
 The size and portability of the battery module can vary so that, although personal transport may be the primary use, other types of battery can be made for many kinds of human scale micro-management of energy resources.

- **Increased lifecycle**
 It is possible to extend the battery life to around 4,000 to 5,000 charge cycles by cooling the cells with improved ventilation to prevent overheating, thus limiting discharge depth to 70%. To avoid individual cells being overcharged, we recommend regular charging with cell balancing.

- **Integrated solar charging**
 The efficiency increase has, in part, been achieved by advances in battery management systems that allow for the smooth integration of solar charging.

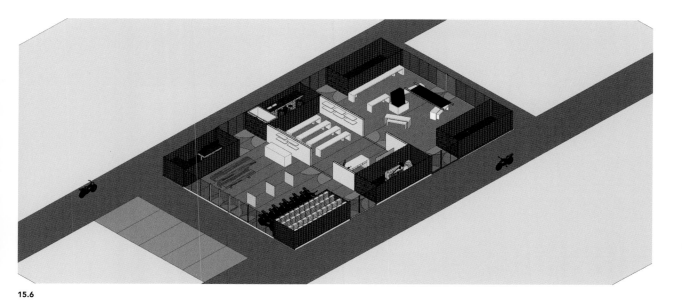

15.6

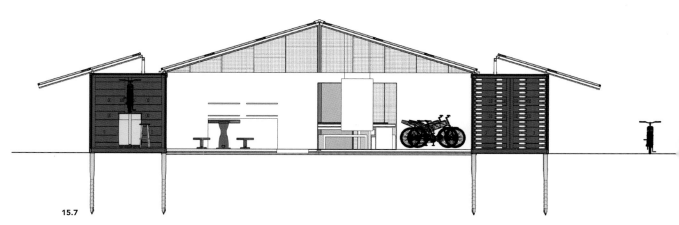

15.7

The local energy hub

The energy hub aims to address numerous problems related to South Africa's interrelated housing and energy crises. The concept is to 'drop in' an energy hub as a demonstration pilot project and measure the effect of the energy use in the existing community. Aiming to operate independently of the grid, this hub would meet the energy needs of existing communities living in situations of electricity scarcity, while providing a number of important services (**figs 15.6–15.7**).

'Energy ignorance' is an adverse factor that the energy hub would be able to challenge by offering

a more cost-effective way of reducing stress on the National Grid. For example, every home we visited had at least two 3 kW electric-bar radiant heaters and the local DIY store was promoting these products enthusiastically. On the same day one-third of Johannesburg had full blackout power cuts because of shortages of grid electricity.

15.5 The appropriate BMS and charging equipment can be made available for a diverse range of uses with scalable power output.

15.6 Aerial view.

15.7 Cross section of community hub.

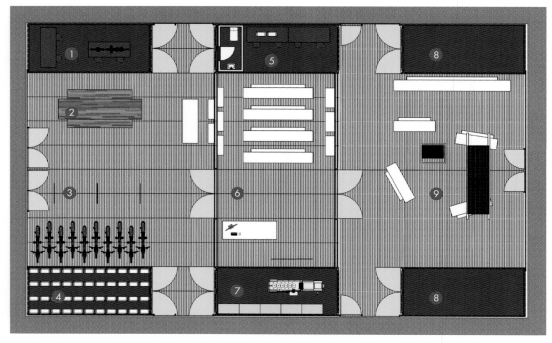

1. Bike workshop/assembly of bikes
2. Café area
3. Exhibition space
4. Lithium Iron Battery storage
5. Battery assembly workshop/WC
6. Classroom and shop (flexible space)
7. Generator/battery bank/Rainwater collection room
8. Stock storage
9. PVs' assembly area

15.8 Six container pop-up community hub.

The energy hub would promote and deliver a number of innovative renewable energy products and systems, tied together by a holistic aim of finding solutions for Africa's poorest communities. As it happens, these solutions apply just as much to wealthier communities facing a similar energy crisis. The cost saving, as well as the saving of carbon emissions, and development of resilience are obvious enough to encourage investment by a combination of public and private finance with overlapping aims and objectives.

Hub specification:
- Completely prefabricated in six small shipping containers, complete with fitted out workshops and battery banks.
- Option of removable screw pile foundations – no problems with sloping sites or car parks.

- First container is vegetable oil generator, rainwater storage and toilet.
- Second container is a fully fitted out workshop for building batteries and bikes. Two bikes and 25 batteries per day would be an achievable output.
- Third and fourth containers are fitted out with electromagnetically locked rental battery banks operated by a smart-charge card system.

Other buildings and facilities would include (**fig. 15.8**):

- One sheltered open-air decked cafe/meeting area, plus coffee bar.
- One enclosed insulated classroom with projection screens and showroom for energy efficient lighting and appliances that could be used as a school or community hub in rural areas.

- The entire compound would be enclosed by a galvanised wire-mesh screen, with options for gabion cages if extra security is needed.
- 140 translucent energy roof panels, each 255 W, provide shelter between the shipping containers to achieve 35.7 kW peak of solar output.
- The whole complex arrives on-site and can be erected and commissioned in two weeks.
- Requires fit-out at a factory in Johannesburg to prepare materials and send out to field.
- Optional microwave transmitter to allow local wireless network hub in cafe and classroom for sports and education events.
- It is a temporary building so can be in place for 5 years or 25 years.
- Add easy-to-build local masonry walls around the shipping containers and replace the mesh screens with glass to create permanent buildings.

Power production

Power generated by the PV roof would be off-grid, therefore allowing the hub to function entirely independently of the centralised National Grid.

Storage

This would be a centrally-owned facility, secured and maintained by the management company, to ensure a well-maintained installation that can stand the test of time.

A large static battery bank would 'absorb' all energy generated by the PV roof, and then redistribute this energy to serve a number of functions and to charge up smaller batteries.

A nominal 75 kW array of integrated PV ZEDroof would provide the shelter required to house a number of functions.

This structure would be erected somewhere central, with good access, preferably at an existing node of commercial and community activity.

Power rental

The energy hub can stock small 0.5–0.75 kWh exchangeable batteries as seen in the ZEDtool 'Solar-charged exchangeable batteries'. They can be dropped off and recharged, or exchanged on the spot for a newly charged unit.

The refurbishment of the batteries would happen inside the assembly facility, carried out by trained local workers. The small batteries are charged up by the larger static battery during the day. People can pay with M-pesa (mobile phone-based money transfer) for their top-up at 20 rand per charge.

The price could be cheaper for drop-off and wait. It could be automated, or employ one or two people.

Covered external space

An important part of the energy hub would be a covered market space for the community to use for trading of food and goods.

This creates the foot traffic to generate interest in the idea and spread the word, also ensuring the hub becomes an important part of the community for everyone in the local area.

Additionally, the PV roof would provide power for a certain amount of chilled storage from an innovative solar-powered ice slurry technology. This adds real value to the stallholders, who would pay a small fee to use the facilities.

Factory and commercial space

The hub would include an assembly plant, putting together ZEDroof panels, Green Box batteries, microbatteries, and other products to be promoted and supplied.

This could potentially employ between 2 and 20 people trained from the local community, depending on the level of assembly and product range most appropriate to the location and size of the facility. Components are delivered from China, Europe and South Africa, stored at the facility and then assembled into finished products ready to rent or sell.

The facility would also carry out maintenance on locally procured products, ensuring that resources are used wisely and components are not wastefully discarded at the first technical glitch.

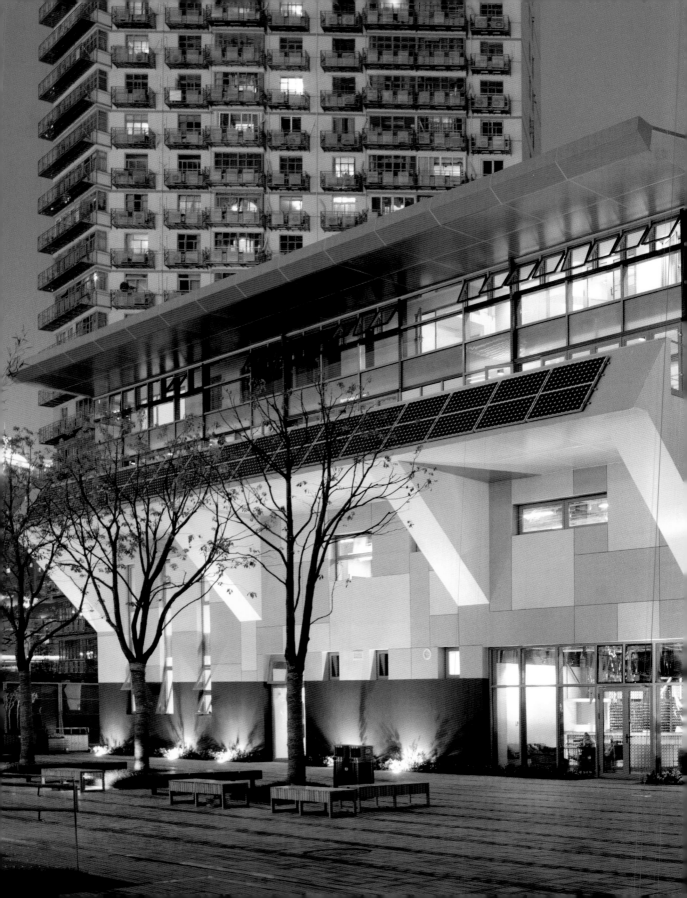

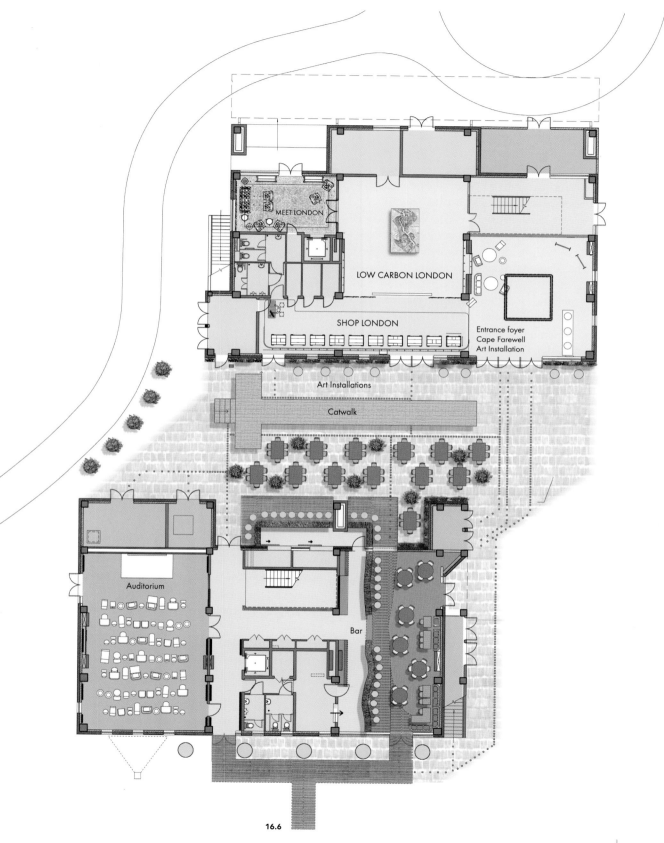

MEET LONDON

LOW CARBON LONDON

SHOP LONDON

Entrance foyer
Cape Farewell
Art Installation

Art Installations

Catwalk

Auditorium

Bar

16.6

Walkable urban neighbourhoods and active street frontages

When reproduced as an urban block, the ZEDpavilion would become a vibrant street, echoing the surviving mixed use lower-rise historic districts of old Shanghai, such as the French Quarter (**fig. 16.5**). Public spaces between buildings can be shaded in summer to act as outdoor living rooms. On a larger scale, pocket parks are created between buildings, reintroducing much needed green spaces into the city and acting as social hubs. Intrusion from parking and vehicular access is kept to a minimum by keeping cars to the edges of urban blocks as much as possible, much like BedZED. This would increase the amount of space allocated to pedestrian areas. The internal layout of the ZEDpavilion model would allow for a live/work community, with office space on the lower two levels and maisonettes above (**fig. 16.6**).

Fresh local organic food: ZEDcafe – a slow food approach

The ZEDcafe and bar would demonstrate how food can be grown locally by organic methods and delivered to the city via solar charged electric vehicles without using fossil fuels or unnecessary packaging.

An on-site biodigester uses food waste to produce biogas for cooking, while the waste stream nutrients can be returned as fertilizer to the farms. Evening events and activities can be held, with shows and lectures on-site, providing an entertaining and informative atmosphere for sharing, learning and relaxing.

From waste to good taste: recycle/freecycle

A team of local artists, designers and craftsmen transformed waste consumer goods and furniture, salvaged from the city's waste stream, to create valuable and fashionable furniture and interior fixtures and fittings, thereby avoiding new purchases where possible. The show flats in ZEDpavilion were used to demonstrate this new way of thinking about home decor and environment (**fig. 16.7**). In a project with a well-known art school in Beijing, CAFA, project architect Yan Guo gave students RMB 1,500 to spend and asked them to come back in two weeks with a chair made from reclaimed materials, robust enough to withstand the high visitor numbers in a world expo, yet that expressed their personality and cultural history. Each student produced a different sculptural chair. When displayed in a large lecture hall, these functional but individual chairs became the exhibit and no other furnishing or interior decor was required (**fig. 16.8**). This process shows how art and creativity can create a stimulating and diverse environment with a very low consumption of resources. The effect was all the more telling, since the room was placed only 50 metres away from high-budget city pavilions celebrating wealth and personal consumption and promoting luxury goods, fashion, shoes and sports cars.

A similar exercise was run with a fashion show exhibiting clothes made by student designers from London and Beijing, again using low-cost reclaimed or low-impact materials (**fig. 16.9**, *overleaf*). Cafe tables were made into a catwalk in the space between the buildings; showing how urban spaces can adapt and change function to host events of this kind.

ZEDbar and cafe

With an internal floor area of 111 m² and an external seating area of over 200 m², the bar can hold fashion shows on the catwalk. Internal seating capacity was 62 and the external plaza can accommodate up to 92 guests.

The undulating, organically formed suspended ceiling has been created from recycled glass bottles.

16.7 VIP room in the Shanghai EXPO London Pavilion, entirely furnished with reclaimed materials designed by SuperGroup London.

16.8 These chairs are made from low-carbon or discarded materials, creating an alternative aesthetic to consumer culture. Allowing every one to be different without costing the earth.

16.7

16.8

16.9

Lit from above, this sculptural piece introduced a diffused, mottled light effect in the bar area (**fig. 16.10**). Local musical talent from Shanghai and elsewhere was responsible for a series of music gigs in the space. These appealed strongly to musicians from the local JZ School who entertained visitors with original and impassioned shows. The school is now eager to continue to host 'in-house' music residencies to talented young musicians, sparking a cultural dialogue to entertain future visitors. Musicians from across the city have expressed the desire to perform at ZEDpavilion with regular music workshops where visitors and artists can relax, enjoy and engage creatively with each other. During the expo, musicians from Europe and South America demonstrated their love of music and their appreciation of what a ZEDlifestyle means. Future proposals will see the beautiful conference space being used as a bigger venue to host concerts and workshops with support from local universities and colleges.

Climate change art

ZEDfactory commissioned well-known British West Country artist Tim Britton of Forkbeard Fantasy to adapt his Carbon Weevils video poem to Mandarin

16.10

for display in the double-height main entrance and for screening in the conference cinema. The Forkbeard piece demonstrates a transition from depressing environmental predictions to humorous and optimistic sentiment that almost anyone can understand quickly (**fig. 16.11**, *overleaf*). In a subject area where much of the discussion tends to be about technology, we think it is equally important to celebrate our occupation of the planet in new, provocative and irreverent ways. As the climate

change art movement grows, we must now encourage artists to provide the emotional commentary on the collective behaviour of our species. Every low-carbon building, product and initiative needs to explain, through engaging artistic means, why this collective challenge is so important.

16.9 ZED fashion show.

16.10 ZEDcafe & bar created from reclaimed glass bottles, including the ceiling.

overleaf

16.11 Carbon Weevils cartoon.

The Great Spinning Mother

...lays down her Fat Reserves...

Her burbling tummy rumbles & burps...

her tiny cleaners swarm

they lick spit suck

limp swish slone

swerve and splurge

...the Larders to sustain all life to come....

...and in these ? great subterranean seas & ooze...

Carbon Atoms wait in humming droves....

for their next time

...to come around...

And so the CARBON WEEVIL is at work..

not just one Carbon Weevil

but an entire species...

...working tirelessly & as one.....

now the oil

syringing it out of

her vast & toothsome pie-crust

evolving even more elaborate Systems...

....mouth parts.

probosci extensions...

and oviposters...

BURROW down

Bring it up

Burn it up & Bring it on!

fade to black

FADE UP...

Let us now observe

Their collective sperm would fit into a matchbox....

...and their eggs into an egg cup.

...its life Cycle

The Carbon Weevil starts out as two

microbial life forms:

& SPERM

it rapidly grows into an Adult Carbon Weevil

...in appearance most like a forked worm

...they are capable of achieving great sizes

Carbon Weevils mostly live in packs...

...in vast spreading nest sites that cover huge areas of the Earth

16.11

as ALL across her gorgeous curvaceous body

and she sustains them as they sustain her.

amidst her complex toothsome bulging self-sustaining...

multi-storeyed space...

for ever laying down and dying...

Layer upon countless layer rolling & revolving round round

she squeezes them harder & harder between her vast plates...

as she lays down her Fat Reserves...

burrowing in and lancing...

the FAT RESERVES...

Excavating...

tunneling...

rearranging...

re-ordering

Releasing the Carbon Atoms.

First the forests...

then the Coal

...and observe the Carbon Weevils evolution...

At the time of shooting the next frame.....

There were precisely 6,713,008,180 CARBON Weevils. alive
MAY 17th 1.00PM

if every single Carbon Weevil on Earth.. was herded together

was herded together..

then rolled up into a single squidgy ball

they would only be this big next to the Earth..

before suddenly shrivelling up

...and dying..

Carbon Weevils are themselves 20% CARBON

and have evolved to re-release this vital carbon

as fast as possible back into the atmosphere

Rather than the slow release technique.

favoured by other species...

which can take anything up to a million years

Weevils lay down intricate Gum trails

made of hot melted carbon...which dries.

of tars creating beautiful patterns when seen from above

crisscrossing

underpassing

Ringing

and by passing

Down there hardened gum trails

the Weevils swarm...

...are regarded by many as the pinacle of Carbon Weevil Social Interface

Carbon weevils have evolved...

...to traject themselves in Herds into the AIR...

inside tubes which travel...

across huge distances

So they can lie in rows roasting themselves...

or conglomerate in huge pan-global hot-air sessions

before catapulting themselves home a few days later...

generated in special hot air chambers

on the other side of the world

Much like their close cousin the Greenfly...

Carbon weevils can drop 320 young a minute

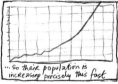
...So their population is increasing precisely this fast

each individual weevil is capable...

of consuming 400,000 TONS of food...

in its 70 yr life span

We are only at the very beginnings of understanding this remarkable and inexhaustible little species..

...and many of its apparently pointless activities and Rituals are still quite quite beyond us....

Suffice it to say that such is the vast time scale of Evolution

...that we may not know for millions of years why it was even here.

before it became swallowed like so many before it...

...into the vast self-regulating memory banks

of The Great Spinning Mother

The End

STOP PRESS. Since the making of this film Rare footage of subspecies...

...... evolving unusual variations to the trademark chimney head...

have been recorded...

...... watch this space...

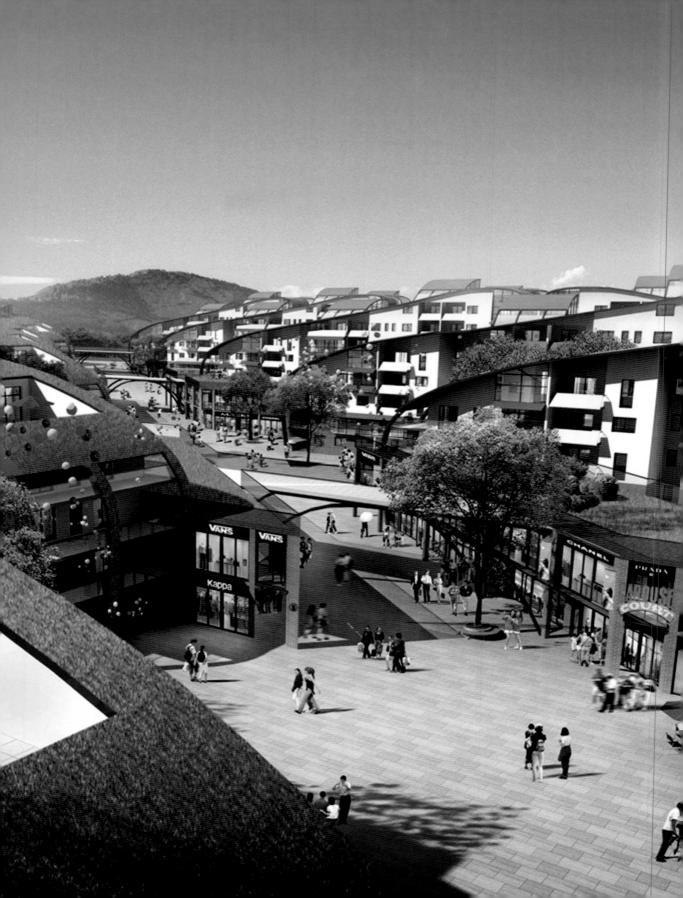

CASE STUDY 7

HIGHER-DENSITY STRATEGIES: LIVING UNDER A PARK

7a: ELION MASTER PLAN

KEY PROJECT INFORMATION

Programme: Master plan
Client: Elion Goldway Holding Co.
Site Location: Tianjin City, China
Project Date: 2014

TOOLS USED

The ZEDroof
Low-carbon transport
Building-level energy systems

7b: GS KOREA

KEY PROJECT INFORMATION

Programme: Mixed use
Client: GS Engineering & Construction Co.
Site Location: Seoul, South Korea
Project Date: 2012

TOOLS USED

The ZEDroof
Low-carbon transport
Building-level energy systems
District-level energy systems
 and food production

As climate change accelerates, the urban heat island becomes increasingly problematic. Peak summer temperatures within the city centre are often 3 degrees higher than the surrounding open countryside. Urban wind-speeds decrease due to building cover, so that the hot air from large areas of solar-absorbing asphalt is seldom mitigated by the normal effects of wind. Many facade-mounted air conditioning units simply dump hot air back into the street and only provide a very limited solution and at a considerable cost. To make things worse, air pollution from fossil-fuelled vehicles is trapped at pedestrian level, causing an increase in urban respiratory disease. Despite these disadvantages, property values in city centres tend to escalate steadily, aggravating the problem by increasing density and raising plot ratios. Eventually, the congestion and air pollution must overcome the convenience of the centralised location, at which point the area will be redeveloped and regeneration can be aimed at maximising quality of life. Older cities tend to have been through this process at different periods in their history and, in the best cases, they stabilise at an optimum balance between quality of life, plot ratio and property value.

17.1 Pedestrian central shopping street.
(Tongshan master plan, Jiangsu, China, 2007).

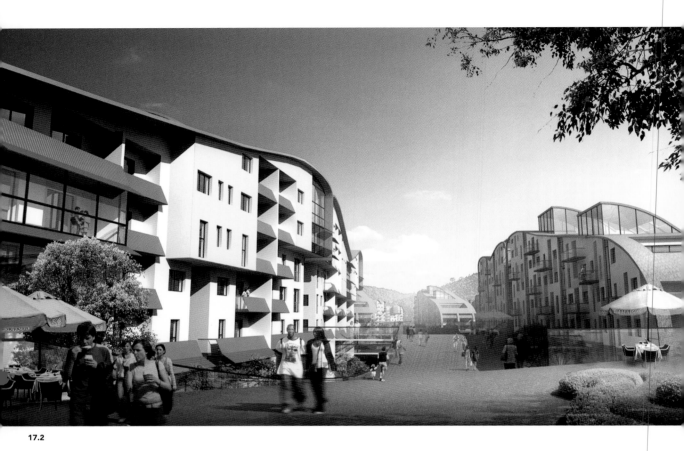

17.2

As housing densities increase, the area of roof exposed to sunlight becomes smaller in relation to the number of people. When apartments are built at a density of 100 homes per hectare, the main exposure to sunlight must come from the vertical facades. At the same time, children need outdoor play space and at high densities the provision of green amenity space can be neglected.

ZEDfactory: Creating rooftop parks in city-centre developments

Increasingly ZEDfactory has been asked to look at developments near city centres in places with boom economies, for instance Tongshan in Jiangsu (**figs 17.1–17.3**) and Dalian Eco-town (**fig. 17.4**, *overleaf*). Clients have insisted on meeting their development brief with high-rise point blocks. Visiting these projects, we became increasingly concerned about the dark parking basements, the overshadowed spaces between buildings, and the social alienation inherent in asking families with children to live so far above ground level with little or no open green space. We drew the conclusion that new urban morphologies must address these issues while achieving the same levels of density.

The common theme in these studies is that parkland or inhabited landscape will always be created on the horizontal roof plane, making the roof as easy to access from stair and elevator cores as the street level. This gives residents and workers the option to be outside quickly, away from air pollution and noise, and surrounded by green parkland. Wherever possible this parkland should descend to street level as a cascading hillside, acting as an open invitation to ascend into a more tranquil realm. This typology allows the roof garden to become a

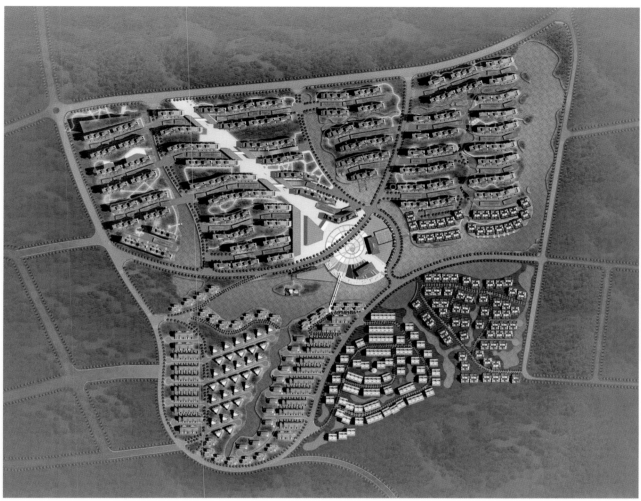

17.3

linear park, joining the separate building blocks with bridges at high level. This strategy was pioneered at BedZED, and the design specification for robust and permanent roof gardens, with a minimum of 300 mm of soil and raised planters for larger trees and shrubs, has now been perfected (figs 17.1–17.2).

The cost of extending the lifts another level easily compensates for the additional sales value created by the shared green open space. In many of our projects we can achieve 75% green site coverage, creating a green and pleasant outlook for every home with almost 100% disabled access to the roof garden from each stair core. In many cities, proximity and direct views of parkland increase property values by around 30%. This creates more than enough sales revenue to offset the modest additional construction cost (fig. 17.3).

The most important aspect of this scheme is to connect the roof plane to street level wherever possible, allowing the communal space to be accessed at ground level with steps or ramps that

17.2 Typical residential block with parkland over commercial space.

17.3 Site plan of Tongshan master plan.

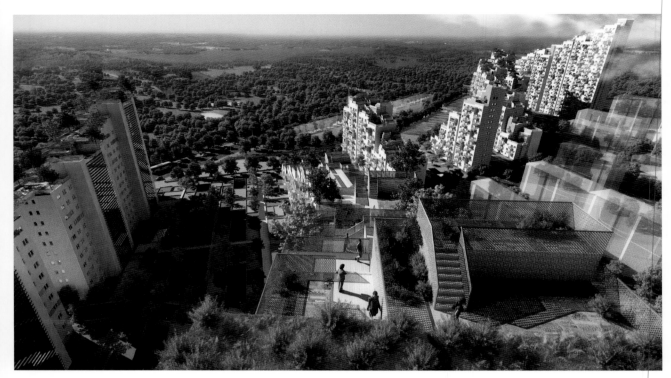

17.4

climb higher and higher to the upper floors of the apartment buildings. This sloping parkland feels similar to a hillside or mountainside. A teahouse, or belvedere, can be placed at the highest point – rewarding the climbers and providing exciting views over the surrounding city (**fig. 17.4**). This idea of bringing the sublime concept of climbable mountainside to ordinary streets has considerable benefits. The urban pressure cooker now has a release valve for those willing to climb uphill.

Where the roof has become parkland, solar energy harvesting must be reassigned to the vertical plane and it will no longer be so critical to optimise the building orientation. This thinking prompted the development of the self-shading, electric-generating Energy Wall through which every scrap of sunlight can be turned into useful solar electricity. As economies of scale are achieved with this component, the cost becomes comparable to any other durable high-quality rainscreen cladding system. This is the same principle as the myriad of leaves on a forest tree. Each leaf receives little

sunlight, and some leaves receive considerably more sunlight than others. The net overall effect is that no sunlight is wasted. Almost no direct sunlight reaches the forest floor. ZEDfactory foresees a future where all larger building surfaces will generate electricity and even at very high plot ratios – up to 50% of annual electric demand can be met from BIPV.

Living under a park

In this section, we are asking how to enhance existing buildings to a ZED standard, with the ultimate goal of making the whole development to be as low carbon as possible. The following two case studies will show how to relocate farming communities in a non-obtrusive way, leaving responsible farming practices in place. These proposed developments are mixed use, incorporating high-rise residential, employment, leisure and retail uses with associated open space within these sites, even in the densest areas.

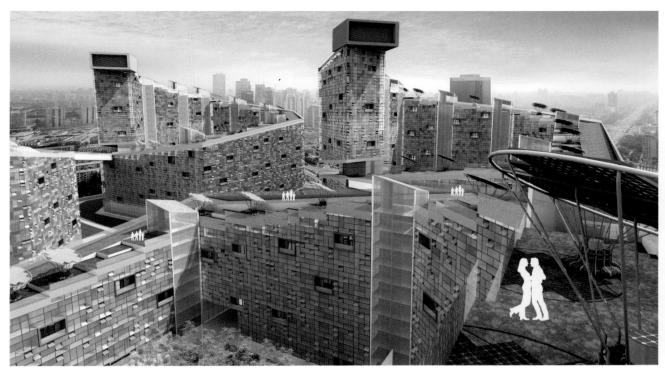

17.5

Low-carbon master planning recognises that different habitation densities require different environmental strategies. It is important to develop a new architectural language responding to the considerable climatic variation found across this beautiful planet, where every design decision, every surface and component of a building, helps create a living, breathing organism that gains its beauty as the outcome of energy constraints or of energy flows experienced in time, a form of evolutionary change in reponse to external pressures.

This holistic system-thinking transcends the pragmatic construction process by daring to dream of an attainable zero-carbon zero-waste society.

In this study, the site has been redesigned to incorporate the following features:

- maximum PV potential
- maximum cross-ventilation for natural cooling of apartments
- high levels of daylighting
- convenient walking and cycling

- mixed-use commercial, community and residential units in close proximity
- local farmers' markets
- zero-waste packaging concepts
- car sharing and car pooling
- maximising the convenience of public transport
- green transport hub
- electric vehicles/e-trike
- green spaces, health and happiness of inhabitants.

The intention is to create an inhabited landscape where people live under a carefully planned sequence of south-facing, solar-harvesting, super-insulated, energy-efficient cliffs of apartments that support a relocation of productive agricultural landscape on all their horizontal surfaces.

17.4 View of roof garden, Dalian Eco-town, China, 2012.
17.5 ParkZED: a theoretical design for high density mixed-use to replace high rise. An EV-only street runs from ground level to roof level, joining up all vertical circulation.

While a common high-density development will cease to have a relationship to its surrounding landscape, our design delicately places the landscape over the top (fig. 17.6). This integrated building form encourages the connection between the manmade and natural forms as a crucial stage in the quest to get humans to live with a lower carbon footprint.

Our strategy encourages wedge-shaped apartment buildings. As one block rises, the adjacent one falls, allowing higher levels of valuable sunlight to each vertical building facade while if they are staggered on plan, it is possible to maximise long-distance views from most of the apartments (fig. 17.7).

17.6

17.6 Object buildings can be wrapped in landscape.

17.7 Dalian master plan site aerial view showing BIPV facades.

17.8 Elion master plan site location.

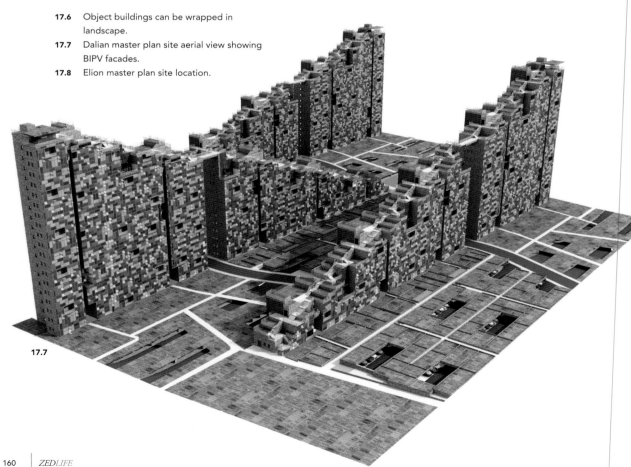

17.7

CASE STUDY 7a

ELION MASTER PLAN

4,200 homes on reclaimed land in Tianjin

The new urban centre of Tianjin occupies a large area of land reclaimed from the sea. Similar in concept to Canary Wharf in London, a business hub built downstream of the historic City on former docklands, it is connected to both the ancient city of Tianjin and the centre of Beijing with high-speed bullet trains. The state-owned developer, appointed by the local government, asked ZEDfactory to master plan a low-carbon community that responded to the location – a wetland lake reserve left over from the land reclamation process (**fig. 17.8**). At the same time, we were asked to provide a mixture of different value and size of home to serve the new financial district currently under construction. The challenge

was to reconcile flood risk with very high-density development and maximize the sales values of the proposed homes by creating a desirable and high-quality public realm.

The ZED master plan has been designed to give the facade of every home the sun-hours needed to generate enough electricity from vertical facade BIPV to power the heating and cooling system and meet the other needs of the majority of every home (**fig. 17.9**, *overleaf*). The stepped apartment blocks have shared roof gardens accessed from the stair cores and are raised above the flood plain, with the under-croft available as parking for electric vehicles.

The pedestrian bridge over an existing dual carriageway connects both halves of the site to create a series of child-friendly, safe promenades. Connecting landscaped routes make the community facilities and neighbourhood shops accessible to every home.

A network of cycle and pedestrian paths through parkland connects to the bus stop, making it more convenient to leave the car parked at home.

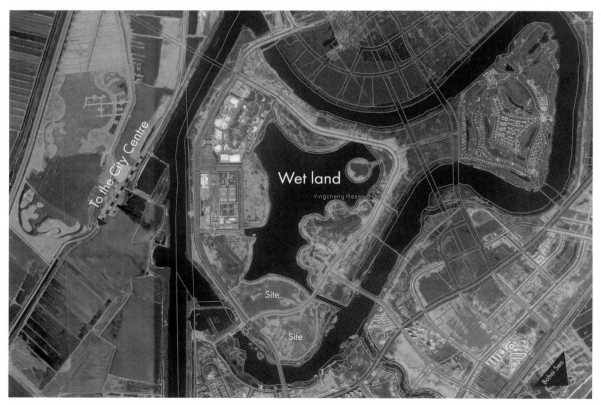

17.8

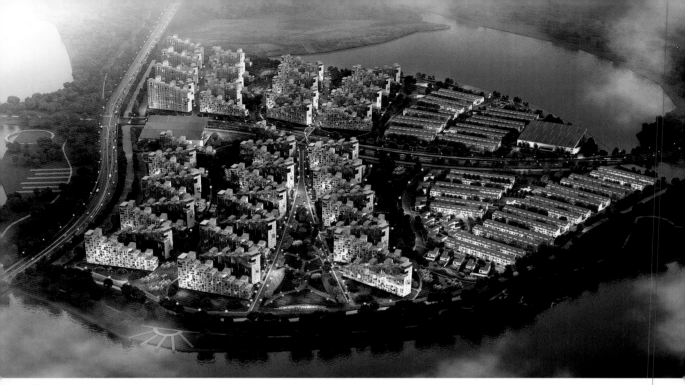

17.9

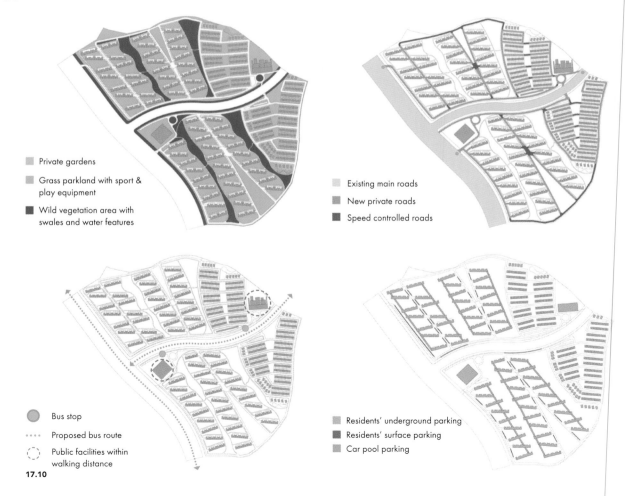

Private gardens

Grass parkland with sport &
play equipment

Wild vegetation area with
swales and water features

Existing main roads

New private roads

Speed controlled roads

Bus stop

Proposed bus route

Public facilities within
walking distance

Residents' underground parking

Residents' surface parking

Car pool parking

17.10

This also sets up the possibility of each home being sold with an e-bike to encourage the use of a full range of transport options. The traffic access still required to dwellings can be achieved at reduced road speeds of 15 mph so that cars do not dominate the development and pedestrians and vehicular traffic are largely separate.

An access road is located along the green corridor that provides privacy for residents and a scenic route back to the home. The villas are located as far as possible away from the roads and close to the nature reserve and water. Public facilities are distributed through the site with hotel, club, sport and a commercial street located at the north corner of the park. These amenities enjoy the beautiful view of the water. The business block is located near the south-east entrance to the site. Schools located to the east and south of the site can use the green open spaces on the site for recreational facilities.

The majority of parking is underground with the ground plane free of cars. A small proportion is at ground level for drop-off and for disabled access. To help with navigation, visitor parking is also on the surface plane (**fig. 17.10**).

17.9 Elion master plan, Tianjin, China, 2014.
17.10 Elion master plan diagrams.
17.11 Overview of GS Korea project.

GS KOREA
Downtown Seoul

The buildings that make up this mixed-use complex form perimeter blocks. Arranged like a rising hillside, they are organised to form four large open courtyards, where residents of the luxury apartments can gather to interact, play sports and enjoy the area. The site contains 434 apartment units of various sizes, virtually the same number as those proposed by a more conventional rival scheme, and adds 3,500 m² of community area. The blocks rise from 4 to 17 storeys. By creatively using the space, the net site-wide green area, including the open water, represents 62% green foliage coverage for the housing and 70% for the recreational spaces (**fig. 17.11**).

The same density of apartments has been achieved as the client's alternative high-rise typology, despite being, on average, eight floors lower. On the roof level trail, hidden among the shrubs and trees, are several exercise areas, Korean-style picnic tables and even a 'natural' spring for filtered drinking water. All lift cores reach the roof level and

17.11

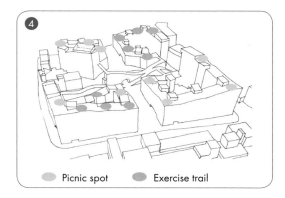

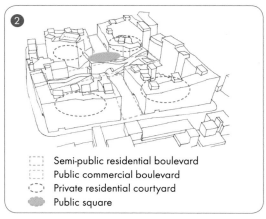

Semi-public residential boulevard
Public commercial boulevard
Private residential courtyard
Public square

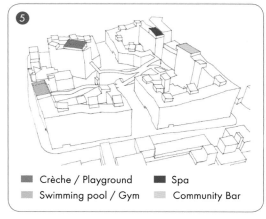

Crèche / Playground Spa
Swimming pool / Gym Community Bar

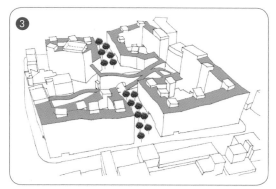

Picnic spot Exercise trail

Solar Tree

① This diagram illustrates how the core pedestrian arteries of the site merge with other vistas running between the courtyards to form a highly legible experience for residents and visitors.

② Diagram to show the divisions and hierarchy of open space.

③ ZEDproposal allows uninhibited access onto the roofs of all perimeter blocks, for residents and neighbours to enjoy. We have also found space for 165 trees across the site. The heat island effect is consequently reduced by the green roofs and trees planted across the site.

④ Diagram to show the range of activities on the green roofs. The shock absorbing roof surface and green roof garden is the perfect place for children to spend time.

⑤ Diagram to show locations and suggested use of community facilities on the pinnacle points of the blocks.

⑥ Solar trees on the roof add animation to the building by tracking the sun's location. They also provide a resting point as residents ascend up the building.

17.12

pedestrians can access all the green roofs via the central commercial building.

The market at the heart of the scheme, located in a sunken amphitheatre, works during the day as a food market, while at night it can function as an open air cinema. It also serves an important role as being a meeting space for social interaction and the cultural centre of the scheme (**fig. 17.12**).

Car clubs, an idea well-established in Europe, can easily be established in South Korea or, for that matter, anywhere in Asia. One car club vehicle replaces the need for six private vehicles, thus reducing the parking requirements of a site. This in turn reduces construction cost, embodied carbon and so on. Crucially, it means that the site requires just one level of basement car parking. Car club access points are located in the underground parking level, in the centre of the courtyards, convenient from all cores. The development also encourages private EV use with multiple charging points and good site access. If the lifts were increased in size so that small electric vehicles could be parked in each apartment hallway, then a radical improvement on conventional apartment typologies would become possible.

The cost saved by not building extensive basement parking can be reinvested in providing each apartment with a compact electric vehicle and access to a communal conventional electric powered car pool.

An alternative is to reduce basement car parking by introducing specially designed e-trike lifts. Residents could park their e-trikes directly outside their apartments, with only a single level of semi-basement parking needed, and naturally ventilated to reduce energy requirements on-site (**figs 17.13–17.14**).

This plan favours the uninhibited movement, charging and refuelling of zero-emission personal transport vehicles, with charging points in every parking bay, taking power from the building integrated PV panels. A charge takes around six hours, and gives a range of around 100 km. In the public areas, charging points are located under the solar trees. Here, electricity comes from both the PV integrated into the tree, and also the wider PV network, or pyrolysis sub-grid.

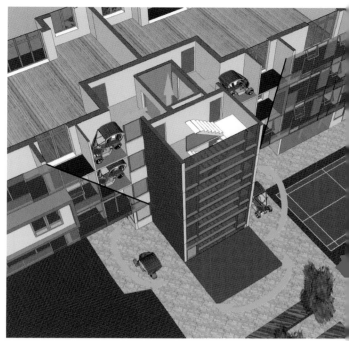

17.13

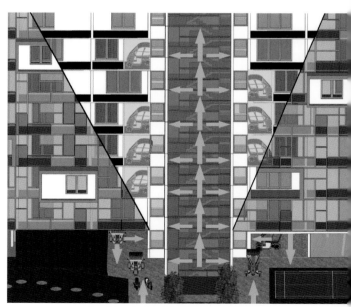

17.14

17.12 GS Korea diagrams.

17.13 Cutaway revealing storage locations of e-trikes outside apartments.

17.14 Section to show the vertical movement of e-trikes through the buildings.

Insulated roof terraces

Much like the Dalian Eco town, the Elion master plan includes green roof terraces for residents and visitors to enjoy, helping to reduce the effect of the urban heat island (**fig. 17.15**).

The roof terraces are formed from large one-metre high steps, which rise as the building gradually increases in height. Each core is hidden underneath these green allotments, but still rises high enough to have level access to the roof gardens for less able-bodied people and pushchairs.

By placing a duplex maisonette at the highest point of each set of four apartments and cutting down the height of the lift shaft, the profile of the core has been kept low, with less impact upon the south facade shape. The roof of the large core can then provide extra allotment space.

In the void spaces underneath the allotments, rainwater storage tanks have been fitted with the capacity of 78 m³, enough for two months' supply of water in the dry season. Add several large cupboard spaces for storing tools and seeds for the farmers and the need for unsightly sheds on the roof is eliminated. Space within the top floor of the core is also available for the storage of tools.

The green roof is mostly used for allotments, providing the top apartments with vegetable gardens, while the lower apartments are served on the ground level. The different types of planting on the allotments will make a vegetation patchwork, with a variety that will add to the pleasure of the walking up towards the tearoom.

Integrating renewable energy systems

The results of the building physics modelling on the Seoul project have shown that the likely energy consumption of the new ZED-designed block could potentially be 730,000 kWh which is equivalent to 56 kWh/m²/year.

17.15

17.15 Solar cool facade system with roof.
17.16 Zero-carbon zero-waste strategy applied to urban high density master plan.

Potential carbon savings

Using heat pumps would produce a saving of 14% CO_2 over the base case conventional typology and specification.

Installing solar hot water tubes to supplement heat pumps would lead to a 19% CO_2 saving.

Installing PV on the facades of the building, while using heat pumps, would produce a 46% CO_2 saving.

A combination of PV on the facades and the flat roofs of the cores, along with solar hot water panels on the facades, plus heat pumps, would produce the greatest saving of 81% CO_2 over the base case.

In order to get a 100% reduction in carbon emissions on the Seoul development, 480 extra horizontal PV panels would need to be installed, which would take up an area of 840 m². This extra electricity could also be provided by a pyrolysis unit using organic and agricultural waste from the residents installed in the local neighbourhood waste transfer station (**figs 17.16–17.17,** *overleaf*).

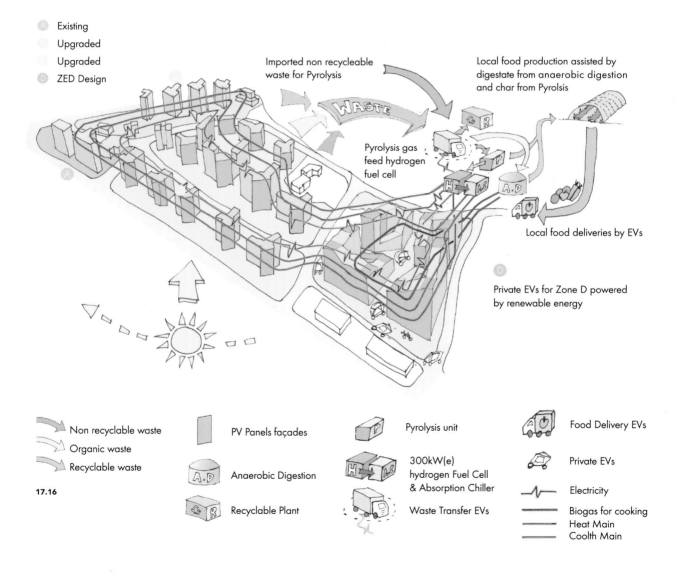

A Existing
Upgraded
Upgraded
ZED Design

Imported non recycleable waste for Pyrolysis

Local food production assisted by digestate from anaerobic digestion and char from Pyrolsis

Pyrolysis gas feed hydrogen fuel cell

Local food deliveries by EVs

Private EVs for Zone D powered by renewable energy

Non recyclable waste
Organic waste
Recyclable waste

PV Panels façades

Anaerobic Digestion

Recyclable Plant

Pyrolysis unit

300kW(e) hydrogen Fuel Cell & Absorption Chiller

Waste Transfer EVs

Food Delivery EVs

Private EVs

Electricity

Biogas for cooking
Heat Main
Coolth Main

17.16

M&E Strategy Specification

① Building Fabric
- Insulation
- Airtightness
- Windows Location
- Glazed balconies could increase amenity space further

② Ventilation
- Natural Cross Ventilation
- Passive Heat and Cool Recovery Ventilation

Heating & Cooling
- Air Source Heat Pump
- Ground Source Heat Pump
③ • Energy Pile
④ • Underfloor Heating and Cooling provided by building centralised GSHP
⑤ • Individual cylinders provide heat and coolth recovery ventilation with domestic hot water provided by small air source heat pump

⑥ Solar Thermal Balcony + PV
- Duty on heat pump is reduced by use of solar hot water on the balustrades

Reduce Electrical Loads
- LED
- Low energy fittings

⑦ Rain Water Recycled
Rainwater runoff is stored under intermediate terraces and fed to gardens on drip irrigation to avoid freezing and evaporation

⑧ Green roof provides recreational area and food production

⑨ PV on garden balustrades

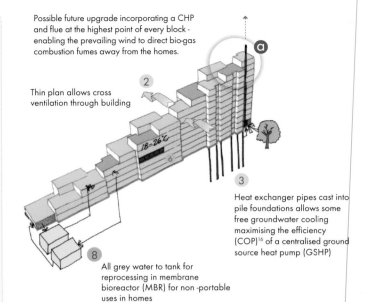

Possible future upgrade incorporating a CHP and flue at the highest point of every block - enabling the prevailing wind to direct bio-gas combustion fumes away from the homes.

Thin plan allows cross ventilation through building

Heat exchanger pipes cast into pile foundations allows some free groundwater cooling maximising the efficiency (COP)[16] of a centralised ground source heat pump (GSHP)

All grey water to tank for reprocessing in membrane bioreactor (MBR) for non-portable uses in homes

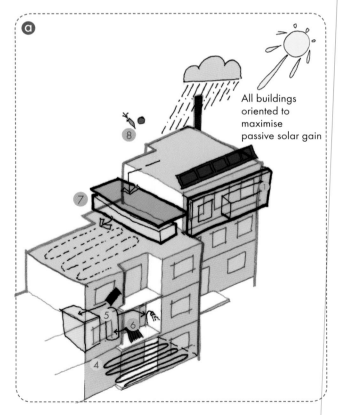

All buildings oriented to maximise passive solar gain

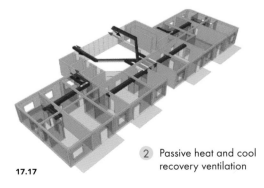

② Passive heat and cool recovery ventilation

17.17

17.17 M&E Strategy Specification.
17.18 View of Elion master plan.

Conclusion

The zero-carbon zero-waste concept has informed every aspect of each master plan, creating desirable spaces in between the buildings and, we predict, translating into considerably higher sales values than the more traditional high-rise development strategies currently favoured. The saving on not having to build expensive underground parking should fund the whole rooftop park construction, demonstrating that many of the features can approach cost neutrality. Reductions in the cost of monocrystalline PVs from China now result in this durable electricity-producing material being the same price as industry standard terracotta rainscreen cladding. European 'Passivhaus' standards of energy efficiency reduce energy demand to the point where renewable energy can meet all of the new development's requirements, sometimes importing from the city grid and sometimes exporting to it.

In a traditional scheme the density dominates without regard to the quality of life, interest or well-being of the inhabitants, but we have deliberately struck a balance between amenity and density. By combining solar energy harvesting with maximum energy efficiency, the homes are made more comfortable to live in and cheaper to run.

The extensive planted roof terraces and landscaped gardens potentially provide displaced and re-housed local smallholders with employment and an easier transition from their current relatively low-density lifestyle. Usually when a city expands it takes away small agricultural plots in the process, but it is now possible to integrate almost the same area of small allotments and vegetable gardens on the horizontal surfaces of the new developments. Contemporary green roof technology makes this both possible and affordable. This approach suggests that high-density dwelling combined with public/private amenity space, which is so lacking in current conventional high-rise developments, could provide a new benchmark for urban expansion or regeneration.

Residents will be able to live low-carbon lifestyles surrounded by parkland, in comfortable apartments, with convenient transport options and locally produced food. As the cost of conventional energy rises, these homes and workspaces will increase in value, showing the developer to be the market leader in providing future-proofed homes in an era of scarce resources, rising lifestyle costs and energy insecurity. Let's see how these ideas raise property values and outperform conventional urbanism in a competitive market (**fig. 17.18**).

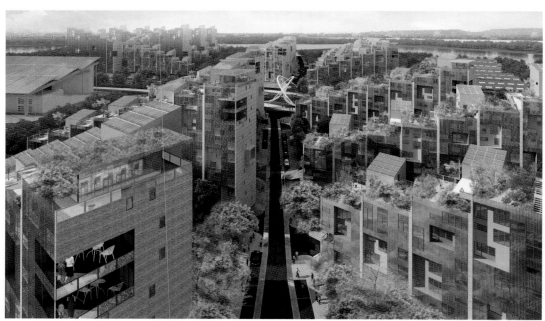

17.18

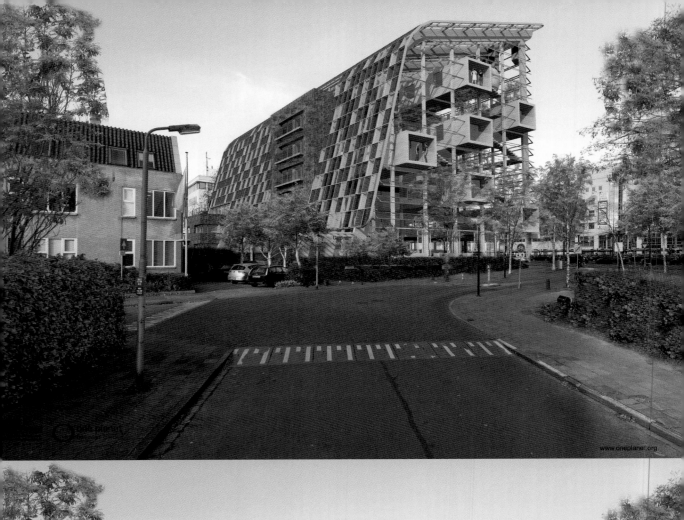

flat-roof office building with a high-carbon footprint could be transformed into a desirable new workplace, without wasting the embodied carbon through demolition.

As a first step, the concrete-framed, flat-roofed existing office has all its suspended ceilings removed to expose radiant concrete soffits for passive cooling. Then new floor screeds are laid with underfloor heating/cooling. Cork insulation boards are used to clad the existing brickwork and new timber windows are inserted in areas with single glazing. A climate-sheltering shell is then supported on glulam portal beams and columns, supporting a new layer of external ramps and stair circulation, and new shared meeting room facilities. The shell is glazed to the east, or west, and to the north, while the south-facing wall and roof surfaces are clad in translucent BIPV panels. ASHPs take preheated air from the highest point in the atrium and can heat and cool the internal volumes using predominantly solar electricity. However, the most important point is that all the flat roof surfaces become green roof terraces and lush gardens. The dull low-value existing office block has become a Business Garden (**figs 18.1–18.2**, *previous page*).

Facilities

The Business Garden stands directly opposite Amersfoort train station. Schiphol airport and Amsterdam are only 35 minutes away and Utrecht is only 15 minutes away.

There are different sized meeting rooms catering from 4 to 200 people, offering space for presentations, congresses, training, lectures, network meetings and exhibitions. There is also a mobility centre providing electric and biogas cars for people to hire.

The Business Garden has 1,600 m² of shared facilities that all members can use (**fig. 18.3**). Tenants who hire office or work space are automatically members. Others who wish to use facilities such as the meeting rooms, cafe or mobility centre, are required to become members for a small fee per year. Some facilities and services are free. Other facilities, such as the meeting rooms and conference centre, can be charged according to use. By sharing

communal services with other companies, it is possible to achieve a higher-quality collective working environment with more facilities than would be possible for an affordable market rent in a conventional workspace.

One Planet principles

The WWF 12 Principles shown below provide an integrated framework for achieving a One Planet footprint. Using technology and behavioural change, ZEDfactory aims for a fossil-free building that over about 30 years repays the carbon footprint used in the construction materials. The building is enclosed in a climate-shell that uses solar energy to provide warmth, grow plants and generate electricity from integrated solar panels (**fig. 18.4**, *overleaf*).

1: ZERO CARBON
Business Garden will be one of the first climate neutral retrofit buildings in the Netherlands! This requires carbon calculations and careful choices throughout the construction and lifecycle of the building.

2: ZERO WASTE
Materials are recycled wherever possible. First, the 40-year-old building is reused, while the interior is renovated to the same standard as new buildings, using low-carbon materials. Second, the operation of the Business Garden uses closed-loop systems and eliminates waste through exploring all possibilities, including a zero-waste restaurant, local seasonal food with less packaging, paperless offices, an on-site composting van, biowaste, recycling to origin all non-degradable wastes, rainwater harvesting, cooking on wood and biogas.

3: REDUCE
Flexible internal layout allows internal rearrangements to be done without generating waste and reducing demands for more material to be brought to the building. There is minimum waste in the construction phase, reusing as much of the existing infrastructure as possible and purchasing highly energy-efficient appliances.

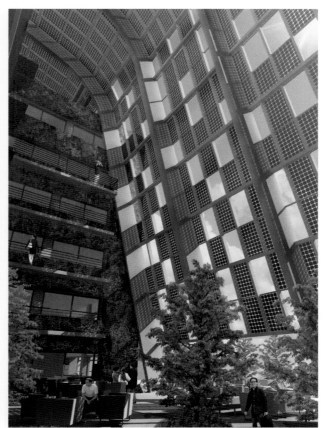

18.4

4: REUSE
Purchasing durable products and introducing scrap-paper bins along the office building to encourage reuse of paper.

5: RECYCLE
Recyclable and composting bins are provided to separate waste and composting facilities integrated with the gardens.

6: LOW-CARBON TRANSPORT
Business Garden is located at a main transport hub, so that users and visitors are encouraged to come on foot or by bicycle, bus or train. Timetables are displayed in the entrance hall. For those who need individual transport, a mobility centre in the basement provides electric cars (charged from the solar panels), biogas cars, scooters and bicycles. Provision of secure lockers, changing rooms with showers and interest-free loans to cyclists make e-bikes practical.

7: LOCALLY SOURCED LOW-IMPACT MATERIALS
A detailed tally is maintained of all materials removed or added to the site during construction and operation, including the carbon footprint of these

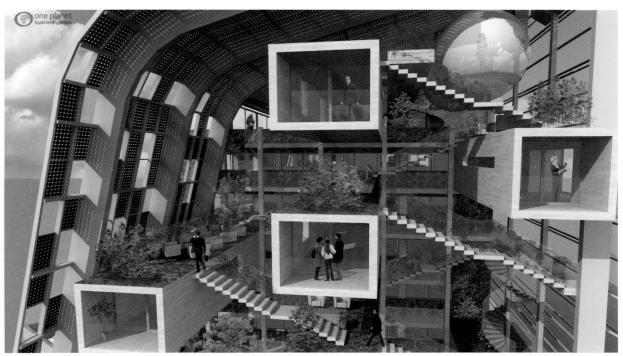

18.5

materials. This enables continual monitoring and reduced ecological impact. The rule is to prioritise natural, reclaimed and locally sourced materials and other low-embodied carbon materials for any major building work.

8: LOCALLY SOURCED LOW-FOOTPRINT FOOD

The cafe and restaurant use local organic food, including some grown in the horizontal and vertical vegetable gardens in Business Garden. The lessons of Wageningen University are applied with zero-waste restaurants, with any food waste being recycled by feeding to chickens or composted on-site in worm bins. The fertilisers generated from composting and worm bins can be redistributed to the garden again.

9: NATURAL HABITATS AND WILDLIFE

The Business Garden aims to be the most biodiverse city building in the country and provides a habitat for a rich variety of plants and wildlife. As well as bushes, flowers, grasses, creepers and trees spread over the building, nesting sites will be provided for insects, bats and birds. But it all begins with healthy soils at the base of the food chain. We try to encourage this by composting and recycling biomass through the gardens.

10: CULTURE AND HERITAGE

Business Garden provides space for exhibitions and activities that stimulate local culture, self-reliance and diversity. Stalls for local arts and crafts, Mrs Beeton's cooking evenings, One Planet movie nights, authors writing Our Common Future 2.0, training courses Fair & Green Deal, children's exhibitions by the Centre for Nature and Milieu Education. Many cultural and heritage activities find their 'home base' in Business Garden.

11: EQUITY AND LOCAL ECONOMY

One Planet gives preference to local suppliers and partners during the construction and exploitation of

18.4 Work in the garden.
18.5 Business garden provides two spectacular enclosed working gardens on the east and south side.

Business Garden. This stimulates the local economy, helps build-up skills and provides opportunities for disadvantaged groups to engage in a busy stream of activities.

12: HEALTH AND HAPPINESS

Business Garden provides a pleasant and green environment where local citizens of all ages can engage in activities that stimulate health and happiness in the local community (fig. 18.5). The construction provides good daylight levels and is well ventilated by natural means.

Environmental strategy

Setting low-impact refurbishment standards that are attractive and affordable

This test project shows how existing buildings can be reused to provide better working conditions than most new buildings, while at the same time demonstrating how to achieve huge reductions in environmental impact.

Business Garden reduces demand for heating and cooling, water, materials, transport and all other consumables, achieved partly by using technology and partly by adapting behaviour.

The building produces up to 200,000 kWh per year of clean renewable energy, giving a budget of 50 kWh/m²/year for its tenants. The actual energy use will be displayed in each space or zone. In order to encourage positive behaviour, users who exceed or underuse their energy budget per square metre of office or meeting space will either pay a penalty or earn credits.

The building is designed to be highly energy efficient and provide a high-quality work environment. It achieves this through good levels of daylight, excellent internal air quality and noise control, and improved thermal comfort. As a bonus, it produces fruits and vegetables to be consumed by its occupiers. The combination of these factors provides a high-quality service, while considerably reducing the ecological footprint.

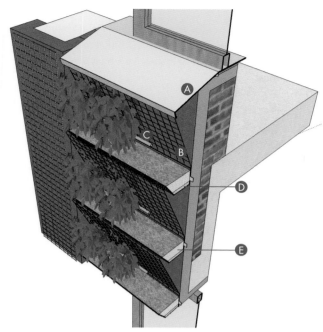

- **(A)** Extended sill providing rainscreen cover
- **(B)** Metal mesh
- **(C)** Irrigation pipe
- **(D)** Gravel base layer to avoid over watering
- **(E)** Soil tray

18.6

Reducing demand for heating and cooling

The Business Garden is well-insulated and well-shaded, with significant amounts of thermal mass and ventilation with heat recovery (**fig. 18.6**). As demonstrated in other existing thermally massive offices with heat recovery and reasonable levels of heat-generating IT, little or no additional thermal input is required. This situation can be further improved by combining active thermal mass with radiant underfloor heating/cooling and providing cross-ventilation for every unit mid-season and in summer. The combination of the climate shell, the external insulation, double glazing and evaporative cooling from plants in the atrium and rooftops creates a pleasant environment for work and business meetings.

18.6 Insulated green wall concept.
18.7 Existing building.
18.8 Proposed north-west view.

Meeting these smaller demands with on-site renewable energy

With 1,000 × 250 W monocrystalline solar electric panels producing up to 200,000 kWh/year of renewable energy, the site can generate around 50 kWh/m²/year for tenants. This annual energy budget should be sufficient to supply a low-intensity modern office building that uses optimised energy consumption equipment, such as LED lighting, shared printing and scanning stations, smart lift, and so on.

Any extra consumption required by individual tenants will be delivered by the city grid from a certified renewable energy provider generating electricity from communal renewable energy plants such as wind turbines in the North Sea, but tenants will be charged extra for this.

Carbon payback

The embodied carbon of all materials used in the renovation of the Business Garden, is carefully calculated and recorded in the Carbon Audit spreadsheet. This includes all materials removed from or brought onto the building site. The goal is to achieve the lowest possible environmental impact during the construction phase and the operating life of the building through maximum reuse of materials already on the site and a very careful choice of new or recycled materials with low-carbon content.

Through passive solar energy and 1,700 m² of solar panels, the building is designed to produce enough renewable energy on-site to meet all of its own operating requirements, but also enough excess renewable energy to gradually compensate over its anticipated lifespan for the embodied carbon emissions during the renovation phase.

Investors always require their financial investment to be recovered with interest over the lifetime of the building, so why should one not also demand recovery with interest on environmental capital?

Conclusion

The Business Garden shows how good leadership and support from the local planning authority can renovate very poor quality existing buildings and

18.7

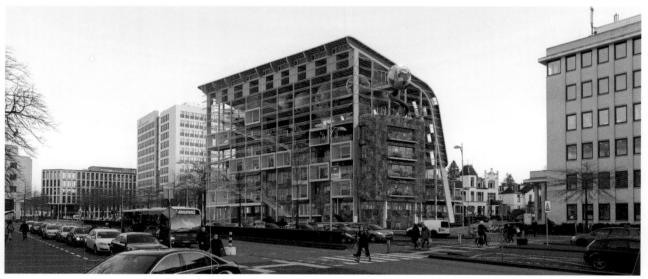

18.8

add significant value at the same time as reducing reliance on fossil fuels. There is no need for large-scale demolition and the massive corresponding loss of the embodied carbon invested in old structures – if we can engage in a large-scale zero-carbon retrofit programme (figs 18.7–18.8). This is unlikely to be achieved by apologetic energy efficient refurbishments that respect the historic building envelope – although this respectful approach would

be very necessary in the historic medieval quarter within the old centre of Amersfoort. There are a great many poor quality and joyless utilitarian structures from the 1930s to the present day that could benefit from being turned into mixed use zero-carbon Business Gardens. Let's make a zero-carbon retrofit programme so desirable to building owners that no government legislation is required to kickstart this important regenerative process.

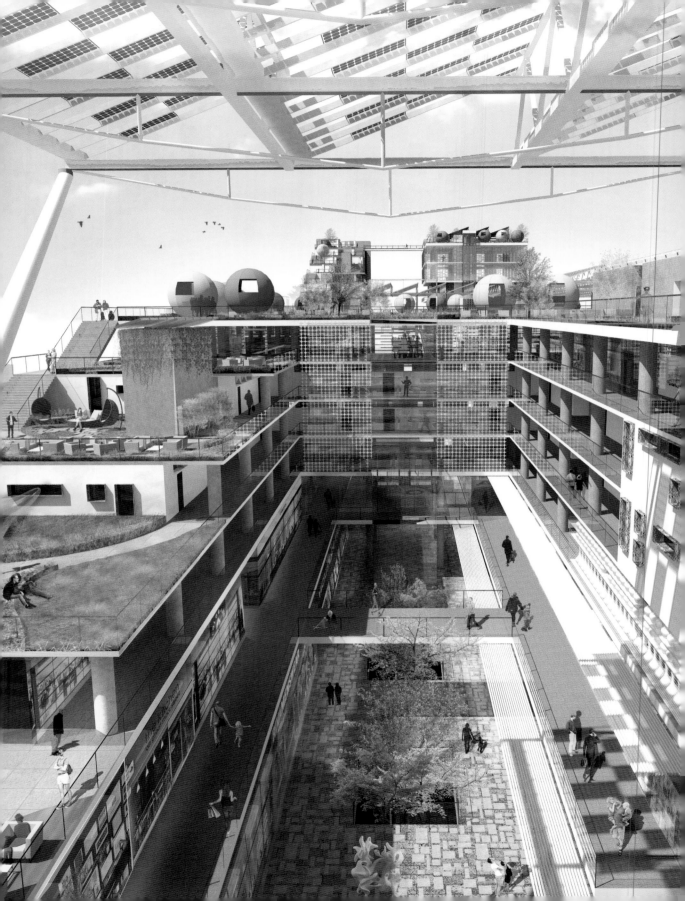

CASE STUDY 9

JINGDEZHEN CERAMIC CENTRE AND THE URBAN SOLAR FARM

KEY PROJECT INFORMATION

Programme: Master plan
Client: Yourun International
Site Location: Jingdezhen, China
Project Date: 2014–present

TOOLS USED

The ZEDroof
District-level energy systems and
 food production
Rainwater harvesting and water re-use

19.1 View of the courtyard in
Jingdezhen Ceramic Centre.

Introduction

Jingdezhen Ceramic Centre (**figs 19.1–19.2,** *overleaf*) shows how a run-down complex of abandoned 1950s pottery sheds can be regenerated to promote ceramic industrial production and create jobs by creating a new architectural ceramic showcase in a city currently focused on traditional pottery (**fig. 19.3,** *overleaf*). By collecting many smaller factory outlets and ceramic galleries into one urban quarter and integrating the best ceramic universities and centres of excellence from all over the world into one gallery/education/ demonstration complex – also designed as a tourist destination – this project launches the work of local artists and the best international ceramicists into the next century.

Once completed, this complex will achieve net zero-carbon emissions, with integrated solar heating and cooling at the same time as providing a new pedestrianised urban quarter. It will integrate production workshops, showrooms, a university, a gallery, a conference centre and hotel, with almost no contribution to the city's serious air pollution or carbon footprint. The cultural and industrial regeneration has been housed within an intricate new master plan.

Letter of Recommendation

ZEDlife, the living manifesto pursued by English architect, Bill Dunster and his team at ZEDfactory, has reminded us of the ceramic industry that has sustained Jingdezhen for millennia. Jingdezhen was the earliest industrialised city that evolved in an era without electricity. The kinetic power for this harmonious, natural low-consumption industry was driven by local mountain spring water. Water power and local biomass sustained the community for the next thousand years until the modern industrial revolution took place.

In recent years, humans have dreamed of living like their ancestors, passing on this tradition and enjoying the gift of the natural environment. And in fact, modern cities are also striving for a new living method that is low-carbon.

ZEDfactory has brought us the surprise. The design for Jingdezhen Ceramic Cultural Centre is a long-awaited project, delivering a world-led zero carbon exemplar that will reconnect us back to our natural, well-being and harmonious past.

The project will collaborate architecture with international advanced technologies and avant-garde concepts. Once completed, this complex will achieve zero carbon emissions, succeeding in a carbon positive status with zero bills, helping us to rediscover our historical 'pottery life' in contemporary fossil powered Jingdezhen.

We believe this zero-carbon, energy efficient building will not only be established in JiangXi province, but promoted throughout the world.

Signature:

Date: 05.2016

19.2

序

英国著名建筑师比尔·邓斯特先生追求的"零碳生活",使我们联想起古代景德镇陶工创造的"瓷器生活",在那个没有电的年代,景德镇已经是世界上最早的工业化城市,那是一种利用山中水流作为动力,原始、自然、和谐、低消耗的生产生活方式。这种自然方式延续了一千多年,直到近代工业化改变了这种状态。

多年来,我们常常冥想回到古代的景德镇,延续传统的方式,享受自然的状态。实际上,我们这个城市也一直在寻找一种新的生活方式,更加低碳、绿色、环境友好。

比尔·邓斯特先生给我们带来了惊奇,他设计的"景德镇花朝国际陶瓷文化交流中心",令人期待,使我们重新回归自然、健康、和谐的梦想生活变得可能,这将是世界零碳建筑的"样本"。

这个项目利用国际先进节能设计理念和建筑紧密结合,建成后可达到碳的零排放,创造能源消费零账单,能让我们找回古代景德镇的"瓷器生活"。

我们相信,零碳节能建筑不仅会在景德镇市、江西省、全中国,而且会在世界其他地区不断落地、推广!

署名:

二零一六年五月·中国景德镇

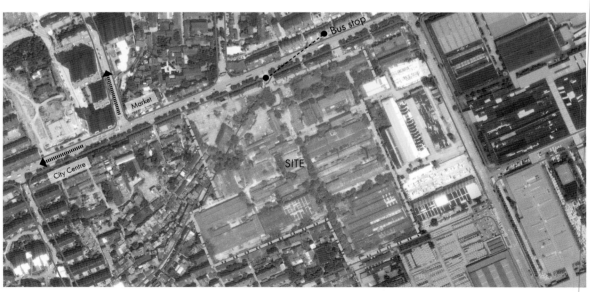

19.3

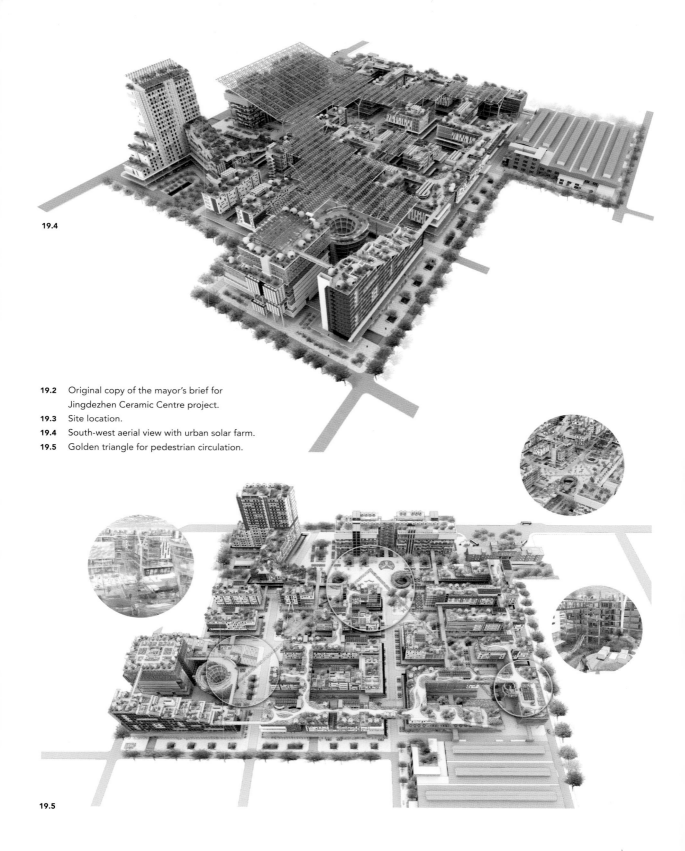

19.4

19.2 Original copy of the mayor's brief for Jingdezhen Ceramic Centre project.

19.3 Site location.

19.4 South-west aerial view with urban solar farm.

19.5 Golden triangle for pedestrian circulation.

19.5

The original site contained mostly structurally unsafe industrial buildings that had to be demolished. The higher quality 'Gateway' buildings are retained at the site entrance.

Typical Chinese shopping malls have a little active frontage and are uninviting on the site.

By splitting the site into walkable blocks, a shopping district can be created.

Once the ground pedestrian routes are created, the blocks are manipulated to create stopping points and plazas.

Public spaces are created within the pattern of urban blocks.

Linkages on high level make full use of buildings at all levels.

Vertical circulation points ensure that all destinations can be easily reached.

Main routes are protected by solar canopy to ensure that they are usable in all weathers, and to create slow circulation benefits to all commercial stores.

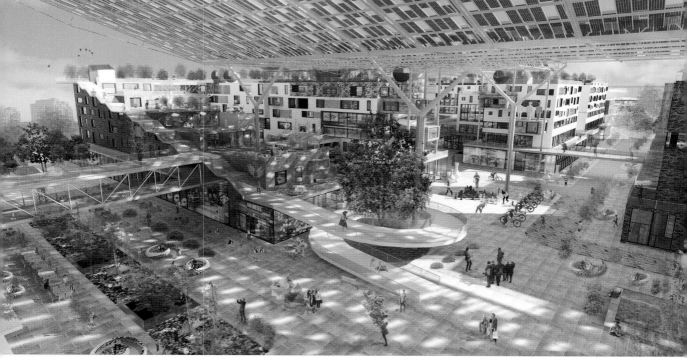

19.7

The master plan is designed around space syntax and renewable energy harvesting, with a green rooftop park providing significant amenity within the industrial context (**fig. 19.4,** *previous page*).

At the three corners of the triangular circulation, special landscapes and landmark buildings have been placed with features such as multistorey glazed ceramic art walls and outdoor performance space to encourage visitors to move across the site between the main destinations (**fig. 19.5,** *previous page*).

Localised urban solar farm

The big idea in this project is to move the solar farm from the valuable farmland outside the city into where electricity is needed in the city centre (**fig. 19.6**). Making the solar farm into a translucent ventilated glazed roof, sheltering the main circulation routes from rain and sun creates pedestrian friendly streets in all weathers and increases the commercial value of plots farthest from the main city road. This is a successful urban

concept demonstrated by world-class urban spaces, such as the Galleria Vittorio Emanuele in Milan and Old Covent Garden Market in London. However, now the covered arcades over the primary circulation routes of our site provide enough electricity to heat and cool the urban quarter (**figs 19.7–19.8,** *overleaf*). Solar cooling technology, using locally produced evacuated tube collectors filled with heat pump refrigerant, result in an excellent load match between maximum cooling demand and available solar electricity and heat. The solar farm provides renewable electricity to power the reversible heat pumps.

Accessible spaces

The spaces between both the new and the existing buildings can then provide natural cross ventilation and daylight. The stepped building massing and vertical circulation encourages visitors from street level to upper gallery floors and a sequence of rooftop gardens connected by pedestrian bridges. This allows the opportunity for communal green open space to be accessed at ground level with steps or ramps climbing higher and higher to the upper floors of the building. This sloping parkland feels similar to a hillside or

19.6 Massing diagram.

19.7 View of central square's east corner.

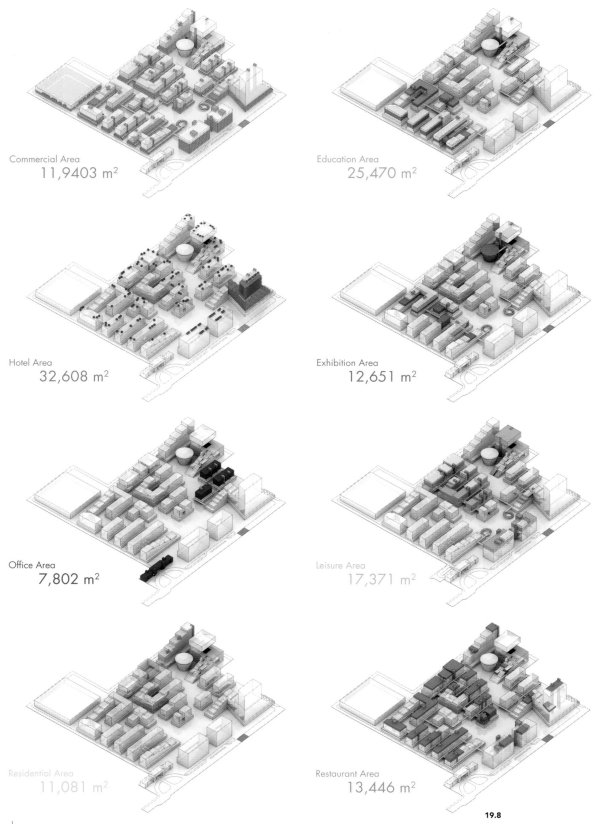

Commercial Area
11,9403 m²

Education Area
25,470 m²

Hotel Area
32,608 m²

Exhibition Area
12,651 m²

Office Area
7,802 m²

Leisure Area
17,371 m²

Residential Area
11,081 m²

Restaurant Area
13,446 m²

19.8

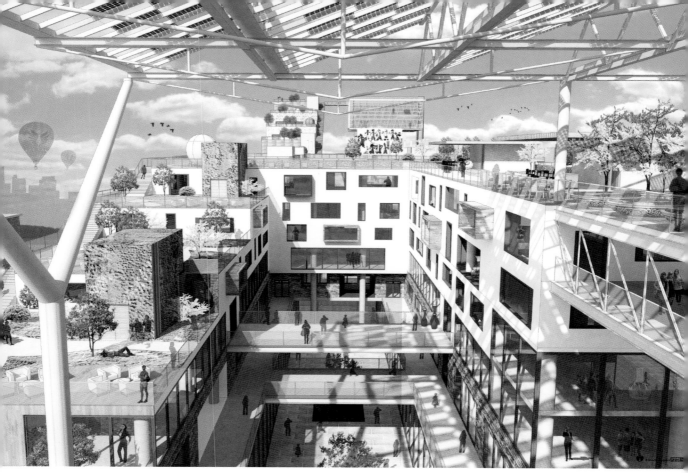

19.9

mountainside. A sequence of rooftop bars and cafes create a valuable new promenade, clearly accessible from street level by grand staircases and regular lift shafts (**fig. 19.9**). It is important that communities are designed so that residents have plenty of access to green space in the most densely populated cities.

Celebrating the local ceramic tradition

The distinctive ceramic facade made from local Jingdezhen porcelain has designs and glaze applied by local artists to celebrate two millennia of ceramic production in the city. The super-insulated cladding and shading system, with specially developed porcelain shade screens, prevent direct sunlight from

19.8 Mixed-use concept.
19.9 Courtyard and roof terrace.

reaching glazed facades. The new energy efficient ceramic facades, with integrated BIPV and green roofing system, will become a new architectural ceramic product range bringing income to the city.

Conclusion

The aim of this project is to enhance the existing buildings to a ZED standard, with the ultimate goal being for the whole development to be as low carbon as possible, ideally being a zero-fossil energy development (ZED) with all its energy needs met from renewable sources (**fig. 19.10**, *overleaf*). This proposed development is mixed use incorporating high-rise residential, employment, leisure and retail, with associated open space within the site (**figs 19.11–19.12**, *overleaf*). By integrating pedestrianisation, energy efficiency and renewable energy into the

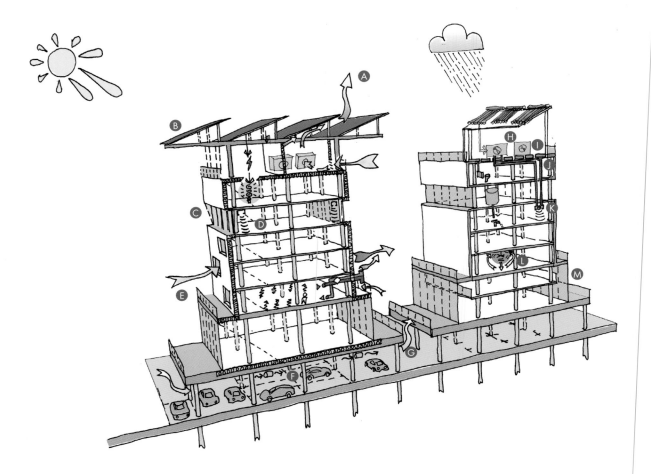

A Heat is extracted from the heat pump units through PV canopy at the tallest point in structure.

B Electricity produced from the PV panels is used directly for lighting and appliances i.e. building+street lighting.

C Recessed glazed façades shade against summer sun but allow low sun passive solar gain in winter.

D Fan coil units are placed at the facade to condition the building where heat and coolth losses are greatest.

E The thin plan depth allows cross ventilation in spring and autumn to reduce cooling load.

F Low power fans drag air across the car parking strata – maintaining cross ventilation and reducing air pollution whilst fossil cars still in use.

G Gaps between the building allow ventilation to the parking level. Large air intake to parking level ensures good ventilation driven by wind pressure.

H Air intake to reversible heat pump is in non-habitable portion of the roof. The heat pump is on vibration mounts to reduce noise and strategically located not to provide acoustic irritation.

I The plant room roofs are clad with solar thermal collectors to power the Solar cooling system. Electricity to run the air source heat pumps is generated by the solar electric canopy spanning between buildings.

J Water from canopy and roofs are stored under the accessible roof surfaces providing gravity fed water for WCs + landscaping.

K The refrigerant from heat pumps is transported efficiently around the building. The central location minimises circulation pump energy.

L Ceiling fans aid air movement ensuring the exposed radiant thermal mass reduces the cooling loads helps in spring and autumn.

M Each internal volume is fed by refrigerant from centre of the building to deliver conditioned demand driven air. Units only operate when windows for natural ventilation are closed.

19.10

19.10 M&E low-carbon building service design.

19.11 View from green roof.

19.12 Public auditorium space below the BIPV canopy.

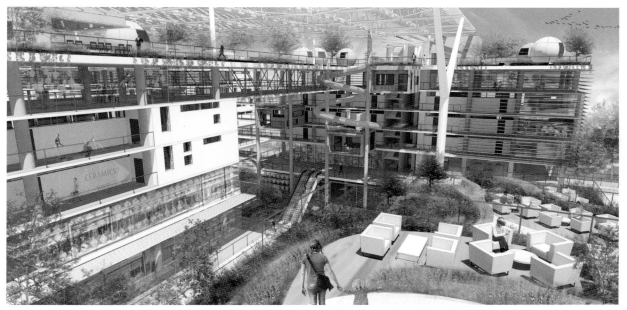

19.11

master planning, significant improvements can be made to traditional urban regeneration.

The tool 'Building-level energy systems: Air sourced heat pumps and solar assisted heating and cooling' has been used in practice in Jingdezhen Ceramic Centre, and this shown clearly in **fig. 19.12**.

By taking the business-as-usual model up to a higher level, an 85% reduction in energy has been obtained with an average loading of 10.1 kWh/m²/year for the conditioning of the buildings. For this amount of conditioning a total of 8,900 PV panels would be required with a suitable energy storage strategy.

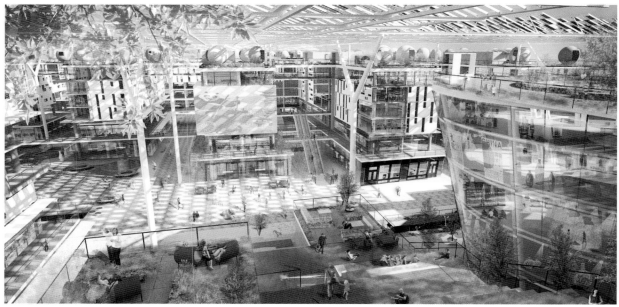

19.12

CASE STUDY 10

BEDZED, 15 YEARS ON

KEY PROJECT INFORMATION
Programme: Mixed use
Client: The Peabody Trust
Site Location: London, UK
Project Date: 2002

Introduction

Completed in 2002, BedZED is a community of 82 homes, 18 live/work units and 1,560m² of workspace and community facilities built for the Peabody Trust in the London Borough of Sutton (**figs 20.1–20.2,** *overleaf*). In putting together designs and proposals for BedZED, the ZEDteam tried to reconcile a higher-quality affordable lifestyle and work style with a step-change reduction in carbon footprint in the middle of an outer London dormitory suburb.

Our definition of Zero [fossil] Energy Development (ZED) is a passive building envelope that reduces the demand for heat and power to the point where it becomes economically viable to use energy from renewable resources generated on-site. The quantity of renewable energy imported from outside the site boundaries must be limited to each citizen's fair share of the limited quantities of national energy resource, as in the case of biomass which can only meet 30% at most of current national energy consumption.

At BedZED, there is an attempt to generate enough renewable energy over the course of a year to meet the whole of the community's annual total

20.1 BedZED (Beddington Zero Energy Development).

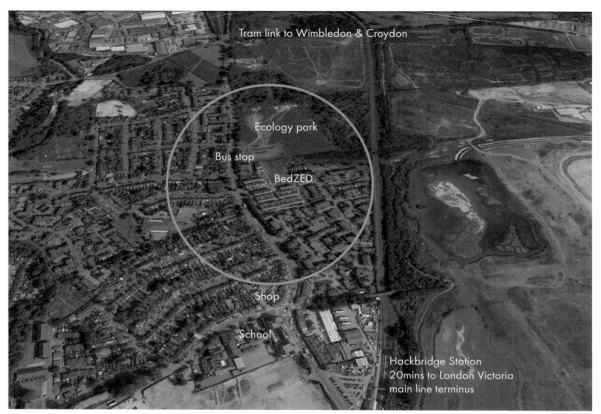

20.2

20.3

heat and power demands. This means exporting electricity to the grid in summer when demand is lower and importing in winter. Recognising that the national reserves of green-grid renewable electricity and renewable biomass are extremely limited, the ZEDfactory group, working with carbon footprinting team Best Foot Forward, have developed the concept of the National Biomass Quota.

Assuming that there would be no switching of agricultural land to produce energy crops, this study calculated that there would only be 250 dry kg of sustainably managed wood fuel per person per year available at under a residential density of 50 homes per hectare. This figure applies to 70% of the UK, with around 500 kg per person per year available in the other parts of the country. This was a time when carbon offsetting was seen as a valid solution to global warming, in which each supposedly low-carbon development aims to outsource its power generation problems to another location. It was clear that we would quickly run out of the resources for generating renewable energy in our own country, so a combination of load reduction and the introduction of building-integrated microgeneration was needed. Recent government energy targets suggest a maximum contribution from offshore wind of around 15% of national electrical demand, a figure based on the productivity of offshore wind turbines. For those who pin their hopes on an international nuclear renaissance, the supply of uranium ore at sufficiently high densities to make extraction sensible from a carbon-saving rationale is limited to the first 15 years.[17]

Many contemporary projects claim carbon neutrality by using many times their fair share of the national biomass resource, but the challenge at BedZED was to show how to provide a holistic living/working community enjoying a high overall quality of life, whilst really limiting the consumption of scarce national resources, such as brownfield land and biomass, to the quotas available if fairly allocated to each UK citizen (figs 20.3–20.4).

20.2 Site location.
20.3 Colony housing, Edinburgh.
20.4 Roupell Street, Waterloo, London.

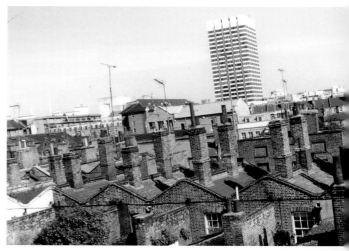

20.4

A local response to a national problem – the wider context

BedZED tries to show that it is possible to substantially reduce a typical household's carbon emissions, and hence reduce its overall ecological footprint, while at the same time increasing overall quality of life. When examined in any detail, the typical contemporary lifestyle in a conventional suburban home turns out to be so dysfunctional that it is possible to rethink each of these daily activities and reduce its carbon emissions at the same time as providing quantifiable benefits to everyone. We believe, in the light of this, that encouraging 'enlightened self-interest' could be the fastest way of reducing the environmental impact of the UK volume housebuilding industry.

Something of this kind is needed, but because alternative lifestyles need to be adopted by a wider market including those who so far are unmotivated to address climate change or reduce their level of resource consumption. A plain economic argument will probably move us faster towards creating a carbon-neutral urban infrastructure in the UK. At the current replacement rate of urban fabric at around 1.5% per year[18] we could predict that if ZED standards became commonplace, Britain could have weaned itself off its dependency on fossil fuels by the start of the next century, while still retaining historic buildings and city centres worth keeping.

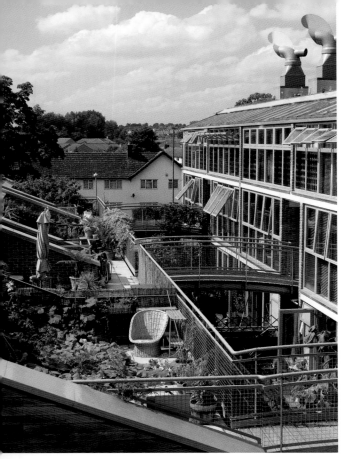

20.5

there has to be a limit to Urban Sprawl...

20.6

There are other factors to consider. We have a lot of the wrong kind of houses inherited from the past and still being built today. Furthermore, they are not grouped tightly enough. Urban sprawl will cover 11% of the surface area of the UK by 2016.[19] And, to add to the problems we already have, we need 3.8 million new homes by 2021,[20] even without allowing for an increase in population. It is getting ever harder for key workers, such as teachers and nurses, to find affordable homes in the south east of England. The country is importing between 60 and 80% of its food,[21] and increased global competition for healthy organic food (currently 70% imported) will become more intense as developing countries raise their expectations and as the world's population continues to rise. Competition for food, fossil fuels and water leads to conflict, so in order to keep supplies flowing, we invest in substantial military and trade resources to ensure supply. The BedZED model, which will soon clock up 20 years,

shows how almost all of the new homes needed could be built on existing stocks of brownfield land, while still providing each household with a garden, and providing enough workspace on-site for future employment opportunities to all resident working adults. Saving agricultural land from urban expansion will become a priority as the number of refugees to the UK increases with accelerating climate change.

The master plan

How can a compact city be created that people want to live in?

At BedZED almost every flat has a small land- or sky-garden and a double-glazed conservatory, integrating the two features most desired by many suburban households (**fig. 20.5**). The original design intent was to reconcile Ebenezer Howard's low-density 'Garden City'

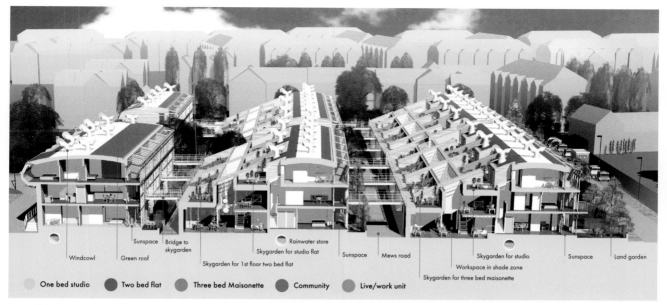

Windcowl | Green roof | Sunspace | Bridge to skygarden | Skygarden for 1st floor two bed flat | Rainwater store | Skygarden for studio flat | Sunspace | Mews road | Skygarden for three bed maisonette | Workspace in shade zone | Skygarden for studio | Sunspace | Land garden

○ One bed studio ● Two bed flat ● Three bed Maisonette ● Community ○ Live/work unit

20.7

concept with the original UK Urban Task Force's[22] agenda to substantially increase residential densities and reduce urban sprawl (**fig. 20.6**).

How can higher densities be reconciled with better amenities than traditional urban templates?

The central block of four terraces at BedZED achieves residential densities of over 116 homes per hectare including live/work units. This provides approximately 400 habitable rooms per hectare and 200 jobs per hectare, at the same time as providing 26 m² of private garden/home and 8 m² of public outdoor space per home (**figs 20.7–20.8**). Even counting in the entire BedZED site that includes a playing field, parking, CHP plant and community buildings, around 50 homes per hectare is achieved. If these standards were commonly adopted it would be possible to reduce UK urban sprawl to about 25% of its current footprint over the next century. This calculation is still based on buildings

20.5 BedZED skygardens linked to terraces by bridges.
20.6 The ecological footprint, or area of productive land, needed to support Greater London is equivalent to the area of the rest of the UK.
20.7 BedZED sectional perspective.
20.8 Coloured plan.

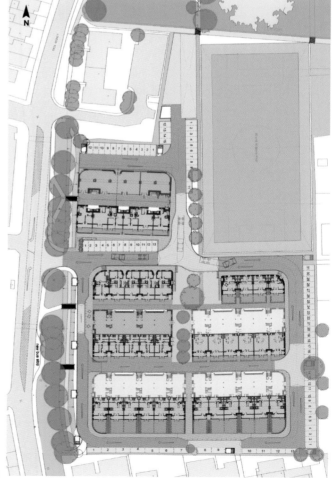

20.8

20.9 Green roof concept sketch.

20.10 Sunspace showing high level
summer sun blocked by
projecting floor above.

20.11 Exposed precast soffits are a
low cost method of achieving
a large exposed radiant
massive internal surface. The
public reaction to the quality
of interior finish has been
favourable at BedZED and
later projects. Right: Sunspaces
provide both insulation and
warmth on sunny winter days.

20.9

no more than three-storeys high, and on retaining
the same high levels of private garden provision
(**fig. 20.9**). This means that almost all the new homes
could be provided by brownfield site regeneration.
The consequences of this are important – it would
save valuable agricultural land and green belt for
biodiversity, leisure and locally-produced organic food.

Planning

Using planning gain to finance carbon-trading initiatives

The outline planning brief for BedZED sought
permission for 305 habitable rooms on the site and it
was this density limit that created the market value of
the site. The current scheme achieves 271 habitable
rooms with the addition of 2,369 m² of commercial
space, which provides in excess of 2,000 m² of income-
generating accommodation, without the Peabody
Trust needing to allow extra funds for the land this
project is built on. In a similar situation, this planning

gain would fund the increased building costs of an
ultra low-energy, super-insulated build specification.
The domestic energy consumption was planned to be
around one-tenth of that of a standard suburban home
built to 1995 building regulations (representing the
norm at the time it was designed), decreasing to about
one-third of a typical home today. This represented
parity with the wider housing market minimum legal
environmental performance standards as they stood
in 2016.

Energy strategy

Limiting demand so that renewable energy sources work

BedZED incorporates 300 mm minimum super-
insulation, triple-glazing, south-facing glazed
sunspaces, thermally massive floors and walls, good
daylight and passive-stack ventilation with heat
recovery. It is equipped with energy efficient lighting
and the latest class A white goods (**figs 20.10–20.12**).

legislation is introduced, a raft of highly paid consultants will try to deliver the minimum legal specification, rather than going with the spirit of the law. This reluctant and cynical behaviour rarely acts in the public interest and would never produce the ZEDlife tools or methodology.

Another aspect of commercial cynicism is to invent an opposition between investment in building fabric and infrastructure and green lifestyles promoted by environmentalists (actually funded by property developers) that are presented as alternatives rather than complementary strategies. The idea that using a car pool and adopting a vegetarian diet is more cost effective than investing in zero-carbon buildings is absurd. If we are to achieve a stable society without competing for scarce resources, we will all be doing everything, including eating a low-meat diet, by 2050. Having tried to solve

the same problems for decades, and having learnt from our mistakes, we at the ZEDfactory believe that we can construct an equitable, pleasant society that can run indefinitely off renewable energy harvested in real time. This optimism is born from years of hard work and research and we believe that our range of tools and methodologies can be easily adopted in many countries and climates. International collaboration and cooperation will be the only way we overcome the challenges of accelerating climate change and overpopulation. We propose the ZEDlife toolkit concept as one practical way of building a collective future that works. Please give this legacy a chance (**fig. 20.14**).

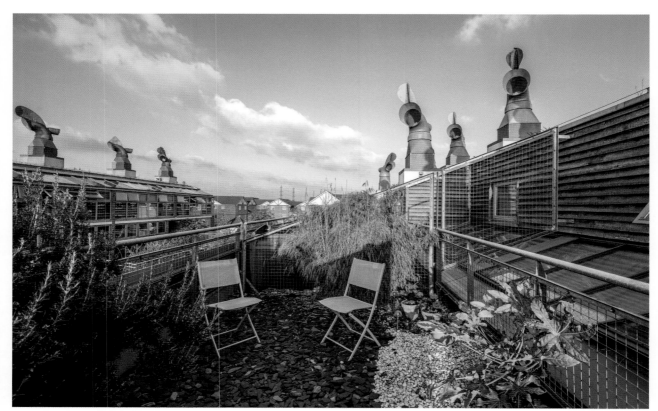

20.14 Skygarden in BedZED.

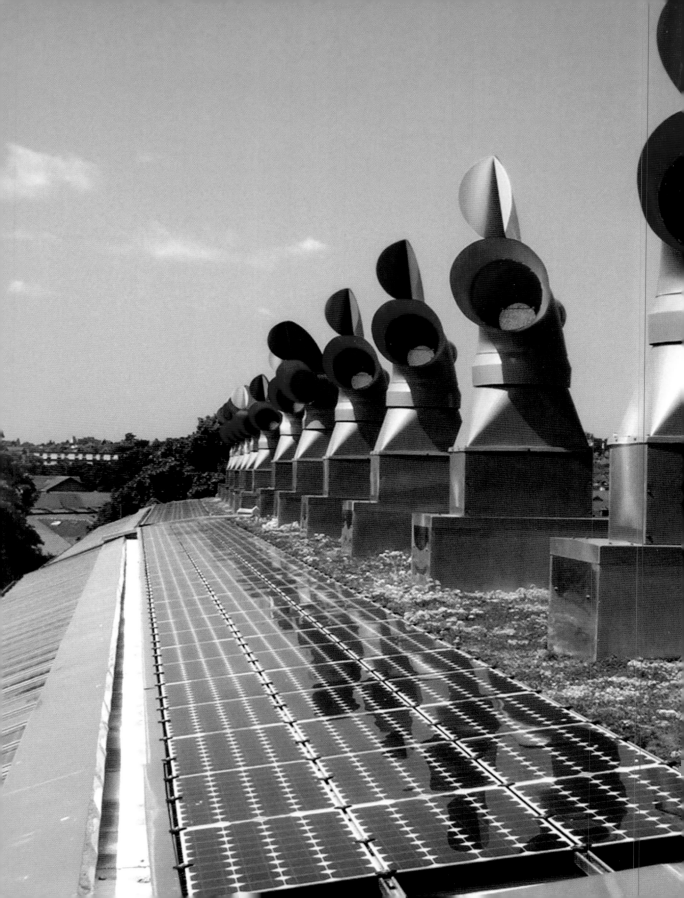

Conclusion

The speed of human evolution requires a collective sense of the direction of travel. The best plan for regulation and politics is one based on realistic and proven technological innovation. We have to design our civil society to anticipate the inevitable changes caused by an expanding human population and accelerating climatic change.

This means we have to work out what kind of human we want to become and take responsibility for designing our own future. In the past, religion provided these guides but, for a lot of familiar reasons, this is unlikely to work today in a multicultural interconnected society. A secular plan coordinating all cultural backgrounds has to work for everyone.

The direction of travel for the majority, then, must begin by finding some simple common targets that almost everyone can agree on and set as priorities. We should have three basic requirements: to be fed, to remove inequality and to sustain future generations. These were embodied in COP21 with its more egalitarian strategy for sharing limited natural capital. If we are to avoid becoming the parasite that destroys its host we must rise to the challenge and plan our ongoing cultural evolution.

The transition of the human species from being a plague on this earth to its only viable future as a planetary caretaker has to become our shared ambition. The transition plan needs to be based on currently available technology, while also prioritising research and development. Through better knowledge and experience, we can accelerate the process of achieving an equitable planet supporting all life forms, not just human, with a stable climate and reduced levels of pollution and consumption of natural capital.

It is hard to imagine how anyone could suppose that we have much choice in this matter. Those that postpone action or lobby against increasingly onerous environmental performance standards are actually trading the lifestyle of future generations for their own short-term material gain. This is antisocial and futile, and it will lead to political instability and unnecessary conflict as anger builds up from those suffering from lack of homes, hunger. or air pollution, or other avoidable hardships and disasters.

How, then, are we to achieve substantial improvements in quality of life at the same time as achieving step change reductions in resource consumption and carbon footprint? The interventions along the way must be gradual but far reaching and effective. Above all, they have to be funded by those that can afford to set the ball rolling. The ZEDlife is one way of planning this transition in a way that we believe is benign and can reward investors requiring a return on their human

capital, as well as what is in their bank accounts. This seems the biggest challenge: how to be radical enough to make a meaningful difference, but still reward conventional funders. To go too far in either direction risks all efforts becoming pointless.

If the motivation is an ethical one, the most important way forward is largely a technical one, with politicians working with architects, engineers and scientists to understand the relationship between what is possible and what is not.

There is always a lobby of existing vested interests against change of any kind and it is important that this is balanced by impartial advice from neutral experts acting in the public's best interests. In the UK this could be the BRE in Watford. It is for this reason that ZEDfactory and the Zero Bills Home Company raised funds to build the first production Zero Bills Home in the UK at the BRE Innovation Park. Impartial feedback from its monitoring will help neutralise claims by the UK volume housebuilder that higher environmental performance standards cannot be met.

The Zero Bills Home at the BRE is only connected to the grid for 20% of the year and still generates some surplus renewable electricity to run electric vehicles. To remove the need for centralised power stations and help reduce air and noise pollution in urban areas, the technology has to be affordable, including durable electric battery storage that can be produced from commonly available materials. This technology can power electric bikes, motorcycles and cars, as well as storing solar energy to match demand.

So this must be a priority and yet almost all advances and production capability on this field are happening outside the UK. Politicians' inability to recognise the problems and begin to solve them by funding the potential solutions is becoming serious. Billions are spent on new nuclear power stations despite their highly dubious track record of longevity and containment of radioactive waste. In the same deliberately blind way, billions are spent on securing access to fossil fuels outside our national boundaries, which are bound to result, sooner or later, in serious loss of life in conflicts as these resources become scarcer.

The ZEDlife initiative, by contrast, tries to show that real solutions are close at hand and can be implemented immediately, and all that is required is industrial collaboration and joined-up thinking.

If the politicians in the UK won't help, the best plan is a grass roots initiative where we all just get on with it.

Anyone out there?

References

1 R. Mason, 'David Cameron at centre of "get rid of all the green crap" storm', *The Guardian* (online), Thursday 21 November, 2013. www.theguardian.com/environment/2013/nov/21/david-cameron-green-crap-comments-storm

2 Greenpeace, 'Kumi Naidoo of Greenpeace responds to Paris draft deal', Press Release, 12 December, 2015. www.greenpeace.org/international/en/press/releases/2015/kumi-naidoo-cop21-final-text-paris-climate/

3 N. Klein, *This Changes Everything: Capitalism vs. the Climate* (Simon & Schuster, New York, 2014).

4 A **U-value** records the rate of heat transference (loss) through a structure. It is expressed in watts (W) per square metre (m²) per degree kelvin (K) and takes into consideration all the elements in the construction.

5 **CFCs** (chlorofluorocarbons) have no natural source, but were entirely synthesized for such diverse uses as refrigerants, aerosol propellants and cleaning solvents. They were created in 1928 and since then concentrations of CFCs in the atmosphere have been rising. Due to the discovery that they are able to destroy stratospheric ozone, a global effort to halt their production was undertaken and was extremely successful. So much so that levels of the major CFCs are now remaining level or declining. However, their long atmospheric lifetimes determine that some concentration of the CFCs will remain in the atmosphere for over 100 years.

 HCFCs (hydrochlorofluorocarbons) and **HFCs** (hydrofluorocarbons) have been increasingly used in the last decade or so as an alternative to ozone damaging CFCs in refrigeration systems. Unfortunately, although they provide an effective alternative to CFCs, they can also be powerful greenhouse gases with long atmospheric lifetimes. The three main HFCs are HFC-23, HFC-134a and HFC152a, with HFC-134a being the most widely used refrigerant. Since 1990, when it was almost undetectable, concentrations of HFC-134a have risen massively. HFC-134a has an atmospheric lifetime of about 14 years and its abundance is expected to continue to rise in line with its increasing use as a refrigerant around the world. The widespread use of HFCs as refrigerants will inevitably lead to increases in their atmospheric concentrations. HFCs have provided an efficient and cost-effective alternative to the use of the ozone destroying CFCs, now banned under the Montreal Protocol. However, with HFC-134a and, in particular, HFC-23 having such long atmospheric lifespans (14 and 260 years respectively) HFCs do pose a significant greenhouse gas problem.

6 **ODPs** (ozone depleting potential) is often used in conjunction with a compound's global warming potential (GWP) as a measure of how environmentally detrimental it can be. GWP represents the potential of a substance to contribute to global warming.

 VOCs (volatile organic compounds): many of these are also hazardous air pollutants. When combined with nitrogen oxides they react to form ground-level ozone, or smog, which contributes to climate change.

7 **TÜV** (in German, *Technischer Überwachungsverein* and in English, **Technical**

Inspection Association) is made up of German businesses that provide inspection and product certification services. The TÜV originated in Germany in the late 1800s during the Industrial Revolution. Today the association forms one of the leading internationally recognised certification and testing houses for solar technology.

8 **MCS** (Microgeneration Certification Scheme) is a nationally recognised quality assurance scheme, supported by the Department for Business, Energy & Industrial Strategy. MCS certifies microgeneration technologies used to produce electricity and heat from renewable sources. MCS is also an eligibility requirement for the government's financial incentives, which include the Feed-in Tariff and the Renewable Heat Incentive.

9 DTI, *The Energy Challenge: Energy Review Report 2006*, Cm 6887. http://webarchive. nationalarchives.gov.uk/20060715135619/http:// www.dti.gov.uk/energy/review/page31995.html

10 J. Copeland and D. Turley, *National and Regional Supply/Demand Balance for Agricultural Straw in Great Britain* (November 2008). Agri-Environment and Land Use Strategy Team, Central Science Laboratory, York. www. northwoods.org.uk/northwoods/files/2012/12/ StrawAvailabilityinGreatBritain.pdf

11 C. Fry, 'Tread lightly: Compost organic waste', *The Guardian* (online), Friday 18 April, 2008. www.guardian.co.uk/environment/ ethicallivingblog/2008/apr/18/ compostorganicwaste

12 United Nations, 'Global Issues: Water', www. un.org/en/sections/issues-depth/water/

13 **EPDM** is an extremely durable synthetic rubber roofing membrane with a 40 to 60 year life expectancy when shielded from sunlight.

14 **FITs (feed-in tariffs)** is a UK government scheme designed to encourage uptake of a range of small-scale renewable and low-carbon electricity generation technologies.

15 **OSB** (orientated strand board) is made up of large flakes of scrap timber that are compressed and bonded together to form a rigid sheet substitute to plywood (ply uses laminated veneers, and chip board uses bonded sawdust). The large flake size gives more aligned cellulose/ wood fibre and means short lengths of UK timber can be used as raw ingredients.

16 The **COP (coefficient of performance)** of a heat pump, refrigerator or air conditioning system is the ratio of useful heating or cooling provided compared to the electrical input to the machinery. Higher COPs equate to lower operating costs and lower electric demand.

17 J. W. Storm van Leeuwen, 'Nuclear power insights', (2008–2012). www.stormsmith.nl

18 B. Vale and R. Vale, *The New Autonomous House* (Thames and Hudson, London, 2000), p. 210.

19 DfT website (formally DTLR and DETR). www. dft.gov.uk or www.statistics.gov.uk

20 See note 19.

21 DETR, *General Information Report No. 53: Building a Sustainable Future* (1996) and SAFE Alliance (now SUSTAIN) Food Miles Campaign 1998. www.sustainweb.org/foodandclimatechange/ archive_food_miles/

22 Urban Task Force, *Towards an Urban Renaissance: Final Report of the Urban Task Force* (E&FN Spon, London, 1999), p. 46.

Index

Page numbers in italics refer to figures.

Image credits

All images by ZEDfactory, unless specified

PART 1

CHAPTER 1
Page 2 *The Guardian* (centre); *The Financial Times* (bottom left);
Telegraph.co.uk (bottom right); Page 7 Rex via Shutterstock (top)

CHAPTER 2
Page 10 Raf Makda; Page 15 Lucy Pedlar; Page 21 Entrade Energy
Services Ltd. (top); Emilio Doiztua (bottom); Page 27 IBSTOCK BRICK
Ltd.; Page 28 Living Space Sciences; Page 30 Julian Calvery (x2)

PART 2

CHAPTER 5
Page 52 BMW Isetta 2014 (top); Rex via Shutterstock (bottom)

CHAPTER 7
Page 60 EPi Ltd. (top); Page 61 Firo002/Flagstaffotos (bottom);
Page 62 Straga (top); Shutterstock (bottom left); Honza Groh (Jagro)
(bottom right)

CHAPTER 8
Page 70 One Planet Foundation and ZEDfactory (top); Page 71 One Planet
Foundation (top and bottom); Page 72 One Planet Foundation

PART 3

CHAPTER 11
Pages 98–99 Drs R. Khodabuccus and J. Lee, 2016. A New Model
for Designing Cost Effective Zero Carbon Homes: Minimizing
Commercial Viability Issues and Improving the Economics for Both
the Developer and Purchaser. *Buildings*, 6(1), p.6

CHAPTER 12
Page 113 Peter White, BRE (top left); Page 115 Peter White, BRE (right
bottom)

CHAPTER 13
Page 118 Tony Karumba/AFP/Getty Images (top); Page 120 Briannomi

CHAPTER 15
Page 134 Headway Group (top); Page 140 Emilio Doiztua

CHAPTER 16
Page 144 Emilio Doiztua (top); Page 147 Emilio Doiztua (bottom);
Page 148 Emilio Doiztua (right); Page 149 Emilio Doiztua;
Pages 150–153 Tim Britton, Forkbeard Fantasy

CHAPTER 20
Page 188 Steve Speller; Page 191 Bill Dunster, Edinburgh 1979;
Page 192 Architectural Association Slide Library (right);
Page 195 Linda Hancock (top and bottom)

Developmental Movement

for children

Mainstream, special needs and pre-school

2nd Edition

Veronica Sherborne

Worth Publishing
www.worthpublishing.com

First published in Great Britain in1990 by Cambridge University Press

This edition published 2001 by Worth Publishing Ltd
6 Lauderdale Parade, London W9 1LU
www.worthpublishing.com

ISBN 1-903269-04-0

Typeset by G&E 2000 Digital Media Group, Peterborough, UK
Printed and bound in Great Britain by Bath Press, Bath, UK

Acknowledgements

Photographs from the first edition were kindly provided by: Swedish Press,
Cedric Barker, Ian Parry, a house parent who took photographs; and chiefly by
Clive Landen, at that time Senior Lecturer, Documentary Photography Course,
Newport College of Higher Education, Gwent.
Photographs were of children from the following schools: Grimsbury Park
School, Bristol; St Paul's Day Nursery, Bristol; Elmfield School for the Deaf,
Bristol; Westhaven School, Weston-super-Mare; Warley Manor, Bath; Romney
Avenue Infant and Junior Schools, Bristol; Henbury Court Junior School,
Hearing Impaired Unit, Bristol; Ravenswood School, Nailsea, Bristol;
Highwood School, Bristol; Stoke Leys School, Aylesbury; Cedars Middle School,
Harrow; and Whittlesea School, Harrow.

Photographs for the second edition are printed with kind permission of the
parents and teachers of Grimsbury Park School, Bristol; Hillingdon Manor
School, Hillingdon; North Hertfordshire Opportunity Class, Radburn School,
Letchworth; and Willows Nursery School, Portsmouth.

The handwriting extracts in Appendix 2 were re-written by first-year pupils at
Comberton Village College, Cambridgeshire. Additional material for the
2nd edition was written by pupils from Hillingdon Manor School, kindly
provided by Pauline Perry, and by a pupil at the Mankkaa School, Espoo,
Finland kindly provided by Tarja Leff.

Original Text Design by Heather Richards
Cover design for the 2nd Edition by Tracey Weeks for G&E 2000

Contents

Contents

Preface

The publication of *Developmental Movement for Children* in 1990 was very important to my mother. She was a very practical person, a do-er rather than a writer, and she was delighted to have put together a written record of her teaching methods. Previously she had written articles about her work from time to time, but had mainly concentrated on recording her ideas in her films; the first being "In Touch" in 1965, through to her sixth, "Good Companions" in 1986.

My mother was always busy, working, teaching, travelling abroad, and looking after her family, so it wasn't until life quietened down that she had the time to write this book. Her work was all important to her, and I know she felt her ideas were better received abroad than at home. That her book is now available once again represents an affirmation of the contemporary relevance and enduring value of her work, which may have been ahead of its time. I welcome the re-publication of *Developmental Movement for Children*, and know that my mother would be really happy that it was back in print. This is very much due to Cyndi and George Hill, and the work of the Sherborne Association.

Sarah Sherborne

Sarah Sherborne
London, June 2001

Forward to the Second Edition

When she wrote *Developmental Movement for Children* at the end of the nineteen eighties, Veronica Sherborne was, in part, responding to a request from those who had worked with her, seen her work and taken her ideas into the teaching context. They had asked her to capture and expand in text form the many ideas that she had developed over years of working in the area of movement, in particular with children and adults with special needs. Veronica had committed observations, theories and principles to paper in the form of articles over a number of years. The ordering and developing of her thoughts and experiences into a book, however, was both needed and clearly welcomed by many students of movement and special educational needs.

Developmental Movement for Children quickly became and remained a seminal text that has both challenged and inspired its readers. It contextualised the work and thinking of Veronica Sherborne, and provided a structure within which educators could work and develop their perception and understanding of the ideas and skills portrayed.

Over the intervening years the field of special education has seen many changes. The language and terminology themselves denote changing attitudes and understanding in relation to people with disabilities. Choosing today to present the text essentially in its original format is not to ignore or denigrate such changes.

Veronica Sherborne wrote in the language of her time; those who knew and worked closely with her are sure that if writing today she would, without doubt, communicate in such a way that the age, race, culture, gender, sexual identity, physical and mental condition of her client group would be represented in language that respected the individuality and rights of the individual. In this new edition, there are some more recently taken photographs of children dispersed within the text. It is hoped that these will assist the understanding and interpretation the reader brings to the writing. However, it is important to emphasise that the body of Veronica Sherborne's original text remains unchanged as a statement of the validity of its content to the educator of today.

In the introduction to her book, Veronica Sherborne reveals the strong influences on her own thinking about the place of movement in the individual's development, as well as those aspects of her own educational and teaching experiences that influenced the way in which she worked. At the heart of her approach to movement teaching was the belief that children
> *"need to feel at home in their bodies and so gain body mastery,*
> *and they need to be able to form relationships."* (1)

It is important for the reader to see these two ideas as central to the understanding of the text, and as central to understanding the movement ideas that ensue from this statement. Similarly, it is important for the reader to separate out the ideas, principles and learning opportunities from the

dynamic and sensitive way in which they are delivered. It was possibly this concern, that experiences put on paper can become clinical and technical, that robbed Veronica Sherborne of the desire to put her life's work down in writing. She was concerned that her work, firmly rooted in the movement theories and analysis of Rudolph Laban under whom she studied, could be misunderstood or misused as a 'programme' or even as a list of exercises if committed to paper. How can the written word adequately capture an experience, a process, a relationship, a dynamic? She deliberated over this factor. Thankfully, finally she did commit, albeit with a concern. I would suggest that those of us who now read her text should seek to bring to our own reading and understanding of her book that same degree of integrity that characterised her work. To understand the Sherborne approach to movement teaching is to understand movement in the context of early child development, and to engage oneself in an analysis of a teaching method.

Understanding the significance of early relationships and the impact of such on communication and sociability is fundamental to understanding the key features of Developmental Movement. By examining the text and the practices of Veronica Sherborne, it is possible to identify those stages of early development that characterise a 'nurturing relationship', that is, a relationship which is seen to facilitate growth and optimum development. This focus forms a considerable part of the book. The significance of early learning experiences are briefly touched on by Veronica Sherborne in her second chapter. However, the reader is encouraged to internalise the features of interaction that characterise relationship play and to contextualise the reading from the beginning in these recognised developmental constructs. Early learning is dependent on the provision of stimulation which must be of such a nature that the recipient's attention is engaged and maintained for sufficient time to allow for a build up of excitement within a tolerable range, so that affectively positive experiences are generated. In other words, from the earliest age, a child needs to be engaged in interactive play that stimulates the child to engage willingly. The educator/care giver is engaged in a 'sort of dialogue' which, like all dialogues, can be reciprocal in nature, dominated or sustained by one or other, or both. In the text, the concern of Sherborne with engaging in such a process is apparent; it is essential to put her 'types of relationship play' into such a framework.

Whichever population group is referred to in the text the same principles underpin the provision of movement learning. In the summary to the book Sherborne writes that -

> "...there is no element of competition in the movement experiences described" (2)

This statement moves the emphasis from what is taught to how it is taught, a fundamental concern of Veronica Sherborne. The context worked within does not put emphasis on the product (although this can be a most pleasurable and significant part of the experience). The way of working is characterised by a concern with how the child learns, how the child interacts, how the child experiences, how the child communicates, how the child feels. It is a way of working that aims to provide opportunity to meet

individual needs, to recognise and value individual qualities, abilities and perceptions. It is a way of working which sets out to give confidence, to engage the participant in non-judgemental teaching, to develop an individual's self esteem and to ensure both consolidation and progression in personal learning.

These principles of working influence the way in which Developmental Movement is planned, delivered, assessed and honed to meet the needs of individuals; that is, the way of teaching and the mode of learning operate within these parameters.

In writing in earlier contexts, I feel Sherborne emphasised the importance of understanding the principles and qualities of the movement experiences that she had described and which are captured again in this text. They must not be misinterpreted or misused as a 'set programme', or as 'mechanical exercises'. The method of teaching and therefore learning is crucial to the effectiveness of the work, to the effectiveness of Developmental Movement. Understanding and analysing the principles underpinning the work, the teaching method and the requirement to observe and plan for the needs of the learner are essential for the reader of this text and thus for the teacher of Sherborne Developmental Movement.

Those who worked and studied with Veronica Sherborne cannot fail to have been impressed by the dynamic quality of the learning experience she created. In such a situation it is too easy to become entranced by the personality of the gifted teacher. However, the analysis of her teaching, the content and teaching method, indicates that it is not simply the personality of the teacher which makes a dynamic learning experience but the operation of understandable principles applied in an appropriate manner. It is from this firm platform of experience and knowledge that Veronica Sherborne's theory concerning the nature of a movement programme has been developed. The evolving theory has, in some ways, given an order and meaning to an original and still, in some ways, personal movement programme. It is hoped that the reader of this work will use awareness of the theoretical constructs to engage analytically as well as empathetically with this most important of teaching texts. Its re-publication is an important landmark in the resources available to those working in movement, drama and physical education in mainstream education and teacher education, and, most specifically, in the area of movement and disability.

Janet Sparkes
Senior Lecturer
St Alfred's College of Higher Education,
Winchester
UK
On behalf of the Sherborne Association UK *March 2001*

(1) page xiii
(2) page 111

Introduction

This book is for teachers in many fields, for parents, student teachers, social workers, educational psychologists, and indeed for everyone concerned with the development of children.

The book is divided into four main sections: Part One, What to teach (Chapters 1 and 2), Part Two, Why we teach it (Chapters 3 and 4), Part Three, How to teach it (Chapter 5), and Part Four, which describes the needs of children and adults who present special challenges (Chapters 6 and 7). The final section, Part Five, is a brief summary of the theory of developmental movement. Chapter 1 will be particularly useful to social workers and nurses, and together the first two chapters will be especially helpful to teachers and physiotherapists.

The theory underlying *Developmental movement for children* which I have developed is based on Rudolf Laban's analysis of human movement. There are many of us who owe a great debt to Laban and his work. In Germany, before the last war, he applied his theories to dance and dance production, and to movement choirs involving hundreds of people. In Britain he applied his theories to work in industry, to the movement training of actors and – through his colleague Lisa Ullmann – to the movement and dance of children. In all the wide-ranging application of his theories, Laban's aim was not so much to make successful performers as to develop the personality, to develop potential, and to help people to understand and experience the widest range of movement possible.

I trained initially in physical education and physiotherapy, but later was fortunate enough to be taught by Laban, and by Ullmann, at the Art of Movement Studio in Manchester. It was a difficult transition to make from the gymnastics of my first training, but from Laban I learnt a different understanding and awareness of the human body and its movement.

In my own work I have applied Laban's theories to the needs of mainstream children, children with special needs, and pre-school children. During the last thirty years I have worked with classroom teachers, physical education teachers, drama teachers, physiotherapists, speech therapists, occupational therapists, nurses, nursery teachers, nursery nurses and teachers in special education, and I have brought up three children of my own. Through my experience of teaching and observing human movement, and of learning through trial and error, I have come to the conclusion that all children have two basic needs: they need to feel at home in their own bodies and so to gain body mastery, and they need to be able to form relationships. The fulfilment of these needs – relating to oneself and to other people – can be achieved through good movement teaching.

When I began to train students to teach children with severe learning difficulties, my first aim was to help the students to work together and to feel secure within the group using partner and group activities. To my surprise the students went on to introduce some of the partner activities to the children with severe learning difficulties, with some success, and it

became clear to me that the children too could relate to each other in the kind of activities that are described in Chapter 1. I later found that this approach to movement teaching was equally relevant to mainstream children. This was also a new idea to me, and an important discovery.

The activities described in this book are referred to here as 'experiences' rather than 'exercises' because they combine both physical and psychological learning experiences. Underlying all these activities are certain beliefs:

- Movement experiences are fundamental to the development of all children but are particularly important to children with special needs who often have difficulty in relating to their own bodies and to other people.

- The input or 'feeding in' of movement experiences has to be more concentrated and more continuous for children with special needs than for children in mainstream schools.

Many parents and caregivers, when they play physically with children, instinctively use many of the activities I have described in Chapter 1. In this book I have analysed and categorised a variety of these activities and have adapted relationship play to the needs of all children. A number of the experiences described in this book are illustrated in the films and videos which are listed on page 121.

It is essential to help all children to concentrate on the experiences described so that they become aware of what is happening in their bodies. In this way they are able to learn from their movement experiences. I call this 'listening' to the body.

Children described in this book as children with special needs are children with severe learning difficulties, children with moderate learning difficulties, children with profound and multiple learning difficulties, children who are emotionally and behaviourally disturbed, and children who are hearing impaired.

Several analyses of my work have been made in recent years, including a dissertation for an MA degree in the Department of Physical Education at the University of Leeds, and a dissertation for a B Ed in Special Education for the Council for National Academic Awards; the Carnegie UK Trust has also awarded a grant for research into my work.

Now the time has come for me to write about my work myself.

Veronica Sherborne

1

Developing relationships

It is impossible to say which comes first, self-awareness or awareness of others. Because it is easier to explain and illustrate, awareness of others is dealt with first here.

Relationship play requires a one-to-one relationship in which a more able, more mature person partners a younger, less able partner, usually a child. Both partners gain from the experience, as they have much to give each other.

There are many ways of organising partners. Parent and child is the ideal partnership, but is not always possible. Student teachers benefit from relationship play with mainstream children as well as with those with special needs, and young people in secondary schools can make supportive partners for children with special needs. Nursery nurses can partner pre-school children. Partners can be found within a school, or be from another local institution. Children in a mainstream class can partner each other, or older children with mild learning difficulties can partner younger children with severe learning difficulties. Primary school children can partner younger children in their school or can work with children with special needs. Senior children with severe learning difficulties, with careful help and preparation, can partner each other, or can learn to partner children with profound and multiple learning difficulties. There are a number of photographs on the following pages which illustrate well the variety of possible partnerships.

The aims of relationship play

Self-confidence

The younger child gains confidence from the way he or she is physically supported; the child finds it safe to commit and trust him- or herself to the care of the older partner. The quality of the interaction between the care-giver and the child has a profound effect on the child. A great deal is communicated through the quality of feeling which the older partner shows to the younger partner. The young child should experience

Note The activities described in Chapters 1 and 2 are summarised in Appendix 1, pages 112-15.

success, a sense of achievement, and an awareness of self-worth. The younger child should become confident enough to show initiative in the way he or she responds to the older partner.

Body knowledge

The child develops body awareness as he or she experiences the body against that of the older partner. The younger child experiences the trunk, the centre of the body and the link between the extremities, in many of the relationship-play activities described here. This helps the child to develop a sense of wholeness, and an awareness that the parts of the body are well connected to each other. The development of body awareness is described in Chapter 2.

Physical and emotional security

When the less able child finds he or she can trust a partner to physically support, contain and handle him or her in a trustworthy way, that child develops not only physical confidence but also a sense of being emotionally secure. Relationship play can be especially beneficial for children who are emotionally and socially insecure.

Communication

One of the advantages of relationship play is the development of a variety of ways of communicating. Initially the young child may have no language and may passively receive movement experiences. Later the child may respond so that a dialogue of shared movement play develops. The child may then take the initiative and reverse roles with the partner, and may start to introduce new ideas into the play situation. The child may have little or no language but can communicate quite clearly through movement play. The caregiver has to be sensitive to the signals that the child may give (see Chapter 4, Observation of movement).

The adult can help the child develop a rich vocabulary of language by encouraging a wide variety of movement activities. Words which describe actions and which are experienced in movement activities are more likely to be remembered and used than words which are not accompanied by physical experience. Such words and phrases might be 'push', 'climb', 'lie down', 'shut your eyes', 'make a house', 'strong', 'gentle'. Prepositions such as 'over', 'under', 'behind', etc. are also learnt as a result of physical experience.

An important aspect of communication is eye contact, and some activities are especially useful because they encourage this. Eye contact is necessary if the child is to concentrate and learn new skills from the caregiver.

Types of relationship play

There are three broad types of relationship:
1 Caring or 'with' relationships
2 Shared relationships
3 'Against' relationships

Caring or 'with' relationships

This type of relationship can be experienced through many different activities, several of which are described in detail here. It is best to demonstrate all activities first so that both partners know what is going to happen. As the activities become familiar this will not be necessary.

Containing a partner

On the whole it is best to start a movement session with a caring relationship in which the older partner gives a sense of security to the younger partner. The simplest form of this is for the older partner to make a 'house' or 'container' for the younger partner.

Cradling

The participants sit on the floor, with the younger partner between the legs of the older partner. The older partner enfolds the younger with the arms, legs and trunk. The older partner rocks gently from side to side, cradling the younger partner, using knees, thighs and arms to give support (Figs. 1 and 2).

The child needs to tip slightly off-balance so that the adult or older partner can feel if the child is ready to give part of his or her weight to the adult to support. When the child is able to commit some of his or her weight to the adult, this indicates that the child trusts the adult. Relaxation is helped if the older partner hums or sings quietly to accompany the cradling action. The free flow of the movement from side to side has a calming, harmonious effect. A free-flow movement is one that cannot easily be stopped once momentum has started. Controlled flow movement is described at a later stage (see page 57).

The older partner has to decide on the right tempo of the cradling and the appropriate range of the sway of the movement to suit the child. Much is communicated during this activity; giving confidence and security through cradling is a skill which the older partner learns with practice. Not all adults can contain in a secure way, possibly because they have not experienced it themselves. The ability to contain, support and use free-flow cradling varies from one caregiver to another. Some people manipulate their partners, but others are both physically adept and have good feeling, and thus give a sense of security to their partners.

Containing with free-flow rocking makes a calm ending to a movement session. The quality of containing and the degree of sensitivity involved are a good contrast to the vigorous and strong activities that have occurred during the session. The activity is also enhanced by the rapport that has been built up between the partners during the session.

When partners are of equal size, the 'container' partner can put his or her ear against the partner's back; this will help him or her to 'listen' to the

5

 One child cradles
another in a school for
children with severe
learning difficulties

2 Day nursery.
Cradling at the end of
a movement session

3 The author supports and cradles a profoundly deaf boy

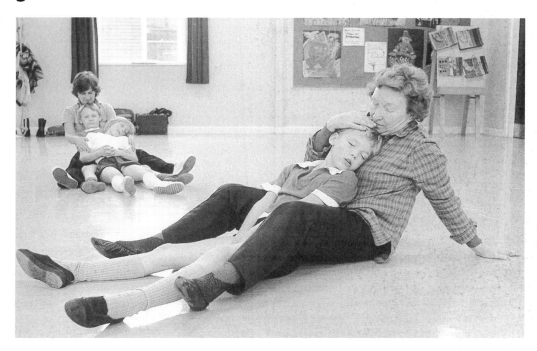

4 Day nursery children rock their partners

partner. The person who is contained may find it more comfortable, and therefore easier to relax, if he or she leans back with the head resting on the supporting partner's shoulder with legs stretched out, rather than being in a curled-up position. The supporting partner may have to put a hand on the floor behind to take the weight of the partner. Cradling is then instigated by the sway of the trunk and shoulders (Fig. 3).

For those children who dare not shut their eyes while being cradled, the supporters may use one hand lightly to cover the children's eyes. The children will then find it easier to 'listen' to and concentrate on what is going on inside their own bodies. Some children need to be contained very lightly while others enjoy the older partner completely engulfing them. Children with severe learning difficulties and young mainstream children can cradle each other sensitively and successfully. Very young children can stand behind adult partners and rock them from side to side (Fig. 4).

Rocking horses Cradling from side to side can be changed to rocking backwards and forwards. The caregiver sits with the child between the legs, both partners facing forward, and grasps the child under the knees. Very small children can sit on the adult's thighs. The caregiver then tips back a little way, and then forwards. As the child finds it safe to be tipped back the caregiver rocks a little further back. In this activity the caregiver gives total support. Eventually the child tips so far back that he or she is upside down with feet in the air above the head. The caregiver's legs are also up in the air and both partners have an unfamiliar view of their feet above them. Children love being upside down. This activity should be accompanied by appropriate vocal sounds, for example 'whee' or 'whoosh'. Children who are shy often relax and laugh as they play at being 'rocking horses'.

Backward When children are confident, the rocking horse movement can be
somersault increased backwards so far that the child, who is upside down, continues the movement backwards over the caregiver's head and does a backward somersault, landing on knees or feet behind the caregiver's head (Figs. 5a, 5b). This activity takes courage and confidence but comes easily to agile children. The children learn to trust their partners and themselves, develop mastery of their bodies, and cope with being disoriented by being upside down and unable to see what is going on. When children cannot see, they have to trust their own body mastery and listen to what is going on in their own bodies.

Some young children, for example some socially deprived children, are not used to physical play with others, and may be reserved and lacking in self-confidence. It is helpful to create an atmosphere of play and fun. One way of achieving this is to cradle the child from side to side until the sway to one side becomes so great that both caregiver and child fall over. Children find that falling over safely in this way is fun, and usually want to repeat the experience. Sometimes pre-school children will instigate the cradling; while sitting in their 'house' or 'container' they will press on their partner's knees to make them start to sway from side to side.

These activities of falling safely and rocking backwards with legs in the air produce much laughter, even in children who find it difficult to play.

5a & b Day nursery. The end of a backward somersault

Supporting Support can be total – that is, the whole weight is carried – or it may be partial, as for instance when a child leans against a caregiver. The following activity is undemanding and encourages a child to relate.

The adult lies down on his or her back, knees bent up, and the child sits astride the stomach so that the partners face one another. The adult can gently bounce the child up and down. The child can lean backwards on the adult's thighs and then tip forward. From this position of being higher than the adult, the child is likely to look down and make eye contact. Commitment of weight to the support of the adult indicates that the child both trusts the adult and trusts him- or herself.

The adult can lie face down and support the child astride the back. In this position the child can cling on with the legs and the adult can hump the child up and down. If the adult feels the child's legs gripping the sides of the adult's body, and perhaps the arms gripping his or her neck, this is a clear sign that the child wants to be involved with the adult. On a slippery floor the adult can creep like a lizard, carrying the child on the back. Some children who feel threatened by eye contact will accept an adult's back as a place to sit and in this way feel it is safe to commit themselves to the support of an adult. Some children initially will only accept physical contact if they are the dominant partners – that is, higher than their partners.

When working with profoundly and multiply handicapped children or adults, the caregiver lies face up and supports the handicapped person along the length of the body (Fig. 6). The caregiver can hold and rock the handicapped person from side to side. The free-flow rocking and the comfort and warmth of the caregiver's body help to reduce spasticity and often the best relaxation is achieved in this way. Eye contact may also be achieved with people who usually avoid it. Sometimes the handicapped person relaxes better on the supporter's back. The human body induces better relaxation than does a mattress or the floor.

Rolling The experience of rolling has much to commend it. It provides an enjoyable way of 'feeding in' to the child the fact that he has a trunk; he or she feels it against the floor, mat, or other supporting surface. The child also experiences the free flow of weight and the movement of the body as a whole, which brings about a harmonious sensation. Rolling is a series of falls, the safest the body can do. It involves letting go of weight and giving in to the pull of gravity. Tense, anxious children roll rigidly like a log, with their forearms protecting the chest and the head lifted. They need help to let the body fall and give in to the pull of gravity, and to allow the impetus and free flow which maintain the continuity of rolling. Down's Syndrome children usually roll even more fluently than mainstream children.

Children need encouragement to roll in a sequential way in which one part of the body follows after another. The roll may be initiated by first turning one hip, shoulder or knee, and then the rest of the body follows, involving rotation, a twist in the trunk. The body can then roll in a flexible, fluent, sequential way. One of the main aims of movement activities is to educate the centre of the body (body awareness), which is so often

unknown and rigid. Flexibility in the trunk indicates that the child is sensitive to and aware of his or her body.

To help achieve flexibility in the trunk, the adult can sit with the child lying across his or her thighs, and can then roll the child down to the ankles and back up to the thighs again. The child's body moulds itself against the adult's legs and will be slightly open when he or she is on the back and slightly closed when on the stomach. The adult uses his or her body to feed sensations into the child's trunk. The adult can then lie back and roll the child right up to his or her chin and then, coming up into the sitting position, all the way down to the feet. A trusting, confident child will roll flexibly, fluently and resiliently, adapting to the adult's body. A tense, nervous child will have to be helped to relax and allow his or her body to 'melt'.

Children who are profoundly handicapped can be helped by the adult to relax. Again in a sitting position, the adult rests the child face down across his or her thighs and gently bounces the child and pats the back. The child's solar plexus - the centre of the body - must rest on the suppor-ter's thighs with the child's arms and head resting on the floor. An anxi-ous child will raise the head. The gentle bouncing induces relaxation, and the child can also be gently rocked from side to side. Children enjoy being patted up and down the spine. This comforting experience can help even the most disturbed or handicapped children (and adults) to relax and to accept new experiences.

The caregiver can do a double roll, holding the child along the length of the body, face to face. The adult has to be careful not to squash the child when he or she is on top, but children enjoy a double roll and like being slightly squashed. They also like being hugged, held and supported during the roll.

Children enjoy rolling other people and this is one of the easiest ways of encouraging children to move an older partner because they do not have to contend with too much weight (Fig. 7). The older partner can help the child to be successful in rolling him or her without the child being aware of this. Some disturbed children only consent to be involved with another person if they are in charge of the situation and they may exploit the situation and roll the partner roughly. As a relationship is built up and as confidence develops, the child becomes more aware of the needs of the partner and treats him or her more kindly. It is important to encourage children to take the initiative and have the experience of being in charge of the adult.

Horizontal rocking This is a useful activity for profoundly handicapped children as it helps to reduce spasticity. The child lies on the back on a mat. The caregiver gently pulls the child up onto his or her side, handling the child on the hip and the shoulder, the bony parts of the body. The child is helped to fall back onto the back and then rolled up onto the other side. The emphasis is on the drop onto the back induced by gravity, which feeds in an experience of weight and heaviness. The free flow of rocking up on the sides and the falling back encourage relaxation. Some handlers are more skilful than others in finding the best rhythm and in combining firmness with sensitivity, but these are skills that can be learnt with practice.

6 A senior boy in a school for children with severe learning difficulties supports a girl who has profound and multiple learning difficulties

7 Day nursery. Rolling an adult

Sliding Another caring relationship involves one partner sliding the other along a slippery floor, pulling him or her by the ankles (Fig. 8). Children enjoy the experience of free-flow sliding and are surprised to see their partner above them; this activity will often produce good eye contact. The older partner can also slide the child in big sweeping movements from side to side, causing the child's waist to bend in a flexible way. The emphasis here is on the sideways movement rather than on the experience of sliding. This is another way of feeding in flexibility to the centre of the body. If the child is stiff and rigid, the caregiver knows that no new experiences are being received by the child. With care, skill and encouragement, it is possible to help children to relax and allow the centre of the body to be more flexible.

The rigidity of the trunk may extend to the legs. Tension in the legs is quite often found in the caregiver and this tension will be communicated to the child. A useful way of helping the legs to relax is for the tense person to lie down on the back. Gently, from underneath, the therapist or caregiver lifts the knee of one leg a few centimetres and lets it fall. As the leg begins to fall more easily, with less tension, the therapist lifts the leg a little higher. The emphasis is on the drop, letting gravity produce the movement. Massaging the thigh muscles can also help. Relaxed legs fall with the feet falling out sideways which indicates that the adductor muscles on the inside of the legs are relaxed. 'Worried', tense legs have the feet pointing directly upwards.

When an adult or older partner slides a child, he or she should notice if the child lets the head rest on the floor, which is a sign of self-confidence. Anxious people will lift the head and look around. If sliding is uncomfortable for the head and hair, the child can put his or her hands under the head, but this will probably not be necessary on a clean, slippery floor. Children with profound and multiple learning difficulties can be slid on a blanket; this is an enjoyable and stimulating experience for them (Fig. 10).

Children can slide adults by pulling their hands or wrists. The adults walk their feet along the floor in order to help children to pull successfully. A number of children working as a group can pull their teacher along. It is important for the children to reciprocate and look after adults.

Tunnels In this activity the child shows initiative and independence in making use of the adult's body. Going under the adult's 'tunnel' may be the first activity in which very young, shy, children show initiative. The adult is on all fours, making a 'horse', and the child enjoys going through all the spaces made by the adult's body. The child can go under the arms, between the legs and out under the sides of the adult's body. A group of children may spontaneously start going under and through the tunnels of other adults or older children, and group play begins, a sign of security. Children particularly enjoy going through a long tunnel made by a line of adults or children (Fig. 11). Small children may also creep over and along the adults' backs.

As children crawl over the top of and underneath their partner's 'horse', their vocabulary can be increased through the physical experience of actions described as 'over', 'under', 'through', 'up', 'down', 13

8 Children with severe learning difficulties slide their partners.
Note the relaxed head of the sliding girl

9 Early years children in co-operative play

1 0 Early years children with
communication difficulties
learning to slide

1 1 Children with autistic spectrum disorders making and wriggling through 'tunnels'

round', 'on top'. In fact, language is continually developed through movement play'. The children enjoy the play so much that learning the meaning of words comes easily as the action and the word are experienced together.

When the child makes a tunnel for the adult, the child will have to balance on hands and feet to make a big enough space for the adult to wriggle through (see top photograph on page 76). Children enjoy seeing the adults' efforts to get through their tunnels.

More advanced support

As already stated, when a child gives his or her weight to the caregiver to support, this is a sign of commitment, of being willing to be involved with another person. It is often very difficult for a disturbed child to commit him- or herself, so the caregiver has to find ways of achieving this commitment that are not threatening to the child. For example, a child in water may not be aware of being supported because of the unfamiliar situation. Some adolescents will not let anyone touch them, but they can be encouraged to allow themselves to be supported by seeing, then imitating, other children around them who are participating in and enjoying the activities.

In this situation it is best to begin with partial support as in cradling, but there are several ways of giving full support which are not threatening. The adult can curl up, face down, and the child is then encouraged to slither over and across the back like a seal. Children also enjoy slithering over the adult's body from hips to head. The child experiences his or her body against the body of the adult.

Balancing on a partner

Children also enjoy balancing on an adult. The simplest form of this, for very young children, is for the adult to sit on the floor with legs stretched out. The child stands on the adult's thighs with hands supported, or can, daringly, balance without support.

Children enjoy balancing on the adult's body in different ways. The flow of movement here is controlled or bound, in contrast to the free flow experienced in cradling, sliding and rolling. Children enjoy standing on the adult's knees when the adult is sitting on the floor with the knees bent up. The child puts a foot on each knee and is helped to balance by holding the adult's hands, often managing to balance without help (Fig. 12). Good eye contact is usually made in this activity and the child focuses attention in a way which may not be typical of that child. All activities that help the child to focus attention, even if only for a short time, give the child practice in the necessary ability to concentrate.

Gripping

The adult can lie face down on the floor and the child is encouraged to sit astride the back. Gently the adult does little humping movements. When the child is ready the adult can rise up onto all fours making a 'horse'. The child is encouraged to grip with the legs and to hold on with arms round the adult's neck (Fig. 13). The adult can sway gently forwards and backwards, and then subside onto the ground again. If the child's grip is secure, the adult can carefully move forward on all fours and give the child a ride. Children under eighteen months are not able to grip securely but older children can learn. Gripping with arms and legs is a

12 The author, working with parents and mainsteam children. Balancing. Note the eye contact and concentration

13 Nurture group for children with special needs. Clinging on with arms and legs

positive indication that the child is prepared to be involved with another person.

Children also enjoy the game of 'baby monkeys'. The adult sits in a sideways position (both legs to one side). The child sits facing the adult astride the adult's lap with legs gripping round the adult's waist and with arms round the adult's neck. The adult leans forward and comes up onto all fours with the child clinging on underneath the adult's body. The adult can put one arm around the child to help the child to cling on. This activity can only be done for a short time as it requires a lot of strength to cling on against the pull of gravity. Children enjoy the experience, and participation in this activity is a clear indication that the child wants to be in contact with the adult (Fig. 14).

Balancing on a partner's back

(Fig. 16). A child can also balance on all fours on an adult's back when the adult is already on all fours. Children often extend themselves and kneel up, and some will eventually stand on the adult's back. They must be asked to put one foot on the shoulders and one foot on the hips and not to stand on the adult's waist. The adult can sense how confident the child is and can sway very slightly so that the child has to concentrate to maintain balance.

Another way in which the adult can give the child support from an all-fours position is as follows. The child sits on the adult's hips, facing the adult's feet, and lies back with his or her back lying along the adult's back with the head lying over the adult's shoulder or resting on his or her head. In this position the child's body is relaxed and open. The adult can sway gently forwards and back. To help the child to get off, the adult can subside onto the floor and roll the child off sideways.

In order to take the weight of adolescents or adults, three, four or five people can kneel on all fours side by side close together, their backs making a new 'floor'. The person who is going to be carried spreads him- or herself face down to lie along all the backs (Fig. 17). The supporters together sway gently forwards and back. This commitment to the support of a group of people is significant for older people who are not used to being carried. The one who is carried can lie face up; while this is a more vulnerable position, it results in better relaxation than when lying face down. The supporters can deposit their load by each one putting an arm round the person, sitting back on their heels, and slowly and carefully unrolling the person backwards over their hips. The person who is being helped to roll off puts out an arm and a leg to help take the weight and make the landing as soft and as comfortable as possible.

Aeroplanes

This is another form of support which is much enjoyed by children. The adult lies face up with legs bent up supporting the child's stomach and legs along the shins, and holding the child on the shoulders. The child is above the adult, facing down, and this is probably the best position there is for gaining eye contact. The child feels that he or she is in a flying position (Fig. 18). Very young children enjoy 'crash landing', when the adult lets the child drop onto his or her stomach. Some children will try lying backwards over the adult. Children are very inventive and will find many variations of such activities.

14 Mainsteam 'baby monkeys' cling onto their parents against gravity

15 Balancing on a parent by a child with learning difficulties

16 A boy with severe communication difficulties demonstrates his total trust in his supporting adult

17 Emotionally and behaviourally disturbed boys supporting and trusting each other

Somersaults See page 8 for an activity involving a backward somersault. A forward somersault can also be very useful in many ways. The adult sits on the floor, legs stretched out and a little apart. The child stands behind one of the adult's shoulders, leans over and rests his or her stomach on the adult's shoulder. The child puts hands on the floor between the adult's legs. The adult enfolds the child's head and trunk, rounding the back and ensuring that the child lands on his or her shoulders and unrolls the spine along the floor. The child's knees and nose are kept close together so that the child is curled up throughout the somersault. The child trusts his or her weight to the adult. He or she cannot see, so has to 'listen' to what is going on in the body, learns to curl up, and develops the control necessary to transfer weight through the spine, so often an unknown part of the body. Children love being upside down, and come back for repeated somersaults. They do not notice that they have been hugged during the process; it is easy to make many friends through this activity. Some children are rigid and, having no feeling of a centre, will open out; the adult will have to mould the child's body over his or her own body. Some children are tense and feel as if they have swallowed a ruler; the aim is to melt this tension. Simpler ways of developing a sense of the centre of the body will be discussed in Chapter 2.

Very young children will somersault and unroll along the adult's thighs. Agile children enjoy doing a backward somersault, having completed the forward somersault. From a sitting position between the adult's legs (back to the adult), the child can swing vigorously backwards, push hard with hands on the floor, and hips and legs will fly over the adult's shoulder. After a lot of heaving and handling the child finishes up standing behind the adult where he or she began the forward somersault. If adolescents or adults try this activity, two extra helpers are needed, one on each side, to look after the somersaulter's hips and help maintain a curled-up forward roll.

Mutual hug All the activities described so far take place close to the floor. In this activity, the adult stands, feet firmly placed on the floor and apart, knees a little flexed, arms held out. The child takes a run at the adult and leaps onto his or her waist, gripping tightly round the waist with the legs and with arms round the neck. The adult hugs the child strongly and gives the child a swing round. This activity is popular because it is a bit risky and the free-flow spin-round is exciting. The child grips the adult and the adult grasps the child in a mutual hug. Some children have to be helped to grip because their legs hang limply down. Learning to grip can be learnt first in safer, less demanding ways, for example by playing 'baby monkeys' or 'horses' (see page 18). This is a useful activity for the end of a movement session when confidence and trust have developed between child and adult. Unfortunately it cannot be done with heavy children and adolescents unless the adults are very strong.

Jumping Until now the emphasis has been on being supported, and on learning to fall and roll. The time comes when children need to defeat gravity and learn to contend with it. Young mainstream children will risk leaving the security of the ground in a jump on their own between the ages of two and

18 'Aeroplanes' require total trust and confidence in each other. Note the eye contact

19 An early years child with learning difficulties learning to roll and beginning to experience free flow movement

three, usually in a jump down from a step. All children can benefit from a supported jump. The partners face each other, the older partner supporting the younger by holding him or her under the elbows. The younger child holds onto the supporter's forearms. The child bounces gently with feet together and can then be bounced round the supporting partner so that the child does not come down on the spot from which he or she took off. Confident, able children can do a flying leap from one foot, landing on the other halfway round their partners. They develop a flexible free-flow way of leaping with freedom, using the knees and hip joints to make 'flying legs'.

Jumping high can be done in groups of three. Two helpers stand one on each side of the person who is going to jump. They support under the elbows and take a 'how-do-you-do' grasp of the hands. With a loud cry of 'and hup', the middle person bends his or her knees and leaps up into the air, pushed higher by the supporters, and achieves height which could not be reached unaided. Before doing this the one who is jumping needs to loosen the ankles with small bouncing jumps to ensure that the feet and ankles are resilient and ready for the landing. The one who jumps always comes down with a different face from the one he or she went up with! The free flow, the height and the exhilaration always surprise people and cheer them up.

Another less demanding aspect of jumping can be developed when one partner lies on the ground spread out in a star pattern. The other partner steps over the limbs into the spaces between the limbs, and over the trunk, if this is felt to be safe. The next stage is to do a little jump over the limbs, then to leap over the partner's stomach. Some children with moderate learning difficulties will successfully leap the full length of their partner from between the legs to the farther side of the head (Fig. 20). Roles are reversed so that the other partner has the same experience of being vulnerable on the floor. This activity catches the interest of children with severe learning difficulties, and they are careful not to tread on the partner.

Transfer of weight from feet to hands

Older children and adolescents can use the body of a partner to get elevation. The supporter is on all fours. The child puts his or her hands on the adult's shoulders and hips. It is important not to put weight on the supporter's waist as it is not constructed to support weight. The child does a few small jumps with feet together, thus transferring weight to the hands, the beginning of vaulting. Children with severe learning difficulties need to have this activity demonstrated, but they enjoy attempting it. Gradually the jumps become higher and springier. When the youngsters have succeeded in getting their hips high, the next stage is to encourage them to jump round the back of their partner and land on the other side. This involves separating the legs, getting height and lift from the knees and hips, and twisting the body, almost the beginning of a cartwheel (Fig. 21). Young adults and adolescents who have severe learning difficulties can partner each other in this activity. Skilful children will perform a cartwheel over their partners, or a through vault, their legs coming between their arms as they jump from one side to the other of their supporting

23

20 A mainstream boy jumps the full length of a student teacher

21 Primary school boys partner each other

partner. Others will leapfrog. All these activities are experiences in weight management.

Swinging Leaving the ground can be threatening for children who are lacking in self-confidence, but the free-flow sensation of being swung is usually very much enjoyed. The easiest swing for young children is for two older people to take the child by a wrist and ankle each. The grasp of the wrist is ideally a double grasp, with each person holding the other's wrist. Hands and fingers alone are slippery and the grasp is not so secure. Between them the older people swing the child gently headwards and footwards a few times and then put the child down. As confidence develops they can take the child higher with the emphasis on taking the head high. As the child gains confidence they can take the child really high until the child is almost vertical. They drop the child's feet and the child lands on his or her feet. The moment of suspension before the landing is much enjoyed; it is near to flying (Fig. 22).

There are some children who crave free-flow, risky sensations and will demand to be swung as high as possible. In order to 'anchor' these hyperactive children, it is best for one adult to take the child by one ankle and one wrist and sweep the child around in a circle with the child's back sliding over the floor. In this way the child derives the free-flow sensation but is grounded at the same time.

When swinging adolescents or adults, four supporters are needed, one for each limb. The grasps for the arm are a double wrist-grip and a grasp above the elbow, and for the leg one grasp on the ankle and the other under the knee. People are very surprised when they are swung for the first time. They are in the power and care of four people and have to trust and commit themselves to these supporters. The sensation of swinging is so enjoyable that children and adolescents usually demand another swing.

This activity is best done towards the end of a session and will be a high-light of the session. It is quite difficult to calm everyone down after a swing unless the preceding activities have physically extended and satisfied them. The caring, 'with' activities must therefore be balanced with 'against' activities which demand strength and energy. (See *'Against' relationships* below.) A good balance between 'caring' and 'against' activities results in a sense of well-being and pleasant exhaustion.

Shared relationships

Rowing the boat The simplest shared activity is one in which partners sit on the floor facing each other, legs outstretched. The legs of one partner may have to lie on top of the legs of the other. Very young children can sit on the older partner's legs. The partners grasp each other's wrists and in the case of very small children the older partner can hold the elbows. Each partner takes it in turn to lie back and then sit up and lean forward while the other partner lies back on the floor.

There are two aims to this activity. One is to help the child lie back so that his or her head rests on the ground, a sign of confidence. The other 25

22 A hearing-impaired child enjoys a high swing

23 Helping a young person with physical and multiple learning difficulties to experience strength

aim is to encourage the child to pull the older partner back up into a sitting position again when it is the older partner's turn to sit up. The adult ensures that the child is successful in doing this by unobtrusively assisting the child if necessary. The adult also observes the strength and determination of the child's pulling action. At one moment the child is higher than the adult, and the next the adult is higher. Eye contact is usually made at these points. In this activity, partners alternately support each other and pull each other, and the child demonstrates confidence in the partner and in him- or herself and contributes to the shared activity.

Balancing with a partner A shared balance, which is more demanding, can be tackled by mainstream children and by adolescents with special needs. Partners sit on the floor facing each other, knees bent and feet apart in a stable position. The partners grasp each other's wrists and, pulling hard, manage to stand up together (Fig. 24). The distance between them will be adjusted to the length of their arms, which are slightly flexed. Partners can then sit down together, balancing each other's weight. They need to keep their hips underneath them and not let them protrude backwards as this makes the partners much heavier and more difficult to balance. This activity can be started from a standing position. Partners take up a firm stance with feet apart, grasp wrists, and lean back so that they get used to the experience of depending on another person while at the same time holding that person up. Children with severe learning difficulties find it threatening to be off-balance, they want to be stable, but through a comprehensive movement programme they can learn to relate in a mutually dependent, mutually supportive way.

 Balancing a partner requires a great deal of sensitive awareness of the other person, while at the same time being in control of the weight-bearing parts of one's own body. Balancing also demands controlled flow, the opposite of free-flowing movement. This means that the action is under the control of the will; it also calls on all the concentration of the two people involved and on their ability to 'listen' to each other. This capacity to listen to and relate can be developed in caregivers. If the centre of the body and the weight-bearing legs and hips are well controlled, the caregiver can give all his or her attention to the child. A heavier adult can balance a lighter child if the adult has sufficient control over his or her own weight, so that the adult gives the child only as much weight to support as the child can manage.

See-saws Agile, well-coordinated children enjoy making a see-saw. One child rises as the other child sinks. They also enjoy sitting back to back, knees bent and with a stable base. They push so hard against each other's backs that they stand up together (Fig.25). They balance with the whole spine in contact with the other person, and then sit down together. This activity requires strong thigh muscles and sensitive cooperation between partners. Children also enjoy an upside-down balance. They lie down on their backs, bottoms touching, legs in the air, holding each other's wrists. They press their feet hard against their partner's feet, lift their feet off the floor and make an arch with their bodies, balancing on their shoulders (Fig. 26).

27

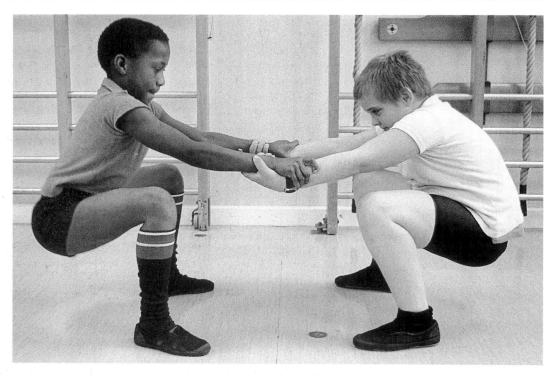

24 Profoundly deaf children balance the weight of a partner. Note the concentration

25 Middle school boys do a back-to-back balance standing and sitting, keeping spines on contact

Children also enjoy a balance standing on an adult's thighs (or those of an older partner). The adult stands facing the child, knees flexed and feet apart. He or she grasps the child's wrists and the child steps up onto the adult, one foot on each thigh. If the child is small the adult may hold onto the elbows. The child leans back, as does the adult, and they perform a spectacular balance (Fig. 27).

Balancing can be experienced by groups of three, four or five people standing in a circle. The controlled flow and the sensitive awareness involved is enjoyed more by adults than by children. The children enjoy the more athletic balances, many of which they invent.

It will be noticed that when children balance, whether it is a shared balance with another person or kneeling on a partner's back, they give their full attention to the activity. Attention spans can be increased if the motivation is strong enough. A great deal of the necessary concentration is caught, or picked up, from the adult. The tone of voice and steady eye contact help a child to concentrate. The child is also more motivated to be involved in activities if the older partner is also enjoying and sharing in the movement play.

Another shared relationship, which has already been described (see page 21), is the mutual hug.

'Against' relationships

When a child has received movement experiences from an older partner in caring or 'with' relationships and has begun to show initiative and to instigate relationship play, the child is ready to experience relationships against the older partner. This readiness may take some months to achieve in the case of very young children, children with severe learning difficulties, or emotionally damaged children. 'Against' relationships will be much enjoyed in early sessions by confident, active children. They may also provide the only way of reaching some disturbed, hyperactive and aggressive children who find that sensitive, caring experiences are threatening, and may initially only accept relationship play if it is exciting and vigorous. In an 'against' relationship the child tests his or her strength against that of the older partner. Tbe older partner adjusts to the strength of the child, and the child develops controlled strength through these activities.

The aim of 'against' relationships is to help the child to focus and canalise energy and to develop determination. It is important for the child to discover and learn to control his or her own strength and to learn to use that strength in an appropriate way, neither exerting too much nor, on the other hand, exerting too little strength or none at all. The task of the older partner is not to dominate and win battles of strength but to 'feed in' experiences of strength to the younger partner. The older partner tests the younger, encouraging effort, and allowing the child to be successful only as a result of using all the energy and effort of which the child is capable. This may be very little or a great deal. There are some adults who find it difficult to allow children to be successful against them. The child must be successful but should be encouraged to work for it. It is essential that 'against' relationships are humorous and are treated as play.

26 Children with autism beginning an upside-down balance

27 A spectacular balance by emotionally and behaviourally disturbed boys

One of the main problems for children with special needs is the inability to concentrate and so to learn from experience. If children learn to use their strength in a focused way, especially along direct, linear pathways, they will develop skills in attending, in directing their energy and concentrating on a job. As a child learns to direct attention to tasks which are enjoyable and rewarding, he or she will be more able to focus attention on activities which are less immediately attractive. Research has shown that children are more able to relate to each other and are more able to focus attention on tasks in the classroom after a movement lesson than when they have not had a movement class.

Squashing the child The adult lies on top of and across the body of the child on the floor. The child is encouraged to wriggle out from underneath the adult's body (Fig. 28). The adult only rests as much weight on the child as the child can cope with, and the child experiences great satisfaction and a sense of achievement on escaping; the child also enjoys the sensation of being squashed. The adult feeds in an experience of strength and determination.

Rocks Other 'against' activities combine strength with stability and are enjoyed by both mainstream and handicapped children. The adult can help a child to be firm and stable in a sitting position on the floor, knees bent up, feet apart (this is essential as feet together do not provide a firm base), hands with fingers spread out and firmly fixed on the floor. The child is a 'rock'. The adult tests this 'rock' by pushing gently on the knees. If the child's body braces against the pressure, the adult can push a little harder, but must not push the child off his or her base. The adult approaches the child from the front in a controlled way, moving on a direct pathway to help create an atmosphere of concentration. Here the voice can help and the adult's attitude can increase the child's sense of firmness and stability. Eye contact is also direct and concentrated. The adult then tests from the back on the shoulders. Again the child braces against the pressure and calls up strength, particularly in the trunk and legs. The adult begins with very light pressure, increasing it as the child's strength develops. The aim is to give the child an experience of firmness and stability, and not to destroy this.

When it comes to the adult's turn to make a 'rock' and to be tested by the child, the adult encourages the child to push hard on the knees. When the adult feels the child has used all his or her strength, the adult falls over, to the child's great delight.

When working with children with severe learning difficulties who have virtually no concept of strength, the adult should sit beside the child, put one of the child's hands on the adult's shoulder and say 'push'. The adult may need to help the child's arm to push. The adult should promptly fall over. Thus the child is rewarded and will make more of an effort next time. Pushing something away, and kicking with the feet, are actions which are seen early in young children. Doing something to a person is a necessary experience for children who are passive, and this activity may be the first indication that the child has some initiative.

31

28 Day nursery. Wriggling out from underneath a nursery nurse

29 Profoundly deaf children test stability and strength in a back-to-back push

Back to back　　There is a variety of ways in which children can test each other's stability and strength and thus feed these experiences in to each other. The simplest one is for two children to sit back to back, knees bent up. They stick their feet into the ground in a firm, wide base in front of them, and their hands stick to the floor behind them. They then push backwards against each other and see how strong their partner is; the result is usually a static battle (Fig. 29). When adults try this, there is always a great deal of laughter, a reaction to the great output of effort. When older mainstream children work with younger children, they soon understand the concept of testing and not winning, and realise that they are developing strength in their partners.

One variation of this activity is enjoyed by all children. Partners sit back to back; one partner is the 'engine', who gives the other partner a slide, or ride, over the floor. The 'engine' has to work hard pushing with hands and feet against the floor, while the partner who is having the ride bends the knees so as to give the least friction against the floor. He or she also walks the feet along the ground. The aim is to travel as fast as possible and the one who is pushed can steer. Roles are then reversed. When a larger partner is pushed by a smaller partner, the larger can help the smaller by propelling him- or herself along the ground with hands as well as feet so that the younger partner is successful in the pushing action.

A relationship through the back is non-threatening and is often more acceptable than a face-to-face relationship. It is comfortable, and it is easy to make friends with shy children through back-to-back rides.

There are three positions in which the body can be experienced as firm, stable and unmovable. These positions explore the body's power to stick to the floor. We have already considered the 'rock' in a sitting position. In a second position, one partner lies face down, spreadeagled on the floor, holding the ground, expressing the idea 'I shall not be moved'. The other partner kneels at one side and attempts to push the partner off his or her base by pushing or pulling on the shoulder and hip. It is virtually impossible to move anyone who is determined and strong. The aim is to confirm the partner's stability and not to destroy it. There is great concentration of physical strength as well as mental concentration of both partners. Children can use the back to push the partner with, or the top of the head, or the feet. When the child pushes the adult, the adult should allow the child to be successful by rolling over. Lying face down is a stronger position than lying face up, but lying face up has the advantage that the opponents can see each other and enjoy the fun involved.

The third stable position is on all fours with one leg extended sideways, foot on the floor, which acts as an added stabiliser. This tent-like anchored position can be tested from all angles – back, front, and both sides. The tester must give preparatory warning where the pressure is to be exerted by putting hands firmly on the body and starting to push gently at first. It is an interesting experience to feel the body brace against pressure and acquire organised strength. It is possible to feed in intelligent use of energy so that the person who is tested gains greater mastery and control over the body. (See Figs. 30 and 31.)

30 Children with severe learning difficulties testing a 'rock'. The girl is stable, but the boy has little awareness of strength

31 Directing energy and 'finishing a parcel'

Prisons The simplest way to introduce strength against a partner is for the older partner to make a containing 'house', sitting on the floor with the child between the legs. The 'house', which is initially a receptive, cradling, sensitive container, becomes a 'prison' when the older partner's arms and legs squeeze and grip the child (Fig. 32). The child is encouraged to wriggle out using the 'front door' (the arms can be prised apart), the side 'windows', or out of the 'chimney'. The older partner lets the child escape while providing just enough restraining power to make the child struggle hard to escape. Most children, having escaped from their 'prison', promptly jump back inside for another battle.

Some very young children cannot understand the concept of pushing against the adult and stay inside passively. If they are held loosely and encouraged to emerge, they may do so. Some children, especially those who are socially deprived, may like being held tightly in a 'prison' so much that they have no wish to escape from this pleasant and probably unfamiliar security.

In the case of energetic and perhaps emotionally disturbed children, the battle to get out of the adult's restraining 'prison' is much enjoyed and provides a safe and vigorous exchange between adult and child. It is a paradox, but 'against' relationships often strengthen physical and psychological contact between adult and child. There is a strong element of play, of rough and tumble and of drama in this type of activity. So much depends on the older partner's estimation of the determination and strength of the younger partner. If escape is too easy it is unsatisfying.

When working with adolescents or adults, those who make the 'prison' should sit behind their partner with legs round the partner's waist, crossing their ankles over their partner's stomach. They put their arms under the partner's arms and hold their own wrists. Being strongly gripped in this way often leaves the prisoners helpless, but with great effort and after a great battle the prisoners eventually escape.

There are some children who are almost impossible to hold. They manage to slide out of any grasp. They are usually highly disturbed children and an 'against' relationship of this type is not appropriate in the early stages of building a relationship.

Caregivers need to have a good relationship to their own strength; that is, they should develop their capacity to be strong and to use this strength in a positive way, should the need arise. They should learn to control this strength and adapt it to the needs of other people in relationship play activities. They also need to be able to use the opposite aspects of energy – sensitivity and fine touch – when it is appropriate. Children instinctively know if the adult has a good relationship to his or her own strength. Many more women than men work both with mainstream children and in special education, and it is essential that they develop this awareness of their own strength.

Boys particularly enjoy the testing of their strength and the rough and tumble of 'prisons'. The teacher has to balance a programme so that the 'against' relationships are interspersed with caring or 'with' experiences. Boys and girls both need experiences of being strong and stable as well as those of being gentle and free flowing. The balancing of opposites is important.

35

32 An older boy with moderate learning difficulties makes a 'prison' for a younger child in his school

2

Developing body awareness

Early development

Significance of early learning experiences

Babies receive movement experiences from their parents or caregivers, who feed in both physical and emotional security as they handle the young child. A confident, experienced caregiver will communicate trustworthiness, competence, sensitivity and awareness of the baby's needs. In handling people of any age, the aim is to be both firm and sensitive. This may seem a paradox, but the firmness induces confidence in the recipient and indicates that the handler is confident in what he or she is doing; sensitivity is experienced as the handler's sympathetic adaptation of the activity to the particular needs of the recipient. Many people are unaware of the messages they are conveying when they handle children, particularly to young babies who are passive recipients and can do very little for themselves.

This sensitivity requires the caregiver to put him- or herself into the situation of the very young child, to anticipate what the child will experience and to make the experience as pleasant and as acceptable as possible. The caregiver needs to accompany activities with a warm supportive voice, talking, humming or singing. Gentle, rhythmical bouncing is comforting, as is gentle swaying from side to side.

Many parents and caregivers have to learn how to handle their first baby. In the not-so-distant past, children in large families looked after their younger brothers and sisters, but these days it is quite likely that a mother has never handled a baby until she has her first child. If she is nervous about handling her baby, this will be communicated to the child. The inexperienced parent has to learn on the first child. The parent, or anyone else, handling a young, physically handicapped child, is understandably nervous and is often tentative and anxious about harming the child. All young children feel safer if they are handled firmly and confidently. The adult has to develop this confidence through practice and experience. If the adult has had personal experience of confident, warm handling as a child, this is likely to be passed on. In movement sessions for profoundly and multiply handicapped children, it is easy to identify those caregivers who have brought up children or who are

physiotherapists. Their confidence, firmness and sensitivity are transmitted to the children. Some people are more skilled than others at creating a rapport with children.

In the early stages the baby is supported, dressed, undressed, contained, carried, bathed, cradled and played with, and the way in which all these activities are carried out will be an important part of the baby's first experiences.

Containing and cradling are whole body movements which feed in to the child his or her totality and weightiness, and have a harmonious effect on the child. The more the baby's body is in contact with the parent's or caregiver's body, the better. The baby who is carried on the front or the back of the adult experiences the rhythms of the adult walking, working, and generally moving about. The child benefits from the sensory stimulus of the adult's movement as well as from the warmth of the adult's body. Physical contact and closeness are very important for the developing baby.

On the whole, babies' bodies fit into the bodies of the adults who hold and carry them. They melt and mould themselves into the adults' bodies in a flexible, resilient way. Babies who have not been held in a warm, caring way are less likely to have responsive bodies. During movement sessions such children often have tense, rigid, non-communicating and unresponsive bodies, while those who have been handled well respond readily and spontaneously to movement experiences. The early learning experiences of being safely held and contained with good feeling have a marked effect on a young child's ability to respond to human contact and to form relationships. Experience has shown that it is possible to help a mother who has had post-natal depression to play physically with her baby, so that although the baby may have suffered initially, a good rapport is eventually built up between mother and child.

Babies respond to having their bodies stroked or massaged. Some African and Asian mothers massage their babies as part of their culture, and massage can be a means of working oil into the baby's skin. In the West we do not have a tradition of massaging babies, but babies do benefit from it both sensorily and psychologically, and it is a valuable means of communicating the mother's concern for her child.

Besides stroking babies it is important to pat and tickle them. Patting and tickling can be quite strong or very gentle, adapted to the needs of the child. Feeding in physical experiences can be repeated as the child grows. It is easier to work with a child who has received physical attention of different kinds.

The baby's interaction with the parent or caregiver

All movement play is a kind of conversation. In the beginning the parent initiates the relationship and the child responds. Parents of handicapped children may find they elicit little or no response, and may feel disheartened and cease to try to stimulate their children. Handicapped children need more sensory stimulation and more attempts at building a relationship than normal children, but it is understandable that parents

and caregivers lose heart if they receive no feedback or very little response.

It is important to encourage the child to focus on the adult's face, particularly on the eyes, and to enjoy and respond to a variety of sounds and noises, and language, made by the adult. This is the beginning of communication. Later the child may initiate his or her own movements and sounds; the adult needs to imitate these and feed them back to the child. The habit of making eye contact can be developed early and needs continuous reinforcement.

Some mothers are under so much stress that they are unable to play or relate to their children; they are in great need of support, and this applies particularly to parents of handicapped children. The time when these parents most need help is at the beginning.

Development of physical skills

Normal babies develop their own powers of moving their limbs. Vigorous kicking movements are seen early, and gradually the control of grasping develops. The physically handicapped baby needs to be stimulated and moved passively to try and feed into the child that he or she has a body. Every handicapped child is different, and it is essential that the family of a handicapped child has professional help from a physiotherapist so that they know how to handle and help their child from a very early age. It is important not to move the child mechanically, but to make the experience as enjoyable as possible, making the learning a play situation.

The caregivers of the handicapped child need perseverance and patience, and they need all the support and advice they can get for the treatment of the child. There is a great temptation to leave a passive, undemanding child to lie quite still all day. Some children with profound and multiple learning difficulties go to schools for children with severe learning difficulties, and may function as if they were a few months old. There is a great need for teachers of these children to have specialist help both in physiotherapy and in movement education, and this information should be passed on and shared with parents and caregivers. (See Chapter 6.)

Whenever possible the young baby should lie on his or her stomach with the head turned to one side. There should be no pillow. Every time the baby lifts the head to turn it, all the muscles of the back and neck are used and are gradually strengthened. It is important to develop strong back muscles in preparation for sitting. Later, if the baby is continually propped up against a pillow, he or she will develop a weak, rounded spine and will find sitting up straight difficult. Being able to sit securely is an important developmental achievement, as then the child's hands and arms are free to reach for and handle all kinds of objects, and hand/eye skills can develop. Sitting is also important for the development of skills involved in eating, chewing and swallowing. The muscles used for chewing food are also the muscles involved in the development of speech. Early on it is advisable to encourage a baby to lift the head from a prone position so as to develop the back muscles.

The next stage of movement against the pull of gravity is for the baby, in 39

a lying position, face down, to push with the arms and raise the top of the body off the floor. The baby will do this partly to see better, and this is the beginning of achieving a position on all fours, preparatory to crawling. It is fascinating to watch a young child experimenting with the ways of coping with the weight of the body. Having pushed the chest off the floor, the child then sits back on his or her heels, supporting the body on the hands and knees. When the child achieves a position on all fours, he or she sways unsteadily. The normal child will discover for him- or herself how to crawl; the handicapped child can be helped to achieve a position on all fours and encouraged to make the first efforts at crawling. (See Chapter 6.)

An earlier form of locomotion discovered by some babies is to roll from one place to another. It is useful to teach a baby to roll over; this can be done by placing an arm or a leg across the body when the baby is lying on the back and pulling it gently. Eventually the baby will learn to turn the rest of the body. With encouragement the baby can learn to turn onto the back again. Adventurous babies will explore a room by rolling. It is advisable to encourage the baby to crawl rather than to let the child use a method of locomotion that is sometimes seen, where the child uses one leg to propel the body forward in a sitting position, while the other leg is tucked underneath. This is because it is better if both legs develop equally in a crawling action. Many people consider that crawling is an important stage in development because it involves the coordination of all four limbs and use of the limbs on opposite sides of the body. Crawling also involves balance and management of the weight of the body, and helps to develop body awareness. However, the method of travelling on the bottom is necessary for children who are visually handicapped. They need to be able to feel what is in front of them with their hands so that they don't hit objects with their head.

Babies love to stand on their parents' thighs and kick against the thighs of the adult, just as they enjoy kicking when they are lying in a cot. This pushing against the adult and extending the knee joints should be encouraged because by doing so the child is strengthening the thigh muscles, in preparation for taking the weight of the body when standing. Any activity which helps the child strengthen thigh muscles is helpful. Taking weight on the long bones of the legs also encourages the bony tissue at the end of the long bones to be strengthened and to grow. When the baby eventually pulls him- or herself into a standing position, the muscles of the legs will be well prepared to take weight. Every step in development can thus be prepared for beforehand.

Normal children are geared towards defeating gravity in learning to sit, crawl, stand and walk; to a large extent they will teach themselves to develop these skills. The handicapped child will experience varying degrees of difficulty in acquiring these skills and will need a great deal of encouragement and, ideally, professional help from a physiotherapist or an experienced teacher.

Pre-school children and school children

It is most important that children become aware of their own bodies. Many writers have discussed the concept of body awareness, and it is interesting to note the different ways of describing this: body concept; body image; body consciousness, body sense; body schema.

On the whole, physical education teaches children to perform skills in manipulating objects such as balls, beanbags, hoops, bats, etc. and to develop skills in relation to movement on large apparatus, climbing frames, slides, swings, etc. These skills which we might refer to as 'objective skills', are valuable to the child and have an important place in education. However, in this book we are concerned with a 'subjective' approach to movement education; that is, with developing awareness of the body. Both approaches to education are necessary; the child should be aware of his or her own body, and learn too how to handle objects and how to cope with the external world. The child needs both 'objective' and 'subjective' skills. Much has been written about acquiring objective skills of all kinds and about the development of hand/eye coordination. Here we are concerned with the development of body awareness.

Movement of the body as a whole

It is important to feed in a sense of wholeness to the child and not concentrate only on movement of separate parts of the body. Whole body movement involving the free flow of weight has a harmonious effect on all children. Wholeness is experienced particularly in rolling on the floor, where weight is used to facilitate the roll. It is also experienced in all forms of bouncing, which can, in addition, be a calming activity. On a trampoline or trampette the child experiences the full weight of the body against the bed of the trampoline and learns to use weight in a positive way. The child may bounce in a standing or a sitting position. Any work on a trampoline must of course be supervised by a qualified instructor, as it can be dangerous.

Sliding is another free-flow experience of the whole body which is enjoyed by children, whether along the floor or down a slide. Swinging on a swing changed the mood of one highly disturbed eight-year-old girl in a school for children with moderate learning difficulties. After twenty minutes on a swing she would calm down and was able to work in the classroom without attacking other people. Swimming, and playing in water, also have a calming and harmonising effect on children.

Awareness of the weight-bearing parts of the body

It is essential, wherever possible, to help children to develop skills in locomotion of all kinds. Children should be able to stand, run and jump, and be able to take part in a variety of sports, dance, and outdoor activities. If the lower half of the body is well educated, the upper half will

look after itself; it is essential to develop a well-functioning basic structure.

On the whole, movement of the non-weight-bearing extremities and the feet are well covered in physical education programmes and in hand / eye activities in the classroom. Children are aware of their feet and hands, parts of themselves which they can easily see and move, but they have to be helped to become aware of their knees and hips. Many children with severe learning difficulties have little control of the weight-bearing parts of their bodies and walk with a wide gait in an effort to maintain balance. Caregivers should concentrate on developing awareness of parts of the body that are not easily seen, of which the child is often unaware, and which play a significant part in all movement.

Awareness of knees Children of all ages, those with special needs and mainstream children, benefit from activities that help them to become more aware of their knees. The knees are the 'halfway house' between the hips and the feet. They are the most important joints for controlling movement of the body in standing, walking, running, jumping, landing, being stable, changing direction, sitting down and standing up. The muscle which controls the knee joint, helping to hold the joint firmly and to extend it, is the quadriceps muscle, the four heads of which extend from the pelvis to the kneecap and into the front of the tibia. If the knee joint is damaged, the muscle tone is lost quite quickly in the thigh muscle and this has to be built up to make the knee joint secure again.

When working with younger children and children with special needs, it is helpful to begin the process of knee awareness by sitting on the floor so that the legs are not bearing weight and can move freely. The children hold onto their knees so that they can feel what is happening to them. They bend their knees up and press them down to straighten their legs out. This is called 'the disappearing knee trick'. Children find many humorous ways of making their knees bend and disappear again. They can, in mime, 'pump up' one knee and prick it with a pin; they can 'wind up' one knee, or pull it up with a thread, and cut the thread. There are many variations on this, some of which the children will find for themselves. For example, still holding onto their knees the children press their bent knees together and then separate them as far as they will go sideways, still bent. They hammer their bent knees with their fists, enjoying the sound. They smack their bent knees, noticing the different sound this makes. They rub their knees and tickle them lightly. The knees should sting a bit as a result of all the hammering and smacking, which helps the children to realise they have got bony knees. The children knock their elbows on their knees and cross them over to touch the opposite knee, crossing the mid-line of the body. They can join their chin to the knee and the nose to the knee. It is useful to feel bone on bone and to join children up to themselves.

Weight bearing The next stage is perhaps rather painful for adults but children enjoy it. The children kneel up on their knees; this may be the first time they have taken weight on them. They can walk on their knees or slide on them using their hands on the floor to propel themselves along. They can

change direction moving backwards and sideways as well as forwards, and they can turn round. These experiences help the children to retain awareness of their knees even though they are now bearing weight and are difficult to see.

Shutting and opening Children enjoy other forms of travel or locomotion that make them aware of their knees and elbows. They curl up, face down, on the floor with their knees and elbows touching on each side. They shuffle forwards with little steps, keeping their knees and elbows close together. With their heads tucked in the children feel very small and can concentrate on the experience of being close to themselves. Then they can try the 'opening/ shutting' animal. They slide their elbows forwards along the floor and slide their knees backwards so that they are lying full length on their stomachs on the ground. With a sudden snap they join their knees and elbows together in a 'shut' position. In this manner they can make progress along the floor, moving forwards by bringing their knees up to their elbows. Many ways of getting about using hands and knees can be discovered and encouraged. The physical contact of the knees against the floor helps the children to experience their knees preparatory to the next stage, in which the children take weight on their feet and legs.

Little legs The children now get into a squatting position on their feet with their knees near their shoulders. They still hold onto their knees so that they do not forget them. With these 'little legs' they can walk, hop, and jump like a frog. They can move forwards, backwards, sideways, and turn round. The knees can move close together, or very wide apart. 'Little legs' are much enjoyed by children as they feel they are like creatures or little people. They are very inventive, discovering different ways of getting about, far more so than adults, who are more conventional.

 The children now 'grow legs', and with their feet apart in a stable position they slowly extend their knees until they are almost standing, but with slightly flexed knees. They can also 'grow legs' in a series of small jerking movements like a puppet. Now that weight is taken on the legs it is easy to forget about the knees so the children still hold onto them and walk about using different directions and different rhythms. The knees can be stuck together or kept wide apart, and they can cross over in a scissor-like way. The children can walk or jump holding onto their knees. They can jump one knee high up sideways and then the other; they can do little jumps on both feet; they can turn around with one knee leading the turn. As they move they feel that their knees are the most important feature of their bodies.

High knees The final stage comes when the children stop holding their knees, and walk and jump. They are still aware of their knees, but now their knees can move more freely. It is useful to help the children experience 'high knees', taking one knee at a time. First the knee jumps forwards up to the chin, then one knee jumps sideways to try to touch the ear. With the child on all fours, one knee can be *lifted* high backwards. It is safer not to *jump* the knee backwards as the child could fall on the face. In this way the child discovers that the knee can be lifted high forwards, sideways and back- 43

wards, and this loosens up the hip joints and teaches the child about directions in space. So often children only jump with their feet together. Movement into space behind the child, where the knee is out of sight, may be difficult initially for children with severe learning difficulties because they cannot see where their leg is. Awareness of space behind can develop quite early, for example when a young child goes downstairs backwards, reaching for the next step.

The teacher now asks the children to run and jump with high knees. This is going against gravity, and elevation may be difficult for severely retarded children. The experience of height and jumping is a necessary contrast to body movement close to the floor. It is best not to jump off two feet and land on two feet as the jump and movement of the legs is restricted. The leap high in the air is off one foot and the landing is on the other foot so that there is a sense of flight and free flow, particularly in the flying legs. Height is achieved by the force of the knee swinging upwards, and with help from the elbows.

Having experienced elevation from the knee, the children can start to control the jumping action and become more familiar with the use of their legs to obtain height. Skipping involves elevation of the body with first one knee leading and then the other, while the supporting leg does a hop. The coordination for this may be difficult at first. Galloping is enjoyed and involves the consecutive lift of each knee. The aim is to develop free-flowing experience of leaving the ground, to defeat gravity, and to retain awareness of the knees during the main part of the necessary effort.

The corollary to flying is to learn how to fall; this will be discussed later (see pages 50-2).

Expressive legs Mainstream children enjoy discovering the expressive use of their legs. They like to find out how to walk with their knees stuck together or with them kept wide apart. They particularly enjoy walking with wobbly knees, or 'jelly' knees, where they have little control over their legs and nearly fall down. This is contrasted with stiff legs with knees pressed back ('no knees'), which makes getting about difficult, or the jelly legs may be contrasted with strong, stable legs with slightly flexed knees. There is muscular control of the knee joint when the leg is flexed.

Children with severe learning difficulties find it very difficult to allow their bodies to be off balance. Many of them need a great deal of help to develop stability and to acquire a normal gait as opposed to a wide or shuffling gait, and it is not appropriate to ask them to move in an off-balance way.

Funny walks Mainstream children enjoy working with a partner who moves in an opposite kind of way: one may squat and walk with 'little legs', while the partner moves with long straight legs. Other partnerships can involve a child who has knees wide apart and is stable while the other moves with knees stuck together, or may have wobbly legs. Drama develops with one partner leading and the other following. Children are inventive and enjoy funny walks. The expressive use of legs is a hallmark of many comics and clowns.

33 Children with severe learning difficulties exploring high space

Awareness of hips Because the hips are central and are not easily seen, they are a difficult part of the body to become aware of.

All children like spinning on their bottoms on a slippery floor. They push themselves round with their hands and enjoy the free-flow spin. It is useful to suggest that at the end of their spin they fall over. It is likely that one child will do this by accident and the teacher will pick this up and ask all the children to try it. It is important that children can fall with confidence in a relaxed and fluent way, so that the experience is not painful. Older children can 'walk' on their hip bones, though this can be painful for thin people.

Children can also become more aware of their hips by lying on their backs with their knees bent up and feet firmly placed on the floor, a little apart for stability. They lift up the hips, balancing on their shoulders and their feet, making an arch with their bodies. A partner can creep through this tunnel.

Children can be helped to become aware of their hips when they somersault over an older partner's shoulder (as described in Chapter 1). The older partner sits, legs stretched out, and the child stands behind the partner. The child feels the spine unrolling along the floor or mat and should be aware of the hips touching the ground at the end of the somersault. When a partner rolls another child along the ground the partner should handle the child on the hip and shoulder and should be aware of the hip girdle and shoulder girdle of the other person.

The most difficult test of awareness of hips is experienced when two people balance each other in standing (see page 28). They face each other holding wrists; they are stable with feet apart and knees slightly bent with their hips kept over their heels, their base. If the pelvis swings forwards or backwards the partners will find it difficult to support each other. The ability to balance the hips over the heels is essential for many sports, particularly skiing.

Awareness of the hips is also seen in bunny jumps or crouch jumps when weight is taken on the hands and the hips are lifted up into the air. High hips are also seen when one partner makes a supporting 'horse' on all fours; the other partner places hands on the 'horse's' hips and shoulders, and jumps the hips high (see Fig. 21).

When a partner tests the stability of a child who is in a stable position or on all fours, the partner must use the whole body, including the hips. There is a tendency for the arms to push forwards while the hips extend backwards. This is an uneconomic use of strength as the tester's weight is not going with the action (Fig. 30 shows a mentally handicapped boy who is unaware of his hips and knees.). Children with good coordination will push, pull or hit a ball with their hips, moving in the same direction as the rest of the body; they take their hips with them. When the centre of gravity is lowered, as happens regularly in all sports and in dance, the hips, the heaviest part of the body, must be balanced over the heels and not allowed to project backwards, as this will lead to lack of control of weight. The hips and spine are the most difficult parts of the body for people to become aware of.

Awareness of the trunk

For all children, particularly young ones, the trunk is an unknown area. The trunk is the link between the extremities, and children who are unaware of their trunk will move in an empty, disconnected way. This is particularly noticeable in developmentally retarded children. A child who is aware of having a centre will move in a connected, whole way. Awareness of the trunk can be observed when children are transferring weight in rolling, tumbling and falling activities. The child experiences the front and back of the trunk against the floor, mat or gymnastic apparatus, and against the bodies of others in activities such as rolling, somersaulting, sliding and creeping.

If a child has a sensitive, mobile centre of the body, this indicates that the child is learning from bodily experiences. It indicates that new experiences are going into the child's body. This is clearly seen when a child is slid along the floor being swayed from side to side. If the waist bends from side to side in a flexible and fluent way, this indicates that the child is relaxed and that information is going into the body. It is impossible to teach new skills in body awareness if the centre is rigid. The stomach and solar plexus are particularly important areas of the trunk and cannot be separated from awareness of shoulders, back and hips.

All the activities which increase awareness of the trunk should be presented in an enjoyable way so that learning is experienced as fun. Awareness of the trunk is best developed against supportive surfaces such as the floor, because the body can move more freely when it is well supported than when the body is standing and balance is a problem. The child is not then concerned with maintaining balance and the trunk can move with greater flexibility from a spatial point of view, and develop greater mobility in all the joints.

Lateral trunk movement

The spine is often stiff and rigid, but children can be helped by learning to creep like a lizard. They should be encouraged to lie on their stomachs on the floor, with the elbow and knee of one side touching. This means that the spine is curved and is concave towards that side. The other hand reaches forwards and the other foot pushes the body forwards until the elbow and knee of the other side of the body meet and the spine bends towards that side. In this way the child creeps forward along the floor, obtaining maximum bending from side to side of the spine. This curving of the spine can be observed from above, and it is useful for a partner to stand above the creeping partner and see how the back bends.

It is possible for physically handicapped children and adults to progress over the floor in this flexible manner, even if they cannot stand. They could even creep over each other until they make a pile of people in the middle of the room. Physical awareness, independence of locomotion, and physical contact, are particularly significant for people who are constantly in wheelchairs. While creeping along the floor, eye contact is focused on other people because it is difficult to look elsewhere.

Unfortunately, not all floors are suitable for spinning, sliding and creeping. Ideally the floor should be clean, slightly slippery, and warm to the touch.

Awareness of the centre

If children can curl up, they are aware of having a centre to curl up to.

Parcels

The simplest way to curl up is to make a 'parcel' or 'package'. The child should lie on his or her side and hug the knees. The partner can then test the child's strength in maintaining a curled-up parcel by pulling gently on the child's limbs – if the child is young or only has a little strength – or pulling vigorously if the child is strong. It is essential not to succeed in opening the parcel; the aim is for the child to develop strength by resisting being opened out.

Many children with severe learning difficulties have little or no awareness of a centre and will have to be helped to curl up. An adult can hug and contain a child to give the child an experience of being curled up in a ball shape and close to him- or herself. Being curled up and centred rather than extending into space is important because movement into space must come from a 'home', a centre, for it to have any meaning. One often sees children in dance sessions and in gymnastics who move in an empty and disconnected way; the movement is peripheral and does not grow from the centre. Once the centre has been experienced then movement into space has some meaning.

Children can experience what it is like to make a parcel by trying to open a parcel made by the teacher. The teacher lies on his or her back, hugging the knees. The children pull at the teacher's arms and legs (not more than eight at a time!), and the teacher slowly allows the group to be successful in opening him or her out, making sure that the children have to work hard in doing so.

A stronger test of the ability to maintain the centre can be tried with more able children. The children curl up face down on the floor and the adult lifts up each child, holding them under the chest and waist. The children keep curled up against gravity; they keep their 'undercarriage' in position while being lifted up (Fig. 34). It is only possible to do this with relatively light children between the ages of three and seven. Children enjoy this and have a sense of achievement. If children come 'undone', one should go back to testing them lying sideways and curled up on the floor.

It is a good idea to work on 'parcels' before attempting somersaults, as children develop the skill of keeping their noses near their knees and keeping their bodies curled up. This means that when they attempt somersaults they will not open out but will keep their bodies in a ball shape throughout the somersault.

It is interesting to compare the ability of a mainstream child of three or four to maintain a parcel against gravity with that of a developmentally retarded child. The child with a well-developed knowledge of the centre will stay curled up, even if only for a few moments.

Forward and backward somersaults (see Chapter 1) teach the child to stay curled up while upside down, and to keep curled up throughout the activity. Sometimes a child will perform an arched back bend when attempting a somersault over a supporter's shoulder, instead of curling

34 'Parcels'. This profoundly deaf child has good awareness of her centre

up and doing a forward roll. The child will need help in maintaining a curled-up position, as it is not good for the spine to be extended so far back.

Besides teaching the child to curl up, somersaults also teach the child to transfer weight successively through the shoulders, back and hips. An 'educated trunk' indicates that the child can move with free flow, flexibility and a high degree of body knowledge, and awareness of how to transfer weight through the body in an economic and fluent way.

Rotation in the trunk

Curling up is a symmetric movement, but twisting is asymmetric and is seen when one part of the body initiates a turning movement, followed by another part of the body. This is seen most clearly when the child is lying on the floor and rolls sideways in a flexible, sequential way, with the shoulders leading the roll followed by the hips, or vice versa. Many children roll in a rigid way, like a log, and will need help to obtain a twist in the trunk. The aim of the flexible roll is to develop flexibility in the body, mobility in the joints of the spine, and fluency in movement.

Rotation in the trunk is also experienced when the child moves from one activity to another, making smooth transitions between the activities. For example, children might sit on the floor, spin on their bottoms, fall over sideways, roll onto their stomachs, and then with a quick twist, sit up again. This involves preparing the body for each new position and action in a sequential way, and demands intelligent use of the body in the management of weight.

An energetic rotation is experienced when children lie on their stomachs with no limbs touching the floor. With a quick twist they roll onto their back, again with only the back touching the floor. Face down, the body is in an open position; on the back the body is in a closed position. A series of rolls and twists in this fashion develops a flexible, mobile use of the trunk, and is enjoyed by more able children.

Learning how to fall

It is important for all children to learn to fall safely and without hurting themselves, but this is even more important for children with learning difficulties. Children can learn in progressive stages how to fall.

1 The smallest fall of the body is experienced when the body lies on one side and falls onto the back (see page 10).
2 The next fall is experienced from a sitting position on the floor with the knees bent and wide apart in a cross-legged position. The body falls to one side, weight is transferred to the thigh, onto one hip, onto the elbow, upper arm and shoulder, and then onto the back, the body remaining in a ball shape throughout. The knee, thigh, hip, arm, shoulder and back can melt quite softly into the ground. The body can then swing up onto the other side so that the child rises up into a sitting position again. The body is experienced as a rolling ball.
3 Children can curl up, face down on the floor, roll sideways onto their back and continue the roll until they are face down again. This curled-

35 Going for a ride and trusting a young friend

up roll is helped if the children slide their knees apart, which makes the transition of weight smoother and more fluent. The children also push with hands on the floor.

4 The next stage is to fall from a position on all fours. The child sinks to one side onto the floor, preparing the trunk to take weight by bending one arm so that the elbow, upper arm and shoulder are ready to support the body. At the same time the knee, thigh and hip of the same side rest on the floor until the child rolls smoothly onto the back. The roll can be continued until the child is on all fours again. This sideways fall and roll is the most comfortable way of falling. It can be practised on a mat, and it is a useful landing strategy when jumping and landing from a height. The body has to turn sideways in the air before the landing. The child lands on hands and feet – a four-point landing – as if he or she was pouncing on the floor; the child then tumbles sideways and rolls.

5 The child can be helped to fall from a kneeling position and then from a standing position. Each time the body 'melts' on one side and parts of the body are ready to take weight safely and fluently.

6 The next stage is to jump on the spot and land on the feet and hands in a pouncing action, and then let the body dissolve into a sideways roll as before.

7 The last stage is to run and jump, make a slight turn in the air so that the body can land with a pouncing action – a four-point landing – and then roll sideways in the same pathway as the run.

Flying and falling call for extremes of weight management, and extremes of height and depth. More able children enjoy running and falling; some fall and slide, some fall and tumble. Less confident, less skilled children need plenty of experience in the earlier stages of learning to fall, so that they develop confidence in the mastery of their bodies. When they find that falling is not necessarily painful, they are more prepared to tackle gymnastic apparatus which involves leaving the ground. In preparation for gymnastics it is helpful to teach falling onto crash mats. These give children with severe learning difficulties encouragement to jump from a height. The aim of all movement education is to develop self-confidence in children through increased body mastery and control.

WHY WE TEACH IT

Movement analysis: The diagram opposite has been adapted from Laban's movement theory as follows.

The circle in the centre of the diagram represents the whole body, both the central part and the extremities. Below this are the two opposite attitudes to gravity: giving in to gravity (allowing it to work on the body), and going against gravity. The six directions in space are listed on the left. Above the circle are relationships with others, and on the right are the movement qualities; the arrows within the box indicate that they are on a continuum. The word 'gentle' is used here rather than 'light' (a more appropriate word might be 'sensitive'), and flow is described as 'controlled' rather than 'bound'. 'Quick' and 'slow' replace Laban's terms 'sudden' and 'sustained'.

3

Movement analysis: Laban movement theory

Laban developed his theories of movement during his lifetime, and by the time he came to England in 1938 most of his ideas had crystallised. I have taken aspects of his movement analysis that are relevant to the needs of the people I teach and have developed a diagram which encapsulates these aspects of human movement (see below). Teachers of movement benefit from personal experience of these different aspects of movement; they need to be aware of *what parts* of the body are moving, in *which directions* in space they are moving and, most important, *how* the body is moving.

Laban's movement analysis falls into three main parts.

MOVEMENT ANALYSIS

RELATIONSHIPS	
threes fours whole group	partner: with/against/ shared

DIRECTIONS

high	low
side	side
back	forward

awareness of parts of the body

awareness of the trunk

MOVEMENT QUALITIES
energy
strong — gentle
flow
free — controlled
space
flexible — direct
time
quick — slow

giving in to gravity	against gravity

RELATIONSHIP TO GRAVITY

key:
rolling
back to back push
jumping in threes

55

1 What part of the body is moving?

In order to assess this, the observer should ask him- or herself the following questions:

- Is the body moving as a whole, or is only one part of the body moving?
- Is the top half of the body involved in the movement, or is it mainly the lower part of the body that is moving?
- Is the central part of the body moving, or is movement confined to the periphery (hands and feet)?
- Are the 'halfway points' – the elbows and/or the knees – being used?
- Is the body moving in a coordinated way?

The body may move in different ways:

(a) in a *successive* way, as for example in hitting or throwing – the different parts of the body move sequentially;
(b) *simultaneously*, for example in a thrusting or pressing action – in a pushing action against a partner the whole body should move in one direction at the same time.

2 In which directions in space is the body moving?

Laban describes the movement of the body in six directions: backwards/forwards, high/low, side to side. Teachers can encourage children to move in directions that are normally neglected and thus enrich their awareness of space.

Backwards and forwards On the whole, everyone moves naturally forwards, and the teacher will have to suggest to the children that they can move backwards, or extend a limb backwards. Using space behind them is difficult for children with severe learning difficulties, because they cannot see what they are doing.

High and low Extending high into space and moving low at ground level should involve the whole body. Often an arm reaches high while the head continues to look forwards, and there is no upward intention in the trunk. Movement low down, at ground level, is often avoided. The greatest extension in these directions is the experience of a leap followed by a fall, first defeating gravity, and then giving in to it. This activity is much enjoyed by primary school children who have been taught how to land correctly (see Chapter 2). When the body moves upwards, this is often accompanied by a feeling of lightness, weightlessness, and when the direction of the movement is downwards, as in a pressing action, the movement is often accompanied by strength.

Sideways Movement sideways is a further help in awareness of spatial directions. If both arms move symmetrically sideways, the body inevitably opens out. If the arms come close to the body, cross the mid-line and move towards the opposite side, the body moves into a closed position. The legs can also

move far apart sideways, or cross over in a scissor-like action. The whole body can move sideways. When working on awareness of knees, the teacher can suggest that the children move their knees backwards, sideways, high and low, and encourage them to develop their own ways of exploring space (see Chapter 2).

These six directions constitute what Laban called the *Dimensional Scale*. He developed far more complex scales in the three-dimensional use of space, and he emphasised the importance of the pathways of movement connecting points in space.

If children have not developed awareness of their bodies, movement into space becomes meaningless and empty. With the development of some body awareness, the spatial directions begin to have greater significance.

Words such as 'behind', 'backwards', 'in front', 'sideways', 'beside', 'high', 'low', 'on top', 'under', 'over', have meaning for the child because they have been physically experienced by the body.

3 How, and in what way, is the body moving?

This is the most important of Laban's movement analysis, and the most difficult to describe. To be understood, this aspect of movement needs to be fully experienced. Laban separated out four distinct aspects of human movement:

- An attitude to *energy* (also referred to as *weight* or *force*)
- An attitude to the *flow* of movement
- An attitude to the *spatial pathways* of movement (which is different from directional movement in space; movement may involve all three dimensions)
- An attitude to *time*

He called these aspects of movement *motion factors*, or *movement elements*, and defined them as *energy, flow, space* and *time*, respectively.

He described the opposite attitudes to these motion factors either as 'fighting against them' or as 'indulging in them' (or enjoying them).

Energy Contrasting attitudes to energy can be expressed, at one end of the spectrum, as 'extreme strength', and at the other end as 'extreme lightness' or 'fine touch'. There are many gradations in between.

Flow This may be a difficult concept to appreciate. The person who fights against the flow of movement is very controlled and can arrest the movement at any time. The movement is under the control of the will. The opposite attitude to the flow of movement is seen when the movement is out of control; once started it cannot easily be stopped. This is seen, for example, in hitting and throwing actions, in spinning and turning movements, in rolling, jumping and running. Some dance styles accentuate controlled or bound flow, as in the pavane and minuet. The whirling

57

dervishes, for example, demonstrate continuous free flow. Exaggerated free flow can produce a trance-like state.

Laban also described another aspect of flow – broken flow – where movement is jerky and arhythmic.

Space
There are two opposite attitudes to space. A person who fights space moves along straight lines, using space economically. The result is direct, linear movement. Direct intention and direct movement are well illustrated, for example, in the actions involved in playing snooker. On the other hand a person who enjoys space moves three-dimensionally, using all the space available: behind, in front, above, below, at each side. The pathways in space are curved, flexible, twisting, convoluted. Flexible winding-up and unwinding movements of the body are seen in a tennis service, although the flight of the ball is directed. There are many degrees in the use of space involving one-dimensional, two-dimensional and three-dimensional movements.

Time
This is a relatively easy motion factor to observe. Some people move quickly, suddenly, hastily, and fight time; others indulge in time and move slowly and with sustainment. In school and in daily living, emphasis is for the most part on speed. It is rare to see a truly sustained movement. It can be seen in the Noh theatre of Japan, and in some yoga movements where the emphasis is on the inner experience of the movement. Sudden movement is particularly dramatic when it follows stillness or slow movement.

Movement qualities
We now have eight movement qualities:

1 strong	**3** bound flow	**5** direct	**7** fast
2 light	**4** free flow	**6** flexible	**8** slow

On the whole, in teaching or observing young children, we are mainly aware of one or perhaps two of these qualities. It is rare to see as many as four at once.

If we take all the fighting attitudes – strength, bound flow, directness and suddenness – we get a punch or a thrust. The opposite attitudes - lightness, free flow, flexibility and sustainment – produce a floating action. *Punch* and *float* are two of Laban's eight *efforts*, which are the different combinations of the eight qualities of movement. Some people use *gliding* movement, involving light, bound flow, direct and sustained qualities. Others use *hitting* actions, involving strength, free flow, flexible and quick qualities. The four other efforts are *press*, *wring*, *flick* and *dab*.

As teachers we should concentrate on the eight movement *qualities* listed above, noticing which are present, which are latent, and which are absent, because this influences what we teach.

In the diagram on page 55, three activities – rolling, the back-to-back push, and jumping in threes – are represented by different arrows. These arrows indicate the different aspects of movement which are taking place at the same time. In a simple action such as rolling on the floor or on a mat, it is mainly the trunk that is involved. Children should move flexibly and with free flow, allowing gravity to help. Some children will roll in a rigid

way with controlled flow and no flexibility; these children must be encouraged to roll in a more relaxed way.

In an activity such as back-to-back pushing, it is mainly the back that is involved, although the 'sticking power' comes from the hands and feet. The attitude towards energy is one of strength, the direction is backwards, the flow is controlled, and there is an 'against' relationship to a partner.

The arrows in the diagram that relate to jumping in threes, with two people pushing the one in the middle as high as possible, describe the main thrust of the group, although they are not all doing the same action. The whole body is involved, the movement is strong in an upward direction, and the movement is on a direct pathway.

The teacher of movement must be aware of which *parts* (or part) of the body are mainly involved in an activity, which *quality* of movement needs to be established, and in which *direction* the person is moving. The children learn about themselves through partner work. The teacher can then introduce work in threes, fours or fives, and eventually in larger groups.

Laban's movement analysis provides the structure that the teacher needs to understand in order to know what to look for in human movement. As a result of this observation, the teacher can decide what to teach.

4

Observation of Movement

The ability to observe and analyse human movement is the most important skill needed for movement teaching. The most significant aspect of movement that we need to observe is *how* children move.

What to assess

The teacher or caregiver should assess the following:

1 *Children's strengths* The adult establishes those ways of moving which come most easily and naturally to a particular group of children. Their movement experiences must be successful. These different ways of moving, or qualities of movement, vary from one group to another and from one child to another. Each movement session should be appropriate for that group.
2 *Latent movement qualities* These are ways of moving which children need to develop in order to acquire a more varied movement vocabulary. It is possible to change one aspect of a motion factor: for example, children who always tend to move quickly can be encouraged to move more carefully and slowly; children who appear to have no energy can be helped to discover a little strength.
3 *Movement qualities which are absent* In some children who are disturbed, the movement pattern is lopsided: some qualities are exaggerated while the opposite ways of moving are not expressed.

Aims

The aim of movement observation is to help children to develop an all-round, balanced movement experience so that they can move in an appropriate way according to the many different physical tasks which they are presented with. Children need to be extended in their range of movement qualities and to have as rich an experience in ways of moving as possible.

Most children demonstrate quite clear preferences for certain ways of moving, and these ways of moving reflect their whole personality. Some children may find it difficult to direct their energy and to focus attention;

others may find it difficult to move flexibly and with free flow. Some children may not be in touch with their energy and appear listless and apathetic; others may show exaggerated strength. Some children may move slowly with fine touch; others may move with marked bound flow and are very tense.

Laban's movement analysis helps the teacher or caregiver to observe in a non-judgemental way (see Chapter 3). Movement sessions can be both diagnostic and therapeutic. The adult decides which activities are beneficial for children and helps the children to achieve, as far as possible, a balanced repertoire of movement experiences.

Through careful observation of movement, the teacher or caregiver can read signals given by the children and assess when it is necessary to change from one activity to another. The adult may see that the children need a new stimulus, or are ready for an activity which is perhaps more controlled, or more sensitive. Each movement session is a journey through a variety of ways of moving which the children need to experience but would normally neglect.

The ability to observe movement develops with practice. Besides being able to observe children's movement patterns, teachers and caregivers also need to be aware of their own movement preferences and limitations, because these will have a marked effect on the children they work with. Ideally, adults need to experience the full range of movement qualities themselves. They can then decide which ways of moving come most naturally to them, and become aware of the movement qualities that they tend to neglect and are less likely to incorporate into their own teaching. In order to provide a balanced, all-round movement experience for children, adults need to develop as balanced a movement repertoire as possible.

Benefits to the teacher

Two examples are given of how movement observation can help the teacher.

The teacher worked with a group of boys who were emotionally and behaviourally disturbed. They were extremely energetic and enjoyed strong, quick activities. Their concentration span was short and the boys needed to be constantly challenged with new activities, though they derived little experience from them. They each had a social work student as a partner, and during their first movement session the boys tended to dominate and exploit the willingness of their partners. They enjoyed a sense of power over the adult. Gradually though, over six sessions, they came to see the adults in a more positive light and began to relate in a more caring and sensitive way. Activities became less competitive and group work and cooperative play developed. It is important to give children like these the rumbustious experiences they crave, and then, as it becomes possible, to lead them towards experiences which touch their more caring feelings, and which are calm and quiet. This may be achieved, to a greater or lesser degree at the end of a session when the children feel

satisfied and exhausted. The adults probably feel exhausted as well, but are rewarded by getting to know a child in a non-verbal way and by the change in the child's mood from uncontrolled energy to one which is relaxed and peaceful.

The opposite situation was observed among a group of pre-school children partnered by nursery nurses. The children were happy to be safely contained and cradled and made no attempts to instigate a different activity. They were encouraged to take the initiative in different ways, for example by sitting on the adult's back while she lay prone on the floor, or by crawling under the adult when she was on all fours. These children had to be helped to find the confidence to play, to discover their energy and strength, and to initiate activities. This process took several weeks and was largely achieved by developing free flow.

Some children need to get closer to their feeling and sensitivity, others need to experience their power and strength.

Observing children

A class of children Here the teacher has to 'read' the group. As a rule the children leave the confines of the classroom full of energy. The movement experience they crave is quick, energetic and free flowing, and the teacher can find many ways of employing this energy usefully. Most young children enjoy speed, strength and free flow, though these qualities may be more apparent in boys than in girls. The content of a movement lesson for children is discussed in Chapter 5. The teacher should base the lesson on what he or she perceives the children need to experience, and should assess the different ways in which the children can extend their movement. This may involve increased body awareness and increased space awareness. Developing new ways of moving does not come so naturally to some children; for example, movement which demands sensitivity and gentleness, slowness, concentration, and the ability to 'listen' to what is going on in their own bodies. Children derive a sense of satisfaction from experiencing a variety of ways of moving, and the teacher should try to balance the opposites, although this may not be possible in the beginning.

Sometimes, rather than taking a lesson relevant to the needs of the majority of the class, a teacher may steer the activities towards the particular needs of one child. This child may be disruptive or extremely lacking in confidence.

The skilled observer of movement will be able to take movement ideas from different members of the class. This encourages the children to work hard because they realise that their efforts are being noticed, and also encourages the children to be inventive in developing the teacher's ideas. The greater part of a movement lesson can grow from what the children discover for themselves, as long as the teacher is quick to see innovative and educationally valuable ideas. The children gain a great deal from trying out each other's movements, and from learning from each other.

Babies A baby's earliest movements can be described as 'global' – all its limbs move vigorously in a random way. Its legs kick strongly and quickly and, as the knee joint is a hinge joint, the action of kicking is direct. A baby's grasp of the adult's finger can be so strong that the adult, pulling the child by both hands, can raise the child a little way. This is best done when a baby has developed head control. Fine touch can also be seen in a baby's hand and finger movements, and a baby will pass a toy ring carefully from one hand to another. Carefulness involves bound flow and sustainment as well as fine touch. These fine touch and careful movements are accompanied by a direct and focusing gaze. The child demonstrates directness especially with the eyes, and every encouragement to direct attention should be given. Reaching movements are at first uncontrolled, but gradually the baby learns to make direct movements in attempts to grasp objects.

A baby shows flexibility when he or she attempts to roll over. As one part initiates the turn, the rest follows. A baby's body is also flexible when he or she squirms in pain; this squirming is a mixture of flexibility and strength, producing counter tensions in the body. When placed face down a baby will demonstrate strength by lifting the head and will eventually push against the supporting surface. Strength is seen in all movements against gravity.

Body awareness is seen when the baby plays with the feet and hands. The adult can feed in bodily sensations by tickling, patting, stroking and rubbing the baby's body. Initially the baby is only able to relate to those parts of the body that are easily seen.

Young children As already stated, most young children enjoy quick, lively, energetic movement. They enjoy repetition of movements and many respond to music and enjoy rhythmical movement. They move spontaneously and rarely show signs of exhaustion or tiredness. When young children work with adolescents or adults they enliven the proceedings with their energy and enthusiasm.

Young children respond well to the challenge of gaining body mastery, whether it is body awareness or developing skills on large fixed apparatus or small apparatus. The movements which they find difficult are those which require fine touch, sustainment, and controlled flow, and those which are restricted in size. Reading, writing and mathematics require close concentration and movements of hand and eye on a small scale, which do not come easily to the young child. These skills may be tackled more willingly if the child has first had the opportunity to express his or her abundant energy.

Older children Older children, while still retaining their energy, are more able to control their movement and can develop a rich repertoire of ways of moving. Children aged between nine and eleven are perhaps at their most able and they can develop a high standard of body mastery, a wide range of movement qualities and can work well with each other. They are capable of many skills and agilities and they are physically confident. One should aim to help children retain this ability, and confidence should be encouraged during adolescence; sadly, it is often lost.

Children with severe learning difficulties

It is impossible to generalise about the movements of children with severe learning difficulties. However, it is possible to say that on the whole they do not display the opposites of strength and sensitivity or fine touch. They move in a middle register of movements which are neither strong nor gentle. Their movement generally is in the middle range, neither free flow nor controlled, neither flexible nor direct, neither quick nor sustained. Progress is made when these children develop some degree of body awareness and when they acquire some strength and gentleness, often against or with a partner. They will also risk a little free-flowing movement, and may acquire some ability to control movement. Concentration requires strength, direct attention and controlled flow, and these qualities can be developed. These children can also acquire a degree of flexibility in the body and an awareness of space around them. On the whole progress is slow but rewarding.

Down's Syndrome children

Children with Down's Syndrome vary but when they are young they have marked free flow and great flexibility of movement. In fact both these qualities of movements are often better developed in Down's Syndrome children than in children in mainstream schools. Some Down's Syndrome children develop a good degree of body awareness, and with good teaching many can take part in movement lessons along with mainstream children. Some of these children may become stubborn and dominating, but others are able to use strength in a positive way. Their difficulty may lie in fine motor control and focused attention. Socially the Down's Syndrome child is likely to be responsive in relating and taking care of other children. On the whole they are a joy to teach and usually have good feeling which is reflected in their well-developed free flow, flexibility and sensitivity to other people.

Hyperactive children

The main characteristics of a child who is hyperactive are exaggerated speed, free flow, and strength. The energy that such a child expresses is extremely disturbing to other people and is exhausting to deal with. The child does not concentrate or direct movement, but may be observant in a fleeting way. A hyperactive child shows no interest in his or her own body and avoids relationships. Many of these children like to be as high up as possible and will climb to dangerous heights; they avoid being grounded.

It is possible to form a relationship with a hyperactive child; strategies for doing this are discussed in Chapter 7.

Children with autistic tendencies

The main characteristics of movement in a child with autistic tendencies are bound flow, sustainment, and fine touch. These movement qualities are often accompanied by long periods of directed attention. Such a child is often obsessed by one particular object. He or she shows no interest in developing body awareness and avoids making relationships, but it is possible to get through to such a child in a one-to-one relationship. Ways of helping the child with autistic tendencies are discussed in Chapter 7.

Emotionally and behaviourally disturbed children

Again there is a great variety among children in schools for the emotionally and behaviourally disturbed. They mostly show extremes of movement qualities: one child will have enormous strength, and another no strength at all; one child will move hastily, and another will hardly move at all; one will demonstrate exaggerated free flow, and another will move with very bound flow. Most of these children show no interest in developing awareness of their own bodies and many find it extremely difficult to relate to another person.

These children respond to movement teaching if they have a good relationship with a member of staff, or if they are in a one-to-one situation with helpful adults, or even with older children. The emotionally damaged child is often intelligent, living in a world where he or she can trust no one, but if the child finds it possible to trust another person, that child has the potential for development. An aggressive child can show his or her tender side as a result of movement experiences in relationship play, and a withdrawn child can begin to relate and respond to other people. Whereas the development in children with severe learning difficulties is slow, the development of emotionally or behaviourally disturbed children can be sudden, dramatic and very rewarding.

The questionnaire on pages 67–8 was originally intended for teachers of children with severe learning difficulties, but it can be adapted according to the needs of other children.

Child's Name ... Age

Approximate level at which child functions ...

...

Observation of relationship between child and partner

1. Can child let partner take his or her weight? Partially ❑ Fully ❑

 In which activities? ..

 ...

2. Can child make eye contact? Yes ❑ No ❑

 When did this occur? ...

3. Does child like being contained? With free flow ❑ With support ❑

4. Can child take care of partner? Yes ❑ No ❑

 In what ways does child take initiative? ..

 ...

5. Can child balance with partner (mutual trust and support)? Yes ❑ No ❑

6. Can child understand what partner says? Yes ❑ No ❑

 Does child respond to voice sounds? Yes ❑ No ❑

7. Can child speak? Yes ❑ No ❑

 What words are used? ...

 ...

Observation of child's self-awareness

Whole body

8. Can child trust own weight on the floor? Partially ❑ Fully ❑

 In which activities? ...

9. Does child enjoy free-flow movement? Yes ❑ No ❑

 In what form? ...

67

10. Can child be firm and stable? Yes ❑ No ❑

In what ways? ...

11. Can child direct and control strength? Yes ❑ No ❑

In which activities? ...

12. Is the child aware of his or her middle? Yes ❑ No ❑

Can child curl up? Yes ❑ No ❑

Parts of the body

13. Is the child aware of knees?

In sitting (no weight) ❑ In standing (weight-bearing) ❑

14. Is child aware of others parts of the body?

Feet ❑ Hips ❑ Hands ❑ Elbows ❑

Face ❑ Back ❑ Stomach ❑

General Observations

15. Can child relate to another child? Yes ❑ No ❑

To two or more? Yes ❑ No ❑

How? ...

When? ...

16. When did partner and child make the best contact? ...

...

17. When was child most involved? ...

When did child concentrate best? ...

18. How did trust and confidence develop? ..

...

...

68

5

Content, structure and methods of teaching

Children with severe learning difficulties

The introductory session

Children with severe learning difficulties are usually in quite small classes, perhaps of six to ten children. These small numbers are necessary because the class will include children with a very wide range of abilities and disabilities. If you are a teacher working with a class of children for the first time, it is important to establish the group, and to help the children to relate to you. First of all, it is important to learn each child's name; to help with this, and to give the children a sense of security, ask the class teacher to join the group. Call the children to come and sit down close to you so that everyone is in a close physical group. To learn each child's name, put your hand on the shoulder or knee of each child, one at a time, and make eye contact. Tell the children your name, having first established if the school uses surnames or first names. This introduction is significant because the children have time to get to know you and they enjoy seeing if you can remember their names.

If the group is shy and intimidated by the situation, you can gather the children together at one end of the room, sitting on a mat. In order to establish the group further, ask them all to move backwards on their bottoms with you, then all move back into the group again, close to each other. Moving on bottoms is done by pushing on the floor with the hands and feet. Do not ask the children to sit in a circle, but note which children sit on the outside of the group. Repeat this several times, moving backwards away from each other and towards each other, making it more interesting by moving into the group more quickly than when moving away. This emphasises the meeting of everyone together.

After a final movement away from each other, lie on your stomach and ask all the children to do the same. There is now more room between the members of the group, who are probably almost in a circle. Again move forwards towards each other, pulling with hands and elbows on the floor, then push with hands and move backwards away from each other. Eye contact between the children and the teacher or teachers is encouraged by the floor level, which limits the eye's range of vision. Some of the best eye contact is made along the floor. Everyone can lie on the floor and smack

the floor loudly with the hands, a kind of drumming which the children enjoy.

When the children have moved backwards and the class has opened out, sit up and ask them to sit up as well, then spin round on your bottom and ask the children to try this. Push hard with the hands and ask them to do the same. Someone always falls over – this should be taken up as something for everyone to try, so that the activity becomes one of spinning, falling and sitting up again. Choose a child with a particularly skilful tumble and ask that child to demonstrate, and then ask everyone else to try to do the same. Gradually the group expands as children realise they need more space for this activity. It is important not to ask the group to spread out; they will make the decision to find a suitable space for themselves when they are ready.

The next development is to ask the children if they can roll. You may need to demonstrate this for a less confident class. Again, you can ask a child who rolls easily to show the rest of the children. All the time these activities are going on, call out and praise individual children by name and encourage everyone for the slightest effort. If one child sits and watches and does not join in, do not worry about it. The child is usually noticing everything that is going on and he or she may join in eventually.

Usually these activities are novel to the children. They join in because the teacher participates in the activity, and encourages and is interested in the individual members of the group.

According to the response of the class and to their ability, you can go on to develop the introductory lesson in different ways. You can call them all together and say, 'Shall we run round the room?'. If the group looks eager to do this, everyone sets off round the room; some will run freely, and some, for example those who are physically handicapped, will do their best.

Progressions In the sequence of events described above we move from restricted movement to much freer movement; from rather bound-flow movement to the free flow of spinning and rolling; and from movement at ground level to moving away from the ground in standing and running.

Security This sequence of activities begins with the security of the group and the security of the floor. The children also develop some security in their relationship with the teacher, and the fact that he or she uses their names plays a key part in this. The fourth type of security – security from the centre of the body – is helped by the falling and rolling activities, when the children feel their backs and stomachs against the floor.

The lesson

If a teacher knows a class well, a good place to begin is to have the children sitting in a circle with their legs stretched out in front of them. The teacher sits with them. The children begin by patting their knees, then bend and stretch their knees while holding them. The teacher accompanies this with the voice and when the knees are pushed straight, everyone can make a sound such as 'whoosh'; the movement should be quick.

SUGGESTED PLAN FOR A LESSON

1	Establishment of the group (children, teacher, teacher's aide). Emphasis on coming together.
2	Enlargement of group. Relationship maintained over a larger area.
3	Movement becomes more individual. Weight management in spinning, falling and sitting up. Development of capacity to make sequential movements. Variety of ways of doing this encouraged.
4	Rolling. Free flow of weight (contrast with rolling stiffly if necessary). Variety encouraged.
5	Away from the floor: running and jumping. Use of space increased.
6	Lesson develops to encourage self-awareness. Possible developments according to needs of class. * If children unaware of knees, spend short time on knee awareness. Repeat running involving use of knees. * Running, falling down and rolling. Sequential movement experience. * Jumping (What helps child to jump? Elbows, knees.) * Return to floor, spin on stomach. Creep along floor. Slide along floor on the back, using feet to push with.
7	End with *either* partner work: * rolling partner, or * sliding partner, or * cradling partner *or* group work: * whole class rolls or slides the teacher (if class is small)

The teacher can then go through some of the activities described in Chapter 2, working on awareness of knees without bearing weight, then move on to activities which are freer and for which the children will be ready, for example skipping or galloping round the room with high knees. After this, the teacher can again 'anchor' the children and introduce activities at floor level which help the children to manage the weight of the body in falling and rolling activities. In early lessons, the teacher will have to call the children together to show them the activity so that it is clear what he or she wants them to try. Later, when a good relationship has been established, the children will understand what is wanted and the demonstration will not be necessary. However, children always enjoy activities more if the adult joins in. Teachers become skilled at initiating a new activity by joining in and observing carefully any variations that children may develop, by accident, which it would be helpful for all the children to try.

Teachers of children with severe learning difficulties have to participate more in their movement lessons than teachers in mainstream schools because mainstream children understand language better and move with greater mastery and confidence. Teachers who participate in movement classes make good contact with their children; indeed, many teachers of children with severe learning difficulties say that they get to know their children better in movement classes than in any other lessons.

The teacher may feel that the children need to experience the freedom of running round the hall or gymnasium at the start of the lesson, coming to ground-based work at a later stage. The teacher should always remember though that children learn more about their bodies against the floor than when they are standing.

Whatever stage the teacher has reached with the children, the second part of the lesson should, if possible, involve partner work. Here the teacher may demonstrate rolling a child, showing the children how to look after their partners as they roll them, and also pointing out how relaxed the child is who is being rolled. The teacher may lie down and ask two or three children to roll him or her. The children can be arranged in partners, and anyone who finds relating very difficult can be partnered by the teacher or the aide, if there is one.

The teacher may decide to introduce sliding a partner (see Fig. 8) and can show the children how to do this. If the class involves older children helping younger children, then the older children will have been shown how to do this in their own movement classes. If the teacher is working on his or her own, the children can all give the teacher a slide. In this case the teacher provides a focus of attention for the children.

Children with severe learning difficulties enjoy sitting back to back, one partner pushing the other along the floor. See-saws are another easy partner activity, or one child can make an arch through which the partner creeps or crawls (as in Fig. 36). The basic plan for movement lessons with these children is to begin with self-awareness and then to move onto awareness of a partner. Partner work may develop so that three or four children work together, or even as a group.

It is possible to combine classes of children where there is only one or two years' difference in ages. In this case the two teachers share the

lesson, perhaps with the help of their aides. The children enjoy the stimulus of other children to work with, but during the lesson the teacher may give each child a somersault over the shoulder, maintaining the teacher-child relationship. Lessons can end with a caring relationship of one child cradling another (see Fig. 1).

Primary or secondary school children can be brought in perhaps once a week to work with a child each. The whole lesson is concerned with development through relationship play (see Figs. 36 and 37, and pages 5–36).

Ideally there should be some form of physical activity every day for children with severe learning difficulties. This could be swimming, work on large fixed apparatus, work with small apparatus, movement, riding, outdoor pursuits or possibly dance and drama. Some teachers at the beginning may find it difficult to sustain a movement session for half an hour and could begin by teaching some activities which encourage body awareness and body mastery, then move on to work on or with apparatus, or even have a session on drama.

In the beginning it is difficult for children with severe learning difficulties to concentrate on their own bodies because they are more familiar with activities in relation to objects. This means that their attention span may be short and their interest hard to maintain, and the teacher may feel at a loss. However, if the teacher is convinced of the value of what he or she is doing, and is enthusiastic, the children will gradually learn to relate to their own bodies and to others, and their attention span will increase.

The development of body mastery and the capacity to relate to other people will help these children in all the other aspects of physical education in which they take part. It is best if they change into shorts and tee-shirts for physical activities. This gives them practice in dressing and undressing, and it helps them to move more freely. Children and visitors should be encouraged to work in bare feet if possible, as this helps the feet to develop greater sensitivity.

Children with moderate learning difficulties

Children with severe learning difficulties do not understand that they are in a special school and are not aware of having failed to enter a mainstream school. Children with moderate learning difficulties are aware that they have failed, and they are likely to have many emotional and social problems. Physically, many of these children are capable of being as able as mainstream children, but they often have a very low sense of self-worth. One sign of this is that they may have difficulty in making eye contact.

The teacher has to assess in which activities the children will feel safe and successful. The class may have a great deal of energy, or they may be diffident and unwilling to move and commit themselves. The teacher needs to select appropriate activities for that particular group of children in order to promote body awareness.

36 A middle school girl
working with a young
child with severe
learning difficulties

37 Middle school boys swing
a boy with severe
learning difficulties

Children with moderate learning difficulties can gain confidence and self-esteem by participating in physical activities, because they are more likely to be successful in practical activities than in intellectual ones. It is very important that these children are successful in developing what skill they have, and experience a sense of achievement. The teacher has to be aware that he or she is working with children who have been emotionally damaged and who have experienced failure.

One group of children with moderate learning difficulties partnered children with severe learning difficulties. The children with moderate learning difficulties had experienced failure in physical education lessons in their own school, but in the school for children with severe learning difficulties they were successful and felt important in movement classes with the younger children. Evidence of this is that they never missed their weekly sessions in the school for children with severe learning difficulties.

Movement classes were held early every morning in one school for children with moderate learning difficulties aged seven to eight. The lesson often lasted an hour because the children kept on reminding the teacher of activities they wanted to do which she had left out. The teacher found that afterwards the children settled down to work in the classroom in a much better frame of mind than when they went into the classroom first thing in the morning. On one occasion the mothers of some of the children came to join in the movement session, so there was one adult for each child. Two of the mothers later remarked on how much their children had gained as a result of their movement classes.

A teacher in one school for children with moderate learning difficulties was successful in involving an older class working as partners with much younger children. Figures 28 and 38 to 41 illustrate this sort of partner work. Elsewhere, youngsters from a mainstream secondary school partnered children with moderate learning difficulties, and in another school, children with moderate learning difficulties, some of them with very low self-esteem, successfully worked with younger children with severe learning difficulties. In spite of their obvious lack of self-confidence, they made a good effort to partner children who were younger and less able than themselves.

Children with moderate learning difficulties need to have some form of physical activity daily. They need to experience success in their efforts in order to develop some degree of self-confidence, they need encouragement to focus attention and concentrate, and they need help in relating to other people.

Mainstream children

Children in mainstream schools look forward to their session in the school hall, whatever form it takes. Unfortunately the hall is usually timetabled for each class only once a week, perhaps twice, and sometimes the class teacher may not take up this opportunity for the class to be physically active.

38 An older girl with moderate learning difficulties helps a younger child in her school

39 A mutual hug. An older boy partners a younger pupil in a school for children with moderate learning difficulties

40 A younger child tries to cradle an older girl in a school for children with moderate learning difficulties

41 Older and younger children meet in a school for children with moderate learning difficulties

The movement class may begin according to the children's needs, or if the teacher is not very confident, the opening activity might be one in which the teacher knows that he or she can control the children. For example, if the teacher is working with primary school children he or she can call them all together (Fig. 42), and go over the children's names. They can be asked what they can remember of the lesson of the previous week.

Running

The teacher could begin by teaching the children how to run. This requires the driving power of the legs with emphasis on the knees. It requires strong action of the elbows, and all four limbs move on a forward-backward plane. It is common to see some children swing their arms from side to side as they run, which does not contribute to the running action. The teacher can pick out different running styles from among the children – some with long strides, some very energetic, some with a marked direct intention - and ask the children to try out these methods. When the teacher says 'Stop', the children should stop as immediately as they can, taking three or four steps to slow down. The aim is to develop speed in running. The children should only be stopped in order to give them a fresh directive to improve their skill.

Falling

The next stage in development is to teach falling. For this the children work through the stages in falling described in Chapter 2, beginning with falling sideways from a position on all fours. They work up to falling from standing, and falling from a jump on the spot. The falls all end in a roll. They then return to running but the run finishes in a fall and a roll. Again, ideas can come from the children on how best to manage the weight of the body so that the fall is comfortable and painless.

Rolling

If the class has difficulty giving in to weight or letting go of weight, it is important to do more work on rolling, helping the children to experience the body giving in to the pull of gravity, before returning to running and falling. It can be explained to the children that they are learning how to look after themselves if they should fall.

Awareness of the centre

It is now possible to move on to a quieter activity, using, for example, awareness of the centre as the theme. The teacher can ask the children to spin on their stomachs, using their hands to propel them round, encouraging them to smack the floor as they go. They can then curl up face down, and move in a curled-up position with knees close to elbows and head tucked in. The teacher can move onto 'opening and shutting' animals and other forms of locomotion close to the floor. If, during the running, it is noticeable that the children are not aware of their knees sufficiently to achieve a good action in the legs, the teacher can move on to activities that 'feed in' experience of the knees, perhaps in standing, such as smacking them, holding on to them, and doing many of the activities described in Chapter 2.

Working with a partner

The next stage is partner work. Partners may have been arranged in the classroom beforehand. If any child has a particular difficulty in moving, an able, caring child can take responsibility for this child. If there is a child

42 An early years practitioner works with a nursery class

43 Middle school boys help each other to somersault

with a behaviour problem, the teacher can work with this child. Partner work may start with back-to-back rides, or with rolling a partner, or sliding a partner. If the class is new to partner work, the teacher can demonstrate the activity, or ask a few children to roll or slide the teacher. As the children become more skilled in partner work, they can move on to shared relationships and 'against' relationships (see Figs. 25, 32 and 43). The lesson can finish with containing and rocking a partner; by this time the children should be able to shut their eyes and relax. If possible, the teacher should give each child a somersault over the shoulder at the end of a lesson. In this activity the teacher contains and supports each child and each child has to trust the adult. The most nervous and least confident child in the class is usually the last in line for the somersault. This activity is a good way for the teacher to relate to every child in the class. Learning to curl up will help the children to stay curled up during the somersault.

Beginner teachers should take a lesson in which the children are earthed' or 'anchored', as they are more easily controlled when they are close to the floor. Activities include spinning on stomachs, spinning on bottoms, spinning and falling, spinning, falling and rolling. Different kinds of rolling may be developed: stiff as a log, curled up, successive and flexible rolling. Children can learn to fall with increase in difficulty of the fall. If the teacher feels confident enough, the children may be encouraged to move round the room more freely. The teacher needs to know and use names, to praise effort, and to have complete quiet when he or she is describing the next activity. To achieve this he or she may have to ask the children to sit down and listen. The teacher must also use the minimum of talking to obtain the maximum physical activity. The children should feel pleasantly tired at the end of a session and must have a sense of achievement.

It is difficult for a student teacher to see individual versions of an activity which would be useful for all the children to try, especially when classes number over thirty. There is greater richness and variety in children's movement than in adults' movement, and with practice the teacher will be able to pick out individual contributions to the lesson. It is important not to ask the same children to show their movement ideas each time, as the teacher needs to recognise the efforts of children who have a low estimation of themselves, however small their contribution may be. All the teacher needs to say is, 'Well done, so-and-so', to let the child know that his or her efforts have been noticed and appreciated.

It is always a challenge to control a large class in an open space such as a school hall after the confines of a classroom, but movement lessons give the teacher a chance to see another aspect of the children and an opportunity to enjoy an activity with the children. For some parts of the lesson the teacher may sit on the floor, and this can be a shock for children who are used to an authoritarian standing figure teaching them. Children may try to take advantage of a new young teacher and exploit the situation if they can. The teacher has to be firm and exert authority while at the same time being encouraging and appreciative of effort.

Planning the programme

The movement lesson should be carefully planned and the activities written down as a reminder. An experienced teacher will be able to see if the activities planned are appropriate and will be able to adjust accordingly. A teacher who is skilled in movement observation can have a flexible approach to the plan and will develop activities which the children discover for themselves. The teacher in this case has to concentrate hard and think quickly in selecting the most valuable variations on the basic theme. One of the most difficult decisions to make is how long a particular activity can be sustained and how long interest can be maintained. The activity is only beneficial so long as the children are obtaining a valuable experience as a result of it. Initially children do not sustain interest for very long but with practice their concentration span increases. An indication of a good lesson is how thoroughly a few activities have been explored. When a teacher starts this kind of work, he or she tends to cover a lot of ground superficially. This is because the children do exactly what the teacher asks and then stop, waiting for the next directive. Confident, inventive and energetic children will explore possibilities and will often, spontaneously, produce a lively activity which the teacher has not anticipated but which adds to the repertoire of the class.

The teacher also needs to be able to 'read' the class and see when an appropriate type of activity is needed, balancing energetic with more careful movement, free flow with controlled flow, strength with gentle movement, fast with slower movement. The teacher should, through observation, anticipate the children's physical need for an opposite type of activity before the children are even aware of this, so that the class does not become restless or perhaps over-excited. This restlessness or excitability is often evidenced by one child who acts as a kind of ther-mometer for the class. An observant teacher should not meet problems of children becoming bored or uninvolved or out of control, and all move-ment classes should be successful in fulfilling the needs of the children.

When teaching a class for the first time, the teacher will have to work in a firmer and more structured way than the teacher who has had time to forge a good relationship with the children and can teach in a more flexible way. The teacher's decision to give the children greater freedom in which to be inventive and show initiative will depend on his or her confidence and ability.

It is advisable to explain to the children why you are teaching certain activities. Even five- and six-year-old children can listen and benefit from the information.

There are some movement teachers who, while very effective, do not develop their classes from what they observe their children have discovered. Instead they feel secure with a prepared list of activities which they repeat from week to week. Gradually new activities are intro-duced as the teacher feels ready to try something new, and a repertoire of activities is developed. Each teacher has to choose a method of teaching with which he or she feels confident, and some teachers may find that a carefully structured series of activities gives them a sense of security. It is

quite common for children to demand an activity which the teacher has forgotten to include in the lesson.

It is interesting at the end of a lesson to ask the children what they enjoyed most. 'Parcels' and 'prisons' seem to be particularly popular. Some of the children will say it is the activity at which they felt most successful, such as 'being strong'.

Teaching points

1 Do not have a 'front' from which to teach but move about among the children. Give the next directive from the back or side of the school hall, or from the centre. This also gives the teacher the opportunity to give a congratulatory pat on the shoulder to children who are doing well.
2 When the children run round the room, do not indicate which way they should run, but let them make the decision. Ask them, 'Which way shall we go?'. The majority run anti-clockwise, even in the first lesson.
3 Do not say when the children should start an activity such as 'Run' or 'Off you go'. It is better if the children make their own decision as to when to begin. It is very tempting to start off a class with a command, but if one is patient the children will soon realise it is up to them when to start. The teacher can say, 'Go when you are ready'.
4 The start and end of a movement class can be an essential part of the movement lesson. For example, one successful class began with several of the children, who had left their shoes in the classroom adjacent to the school hall, rolling into the room from the classroom door. Children with severe learning difficulties can travel back to their classroom in different ways, on their bottoms or sliding a partner. (This, of course, depends on the cleanliness of the corridors.)
5 On entering the hall, it is a good idea to ask the children to practise an activity from the previous week until everyone is ready. The teacher can then call the class together and ask them what they remember from the previous lesson.

Partner work When children work with a partner, the noise level goes up as the children talk to each other. The teacher should tolerate this as long as, at a signal, the children respond and are quiet. Such a signal might be clapping the hands, or calling out in low but carrying voice, 'Sit down everyone' or 'Stop everyone'. The teacher needs to use a low tone of voice; the same tone as the children only exacerbates the general noise level.

The teacher may be working with two classes, one older and one younger, and this will contribute to the noise level. The teacher who involves large numbers needs to have a high noise threshold and be able to control large numbers.

Group work It is a sign of progress when children can work well together in groups. One of the simplest developments of this arises from partner work when

three couples join hands in a ring. They proceed to tie themselves into a knot without letting go of hands (Fig. 44). The knot is made by going under and over each other's arms. When firmly knotted the group can try to move, all in the same direction! They can sit down together, rise, and untie the knot without letting go.

Another group activity, originally suggested by a bright seven-year-old boy, is to make a tunnel through which children can creep (see Fig. 11). Several children on all fours might carry other children or the teacher in a long line on their backs (see Fig. 49). Four older children can give a fifth child a swing (Fig. 37). A 'pile' of people is enjoyed particularly by physically handicapped children.

Security As has already been mentioned at the beginning of this chapter, there are four aspects of security: security with other people in the group; security with the teacher; security in connection with the floor; and security from the centre of the body, or having a 'home'.

While children growing into adolescence feel more secure with a partner than on their own, younger children do not find it easy at first to work with a partner, and this has to be regarded as something to aim for. However, if partner work is a regular experience for young children, this will give them confidence. One reception class which worked once a week with a junior class of nine- to ten-year-olds was able to partner a class of six-year-olds from a socially deprived area. They were immediately confident in partnering unknown older children from a multicultural school.

Relating movement to classroom work

Infants enjoy writing about and illustrating movement activities which they have done, particularly if partners from an older class are involved. It is interesting to check in their drawings of the human body whether the legs are depicted as a straight line, or if knees are drawn in and the line bent. An art teacher in a school for children with severe learning difficulties noticed that one girl introduced a trunk into her paintings of herself where before the legs had been attached to a round shape depicting the head and body combined. The teacher felt this was the result of her increasing awareness of having a centre to her body.

Many forms of locomotion along the floor can be likened to movements of animals, and one can devise a lesson on evolution, beginning with creatures with no limbs who can only wriggle, and then moving on to the development of limbs and the animals that can creep and crawl and hop and spring.

A project on 'myself' or 'me' can be connected with the development of body awareness. There are many action words which can be learnt arising from movement lessons, for example 'creeping', 'slithering', 'sliding', 'rolling', 'falling', 'opening', 'shutting'. Words are more meaningful if they are connected with a physical experience.

If movement is well taught in a school, it should have an effect on the way children conduct themselves in the classroom. If older children 85

44 Primary school boys work with reception children to make a 'knot'

45 'Looking after a friend' – a 'with' relationship

46 A boy with communication and co-ordination difficulties is helped to jump

47 A nine-year-old makes a 'tunnel' for four-year-old reception class children

partner younger children within a school, this will help both groups to relate to each other and will help the younger children to behave with some of the maturity of the older children (Figs. 44 and 47). Effects of good movement teaching may be seen at playtime as well as in more organised aspects of school life. An increase in self-esteem, a feeling of security with other children in the school, and the development of skills in building relationships, can have a positive effect on a whole school.

6

Movement for children and adults with profound and multiple learning difficulties

On the whole it is teachers and physiotherapists who work with people with profound and multiple learning difficulties (PMLD), and they are faced with many difficult problems and challenges. The number of children with PMLD appears to be increasing, and there is a demand for methods which will help adults with PMLD in subnormality hospitals and in hostels. Movement for both adults and children has to be carried out on a one-to-one basis and, as the adults become heavier and more difficult to move, two people may be needed to work with one adult. Working with children and adults with PMLD can be physically strenuous and is time-consuming. Methods of working with adults are included in this section because the movement experiences involved are similar for both children and adults.

Description

People with profound and multiple learning difficulties are severely physically handicapped and have severe learning difficulties. Some may function at the level of a child of a few months old. The older people in hospitals and hostels are often institutionalised and may have deteriorated so that they are isolated and do not communicate. They may have developed self-mutilating behaviour or obsessive movements as a result of the lack of external stimuli.

The range of ability and disability of people with PMLD is very wide, so it is difficult to devise a programme which suits everyone; each person has individual needs. They may suffer from different kinds and degrees of spasticity or cerebral palsy. In this condition spasticity may occur in one or more limbs or may involve spasticity in the trunk and all four limbs. The flexor muscles are stronger than the extensors so that, for example, wrist and elbows become bent. Adductor muscles in the thighs are stronger than the abductors so that a scissor position results. Occasionally there is an extensor reflex when the handicapped person arches backwards. Some people with PMLD may be flaccid and have very little muscle tone, and others may have uncontrolled movement. Some people may have little or no voluntary movement except perhaps of the eyes. They may have no language and may not understand language, but will respond to

the tone of voice of the caregiver. They may be partially sighted or have no sight at all, and they may be hearing impaired or profoundly deaf. They may avoid eye contact. They may not be able to sit or roll over. Some people may be able to sit up, some may possibly take weight in standing with support, and some may be able to walk with help. Life can be made more difficult for those who work with people with PMLD if one or two in the group are not physically handicapped and are mobile but have marked emotional and behavioural difficulties. These people may be destructive and aggressive to others in the group.

Aims

- To help the children or adults to form relationships as far as they are able
- To feed in physical sensations which promote body awareness and control and a sense of well-being
- To provide appropriate stimuli of all kinds to help children or adults develop their resources as far as they are able
- To encourage independence and initiative wherever possible
- To improve the quality of life for the profoundly handicapped

Social and emotional needs

Supporting and containing Everyone needs to feel secure and needs to be able to relate to other people, though the ability of the profoundly handicapped to experience this may be very limited. The teacher, caregiver, parent or therapist can give a sense both of security and of confidence through activities such as supporting and containing. Supporting the weight of someone with PMLD, in whatever way, is significant, because in committing his or her weight the adult or child demonstrates confidence in the supporter and in himself or herself. Supporting can be partial or full.

Cradling An example of supporting and containing is cradling; the caregiver sits behind the handicapped person, making his or her body into a 'chair', and gently rocks the person from side to side, accompanied by humming or singing. (See Fig. 48 and Chapter 1.) Children can also be rocked backwards and forwards to the point where the child is almost upside down. This is much enjoyed by children, and is also enjoyed by adolescents, but the supporting partner in this case has to be particularly strong. The free flow of the cradling helps to reduce spasticity, promotes a relationship between supporter and supported, and prepares the handicapped person for further movement experiences. Cradling can be used as a preparation for speech therapy.

Supporting The caregiver can lie on his or her back and support the handicapped person full length along his or her front (see Fig. 6). The handicapped person lies face down with arms and legs spread out on each side of the

48 A senior boy in a school for children with severe learning difficulties supports
and contains a girl who has profound and mutliple learning difficulties

caregiver. This is probably the best position in which to achieve relaxation. The caregiver embraces the handicapped person and may sway gently from side to side. This is a good position for achieving eye contact, although the caregiver may be dribbled on.

The supporter can lie face down and the handicapped person is laid along the caregiver's back, also face down. Again the limbs are encouraged to fall to each side of the caregiver's body, unless the handicapped person has tense, spastic legs and arms. It is often difficult to open out an adult who has developed a curled-up, flexed position, but it can often be achieved by gentle means, and gradually the stiff, institutionalised adult lets go, even when this is a completely new experience. The caregiver can rock gently or hump his or her back gently. The aim of both these experiences is to encourage relaxation and to help the handicapped person feel his or her body against another human body and establish a primitive form of communication. It is possible in this situation to feel a great physical warmth. This exchange of warmth between bodies helps the handicapped person to relax. Sometimes the relaxation is better when the handicapped person lies on the caregiver's front, and sometimes on the back.

Handicapped people need to feel their bodies against the bodies of others. There are many activities which feed in to the handicapped person that he or she has a body; this can be experienced through contact with another person, or through lying on the floor or other supporting surface. Emphasis is on the whole body experience and on the trunk as the centre which connects the head to the extremities. Sensorily deprived people, such as those who suffer from rubella and have little or no sight or hearing, particularly need this kind of sensory stimulation and information.

Bouncing Another way of giving support is for the caregiver to sit on the ground with legs stretched out in front. The handicapped person lies face down across the caregiver's thighs with the stomach resting on the thighs. The caregiver can bounce or rock the handicapped person gently and this has a comforting effect; the gentle bouncing and rocking can help people who scream continuously to become quiet. Pressure on the solar plexus in a rhythmic movement of this kind has a calming effect. In this position a handicapped person can be patted up and down the spine, a sensation which is enjoyed. Gentle bouncing was used by a teacher to help a severely spastic boy who was too rigid to sit, to slowly relax until he was in an inclined sitting position in which he could be fed. The teacher sat on a chair and held the boy across her lap lying on his back. This process took fifteen minutes before the midday meal.

As described in Chapter 1, the handicapped person can lie on his or her back on a mat while the caregiver, kneeling beside the handicapped person, pulls the person onto his or her side to rest the stomach against the caregiver's thighs. The caregiver pulls on the handicapped person's hip and shoulder and then lets the person fall back onto the mat. This fall, giving in to the pull of gravity, helps the handicapped person to relax. This experience of falling should be repeated a few times, emphasising the heaviness of the drop onto the back.

Horizontal rocking The sensation of the free flow of weight can be increased by horizontal rocking in which the handicapped person is pulled up on one side towards the caregiver, allowed to fall back, and then pushed gently up onto the other side and again allowed to fall back. This experience can reduce tension in the neck and can have a relaxing effect on the whole body.

Rolling It may be possible to encourage the handicapped person to initiate a rolling action. If a child is involved, the child lies on his or her back. The caregiver bends the child's right knee across the child's body, thus making it easier for the child to start to roll to the left. A roll can also be started by gently pulling the right arm across the body; the caregiver lies on the floor and makes eye contact at floor level. The child's head may have to be turned or the child may voluntarily turn the head in order to look at the caregiver, who uses words of encouragement.

Sliding Sliding along the floor is an enjoyable free-flow experience and this can be done with the handicapped person lying on his or her back on a blanket (see Fig. 10). A child who is very thin can be slid on a sheepskin rug.

Swinging Adults with FMLD who have neck control can be swung by four supporters each holding a limb, and they will enjoy the free-flow movement and attention of four people; some tense adults may let go of the tension in their limbs. Children who are flaccid and do not have muscular control, and those who are very spastic, can be swung in a blanket. The handicapped person can be carried on the backs of supporters who are on all fours, and gently swayed (Fig. 49).

See-saws See-saws can be done in threes with the handicapped adult supported by a caregiver sitting behind, while another caregiver sits in front holding the handicapped person's hands. Between them they help the handicapped person to lean backwards and forwards. Eye contact may be achieved here and the action can be accompanied with a song. If the caregiver is working with a child, only one caregiver seated in front is usually necessary.

Enjoyment comes from the free flow of weight and is experienced through such activities as cradling, rolling, sliding, bouncing, swinging and rocking. Free-flow movement of the whole body produces a harmonious state and helps the person with PMLD to relax, to trust other people and to begin to communicate.

Stages in relationship play

At first the person with PMLD receives experiences passively. Then there may be some signs of a response so that the caregiver is made aware of which activities the handicapped person prefers and enjoys. The person with PMLD may indicate that he or she wants to repeat the activity.

Obsessional movements begin to disappear as the handicapped person finds the movement experiences interesting and involving. The handicapped 95

49 Seniors in a school for children with severe learning difficulties support a girl who has profound and mutliple learning difficulties, and sway her gently

person starts to initiate activity and the caregiver should respond to these signals and make use of the activities to increase the handicapped person's repertoire of movement.

The handicapped person may be able to look after the caregiver in different ways, such as pulling the caregiver up in the see-saw movement, or cradling the caregiver or another handicapped person. This is important, as people with PMLD have little opportunity to look after someone else.

The role of the caregiver

Communication skills

The caregiver has to develop his or her communication skills in order to help handicapped people to cooperate and to extend their movement vocabulary and experiences. Eye contact and facial expression are important, as many people with PMLD respond to facial expression, voice and movement. The caregiver should whenever possible be at the same eye level as the handicapped person, and may sometimes be lower, giving the handicapped person an opportunity to look down at the caregiver.

Voice

Voice is particularly important as a means of communication, and voice sounds – humming, singing, and the use of descriptive words – all support the movement experiences. The voice should be kept low, quiet and encouraging, and it can also enhance the fun and enjoyment of the activities. The voice can be used rhythmically to accompany movement and the caregiver requires sensitivity in finding the right rhythm to suit each person. The voice therefore is a more appropriate accompaniment for activity than music; when music is used as an accompaniment to movement, the rhythm is imposed from an outside source and may not be appropriate. The handicapped person may make sounds during activities and the caregiver should respond to these either by imitating the sounds or giving a vocal response as though a conversation had developed. People with PMLD may even join in singing.

The caregiver starts with an activity which the handicapped person enjoys, develops variations on this, and gradually introduces activities which the handicapped person needs but would have initially rejected. The aim is to extend the range of movement experiences and to do this the caregiver may have to be firm but is also rewarding and encouraging. Some adults with PMLD may reject all human contact, and a few may be aggressive, and the caregiver may have a struggle to begin with. A calm approach and a sense of humour are very helpful, with the emphasis on play rather than on coercion. Sometimes the handicapped adult will observe that everyone else is enjoying themselves and will eventually consent to join in. Playing, and enjoying human contact, may be very strange for some adults. As the handicapped person finds the sensations enjoyable, and not threatening, resistance gradually decreases.

The caregiver has to be generous with his or her energy and the use of the body as a teaching resource. The shared experience is rewarding for both participants but is demanding for the caregiver, particularly when working with large adults with PMLD. A team of people working 97

together, partnering the handicapped in a movement session once a week, can make the job of building relationships and of feeding in necessary movement experiences more enjoyable and feasible.

Physical needs

While movement experiences can help to contribute towards the social and emotional needs of people with PMLD, their physical needs are also met by movement experiences, which help to reduce tension and promote some degree of self-awareness. Tension can be reduced by gentle stroking and by various free-flow experiences.

Some people with PMLD need to develop their strength, however limited this may be. Anti-gravity muscles need to be developed wherever possible. The significance of the development of back and neck muscles is described in Chapter 2. People with PMLD should be placed face down for some parts of the day, either in a lying position or supported by a wedge in a reclining diagonal position; this latter position allows the hands to be free, and both positions encourage symmetry of the body, which is very important for those people who have spasticity down one side of the body. There is a tendency for people with PMLD either to sit propped-up for long parts of the day, or to lie on their backs. Profoundly handicapped people will resist new positions, especially if they have spent many years lying on their back. Wherever possible, back muscles need strengthening in order to achieve a sitting position, and legs need to be strengthened in order to take weight in standing. A prone board inclined at an appropriate angle can help the handicapped person to stand in a stable position and develop some strength in the legs and, as in sitting, the hands are free to play with objects.

In order to help people with PMLD to get into a crawling position, a foam cylinder can be placed under the stomach and the person can be encouraged to take weight on hands and knees. The handicapped child, lying face down, can be pulled up into a crawling position by the caregiver, who stands astride above the child and who can adjust the support necessary for the child. If the child is small, the caregiver can support under the trunk with one hand while the other helps the limbs to move forwards in a crawling action.

Locomotion Profoundly handicapped people need encouragement to move independently, if this is at all possible. This may develop through rolling, creeping or crawling, eventually leading perhaps to standing and walking.

The physiotherapist is the best person to advise on suitable sitting and standing positions. Each person will need a different solution to his or her problems. The profoundly handicapped need to be manoeuvred gently into different positions during the day and should not be left in one position for a long time. The lifting and handling involved is best supervised initially by a physiotherapist.

Movement in water Water provides greater freedom of movement for profoundly handicapped people; they benefit from the increased range of movement,

increased relaxation, and the stimulus that water can give. It is possible for some people with PMLD to move independently in water. Water is particularly helpful to those who suffer from rubella and who are profoundly handicapped both visually and aurally. People who are profoundly handicapped and whose bodies are asymmetric owing to spasticity on one side of the body, will have difficulty in balancing in water and some kind of inflatable support may be used. Each person with PMLD will need the support of a caregiver. For this, young people from secondary schools can partner the handicapped, under supervision.

On the whole it is necessary to have the water temperature several degrees higher for physically handicapped people. Hydrotherapy pools are warm and shallow, but in some places they are too small for more than a very few people.

Feeding and toileting These ministrations take up a large part of the day for people with PMLD and it may be difficult to make time to give individual attention to everyone and to carry out the activities described. The same muscles are used in talking and eating. Some children have to be helped to masticate and gentle massage of the cheeks can be helpful. Cooperation with the speech therapist is also very helpful.

Planning a programme

It is a great help to people with PMLD if they can have a movement session once a week, when work can be done on a one-to-one basis. Ideally they also need a session in water at least once a week. Much movement work can be done in the classroom with individuals by the teacher and aides, with help from the physiotherapist. There is a tendency for profoundly handicapped children to stay in their classroom all day, but it is valuable for them to be active in the school hall and have the stimulus of fresh people to work with. One way of providing a one-to-one working relationship is to enlist the cooperation of senior children with severe learning difficulties in the school, and to teach them how to carry out simple activities under supervision in movement sessions (see Figs. 6 and 48).

It is advisable to start a stimulating movement programme while children are young, to keep their bodies as mobile as possible and to teach them to accept and to make relationships. It is a very important contribution to the progress of children with PMLD if their parents can be involved in movement sessions, so that teachers, physiotherapists and parents can all work together for the benefit of the children. Carefully planned activities should be started as early as possible both at school and at home.

The situation is more difficult in hospitals and hostels for adults with PMLD, but where physiotherapists have initiated movement sessions involving a team of helpers, they have observed that the behaviour of these institutionalised adults has improved.

7

Movement for psychologically disturbed children

This chapter describes activities which can help those children with whom it is difficult to make relationships. These are children who actively avoid relationships; they present us with a particular challenge. They are rewarding to work with but they may be very testing. Such children have individual needs and the following examples are included here to show how relationships can be developed in different ways.

Children with autistic tendencies

These children can be helped to relate on a one-to-one basis.

Stephen was tall for his age, pale with delicate features, and joined in movement sessions in his school for children with severe learning difficulties with the help of an older boy from a school for children with moderate learning difficulties. Stephen had movement sessions over a period of three or four years. During this time he acquired the confidence to join in all the activities and voluntarily committed himself to being supported by older children. He made progress through participating in simple and non-threatening partner experiences (as described in Chapter 1). He slowly learnt both to trust other people and to trust himself.

One young woman in an adult training centre initially resisted partner work. She gradually gained confidence and began to relate to a partner, losing her strong resistance to physical involvement. Over the space of a year she began to enjoy relationship play partly through seeing the enjoyment and participation of the others in her group.

A postgraduate student spent one day a week for six weeks trying to make a study of a small boy with autistic tendencies. Like so many similar children, he loved music and watching the record player. He avoided contact with the other children and was always on the edge of the classroom. He consistently avoided the student by running away from her. Towards the end of her study, I was asked to supervise her, and I suggested that we went into the school hall. There I slid the boy along the floor by his ankles so that he could enjoy the free flow of sliding. I obtained good eye contact with him because he was surprised to see someone so much higher than he was in this unfamiliar situation. I got down to floor level and worked with him carefully, doing see-saws and cradling, then asked the student to place

the boy astride my back while I was on all fours. In this position I swayed gently forwards and backwards, and when I felt he was secure, I took him for a careful ride. At the end of about ten minutes of playing together, I sat down with the boy between my legs and he leant back against me. He was relaxed, trusting me. I then asked the student to go through the series of activities which I had just done with the boy, which she did. When the student and boy stood up to leave the hall, the boy lifted up his arms, indicating silently that he wanted her to pick him up. The student was very moved because, after weeks of frustration, she had at last got through to him.

Hyperactive children

There are various strategies which can be used to relate to hyperactive children.

On one occasion a physiotherapist lay across and on top of a particularly noisy and energetic boy in a hospital in Norway. She squashed him, and used her body to roll him. This had an immediate effect and from then on he related to her, and he no longer ran shouting round the hall. In the same session another boy who could not speak but could only grunt, lay on the floor on his back shaking an arm and a leg in the air, demanding to be swung. He got his swing but he was swung round with his back sweeping the floor by a student, so that he had the free-flow experience combined with being earthed at the same time.

I was once in a school hall with a highly disturbed group of children. One boy ran constantly round the hall. I caught him in mid-flight, held him round his waist facing away from me, gave him a swing and then released him. He continued running. I caught him and swung him again. I did this three or four times. Then my attention was distracted and I failed to catch him. I felt a tap on my shoulder and there he was asking for a swing. The fact that I had to hug him tightly went unnoticed because the free-flow swing was so enjoyable.

On only two occasions have I had to ask teachers to hold onto their child partners and not to let them go because the children's main aim was to run away and be chased. The first time I assigned one hyperactive boy in a mainstream school 'nurture class' to an experienced movement teacher because I knew that she would be able to cope with him. He succeeded in escaping once and I caught him and returned him to his partner. The teacher made relationship play such fun and so rewarding that the boy no longer wanted to run away and found it was more enjoyable to stay with the teacher.

On the second occasion a very active boy of eight was partnered by a woman teacher who could not cope with him. I asked her to make a 'house' with her body and hold the child firmly inside and let him watch the session. He watched the movement activities of his class and when the session was over and the other children had left, this boy went into the middle of the hall and proceeded to do, by himself, the activities which he

had been watching. This took place at a teacher's centre in Brisbane and some of the teachers in the morning group returned in the afternoon to see what the boy would do in the second lesson that day. When the boy returned in the afternoon he joined in quite normally with the other children, to everyone's surprise.

An extremely hyperactive boy came with a group of children with severe learning difficulties to work in the college gymnasium once a week for eight weeks. We made no progress with this boy. He flitted from one piece of apparatus to another. His favourite place was in the dark apparatus cupboard where he sang to himself. He would not speak but his choice of song often expressed what he was feeling. The boy's partner was a man with children of his own but he found it difficult to relate to the boy. On the last session the boy worked with a woman student on a crash mat. She was able to communicate through physical play, and the boy felt happy with her. He climbed over and under her, rolled and somersaulted, and stayed with her for the longest period he had stayed anywhere pursuing one kind of activity. At the end of the session the boy's male partner made a 'house' on all fours and the boy crept inside and stayed there. We were sad that this was our last session with the group, as we could not build on the progress that had been made. The boy's parents said the only nights their son slept well were after the days he came to our gymnasium. As he grew older the boy became more uncontrollable and his parents had to place him in a subnormality hospital.

Children who avoid relationships

While working with teenagers with severe learning difficulties in Toronto, I was told that one girl would not let anyone touch her. This is not unusual, but it is possible to help a child eventually to forget to avoid contact and to join in the activities which the rest of the children are enjoying. In this case the girl saw how much the other teenagers in her class were enjoying lying on the backs of others and being swayed gently, and she could not resist climbing onto the backs of three people side by side on all fours (see Fig. 17). She lay on them face down and they swayed her gently. Teaching staff who knew her well were most surprised.

Another teenage girl with severe learning difficulties would not let anyone near her; her reaction was to swear and to spit. However, she wanted to bounce on a trampette and accepted the support of two students - one on each side of her and therefore not face to face, which might have been more threatening. She also allowed someone to push her on a swing, another free-flow experience. She had an excellent class teacher and learnt to do forward somersaults over the teacher's shoulder. Initially she refused, saying, 'I will hurt you. I am too heavy for you,' but gradually she copied others in the class and became adept at somersaults. She was not threatened by being supported and enfolded by the teacher. She went on to an adult training centre where she joined in all the movement and physical education activities going on there.

Children learn a great deal from watching each other, so it is helpful if children who resist involvement with others are in a class with children who are not inhibited in the same way. A mixed-ability group of children can lead to a richer movement experience for all.

Maria was about twenty-two. She lived in a hostel but before that had spent many years on a ward in a subnormality hospital. She twiddled a shoelace all day and was isolated; when approached she could be extremely violent. I worked with her for just one hour on a teachers' course, but I felt I had to take a risk and invade her isolation.

A group of five teachers and physiotherapy students were working with her and observing her. We started by trying to give her a swing, holding her round the waist; this she violently resisted. Then we tried to swing her with four people holding her limbs; this she accepted only reluctantly. The only activity she allowed was to be slid along the floor, which was a step forward. A great deal was going on in the gym and she could see other people from her hostel enjoying themselves. She eventually allowed herself to be played with and cradled by a student physiotherapist who showed great maturity and courage because Maria had already attacked another student. The student cradled Maria and stroked her arms; when she stopped, Maria indicated by taking the student's hands that she wanted this to be continued. They had face-to-face eye contact and a lot of fun together. Maria seemed to know that this particular person was not afraid of her. At the end of the session the student and Maria sat hand in hand, talking, waiting for the bus to take Maria back to the hostel. It was hard to believe it was the same girl.

Unfortunately the staff in the hostel could not give Maria the attention she needed because of the demands of the hostel's many other residents who were more amenable and less violent. However, relationship play was subsequently implemented for the other residents in the hostel.

Disturbed people, children and adults, know at once if others are afraid of their reactions; they also know that fun, humour and play have a great contribution to make towards diffusing anger and violence. Some of those who work with disturbed people have enormous resources, but this session with Maria stretched those of us who worked with her to our limits.

At one time I worked in a neuro-psychiatric clinic in Rome with very disturbed young children. One boy was totally isolated; he moved around shuffling on his bottom and was only interested in objects in a box. I lay on the ground beside him and looked up at him. He was not used to seeing people below him and he gave me the deep look I have occasionally had from very disturbed children. From then on he acknowledged my presence. Speech therapy students partnered these isolated and disturbed children with great sensitivity. On the second day I was asked to show how the children could work with each other. This was a tall order, but by the end of the session one child was able to cradle another, which was surprising, as the children had very little to give each other. The people watching were very moved to see that such disturbed children could be so gentle with each other.

Emotionally and behaviourally disturbed children

Children in schools for the emotionally and behaviourally disturbed are those who have suffered emotional damage and cannot be contained in a mainstream school. These children have a great need to experience security, both emotional and physical. The children find it very difficult to make relationships, either with adults or with other children.

Working with disturbed children is challenging, rewarding, and extremely interesting. As the children are afraid to commit themselves to a relationship, work with them depends very much on their relationship with a member of staff on whom they can rely.

All children love to play, so activities have to be presented in an unthreatening and enjoyable way. Figures 16, 17 and 27 are all photographs of emotionally and behaviourally disturbed boys, which were taken by their house parent. She started movement play with a small group of about six boys before bedtime. They got into their pyjamas and used a space which was carpeted and had easy chairs. The house parent slowly built up the boys' confidence in her, and then in each other, until they were prepared to support each other. Eventually, after experiencing different ways of supporting each other, one boy was able to cradle another. It is always difficult for emotionally damaged children to get close to their feelings, so it is an achievement when one boy can be gentle with another. The boys took part in the movement sessions as fun, and did not realise the philosophy underlying their activities.

Emotionally and behaviourally disturbed children are usually quite intelligent, if not very intelligent, and they can develop ideas quickly. They can also make dramatic progress when they find it is safe to trust another person. The quality of the member of staff, or of the partner, makes a marked difference to the child. It is noticeable that very disturbed children have the ability to see which partner will be able to help them, someone they can respect and trust. In the case of student teachers, such a child will often choose the psychologically mature student. The more disturbed the child is, the more he or she will test the partner.

Many emotionally and behaviourally disturbed children take refuge in a fantasy world, and dramatic play may be a natural progression from movement. Disturbed children in schools for children with severe learning difficulties respond to dramatic play, and it is clear that some of them lead a rich internal fantasy life.

When working with emotionally and behaviourally disturbed children, progress can be relatively quick, whereas when working with children with severe learning difficulties, progress is slow but usually steady and is therefore rewarding.

Elective mutes

Children who are elective mutes often respond well to movement and dramatic play. In one nurture group a boy said 'Bye bye' at the end of his third movement session, much to the delight of his teacher.

Teacher qualities

Ideally, the teacher or caregiver who works with psychologically disturbed children needs to have the following qualities.

1 *Emotional stability*
Emotional stability and physical stability develop together; sometimes they are acquired during childhood, sometimes they are learnt to some degree during training, and sometimes they are present in the adult as a result of life experiences. The emotionally mature person knows where he or she stands; what behaviour he or she can accept; and how to cope with unacceptable behaviour. Disturbed children may test adults to their limits so that the adult has great need of inner resources.

Some teenagers are more equipped to give stability to disturbed children than some adults.

2 *The capacity to relate to the disturbed child*
The adult has to find the strengths, the growing points, in each child. This may be the result of intelligent observation, or may be the result of a decision made intuitively though based on experience. The adult needs to give the child his or her value, respect the child, and build on what the child has to give. Encouragement, appreciation, firmness about boundaries of behaviour, and constant availability, are part of the treatment involved.

The adult has one foot in the child's world and one foot in the adult's world. People who are separate can make a relationship, so the adult who is sympathetic and understanding also needs to regard the child objectively. In many ways they relate as equals; the adult learns to relate to a child who has been emotionally damaged, and the child learns to trust the adult.

3 *A sense of humour and an ability to play*
When activities are presented in the form of enjoyable play, the disturbed child finds them less threatening. Disturbed children find it difficult to commit themselves to a relationship with another person or even to allow the proximity of other people. Some disturbed children find it very difficult to play but they are attracted towards play activities, and if they can trust the adult then progress can be made.

4 *Directness and honesty*
Disturbed children usually have insight and an intuitive perception about other people, so any pretence on the part of adults will be noticed. These children may reject contact with adults because the children do not pretend and are on the lookout for adult deceptions.

5 *Resilience and stamina*
Working with disturbed children is demanding and exhausting both emotionally and physically. Teachers and caregivers need to find ways of re-charging their batteries so that they do not become

depleted. Working as a member of a team who are all operating with the same values and ideas will help the individual.

DEVELOPMENTAL MOVEMENT
a summary

Developmental movement: a summary

Each teacher or caregiver can make use of the material described in this book in his or her own way. Teachers develop their own variations and ideas, as do the children they teach.

Movement sessions can provide a preparation for many other physical activities. Children benefit from a rich and comprehensive programme and ideally this should include work with apparatus, swimming, outdoor pursuits, sports of all kinds, and different types of dance and movement activities as preparation for drama. All these activities are tackled more confidently if children have developed some degree of body mastery and have learnt to adapt and relate to other people. Developmental movement can provide a basis from which children can explore other activities.

It will be noticed that there is no element of competition in the movement experiences described here; everyone is successful in some way and everyone is praised and encouraged to pursue further effort.

Teachers have used the developmental movement described here with partially sighted and blind children, and with physically handicapped children, with encouraging results. The development of body awareness and relationships to others are significant for both these groups. These methods have also been used with hearing impaired and profoundly deaf children, who have proved responsive and quick to learn.

Developmental movement can help children in two main areas:

1 *Physical development*
- Children experience what it means to feel 'at home' in their own bodies.
- They learn to use and control their bodies in many different ways and acquire a balanced movement vocabulary.
- Emphasis is not on acquiring particular skills for certain sports or activities, but on developing general skills in the mastery of many aspects of movement which can be applied to different physical tasks the children may meet.

2 *Development of personality*
- Children acquire a stronger sense of self, of their identity, through developmental movement.
- They become more confident in their own abilities.
- They learn to use their initiative and inventiveness.
- They learn to be sensitive to the needs and feelings of others and become more skilled in communicating and sharing experiences with other people.
- They learn to focus attention on what they are doing and to learn from movement experiences.
- Children experience a sense of achievement and fulfilment when developmental movement is well taught.

Summary of activities in Chapters 1 and 2

Activity	Page no.	Development of child
I Developing relationships		
Caring or 'with' relationships		
Containing		
1 Cradling	5	security • relaxation • trust
2 Containing with support – 'rocking horses'	8	commitment of weight • sense of play
3 Containing with falling	8	security • sense of play
Supporting, commitment of weight		
4 Astride caregiver's stomach	10	trust • eye contact
5 Astride caregiver's back, caregiver lying down	10	trust • gripping with legs
6 Caregiver sitting, bouncing and patting child's back	11	awareness of stomach and back • comfort • rhythmical movement
7 Slide over caregiver's curled-up body	16	experience of body against caregiver
8 Caregiver sitting, child standing on thighs	16	balance • confidence • concentration
9 Caregiver on all fours ('horse'), child lying on caregiver's back	16	trust • relaxation
10 Caregiver on all fours, child astride back	16	gripping with arms and legs • commitment to relationship
11 Caregiver sitting, child standing on bent knees	16	balance • confidence • concentration
12 Caregiver on all fours, child on all fours on back	18	balance • confidence • concentration
13 Caregiver on all fours, child standing on back	18	balance • confidence • concentration
14 Three, four or five people on all fours, child lying on their backs	18	trust • relaxation
15 Aeroplanes	18	trust • confidence • eye contact
16 Somersaults	21	trust • awareness of centre of body • weight transference • body awareness against caregiver

Activity		Page no.	Development of child
	Rolling		
17	Caregiver sitting, rolling child up and down body	11	awareness of the body against caregiver • flexibility in trunk
18	Double roll	11	being contained and squashed (gently!) • awareness of body against caregiver
19	Child rolls caregiver	11	initiative • concern for partner • responsibility
20	Horizontal rocking	11	relaxation • awareness of body against mat or floor
	Sliding		
21	Sliding	13	relaxation • flexibility in spine • eye contact
	Tunnels		
22	Caregiver on all fours	13	initiative • exploration
23	Several caregivers' tunnels	13	initiative • exploration
24	Long line on all fours	13	
	• child creeping underneath		confidence • exploration
	• child creeping along top		awareness of body against backs • concepts of 'under', 'through', 'over', 'on top'
	Gripping		
25	Caregiver lying on stomach, child astride back	16	gripping with legs • commitment of weight
26	Caregiver on all fours	16	gripping with arms and legs • commitment to relationship
27	'Baby monkeys'	18	strength • commitment to relationship
28	Mutual hug, caregiver standing	21	confidence • shared commitment • strength

Activity		Page no.	Development of child
	Jumping		
29	In twos	21	confidence • control of weight • elevation
30	In threes	23	confidence • control of weight and strength • elevation
31	Over partner's body	23	adaptation to partner's body • elevation
32	Partner on all fours, transference of weight from feet to hands	23	control of weight • elevation
	Swinging		
33	Swinging	25	commitment of weight to supporters • free flow • relaxation
	Shared relationships		
1	Rowing the boat	25	relaxation of head • strength in pulling
2	Balancing partner, standing (see-saws)	27	sensitivity to partner • weight management • strength
3	Back-to-back balance	27	strength in legs • dependence on partner
4	Upside-down balance	27	agility • body awareness • strength • mutual dependence
	'Against' relationships		
1	Lying on top of the child, squashing	31	strength • determination
	Testing 'rocks'		
2	Child sitting, knees bent	31	strength • stability • determination • focused attention
3	Child lying face down	33	stability • controlled strength • concentration
4	Child on all fours ('tent')	33	stability • strength • focused attention
5	Children back to back	33	strength • concentration
6	Back-to-back rides	33	strength • cooperation • concentration
7	Prisons	35	strength • determination

2 Developing body awareness

Whole body

1	Rolling, sliding, bouncing, swinging	41	experience of harmonious connection of body • experience of weight and free flow

Activity	Page no.	Development of child
Parts of the body		
Awareness of knees		
2 Non-weight bearing	42	sensory input of knees • inventiveness
3 Weight-bearing, kneeling	42	sensory input of knees • inventiveness
4 'Open/shutting animal'	43	awareness of centre, elbows and knees
5 'Little legs'	43	discovery of different forms of locomotion and directions in space
6 Standing, knees bent	43	locomotion • directions in space • inventiveness • mobility in hip joint
7 'High knees'	43	elevation flight and free flow • mobility in hip joint
8 Skipping, galloping	44	control of knees • elevation
9 'Funny walks'	44	inventiveness • humour
Awareness of hips		
10 Spinning	46	hips felt against floor • free flow
11 Somersaults	46	experience of high hips and hips against floor
12 Balancing in twos	46	control of hips under body and over feet
Awareness of trunk and centre		
13 Rolling	47	trunk felt against floor • free flow • flexibility in spine
14 Sliding	47	back felt against floor • flexibility in spine • free flow • relaxation
15 Creeping	47	front of body felt against floor • flexibility in spine • coordination of limbs
16 'Parcels'	48	experience of a 'home' • body is close to itself • strength
17 Somersaults	21,48	maintaining centre • transference of weight
18 Twisting roll	50	flexibility in trunk • free flow
19 Rolling in ball shape	50	transference of weight • free flow
20 Falling		
• from lying	10,50	relaxation • free flow
• from all fours	52	transference of weight • free flow •
• from standing	52	management of body weight • free flow •
• from jumping	52	transference of body weight

Children's comments

The following are extracts from comments written by 12-year-old children from a middle school about their movement classes with young children with severe learning difficulties.

I worked with a girl called Helen who had difficulties with the things we take for granted like walking, sitting and just staying still. It was nice to do things with handiccap children because when you saw them enjoying themselves it made you feel proud because you had helped this child to do what it can.

clare.

I feel that handiccaped children need to work with normal children and like working with normal children. The handicapped children do things they wouldn't normally do and learn different things. I like working with them because they are nice to talk to and its nice to see hancapped childron enjoying themselves. I think there are quite a few things that Whittlesea children find hard but they try their best even though they have disabilities.

Joanne

P.E with the whittlesea children was a lot different to a normal P.E lesson. Bacause in a usaul lesson we dont have to work as hard were being taught, but with the whittlesea kids we were teaching them. we done all different activities like bumpy rides, briges, trying to push each other over when we were in a strong position, and we done a lot more. I think that sherborne P.E. is very good for the children. its not only good for the whittlesea kids. Its also good for us.

David

We do things like give them bumpy rides, make tunnels, stick them to the floor and try to push them over etc. The little girl we (my partner and me) had was called Andrea, and she was so cheerful. It was nice to see her enjoying it, but inside she could be hurting. So we try to relive the pain by being happy ourselves and by doing activities with her and it worked. People think that they're just an empty sole, but there not they feel, see, smell, touch, love, hate, hurt and be happy. so they're just the same as us, but they can't use them the way we do. I found their strengh hard because they're so strong. I think they find mixing with people hard because people don't want to know them, and I don't like that at all.

Rebecca

The first time we had P.E. with the handicap children I was amazed in the way that you make friends straight away and I was surprised at the helpers who just treated the handicap children like there was nothing wrong with them one of the helpers said to me "be firm with him hes being rather naughty today" I could'nt see what was wrong with his behavier he seemed well behaved enough to me. We don't get much time with them but the time we do get is a lot of fun

Paul

The difference between P.E with Whittlesea and a usual P.E lesson is you have to be a lot more patient with Whittlesea because they don't understand things as well as we do. We done a lot of activities with the little children and it was fun for both them and us. The Whittlesea children are no different to us except their ability to do things and the way they were born, its not their fault they have turned out like that. The thing i enjoyed the most was back to back.

viren

117

When we do P.E. with the handicapped children the things we do are a lot different from normal P.E. lessons, and I found it alot easier and I am not really very good at P.E. but the teachers explained that it helps them and mostly thier stomach muscles. Sometimes the boy or girl may find it a bit difficult to understand you so you learn a few simple hand sighns like stand, sit and lie down. Sometimes when the boy or girl is supposed to lie down and relax, as you straighten them out you notice just how tense their muscles are because they are not aware that they have muscles in those places.

Daniel

Additional comment from children from Hillingdon Manor and Mankkaa schools.

Sherborne movement is fun and beneficial. I could say that it does suit people with autism. I am clumsy in some ways. Movement in this form has helped me with my body awareness so that it is easier for me to learn to control my body better.

Henna, Age 15

The things I like best about Sherborne are making up movements as we go along and playing duck, duck, goose!

Jermaine age 13

Things I like doing in Sherborne are rolling from one end of the hall to the other. My friend helps me roll. It is great because people do good movements and you learn to trust your partner.

Jameson Age 11

My favourite activities in Sherborne are when we have to get to the other side of the room without walking and when we have to think up our own movement. I've learnt a lot of things from Sherborne such as learning to trust my partner. When I first experienced Sherborne I was very skeptical and now I'm very excited.

Iris Age 13

I like being like an egg I like being a parcel I like bouncing it makes me laugh

Love Kirk

Appendix 3

Comments from practitioners

The work of Veronica Sherborne is timeless. It continues to thrive in the worlds of very special people. She does not deviate from the central focus of developmental movement - the inherent worth of each individual and their potential to succeed in relation to themselves, others and the world around. The special learner is led from a world of passivity and indifference into an exuberant realisation of their own self worth and self esteem.

I am! I am a unique and valued human being!

Flo Longhorn, Consultant in Special Education, Luxembourg

As a dance, movement and physical education teacher, Developmental Movement has been the "core" to which I have returned many times in a teaching career spanning thirty years. It has been used successfully with pre-school children and students with a range of Special Educational Needs. Developmental Movement is, and can be used to support many areas of the National curriculum, and sits comfortably with the Q.C.A. Curriculum guidance for the Foundation Stage.

Alleyne Gainham Dip L.C.D.D., F.I.S.T.D., Adv.Dip.Sp.Ed, UK

Since 1984 I am working in Katrinahof, a special education elementary school for children with moderate and severe mental handicaps. In 1990 I became acquainted with Developmental Movement based on the work of Veronica Sherborne (DMVS) through colleagues at my school. Since the children come to school beginning at age 3 and leave at age 13, I have some of them under my guidance for 8 years. I saw them, literally and figuratively, "grow from the ground up", and more importantly, enjoy the movement sessions themselves. After 10 years I still remain enthusiastic with DMVS and I look in wonder at its effect on the development of the participating children.

Bart Jamine, Belgium

When I first got acquaintance with the work of Veronica Sherborne, it was the sensitive style of the interaction that interested me the most. By giving Developmental Movement in a normal school in Brussels as well as in a special school, I could feel that all the children enjoy it and "grow" during the sessions. We have a group where children with visual problems work together with other children. For the hearing impaired children, communication, taking initiative is not evident. Developmental Movement can help us and them to learn to co-operate as equal partners. After several years, I still feel the strength of the work and I am convinced to go on working with it.

Erika Malschaert, Belgium

Useful resources

Books

Bettelheim,B. *Good Enough Parent* Chapter 13
(Thames and Hudson, 1995)

Caldwell, P. *Getting in Touch: Ways of working with severe learning disabilities
and extensive support needs*
(Pavilion 1996)

Chesner, A. *Dramatherapy for People with Learning Disabilities:
A World of Difference*
(Jessica Kingsley 1994)

Chesner, A. *Groupwork with Learning Disabilities: Creative Drama*
(Winslow Press 1998)

Dibbo, J. *Caring And Sharing*
& Gerry, S. (Library and Media Services, University of Plymouth Pubs,1995)

Douglas, M. *Primary Dance*
(Hodder & Stoughton, 1999)

Finnie, N. *Handling the Young Cerebral Palsied Child at Home* 2nd Edn
(Butterworth Heinemann, 1991)

Haywood, K. *Life Span Motor Development*
(Human Kinetics, 1996)

Laban, R. *Modern Educational Dance* 3rd Edn
(Northcote House, 1988)

Laban, R. *Mastery of Movement* 5th Edn
(Northcote House, 1998)

Liedloff, J. *The Continuum Concept* Chapter 3 'The beginning of life'
(Penguin 1986)

Lindkvist, M. *Movement and Drama with Autistic Children*
(Sesame Institute leaflet)

McCurrach, I. *Special Talents, Special Needs: Drama for People with
& Darnley, B. Learning Disabilities*
(Jessica Kingsley 1999)

Payne, H. (Ed) *Dance Movement Therapy: Theory and Practice*
(Routledge 1992)

Pearson, J.(Ed) *Discovering the Self through Drama and Movement
- the Sesame Method*
(Jessica Kingsley 1996)

Piotrowski, J. *Expressive Arts in the Primary School*
(Cassell 1996)

Upton, B. *Special Educational Needs*
(Routledge, 1992)

Wright, H. *Physical Education for All: Developing Physical Education in the*
& Sugden, D. *Curriculum for Pupils with Special Educational Needs*
(D. Fulton 1999)

Films and videos

In Touch	Movement for mentally handicapped children	1965
Explorations	Movement for drama	1971
A Sense of Movement	Movement for mentally handicapped children	1976
A Matter of Confidence	Movement for children and parents in a socially deprived area	1980
Building Bridges	Movement for mentally handicapped adults	1982
Good Companions	Movement for normal and handicapped children (video)	1986

* *Selected for preservation by the National Film Archive*

Distributed by Concorde Video and Film Council Ltd, Rosehill Centre, 22 Hines Road, Ipswich, Suffolk, IP3 9BG UK Tel: 0044 (0)1473 7260112

Material relating to Veronica Sherborne and Sherborne Developmental Movement is kept in the Archive Section in the University of Birmingham Library, Birmingham, UK. It includes videos, slides & photographs of SDM sessions, papers and articles by and about Veronica Sherborne and SDM. Details of access to the Archive Section can be obtained from the Chief Archivist (Tel: 0044 (0)121 414 5838) or from the Sherborne Association (Tel: 0044 (0) 23 92 711632)

A complete list of materials is available on the Sherborne Association website www.sherborne-association.org.uk

Veronica Sherborne
1922-1990